Washington Seen

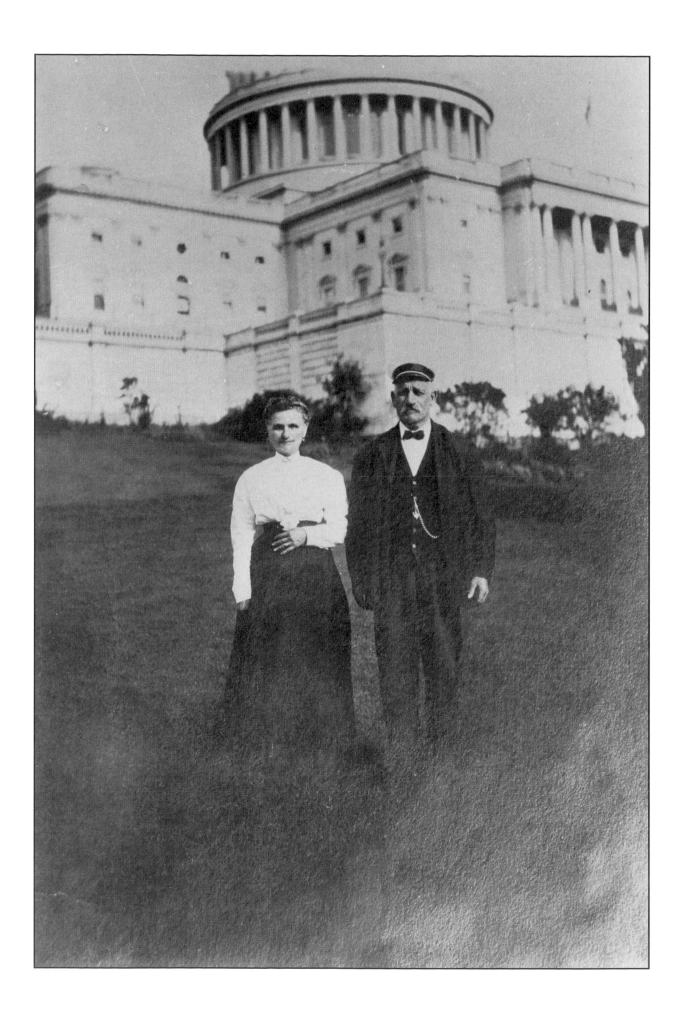

Washington Seen

A Photographic History, 1875–1965

Fredric M. Miller and Howard Gillette, Jr.

The Johns Hopkins University Press

Baltimore and London

For Naomi and Margaret

The Johns Hopkins University Press
2715 North Charles Street
Baltimore, Maryland 21218-4319
The Johns Hopkins Press Ltd., London

Frontispiece: Recently arrived Washington residents Nicola Masino, a grocer,
and his wife, Maria Rosa, circa 1910

Library of Congress Cataloging-in-Publication Data

Miller, Fredric.
 Washington seen : a photographic history, 1875–1965 / Fredric M. Miller and Howard Gillette, Jr.
 p. cm.
 Includes index.
 ISBN 0-8018-4979-9 (hardcover : alk. paper)
 1. Washington (D.C.)—History—Pictorial works. I. Gillette, Howard. II. Title.
F195.M52 1995
975.3'03—dc20 95-2948

A catalog record for this book is available from the British Library.

Contents

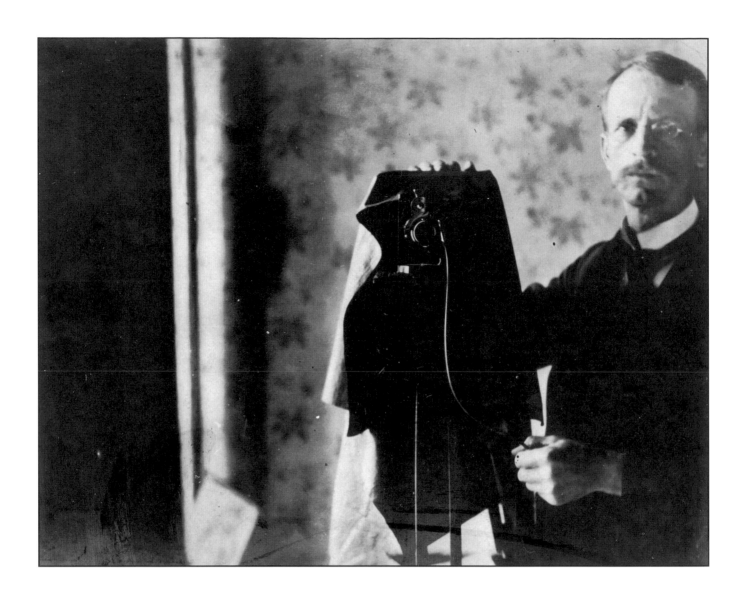

Henry Arthur Taft, self-portrait in his bedroom mirror, 1895

Preface

Understanding Washington as a city has always been difficult. This planned capital, deliberately set on the margin between North and South, can seem unique, fundamentally different from America's other great cities, with their immigrants, industries, and regional identities. Yet Washington has been, like them, a complex concentration of people, jobs, neighborhoods, and all the other components of city life. The allure of politics and monuments and the peculiar nature of government work can obscure this essential urban reality. But it can be revealed through photography. Photography can make visible the city Washingtonians created and in which they lived and can show how that community changed over time. Thus seen, Washington is not an aberration but a city both shaped by contemporary historical developments and, as a capital, linked to the very oldest urban traditions.

This book uses photography to look at Washington from the 1870s to the 1960s, a period during which it was in many ways a quintessential modern American city. Earlier, the sprawling capital lacked both a substantial population and basic urban services; afterwards, the city became only one component of a vast metropolitan area. But for most of this period Washington was dynamic and expansive, gaining new neighborhoods, rebuilding its downtown, and dominating the surrounding region. Starting in 1875 at about 150,000 people concentrated below Florida Avenue, the population doubled by the turn of the century and had doubled once again by the mid-1930s. It peaked at over 800,000 in the immediate post–World War II years. Although by then urban development had extended beyond the District of Columbia's sixty-seven square miles well into Maryland and Virginia, the city still had a larger population than all the suburbs put together. Only in the 1950s did its population start to shrink and a new metropolitan pattern clearly emerge.

Fortuitously, our period coincides with the great age of urban still photography. Photography initially burst upon the world in 1839 in the form of daguerreotypes, images fixed on specially treated metal plates and named after their French inventor. Despite the marvelous clarity which made them immensely popular for portraits, daguerreotypes had a major flaw; they were single positive images and could not be duplicated. In the 1850s they were superseded by the wet collodion glass plate, on which was produced a negative image capable of generating multiple positive prints. Exposure times remained fairly long, and this new process demanded that photogra-

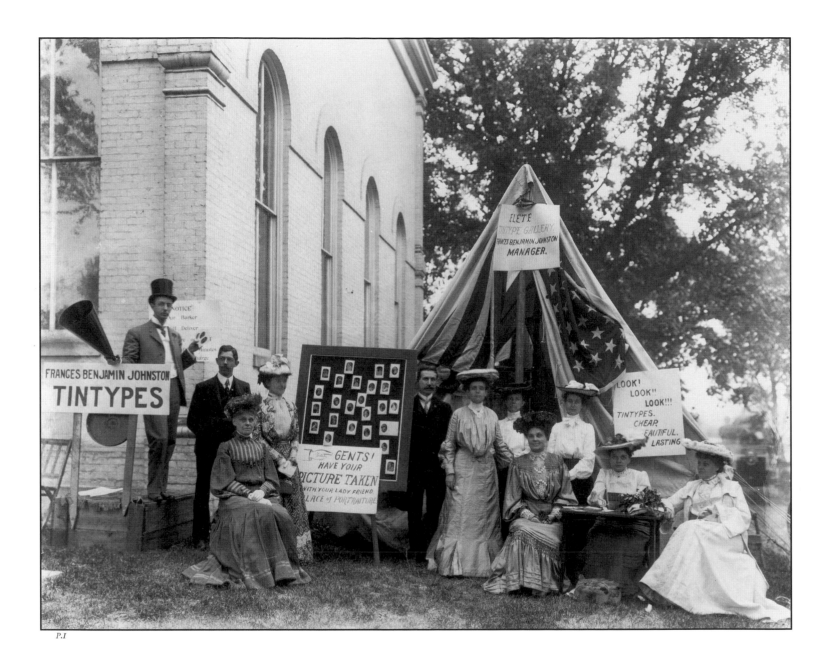

P.1

Frances Benjamin Johnston was Washington's premier professional photographer at the
turn of the century. Her projects ranged from rich examinations of daily life—in schools,
work places, and recreational activity—to documenting the architecture that characterized
the newly invigorated capital city in the early twentieth century. Demonstrating the popu-
larity of the pictural record, Johnston (sixth from right) here seeks out clients at a country
fair held in May 1906 at the Friendship estate, to raise funds for victims of the previous
month's earthquake in San Francisco.

phers coat the plates immediately before exposure and develop them immediately afterwards, so working outdoors meant carrying a portable darkroom.

Daguerreotypes and collodion glass plates were well suited to the photography of important personages and grand buildings, and early photography in Washington emphasized both. The city's first professional photographer was John Plumbe Jr., and his circa 1846 views of public buildings are its earliest surviving images. After an unsuccessful attempt in 1849, Mathew Brady established a permanent studio, managed by Alexander Gardner, in the city just before the Civil War. The war itself brought many more photographers to Washington and led to the first regular government sponsorship of photography, a practice which continued thereafter. By the 1870s professional photographers like the Bell brothers were an ordinary feature of the city, concentrating mainly on studio portraiture, with occasional illustration of important buildings or grand urban vistas. With rare exceptions, however, informal portraiture and depictions of daily life and action were still severely constrained by the technical limitations of the medium, the same limitations that had prevented photographers from capturing any battle scenes during the entire Civil War.

These limitations disappeared in the last quarter of the nineteenth century when photography as we still know it was created. A new process, using dry gelatin-covered glass plates, was introduced to America in 1879. It allowed photographers to purchase already treated plates and expose and develop them whenever convenient; no longer was it necessary to have a darkroom at hand. The new gelatin plates required shorter exposures than the old collodion ones. While a fast collodion exposure measured five seconds, having dry gelatin plates enabled photographers to shoot in only a fraction of a second. Motion could now be frozen easily, tripods dispensed with, and handheld cameras with exposures as low as one-thirtieth of a second became practical. Epitomizing the new era, the first Kodak snapshot camera using gelatin roll film appeared in 1888. Artificial flash lighting was gradually perfected and, together with electric lights, widened the range of indoor photography.

Photographers took advantage of these changes to develop a wide variety of styles and formats over the next half-century. The new technology made feasible the depiction of urban life in all its richness and variety. Official government photographers, hobbyists like Henry Arthur Taft, commercial photographers, social reformers, ordinary citizens shooting snapshots, documentary photographers, and photojournalists each viewed the city from a different perspective. After World War II, black and white still photography was itself overtaken by color photography, home movies, and television, but it left its imprint on an entire era. While we usually imagine the American Revolution or the most recent decades in color, our historical memory of the years portrayed here is indelibly drawn from photographs in black and white.

It is this photographic legacy that allows us to see not only the people and buildings of the past, but also to explore the processes, arrangements, and assumptions which shaped cities. In the late nineteenth and early twentieth centuries, scenes of Washingtonians at their jobs show us a surprising number of industrial and construction workers. They remind us who built and maintained the rapidly expanding federal complex. Shopkeepers and street vendors abound, as do professionals and office workers. Going into factories and offices, government and private photographers

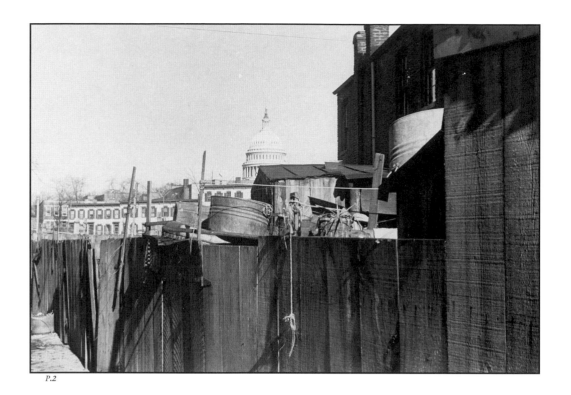

P.2

Over the course of Washington's development as a world capital, photographers with sharply defined social goals have frequently juxtaposed its official buildings with unsuitable living conditions for local residents. This 1937 picture by Farm Security Administration photographer John Vachon was but one of a number of twentieth-century images revealing the tension central to a place that was both capital and city.

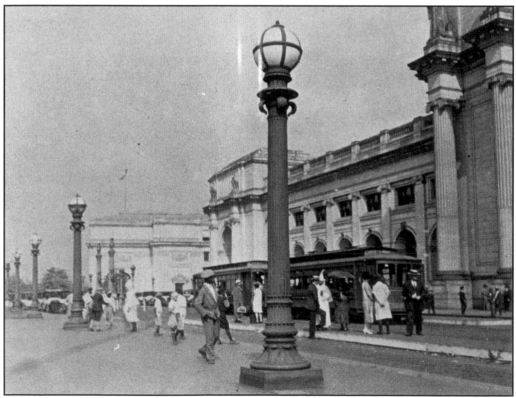

P.3

The unintentional message. A photograph taken by the city's power company to document an ornamental lighting fixture at Union Station inadvertently captures a startling scene not just of a hooded member of the Ku Klux Klan chatting with white residents going about their daily travels but also the contemplation of curious blacks. Taken August 8, 1925, as some fifty thousand members of the Klan dispersed from a march on the Capitol, the picture confirms what the Baltimore *Afro-American* reported, that however offensive to the city's sizeable black community, the march nonetheless drew a crowd of black observers.

vividly (if unintentionally) revealed that work and status were apportioned according to race and gender. Images of social life, recreation, and leisure convey a similar message. The physical evolution of the city is chronicled not only in the familiar depictions of major buildings but in the rarer views of new row houses and municipal improvements. Government-sponsored documentary photography provides many of the most arresting images of the New Deal and World War II, while two of the most crucial developments of the postwar years—suburban growth and racial integration— proved well-suited to the techniques of photojournalism.

Photography, nevertheless, has its limits. Like any other historical document, a photograph is a conscious creation, a selection of reality made for a purpose and often requiring the consent of the subject as well as the will of the creator. Because of technical limitations, most older images were taken outdoors in the daytime or, if indoors, had to be carefully posed. There are, therefore, relatively few pre-1930 informal domestic scenes depicted in this book, and the city's vibrant nightlife is similarly underrepresented. Yet the fascination of photography is that images taken for only one purpose can later illuminate a whole world of customs and social arrangements. The most striking examples in this book relate to race, from the integrated police force of 1878 to the numerous illustrations of segregation in the first half of this century and finally the efforts at integration in the 1940s and 1950s. Taken as a whole, these images help trace the complex evolution of local race relations, which has formed such a crucial element of Washington's history. Although none of these photographs was taken to make a point about race, they now seem dominated by it. They show us how photographs do not stand simply by themselves but become products of the values and experiences we bring with us as we contemplate them.

This book is thus something of a conversation with the past. It attempts to explain how Washington developed over nearly a century and to trace the roots of the area as we know it today. We begin in the late nineteenth century, a period in which the modern city emerged and stabilized after the continual turmoil of the Civil War and Reconstruction. It was during these years that the federal civil service and other white-collar jobs began to assume their familiar shapes. Trolley lines spearheaded the city's physical expansion, and technologies ranging from electric lights to steel-frame construction helped form a new commercial downtown. But all was not progress. Racial segregation gradually worsened after the false dawn of the Reconstruction years, and the city began a century without self-government.

During the period covered by the book's second part, between the turn of the century and the Great Depression, racial segregation hardened into a virtual caste system. At the same time, the steady growth of federal employment spurred both the further creation of new neighborhoods—now accelerated by the advent of the auto-mobile—and the re-creation of the city's center according to a new master plan. The years of the New Deal and World War II, covered in Part 3, were a time of paradoxical prosperity for Washington, as the federal government assumed vast new national and then international responsibilities. Washington, like other cities, felt the effect of these changes, first in the New Deal employment and housing programs and then in all the wartime activities, from rationing to bond rallies. The book's final section, covering the years from the end of the war to the mid-1960s, chronicles how political, social,

and economic pressures finally transformed both race relations and the nature of the region. The grudging end of formal racial segregation, the pressures of the Cold War, and government urban renewal, highway, and housing policies combined with postwar prosperity to form a new metropolitan pattern. Tens of thousands of white families moved to the suburbs, which grew more populous than the city itself. Washington's black population, which had been remarkably stable at between a quarter and a third of the total since the Civil War, became a majority in 1957. By the middle of the 1960s, even as Washington began to recover some form of self-government, a divided and dispersed metropolis had clearly replaced the city-centered region of the preceding century.

These basic historical themes are expressed in the book's organization, but the richness and fascination of photographs lies in their power to say many different things at once. There are hundreds of stories here, revealed in the details of individuals' appearance and dress, in the people with whom they are seen associating and the objects that surround them, and in the settings in which they appear, as well as the manner in which photographers recorded them. We have not, and could not have, identified all of these stories. We are happy to leave it to our readers to make their own discoveries and give their own added meanings to these images. The result, we hope, will be a deeper appreciation of both Washington and its history.

Acknowledgments

This book has been prepared with the assistance of a grant from George Washington University's Center for Washington Area Studies. In addition, we are grateful to the Historical Society of Washington for making available to us its valuable photographic collections. We wish to thank the Society's former curators of collections, Mary Beth Corrigan and Cheryl Miller, and former executive director John V. Alviti for their cooperation and support. Staff in the Division of Prints and Photographs of the Library of Congress, the Still Pictures Branch of the National Archives, the Smithsonian Institution Archives, and the Montgomery County Historical Society also have been generous with their assistance. In addition we would like to thank the director of the District of Columbia Public Library's Washingtoniana Division, Roxanna Deane, staff member Matthew Gilmore, and especially curator of photographs Mary Ternes. We are grateful as well for the support of staff at other institutions: Philip Ogilvie and Dorothy Provine at the District of Columbia Archives; Jessica Kaz at the Jewish Historical Society of Greater Washington; Francine Henderson, director of special collections at George Washington University's Gelman Library; Donna Wells at Howard University's Moorland-Spingarn Research Center; and Eileen McGuckian, director of Peerless Rockville.

Church historians have done much to preserve the important records of their institutions, and we extend our thanks for providing photographs from these institutions to Carter Bowman at Mount Zion United Methodist Church; Anne Louise M. Tatum at St. Mary's Episcopal Church; James Breen at St. Aloysius Catholic Church; and Lois England at Washington Hebrew Congregation. The pictures of Holy Rosary Church were drawn from materials gathered for an exhibit on Washington's Italian-American community and now held at George Washington University's Gelman Library. Other individuals who provided family portraits that helped personalize the story of Washington's development are Elizabeth Clark-Lewis, Dwight Cropp, Julia Foraker, Shirley Green, Richard Longstreth, and Adelaide Robinson. We are grateful as well to Godfrey Frankel for providing a selection of his photographs and especially to Robert McNeill, who not only made available his extensive collection of Washington photographs but also provided a great deal of information to establish the context of his work in the mid-1940s. Robert Truax also provided timely assistance.

Part I Modern City, 1875–1900

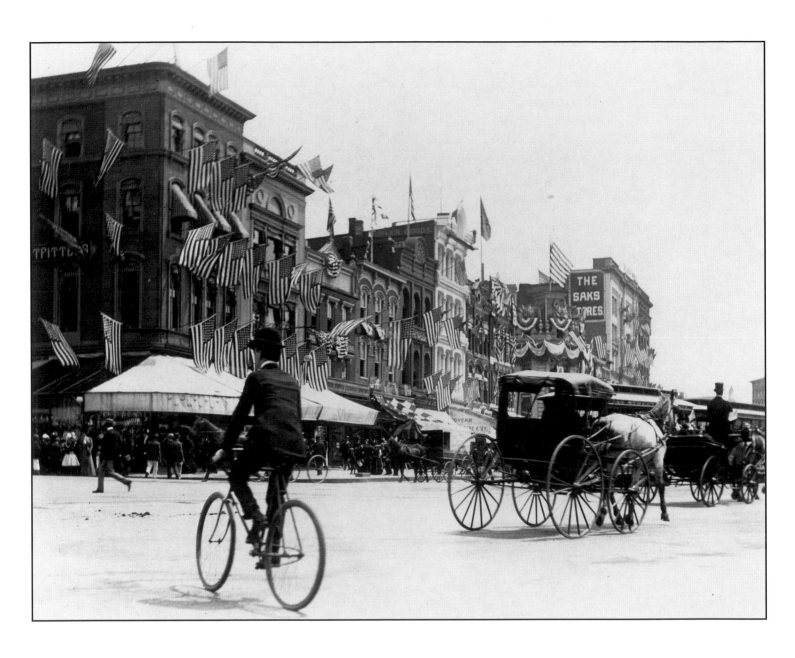

The Peace Jubilee on Pennsylvania Avenue, October 1899

The New Urban Landscape

From the dramatic events that tore the nation apart during the Civil War and Reconstruction, the city of Washington emerged as a modern metropolis and a dynamic regional center. It did not industrialize, as other major cities did, but found its engine for growth in the increasing importance of the national government it housed. Spurred initially by wartime emergency, the federal presence continued to grow after the war. This expansion included, for example, an extensive program authorized by Congress to provide war veterans with pensions. The Homestead Act of 1862 signaled expanded federal interest in western development—and the need for a land-office bureaucracy. Establishment of the Department of Agriculture the same year added yet more government employees, as did the growing demand for patents and for an accurate census. From an 1859 population of just over 60,000, including 1,268 civilian government employees, Washington grew to nearly 110,000, including more than 6,000 in federal employment, in 1870.

A key agent in the city's modernization was its experiment in territorial government from 1871 to 1874. Utilizing a powerful new board of public works, directed with flair as well as extravagance by developer and politician Alexander Shepherd, the new government attempted to overcome years of neglect by transforming the face of the city. Shepherd directed scores of workers to plant trees, level and pave streets, and lay sewers. By covering the badly polluted Washington Canal and converting it to a trunk sewer, he removed a notorious nuisance from the heart of the city. In an effort to reduce the costs of paving Washington's wide streets, Shepherd introduced a strip between the sidewalk and curb that could be planted with trees and grass—an area generally referred to as parking—and thus enhanced the beauty of the core city. A guidebook to the area, published in 1886, proclaimed of Shepherd's efforts, "Nearly all the old landmarks have disappeared, and out of a rude, unpaved dilapidated town has risen a stately city, with most of the resources, the pleasures, the superiority of a metropolis."

Shepherd drew the praise of Washington's emerging business community, but the costs of improvement far exceeded his authorized budget. Congress responded by replacing the territorial form of government with a presidentially appointed commission, a change that eliminated popular elections in the city. In order to assure a continued program of physical improvement, however, Congress assumed responsibil-

ity for half the city's budget and directed that public works be carried out by experts, requiring that one of the city's three commissioners be a member of the Army Corps of Engineers. Boosted by the formation of the new Washington Board of Trade in 1889, the city secured federal support for carving out a beautiful park along Rock Creek, which ran from the Maryland line through Washington's developing residential sector to the heart of the city. The park assured residents that open space designated for rest and recreation would remain easily accessible despite the advance of development. In addition, the District Commissioners, working with the Corps of Engineers, secured the transformation of marshes along the Potomac River into parkland. Such physical improvements, added to the growing opportunities for federal employment and associated economic activities, served as a powerful magnet for growth. Washington's population nearly doubled in twenty years, from 147,491 in 1880 to 278,785 in 1900.

Rapid growth placed a premium on the city's older sections, and by the turn of the century land use throughout Washington had become increasingly specialized. At the city core, real estate prices rose to the point where many residences were converted to commercial use. Spurred by early access to the new electric lighting grid and a convenient location near government jobs, a distinct downtown sector emerged north of Pennsylvania Avenue. It was dominated by dry goods establishments—numbering almost one hundred by 1880. Retail shops concentrated along 7th and F Streets, N.W., and banking houses rose opposite the U.S. Treasury at 15th and F.

One effect of growth was pressure to construct tall buildings on prime land; following the precedent set by Chicago, where the first skyscrapers went up, Washington began to acquire the new steel-frame buildings that could exceed previous height limits. Among the more important of these structures was the Baltimore Sun building, completed at 1317 F Street in 1887. The Sun Building attracted imitators downtown, but a harsh reaction set in with the construction in 1894 of the 14-story, 165-foot Cairo Hotel on Q Street, N.W., between 16th and 17th Streets. Nearby residents complained that it "would not only be a menace to the surrounding dwellings in case of fire or other catastrophe, but would depreciate their property by shutting off the light and air." Recognizing these health and safety concerns, the city in 1894 limited residential structures to 90 feet and commercial structures to 110 feet. While Congress subsequently allowed commercial structures of up to 160 feet on the north side of Pennsylvania Avenue and 130 feet elsewhere, Washington's height restrictions assured it both a distinctively low skyline and further pressures to spread outward.

In the older intown neighborhoods, such as Georgetown, Foggy Bottom, and Capitol Hill, as open land became scarcer, developers built structures at the back as well as on the street fronts of the deep lots prescribed in Pierre Charles L'Enfant's 1791 plan for the city. At first the smaller structures on the back alleys included carriage houses and other buildings to accommodate service functions. With the rising demand for housing in the 1870s and 1880s, opportunistic property owners converted many of these buildings to residential use. As crowding increased and landlords sought to maximize profits, living conditions in the alleys deteriorated, creating a complex web of slum conditions in the interior of otherwise perfectly acceptable residential blocks. Modest buildings at best, these structures housed the city's poorest residents. Before

the Civil War a majority of alley dwellers were white, but following the influx of huge numbers of freedmen during and after the war, the racial composition shifted dramatically. According to a police survey done in 1897, 93 percent of the 17,000 alley dwellers counted were black, a quarter of the city's entire African American population.

As older areas that had once offered convenient intown locations for residence became more congested, many of the city's white middle-class residents took advantage of improved transportation to settle in the less developed outer areas. The provision of horse-drawn streetcars and then, after 1888, electrified trolleys, facilitated commuting, making more accessible the amenities of spacious lots and healthy environments free of the noise, congestion, and disease that had become associated with the areas of original settlement. Names like Mount Pleasant and Palisades provided the immediate connotations a developer needed to make his emerging settlement attractive. Some investors, like those who financed LeDroit Park, just north of the original city, went further, by planting trees and commissioning a leading architect to design spacious homes. By the turn of the century, a population that had largely been concentrated in the area laid out by L'Enfant below Florida Avenue (called Boundary Avenue before 1890) had spread throughout the previously undeveloped Washington County, west of the Anacostia River and north to the Maryland line.

The territorial government of the early 1870s had consolidated political control over Washington County. That power passed to the District Commissioners, but until the last part of the century, no regulations existed to assure uniform development of the outlying areas. As a result, new subdivisions sprouted up without conforming to any existing street plan. After several decades of jumbled development, the commissioners in 1888 and 1893 secured highway legislation intended to guarantee that new roads and building plots would conform to the existing street plan of the core city. Further legislation established a pattern for street naming and numbering, to make the extended city more decipherable. Additional regulations simplifying the extension of sewers, water mains, and street lights into the county assured convenient services to all parts of the metropolitan area.

The introduction of poles and wires by the new Chesapeake and Potomac Telephone Company beginning in 1878 and the installation of lines for telegraph and trolley service threatened to disfigure the landscape, and Congress's failure to require railroad tracks in the city to be laid at grade further marred the city's physical plant. By the turn of the century, however, the railroads, after more than a decade of resistance, had agreed to adjust their tracks to accommodate street traffic, and more than half the city's electrical lines had been placed in underground conduits. Commenting on a maturing physical plant that now extended throughout most of the federal territory, the local press could boast of the emergence of a "Greater Washington" that made no distinction between early city settlement and its newer residential suburbs. Here, local residents claimed, was a city poised to play a prominent role as a world capital.

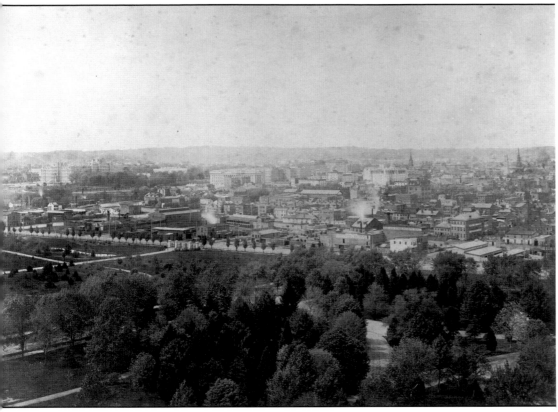
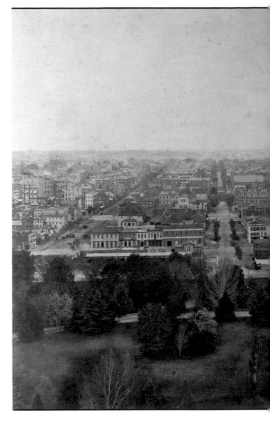

1.1

This panoramic series of photographs reveals the growth of the central city alongside the as-yet not sharply distinguished federal presence. Such panoramas were enormously popular in the mid-nineteenth century and were usually designed to impress viewers with the scale of the modern city. Photos 1.1–1.5, made somewhat later than the 1875 date usually attributed to them (as indicated by the presence of the east wing of the State, War, and Navy Building, which was completed in 1879), are by Baltimore-based Francis Hacker, a specialist in railroad photography. He shot the series from the tower of the then-new Smithsonian Institution, one of the few places high enough to afford a view of the growing city that would encompass the Capitol set on its Capitol Hill pedestal. Although Hacker did not record his purpose, it may well have been to document the improvements engineered by the Board of Public Works during the short tenure of the territorial government, from 1871 to 1874.

In the upper left of photo 1.1, just to the right of the State, War, and Navy Building (now known as the Old Executive Office Building), one can see the White House and the Treasury Building. In sharp contrast to these important government structures, in the right foreground is a complex of warehouses, storage yards, and factories that constituted the notorious Murder Bay section. Looking north along 11th Street (photo 1.2) with 12th Street on the left, one sees the buildup of commercial structures in the foreground and the first

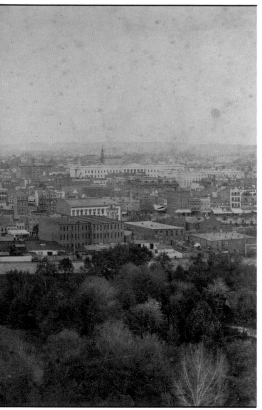

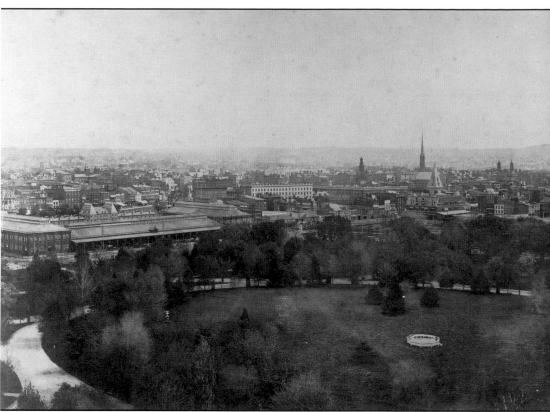

1.2

1.3

highrises to the left along F Street. Only the monumental and classically designed Patent Office (right midground), dating from the mid-nineteenth century suggests the government presence. Photo 1.3 is dominated by the Center Market, its link to the rail line extending to the right, and streetcar lines leading outward from its far side towards the city it served. Standing out at the center of the photograph is the Metropolitan Hotel on Pennsylvania Avenue at 6th Street. Founded as Brown's Hotel in the early part of the century, the original structure was enlarged to five full stories and faced in white marble in 1850. The hotel changed its name after owner Jesse Brown's sons sold it in 1865. The towering 240-foot Gothic spire to the right identifies the Metropolitan Methodist Church at C Street and John Marshall Place. The tallest privately owned structure when it was completed in 1872, Metropolitan Methodist's spire remained a landmark in central Washington until the church's demolition in 1936. The spires on either side mark First Presbyterian Church, on 4 1/2 Street near Louisiana Avenue, and Trinity Episcopal Church, at 3rd and C Streets, N.W.

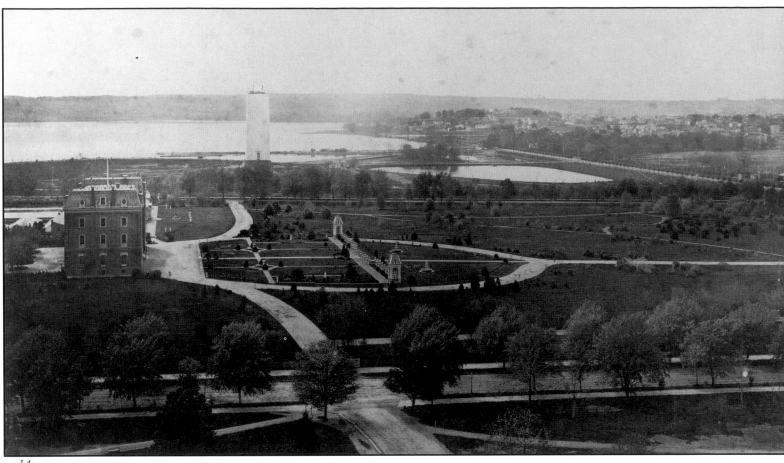

1.4

Intended to link the Capitol with the White House, the Mall as depicted by Hacker around 1879 showed little of the grand formalism intended for it by Pierre Charles L'Enfant nor the cohesive romantic treatment later proposed by America's premier landscape architect, Andrew Jackson Downing, in 1851. Instead it was divided into several discrete and unrelated gardens. The stump of the Washington Monument (1.4), its construction abandoned for thirty years after a nativist controversy paralyzed fundraising for its completion, serves as dramatic testimony to the government's unfinished agenda. Beyond the monument lie the Potomac Flats, a source of disease until they were converted to parkland in the 1890s, and running along the right is the newly constructed Avenue B, which replaced the Washington Canal and subsequently was renamed Constitution Avenue. The Department of Agriculture sits in lonely splendor at the left foreground, a mere suggestion of the growing government presence. The view towards the Capitol (1.5) reveals the buildup of the Capitol Hill neighborhood and substantial structures along Constitution Avenue. The U.S. Botanic Garden, dating from 1842, lies directly below the Capitol in this photograph. Less appropriate to the original intentions for the Mall are the rail tracks and rail cars passing by en route to the

Baltimore and Potomac station on 6th Street. Although having rail lines cross the Mall was opposed by those who wanted to preserve it as a park, when the B&P was granted the right to build its station in 1871, railroad supporters gained sufficient support for the convenient location on the Mall.

A view from the Capitol dome east across Capitol Hill (1.6), taken about the same time as Hacker's panorama, reveals the rapid filling in of a neighborhood whose proximity to government offices helped it benefit from the expansion of federal powers during and after the Civil War. The formal and stately Carroll Row (right foreground), built about 1800, when Congress first arrived, served variously as a hotel, boarding houses, and a home for political prisoners during the war, before being razed in 1886 to make way for the Library of Congress. In contrast, nearby are recently completed freestanding Victorian homes. All the structures along 1st Street, in the foreground, show the effects of the territorial government's public works programs. Alexander Shepherd's grading efforts often left the foundations of buildings exposed and their entrances suspended high above the pavement, which is why so many older homes in Washington employ long stairways to reach their first-floor entrances.

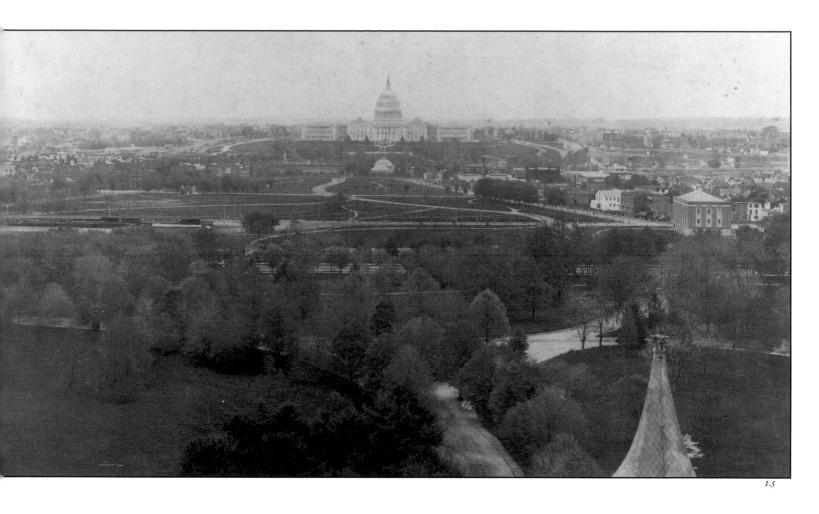

1.5

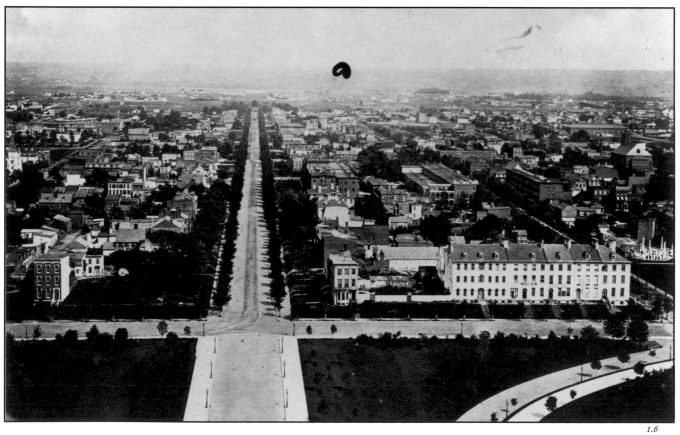

1.6

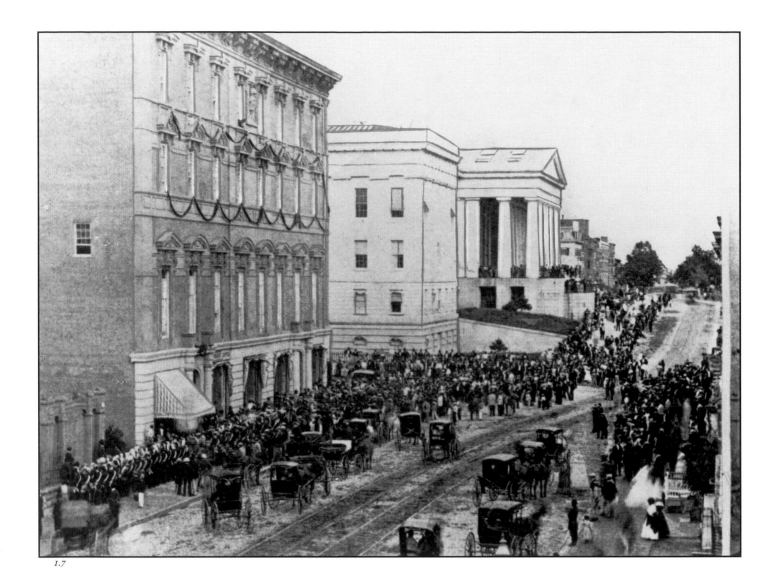

1.7

1.8

Alexander Shepherd's modernization program left its mark throughout the city. An example of what workers faced in grading city streets appears in the 1873 record (1.7) of a Knights Templar parade as it passed along F Street in front of the classical façade of the Patent Office building (now the National Museum of American Art). The photographer captured the dips and slopes that characterized many of the city's major streets before improvement. Photo 1.8 was made by the Bell Brothers studio around 1873, at the old War Department building, just west of the White House at 17th Street and Pennsylvania Avenue. It reveals the massive work involved in laying pipes to drain city streets and to provide homes and offices with water and sewer service. Originally known as the Northwest Executive Building, the War Department building was demolished in 1879 and replaced by Alfred B. Mullett's massive Second Empire period State, War, and Navy Building, now known as the Old Executive Office Building.

Despite efforts to modernize the city, much of the older urban core retained a rough hue, not least the area popularly branded "Murder Bay," between 13th and 15th Streets from Pennsylvania Avenue south to the Potomac River. This 1872 view at the edge of Murder Bay, looking southwest from the corner of 12th and D towards the still unfinished Washington Monument, reveals the unpaved streets and mixed land uses, such as a machine shop and restaurant almost adjacent, that distinguish the area from a modern downtown. Bisected by the noxious Washington Canal, until the canal was filled in at the direction of Alexander Shepherd's Board of Public Works, the area attracted largely marginal uses, such as mills and lumber yards, temporary homes for freedmen living as squatters in the war years, and the bars, gambling dens, and houses of prostitution that gave the area its name.

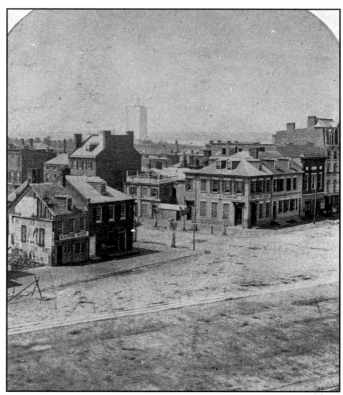

1.9

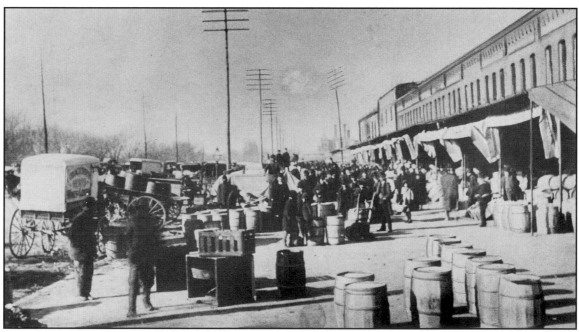

1.10

In contrast, when it opened in 1872, the Center Market, on Pennsylvania Avenue between 7th and 9th Streets, N.W., was considered the most modern as well as being the largest building of its kind in the United States, with accommodations for one thousand stalls, a spacious café, an ice plant, and the city's first cold-storage vaults. Use of the site for marketing reached back to the founding of the city. The new building, designed by prominent Washington architect Adolph Cluss, replaced commercial buildings whose inadequate facilities had prompted Alexander Shepherd and others to organize a private company to erect the grand new structure. In addition to its facilities inside, the market offered space on B Street shown here in 1888 for up to three hundred wagons, from which farmers sold produce directly to shoppers on the sidewalks. Droves of customers descended on the market on foot or in streetcars from every direction.

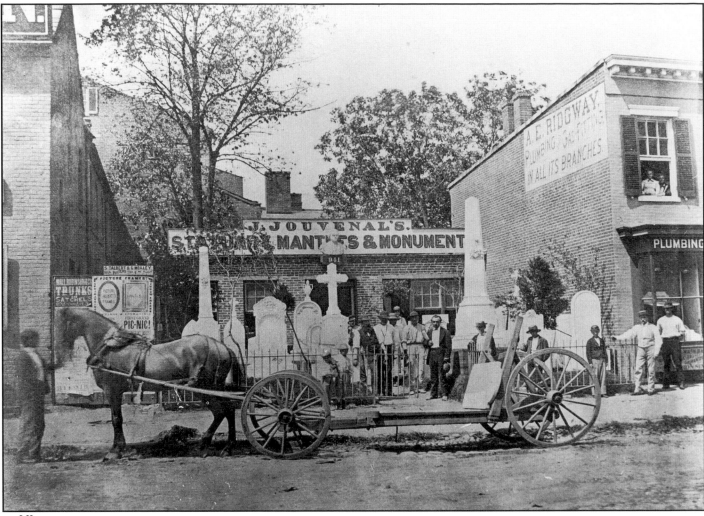

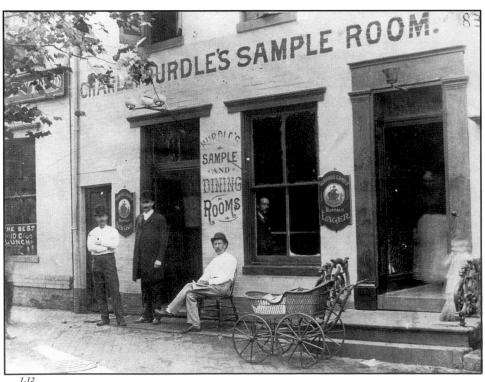

Some older land uses survived in the downtown, such as the Jouvenal studio and marble works at 941 D Street, pictured here (1.11) in 1875. The site had once held the residence of Peter Force, former Washington mayor and an early benefactor of the Library of Congress. The company's founder, Jacques Jouvenal, a German-born sculptor who immigrated to America in 1853, moved to Washington in 1855 to take advantage of the demand for ornamentation of new public buildings and spaces. It was in this studio that Jouvenal carved the statue of Benjamin Franklin that stands at 12th Street and Pennsylvania Avenue in front of the Old Post Office.

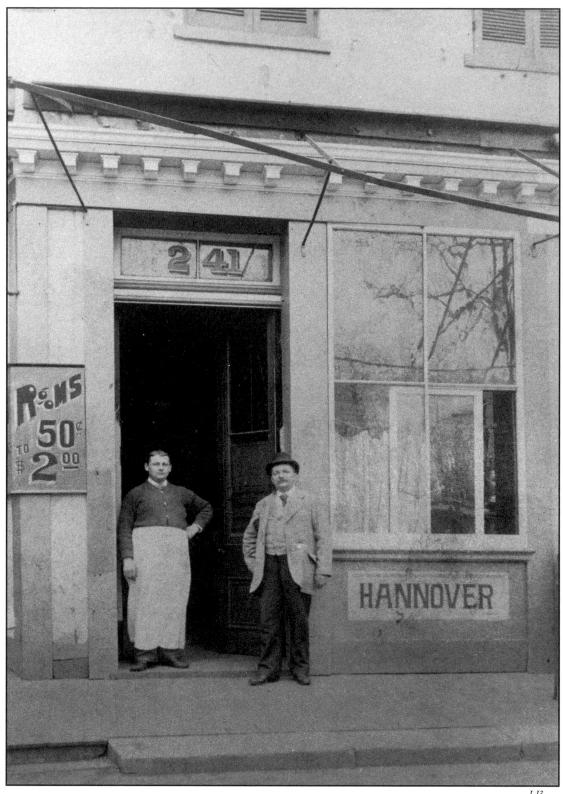

1.13

Other small establishments remaining downtown were the dining and boarding houses that dotted the area, ready to serve boarders or travelers come to Washington on public business. Reflecting the strong ethnic presence in such services was Hurdle's Sample Room (1.12), at 1222 D Street, shown in 1885, run by an Irishman, and the Hannover hotel, at 241 Pennsylvania, N.W., shown here in 1896 (1.13), owned by German-born Henry Dismer. Dismer, who ran the saloon inside the boarding house, is shown in front of the establishment along with an unidentified waiter.

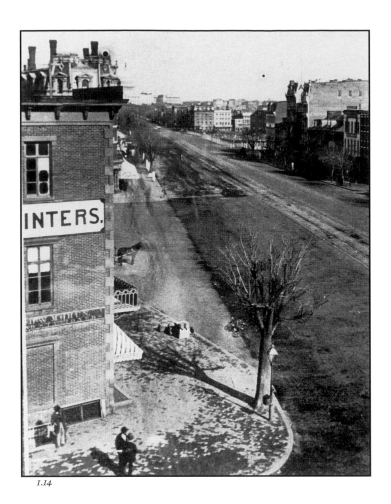

Two views of Pennsylvania Avenue, 1874 (1.14) and circa 1893 (1.15), show how the avenue's width helped divide the more substantial commercial establishments of the new downtown, on the north, from the seedy properties associated with Murder Bay on the south side. The first photograph was taken from the northwest corner of 11th and Pennsylvania. Shown in the second picture, on the north side, are the Castleberg jewelry store in the foreground, the Temperance Fountain at 7th Street, and the National Bank Building just beyond. The larger structures in the foreground of both photographs replaced Federal period row houses that once extended along much of the length of the avenue. While both photographs show trolley tracks, in the second, power has been added through a third rail in the center, marking the end of the horsecar era.

1.14

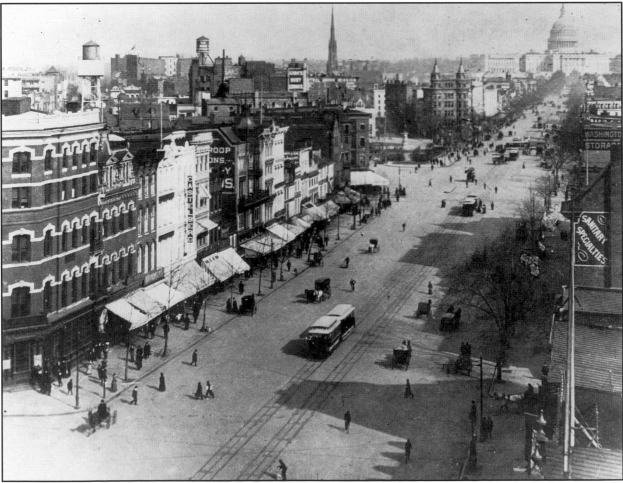

1.15

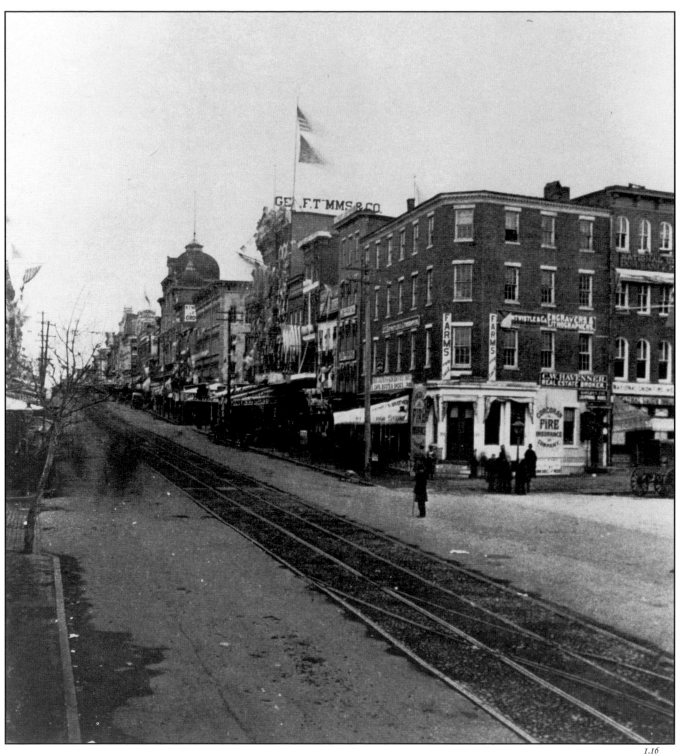

The streetcar line also dominated the major commercial thoroughfare into the downtown, 7th Street, seen in photo 1.16 in 1881. A juxtaposition of the older homes converted to commercial use in the foreground and large department stores introduced later, 7th Street served as home to many retail and commercial establishments. In this photograph, the Corcoran Fire Insurance Company occupies the building at the corner of 7th and Pennsylvania, and the conspicuous domed structure halfway up the block is Odd Fellows Hall, at 423 7th Street, shown after its remodeling in 1872.

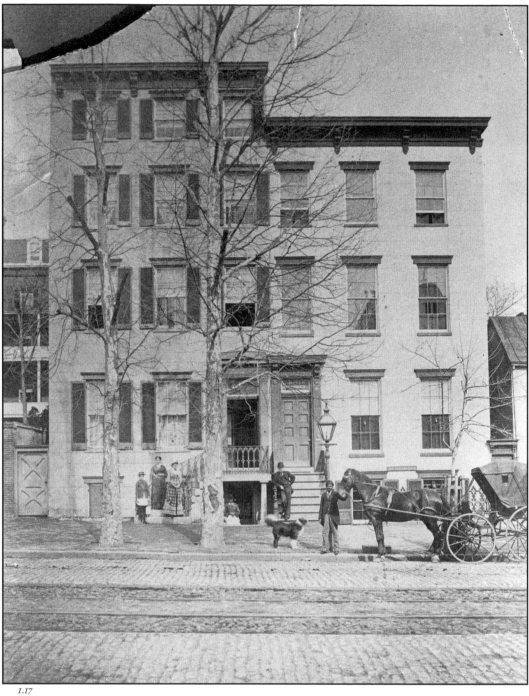

The onward march of commercialization made homes like that of the McCartry family at 11th and F Streets, pictured at left in photo 1.17 around 1890, increasingly out of place in downtown. The building on the right housed a doctor's office and home. His coachman and gig await his use. At far left, recessed from F Street, is the St. Vincent Orphan Asylum, which occupied the site from 1849 until 1901, when it was torn down to make way for an addition to the Woodward and Lothrop department store. Founded by New England retailers Samuel Walter Woodward and Alvin Mason Lothrop, the company first opened as the Boston Dry Goods House in the old central market at 9th and Pennsylvania Avenue. The store moved to the new Carlyle Building at 11th and F Streets in 1887. Photographs from 1889 and 1890 (1.18, 1.19) at 9th and F, several blocks away, document the demolition of low-rise buildings and their replacement with the highrise Washington Loan and Trust Company office building, which still stands. Organized in 1889 by Brainard Warner and John Joy Edson, two leading Washington businessmen and founders of the Washington Board of Trade the same year, the new organization was the city's first trust company.

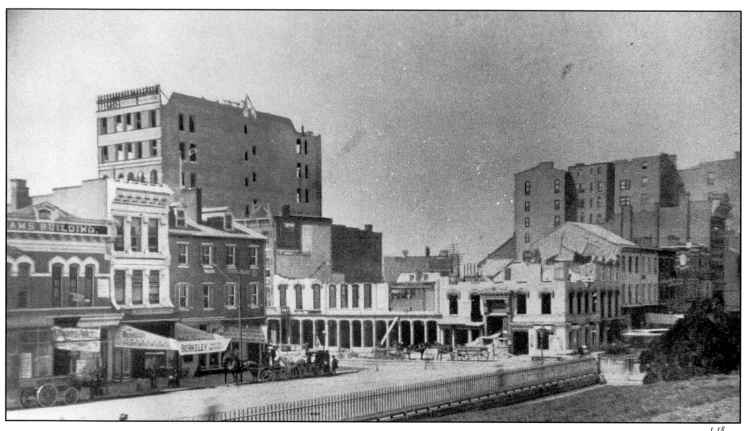

1.18

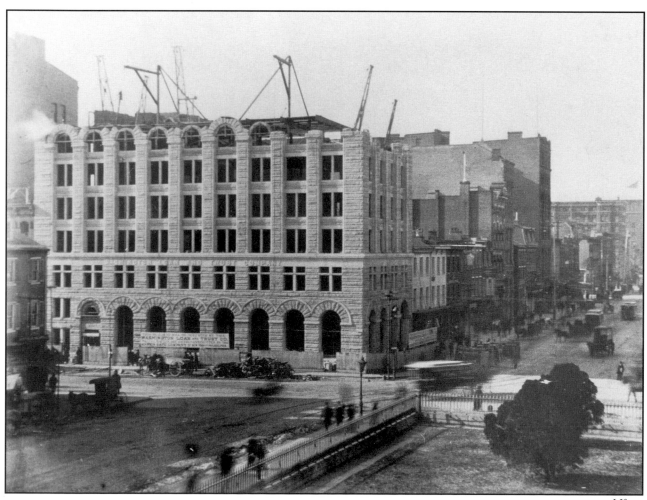

1.19

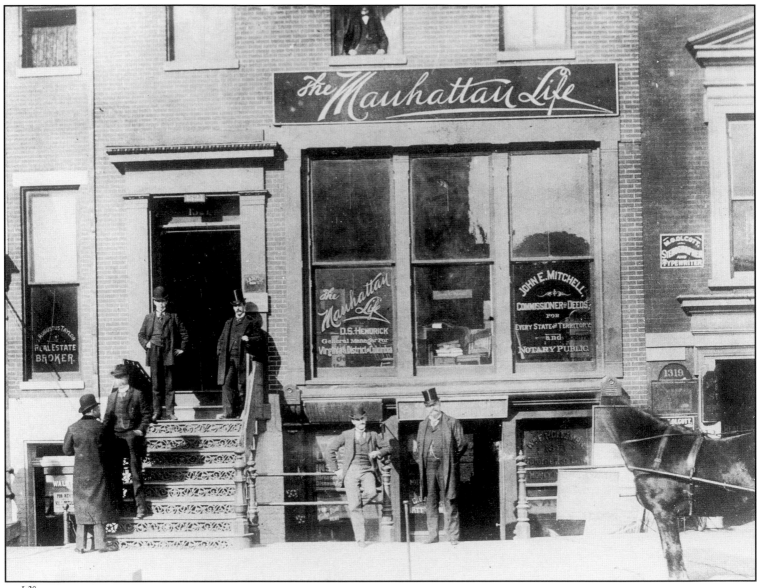

I.20

The downtown's transformation into a more complex and varied business center was marked by the arrival of a range of new commercial establishments. Companies like Manhattan Life Company at 1410 G Street, shown circa 1894, gave employment to a growing professional sector. The formal attire worn by these employees is evidence of their status. Signs on either side of Manhattan Life advertise two other white-collar occupations that thrived in the capital, notary public and stenographer-typist.

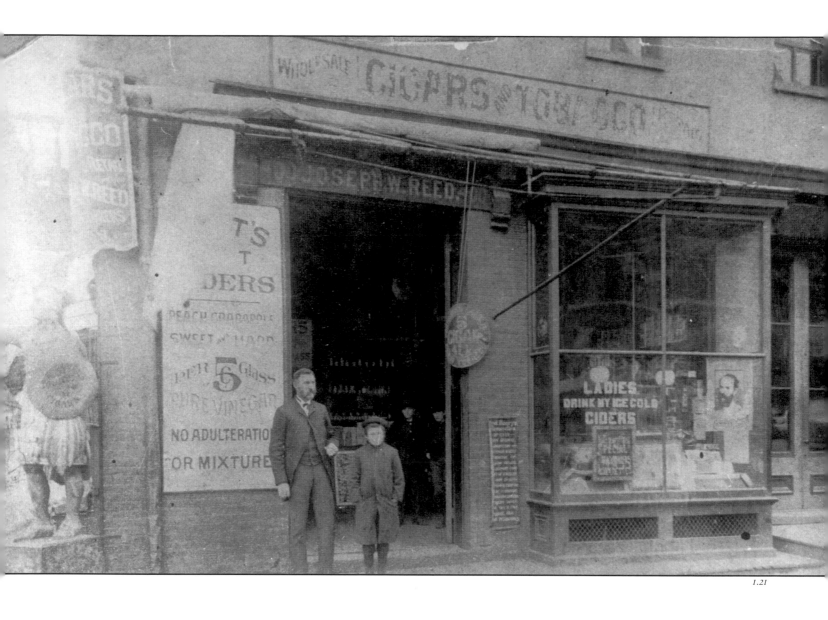

1.21

Joseph Reed offered cigars to gentlemen and soft drinks to ladies. His shop at 9th and D Streets, complete with stereotypical cigar store Indian, is pictured circa 1890.

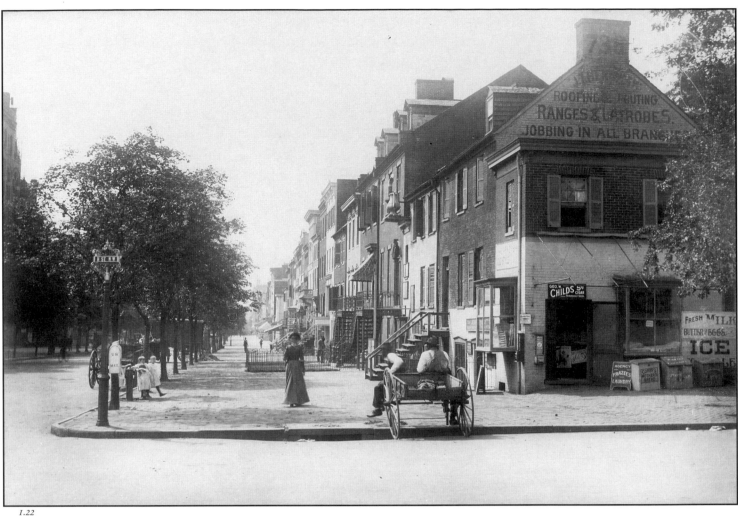

1.22

A systematic street survey conducted at the turn of the century recorded details of the city's residential neighborhoods, many of which were changing as the commercial and government presence expanded. A view of 13th and H Streets (1.22) taken about 1900 shows a typical row house development, on a tree-lined street, the planting a product of Alexander Shepherd's beautification program. The corner structure has been converted to commercial use, however, bringing with it the wagons and presumably crowds of customers that later made such mixed land uses the subject of zoning regulations.

The rooftop view from Capitol Hill (1.23) taken at 2nd and Independence, S.E., for the same survey shows the fully builtup character of the area at the turn of the century, with homes built on both the street fronts and interior alleys and only the occasional church steeple breaking the uniform line of row house development. Looking the other direction (1.24), over the area's rooftops toward the Anacostia River, one sees the power plants that prevented such homes from attaining an upper-class character. Still, with its close proximity to government employment, the area closest to the Capitol maintained a solid middle-class character.

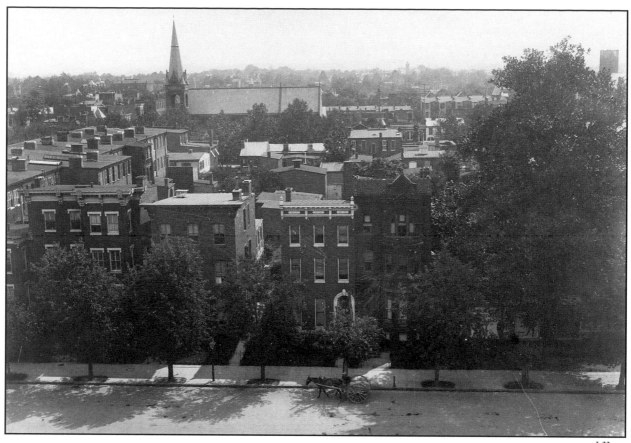

1.23

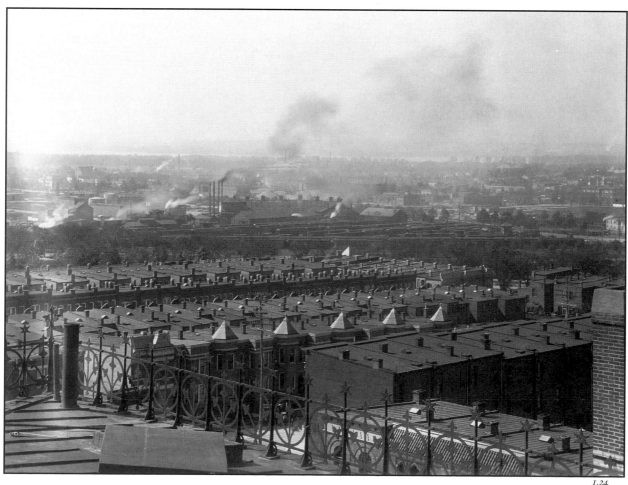

1.24

I.25

An omnibus, a relic of the era before streetcars, stands on Pennsylvania at 6th Street in 1881. This cab was presumably used to ferry federal employees between departments.

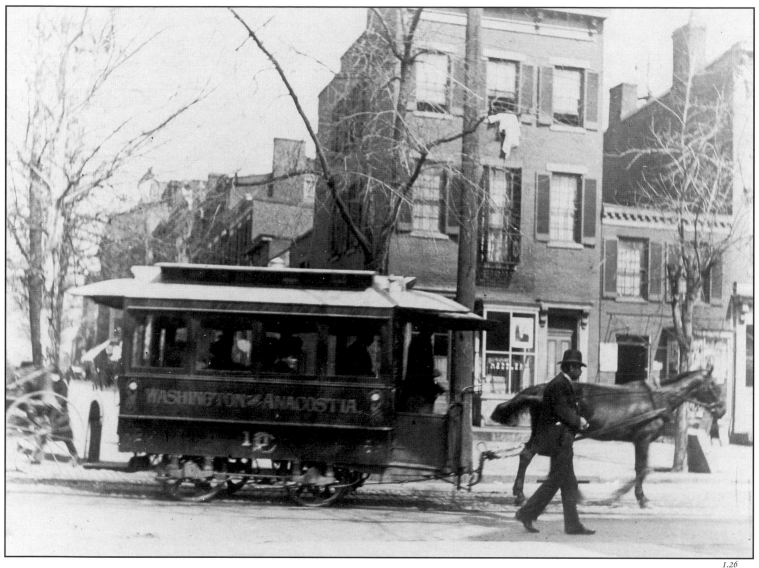

More typical in the expanding city were streetcars (1.26). Some continued to be drawn by horse into the last years of the nineteenth century, even after the introduction of electrical service in 1888. This photograph was shot sometime between 1895 and 1900 by Henry Arthur Taft, an employee of the Government Printing Office and a meticulous recorder of daily life in the capital at the turn of the century. The Washington and Anacostia line ran to the town of Anacostia, south of the Anacostia River, where residents for years had lobbied for better transportation downtown. Local transportation lacked much in the way of congressional supervision, and the number of streetcar lines and separate companies proliferated in the 1880s and 1890s until a process of consolidation began in 1895, culminating in 1900 with the merger of thirteen different companies to form the Washington Traction and Electric Company.

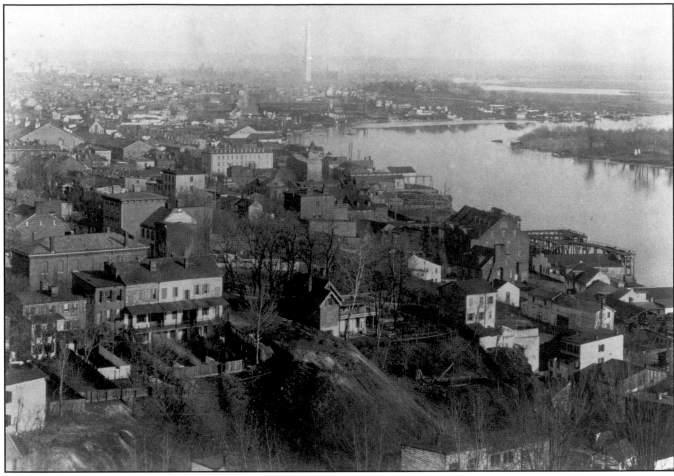

1.27

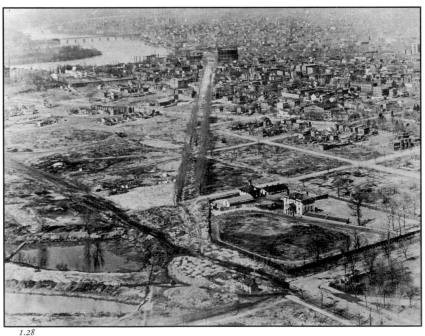

1.28

As improved streetcar service made it possible for Washington residents to move farther from the city core, some intown neighborhoods witnessed a shift in their population. By 1900, about the time the aerial view of Georgetown in photo 1.27 was taken, the streets along its waterfront were honeycombed with industry: mills, cooperages, stables, iron foundries, warehouses, fertilizer manufacturers, and lumberyards. Along the waterfront, ships exchanged ice from Maine for coal brought in by the Chesapeake and Ohio Canal. While these industries offered employment to some of the fifteen hundred residents living nearby, they were considered nuisances by many older and wealthier residents, who moved to the newer and more exclusive residential areas to escape them.

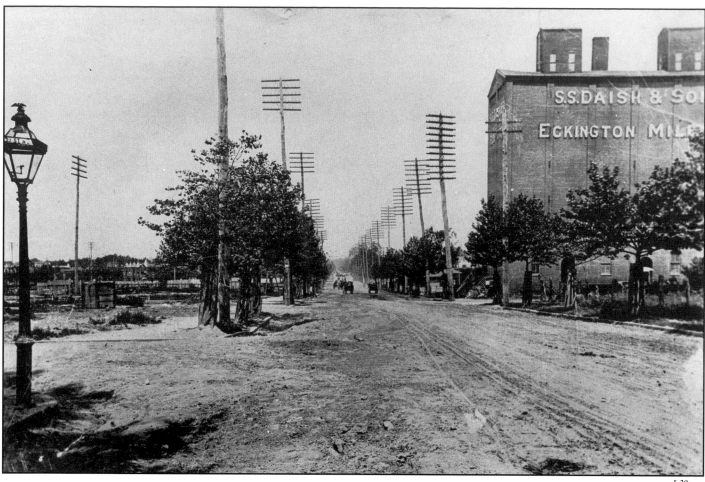

Many parts of the city remained undeveloped or only partially developed at the end of the nineteenth century. Looking towards Georgetown along Virginia Avenue, a view of Foggy Bottom from circa 1894 (1.28) shows the lack of development where swampy ground discouraged residence. One of the few uses of the area was a race track (right foreground), on the site where the Pan American building now stands. The Van Ness Mansion, built between 1813 and 1817 by Benjamin Latrobe for one of the city's most prominent families, stands abandoned at the edge of the race track. Running diagonally across the foreground is B Street, but a muddy road over what was once the City Canal. Beginning just above B Street is Virginia Avenue. Closer to the river, one can see the concentration of industrial uses, most notably the Washington Gas Light Company tanks, which dominated the land in the southern section until they were torn down in 1954. Also adding to the industrial character of this part of the waterfront were the Cranford Paving Company at Easby's Wharf, directly on the water-

front, and the Alert Brewing Company, which opened in the 1870s. It was joined by the Heurich Brewery at 25th and Water Streets in 1895. Although the east end of Foggy Bottom, the part closest to the White House, remained a preferred residential area, homes closer to the waterfront were occupied primarily by blue-collar workers whose choices of residence were dictated more by their low cost than their convenience to work.

On the other side of town, another neighborhood initially slated for predominantly residential development, Eckington, witnessed the introduction of some industry, as rail lines entering the city bisected the area. The Silas Daish and Son flour mill (1.29), shown here in 1889 at 3rd and Florida Avenues, N.E., was one of only two flour mills in the city, the other being located nearby on Delaware Avenue, N.E. The lack of paved streets and the intrusion of telephone poles were among the sources of complaints from residents, many of whom felt that promises of idyllic residential living had been dashed by the intrusion of business activity.

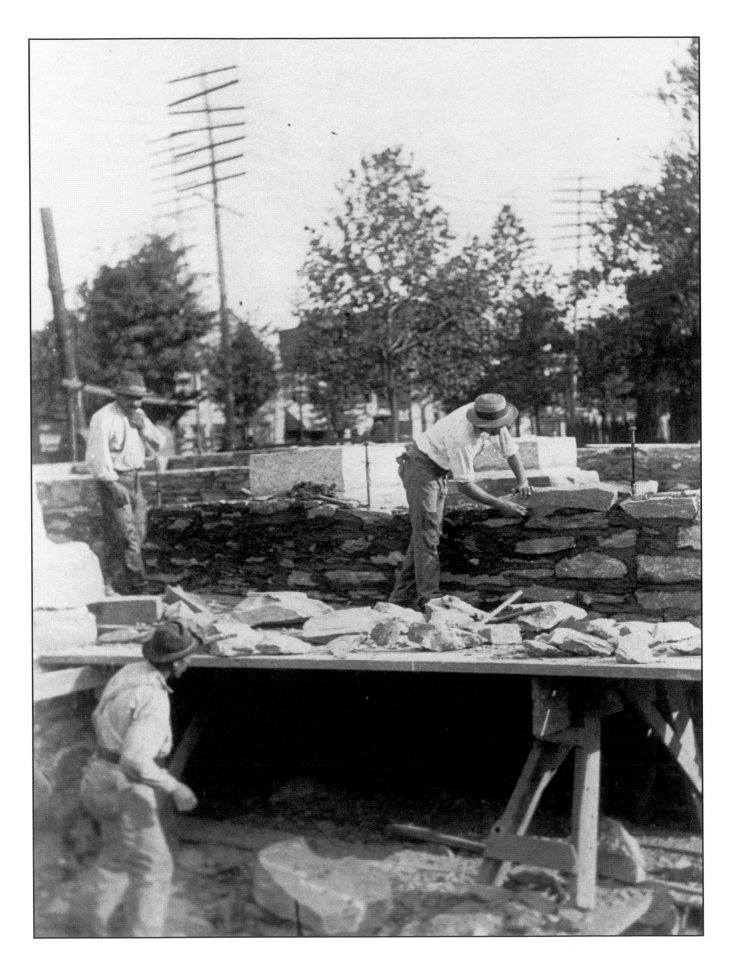

Masons working on the Capital Traction Powerhouse, 14th Street and Pennsylvania
Avenue, 1891

2 Washingtonians

Who were the people who flooded the newly invigorated capital city? Before the Civil War, the American-born white population was distinctly southern. The numbers of European immigrants and African Americans were equal, with about ten thousand of each in a total population of sixty thousand. The city's black population more than kept pace with the influx of white Americans—many from the North—during and after the war; but the volume of immigrants slowed to a trickle, and by 1870 blacks outnumbered immigrants by a three-to-one margin, as the latter were drawn to areas of industrial development farther north. The city's overall population in time became about one-third black and held at that proportion through World War II. Those European immigrants who did make their way to Washington tended to seek positions as craftsmen, shopkeepers, or manual laborers. The erection of important new government structures, such as the Pension Building and the Library of Congress, offered work for both skilled and manual workers. The success of German-born Christian Heurich's brewery created opportunities for Germans both in his plant and in building and furnishing the substantial mansion he erected in the fashionable Dupont Circle area.

In 1890, Washington listed about as many manufacturing jobs, twenty-three thousand, as jobs in government service. Unlike factories in other cities, which produced goods for national and international markets, Washington's 2,295 firms confined their sales largely to the local area. Lacking the heavy investment that produced the huge assembly-line plants of northern cities, Washington's firms remained relatively small, their products geared to immediate needs in such lines as carriages and wagons, engraving, clothing, plumbing and gas fittings, printing and publishing. With many government contracts available, printing and publishing were especially prominent. In 1890 the city listed sixty-nine such firms, employing forty-five hundred workers who earned an average of $800 a year. The Washington Board of Trade, organized in 1889, established a committee to promote manufacturing, but it resisted the construction of large plants, whose smoke or congestion might compromise the beauty of an area already conceived of as a national tourist attraction. By 1900 the Smithsonian Institution counted more than 350,000 visitors annually, and with such numbers promising to grow, local boosters could always find a good reason not to worry about the city's failure to diversify economically.

While industry languished, bureaucracy blossomed. The civil service reform implemented in 1883 provided the growing army of government clerks the kind of security in their jobs that encouraged them to make long-term commitments to their community: building homes, forming residential and social associations, and agitating for such amenities as streetcars and parks that could make their city comfortable and attractive. By 1890 the government listed twenty-three thousand local employees, more than Washington's entire population in 1840. But they were not the only new-comers; they were joined by the host of workers needed to provide essential services. The 1880 census listed seventy-seven blacksmiths and seventy-three shoemaking shops in Washington. With wages well below that of government clerks—blacksmiths made approximately $325 annually compared to a standard clerk's salary of $1,200—they lived modestly. In contrast, the city became home, at least during the winter season, to a growing body of socially prominent men and women taking advantage of the mild climate and the new social opportunities provided by the expanding federal presence.

The city's African American population seized the opportunities offered by freedom, entering the segregated public schools in record numbers and showing dramatic gains in levels of literacy. While the appointment of African Americans to prominent positions in the government remained limited to a select few, like former abolitionist Frederick Douglass, who served as marshal of the District of Columbia and as minister to Haiti, civil service reform boosted black as well as white employment opportunities. Between 1883, when the Pendleton Act was passed, and 1892, federal employment of blacks in Washington rose from 620 to 2,393. Blacks also found employment in city government, although as late as 1891 they held only twenty-five jobs above the rank of messenger and day laborer. Given the rich educational opportunities in the professions and the liberal arts offered by Howard University, founded in 1867 with government assistance, and the Preparatory High School for Negro Youth (later M Street High School), established in 1870, it was little wonder that blacks sought out Washington as a place of residence. Their employment was limited by racial job ceilings, and their civil rights were gradually compromised by the demise of laws passed by the territorial government granting equal access to public accommodations. However, with far greater racial restrictions in the deep South and the bar to their employment in northern industry, blacks rapidly made Washington the leading national center of black culture and ideas.

In this environment of expanding opportunities for employment and recreation, most Washingtonians settled down to a comfortable middle-class existence. An 1885 guidebook may have exaggerated, however, when it proclaimed that in Washington one could at last find an American city that offered "escape from the din of moneygrubbing" and "where culture can shake hands with genius in all forms, where merit, not money or grandfathers, is the entree to society." The city had its share of ostentatious living. Wealthy families seeking association with the new national power sought to make their mark by building stately mansions along the city's broad avenues, especially Massachusetts Avenue near Dupont Circle and 16th Street approaching the White House. But more typical were the row houses that filled in the remaining lots of the old city. A popular building form before the Civil War, for the rest of the century it became the rule. Following restrictions imposed by building codes

intending to prevent fire, new homes went up in brick rather than wood. This relatively cheap construction material, drawn from local sources, offered clerks with modest but steady salaries ideal dwellings for raising families.

Outside their homes, Washington residents formed a rich social life, which, while considered modest compared to that of New York, nonetheless was extensive and diverse. Washingtonians mixed in taverns and markets and formed a range of associations determined by race and ethnicity as well as location. On weekends they picnicked on the open land still found near the city or in the new Rock Creek Park. A number of them built their own summer homes outside Washington or visited one of the hotels that were springing up in surrounding towns. While blacks were excluded from many public facilities, they found their own social refuge at such summer resorts as Highland Beach near Annapolis. By the end of the century, in short, Washington had assumed a cosmopolitan character that made it a leading destination for those seeking not just government employment but the chance to settle down.

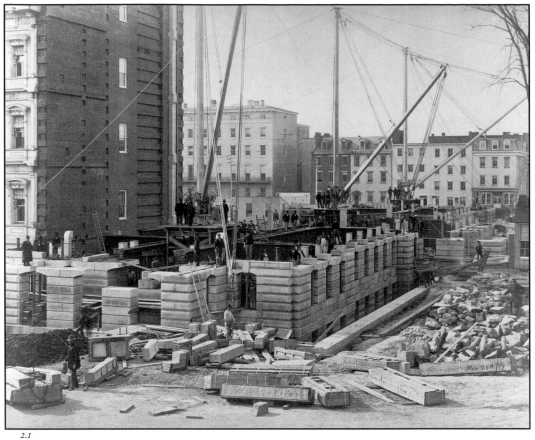

2.1

2.2

30

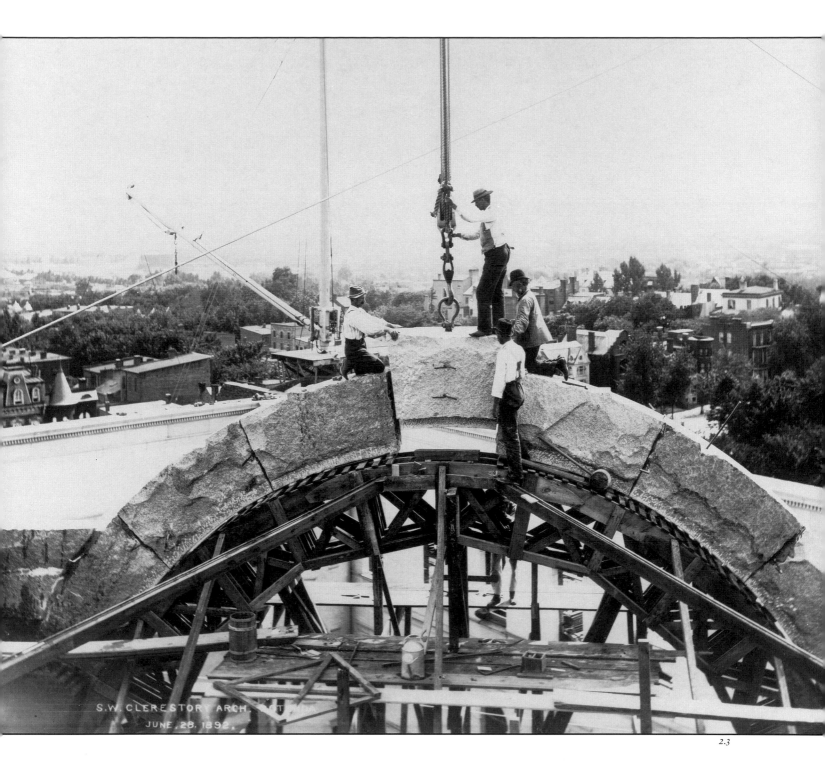

S.W. CLERESTORY ARCH.
JUNE. 28. 1892.

2.3

An expanding city provided plentiful opportunities to construction workers, both skilled and unskilled. This 1879 photograph of construction of the north wing of the State, War, and Navy Building (2.1) shows about as many supervisors overseeing work from the higher elevations as laborers below. Photo 2.2, showing construction of the Pension Building in 1883, reveals a racially mixed work force including white bricklayers and black hod carriers, with superintendent of contruction Zephaniah Jones in the center. Both photographs show the close proximity of residences to these large public buildings. The photograph of workers setting the southwest clerestory arch of the new Library of Congress, dated June 28, 1892, provides a stunning panorama of the Capitol Hill neighborhood below. The photograph was taken by Levin Handy, Mathew Brady's nephew by marriage, who was commissioned to document the building project. Many of the craftsmen employed for the library's construction were Italian, part of the migration of skilled builders to the city.

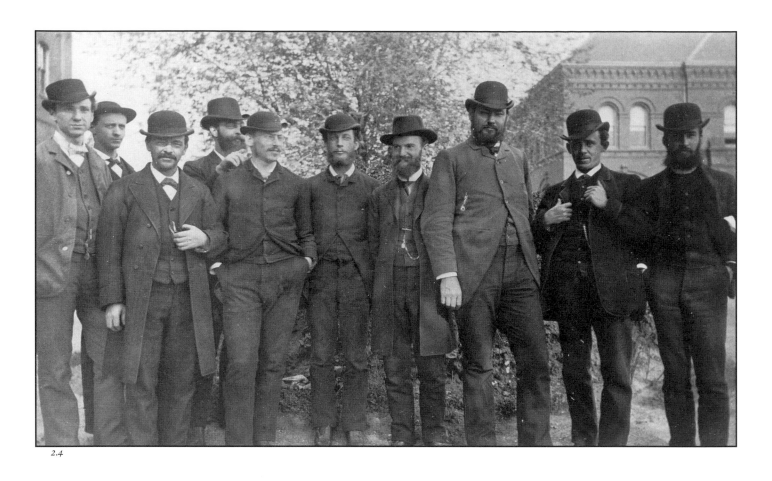

2.4

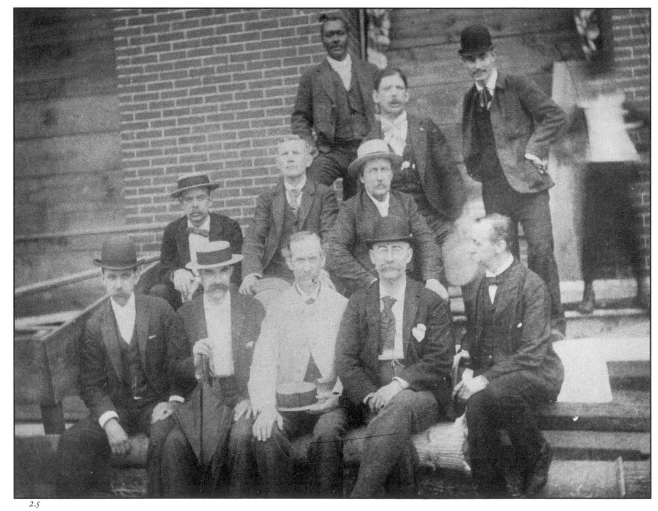

2.5

32

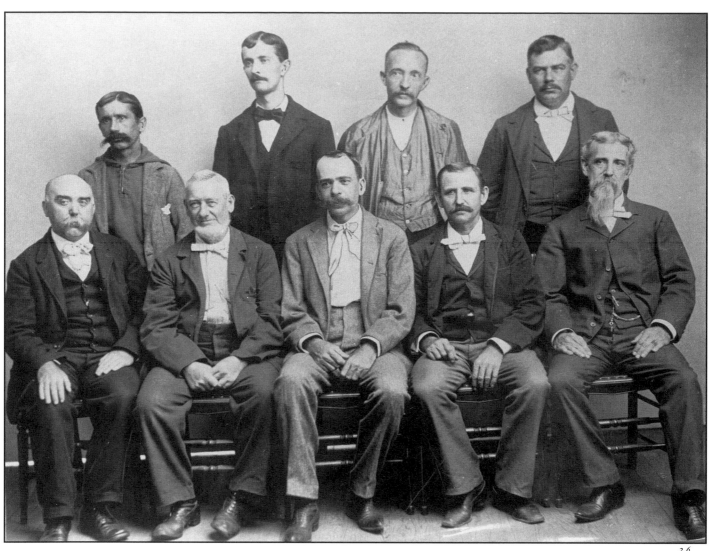

As the prime employer in Washington the federal government offered a range of work opportunities. The growing importance of science as a federal enterprise brought a number of specialists to the city. An 1885 staff portrait (2.4) of the Bureau of Chemistry in the U.S. Department of Agriculture survives in the papers of Harvey Washington Wiley, third from the right, who ran the bureau from 1883 to 1912. Wiley, a chemist, teacher, and lecturer, was best known for establishing the standards of food purity that led to passage of the Food and Drugs Act of 1906. The chemists' formal attire befits the relatively elevated status of the government scientist. In an age that demanded more formality in the workplace, a similar standard of dress was adhered to by printers and bookbinders, like those shown in photo 2.5, employed in the War Department's Record and Pension Office in 1893. The only African American pictured, Henry Thomas, was identified as a messenger. Although experiencing the confinement blacks typically found in the lower ranks of government employment, Thomas also donned a suit for this portrait, in line with the high status that the position brought him in the black community. Photo 2.6, taken about 1890, shows the "mechanical force" of the Smithsonian Institution's National Museum. Seven of the nine men are dressed in clothing which probably indicates that they were skilled workers, enjoying secure jobs and a middle-class style of life.

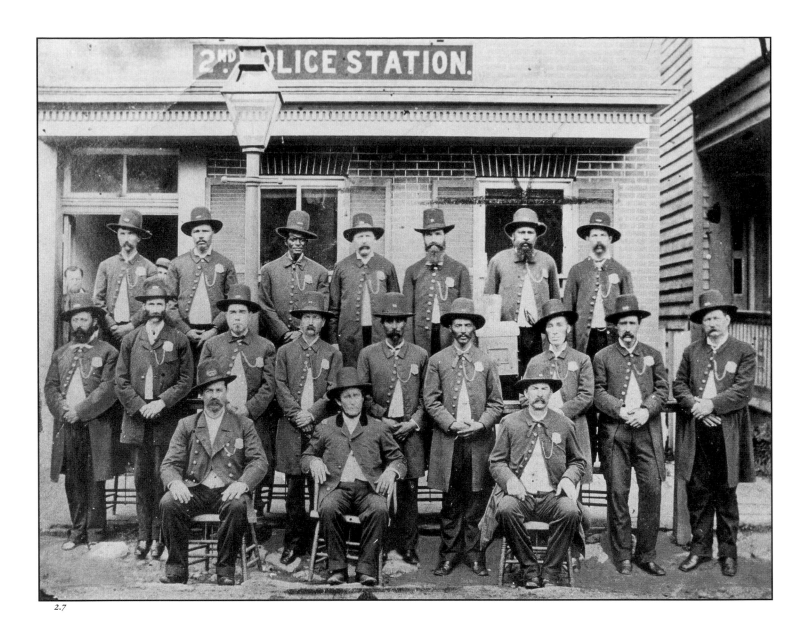

2.7

Although racial divisions hardened after the Civil War, one legacy of Reconstruction was an integrated police force, as this photograph of the men assigned to the second precinct (2.7), dated September 12, 1878, indicates. African Americans were first appointed to the force in 1869. The officers of this precinct, pictured in front of their headquarters at 2040 Georgia Avenue, were responsible for policing the emerging residential quarters north of the old city, above Florida Avenue and west of the Anacostia River. Their uniforms mark the professionalization of the force, which dates from the 1860s. Although blacks served on the police force in significant numbers, they generally were passed over for promotion.

Members of the private fire companies common in nineteenth-century American cities typically resisted giving up their voluntary status and the close social ties that accompanied it, but the Vigilant company, located on lower Wisconsin Avenue in Georgetown, became part of the paid city force in 1870. In this photograph (2.8) from around 1880, only the legend at the top of the building they had occupied since 1829 reveals their once independent status. The federal government formed its own paid fire company during the Civil War. Clashes between these "regulars" and the city volunteers contributed to the decision in 1864 to form a paid city force. The Georgetown companies were brought into a reorganized system for the entire District of Columbia in 1870. The Vigilants moved out of this building in 1883.

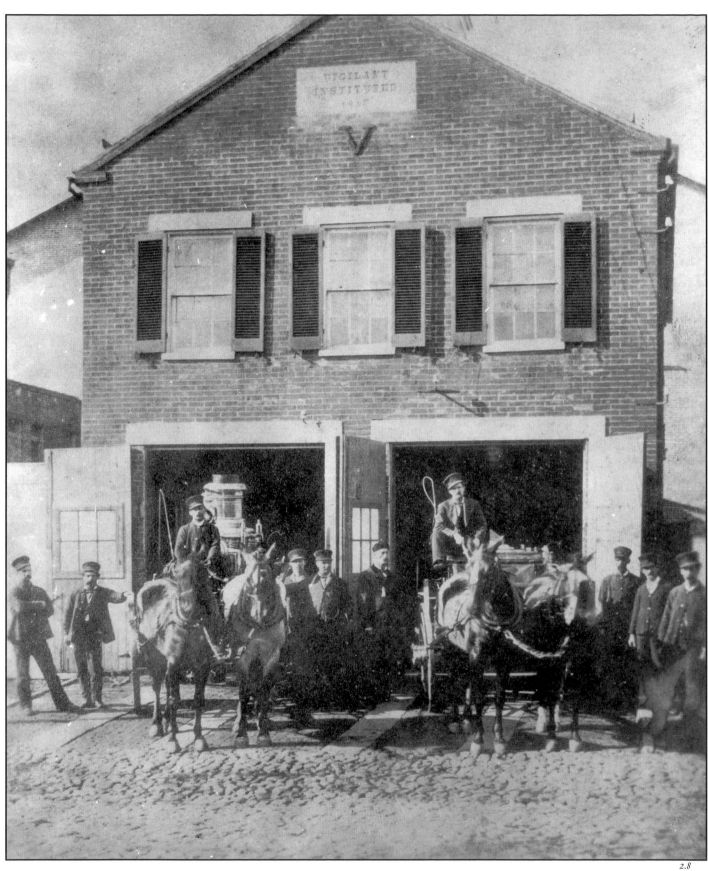

2.8

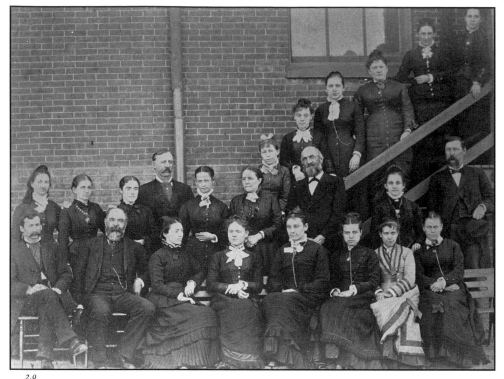

2.9

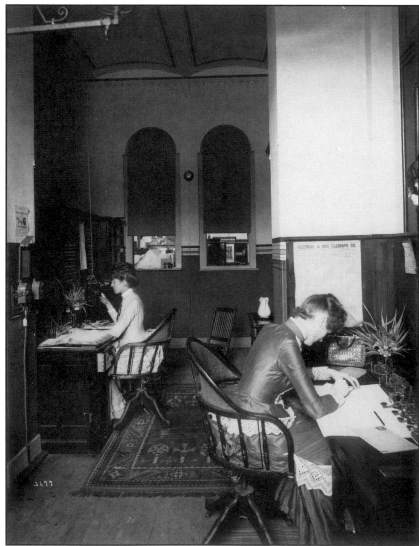

2.10

Education was a very important part of local civil service employment. This 1879 portrait (2.9) of the teaching staff at Jefferson School, on H Street between 7th and 9th Streets, S.W., illustrates the large number of women employed in teaching. The school system in Washington remained rigidly segregated racially, despite efforts at integration during Reconstruction. Jefferson School, built by the prominent German architect Adolph Cluss in 1872, during the territorial government, was the largest school in the city in the 1880s.

Another growing service role for women emerged with the invention of the telephone, which was first introduced to the city in 1877 and enhanced a communications network that was increasingly important to a growing bureaucracy. Appropriately enough the first connection in Washington ran between two government offices, Fort Myer and the headquarters of the army's chief signal officer. The two operators seen in this 1880s photograph (2.10) were running the telephone system at the Smithsonian Institution.

Formed by George C. Maynard in 1879 as the National Telephone Exchange, Washington's first telephone company operated under an exclu-

sive license offered by Bell Telephone. Alexander Graham Bell marketed his invention first in Washington, recognizing its importance as a center for science and expert information. From only 400 telephones in Washington in 1879, the number grew to 1,150 four years later, about one phone for every 140 inhabitants.

While Washington lacked the heavy industry that marked other major American cities, it did develop a range of light industry as well as service occupations. Schmid's box factory, seen here in the 1880s (2.11), was located in a four-story building, once a substantial residence, at 317 12th Street, in an area that was emerging as the heart of downtown. We see the male employers standing in front while the female workers look out from the work floors. In the interior shot (2.12) some of those women pose with a male supervisor.

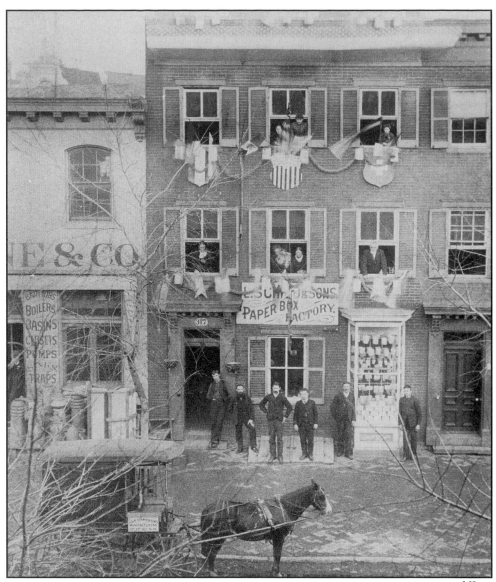

2.11

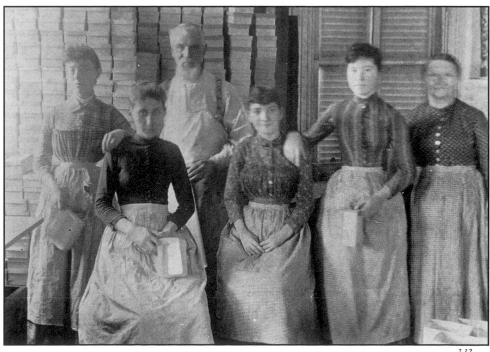

2.12

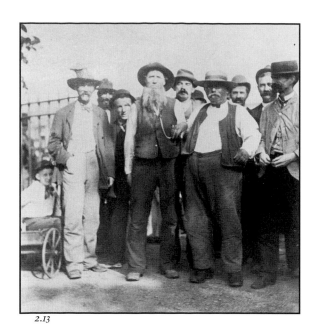

2.13

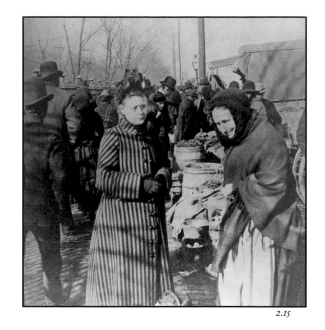

2.15

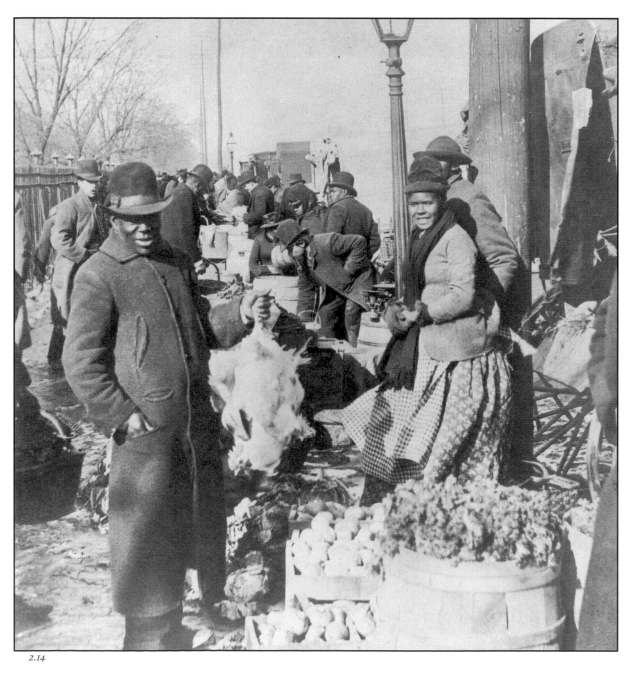

2.14

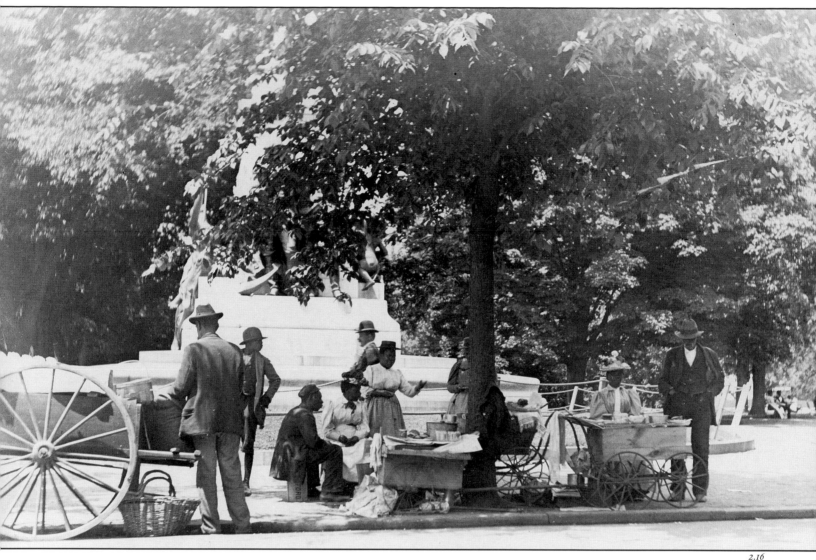

The old Center Market, located on Pennsylvania Avenue between 7th and 9th Streets, where the National Archives building now stands, provided numerous employment opportunities and the occasion for residents of all backgrounds to mix. An 1891 photograph (2.13) portrays a group of the fruit and vegetable gardeners who sold their goods at the market. Photos 2.14 and 2.15, from 1889, capture the vitality of exchanges between customers and dealers, both of which included a number of African Americans. The photographs were taken for a firm that marketed stereographs of interesting scenes of daily life. The Washington *Star*'s chronicler of old Washington, John Clagett Proctor, may have been thinking of someone like the woman on the right in photo 2.14 when he wrote in 1939 of Christmas seasons past, "We cannot forget those kindly colored women who, at this time of the year particularly sold bunches of sage and thyme, as well as peppers, eggs and other small farm produce, when they were not huddling around an improvised stove in order to keep warm. Queer sights! We shall probably never see them again—hood drawn closely over the head with a large muffler around the neck and with the edges of old bandanna handkerchief peeking through; with more clothes on than Admiral Byrd will wear in the Antarctic." For those lacking the fee to take a stall in the Center Market a street corner offered an alternative venue, as illustrated in a picture of vendors gathering at Lafayette Square about 1891.

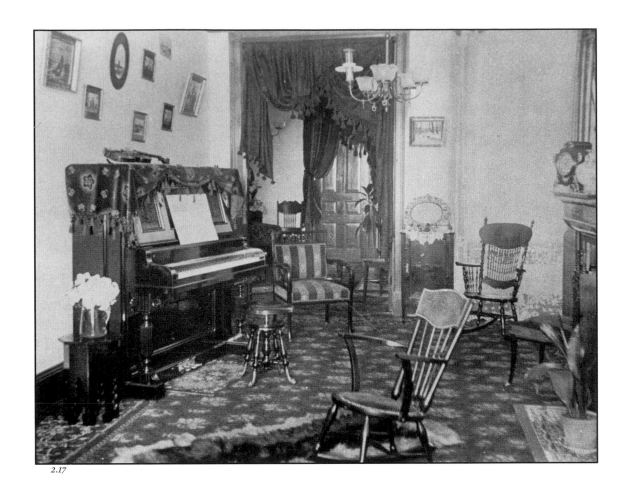

2.17

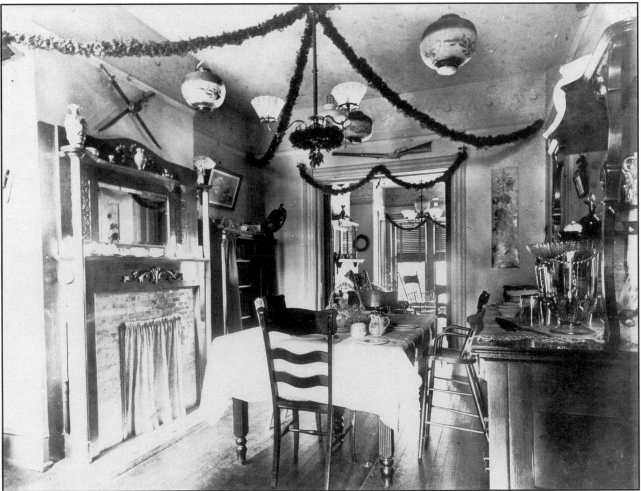

2.18

40

The stabilization of employment, both public and private, and the expansion of residential development allowed many Washington residents in the latter part of the nineteenth century to settle into a comfortable mode of living. Each of the domestic interiors shown here, shot at the end of the century, reveals the embellishments of the middle-class home. The parlor of the Henry Jeuneman home at 514 C Street, N.W., features not just the piano that was such a fixture of Victorian culture but decorative objects gracing the fireplace and rocking chairs that may have appeared antique but probably were mass produced. The dining room of amateur photographer Henry Arthur Taft's home (2.18), at 628 9th Street, N.E., in a new Capitol Hill row house to which his family moved in 1898, also utilizes standardized furnishings. The fireplace, with its built-in mirror and glazed tile surround, appeared in a number of 1890s row houses. The cut glass and china, rather than silver, decorating the sideboard and mantel confirmed a middle-class taste as well as standard of living. The Chinese lanterns among the Christmas wreaths and swags decorating the home reveal an oriental style that was popular at the time.

Although African Americans constituted a smaller portion of the middle class, details of this parlor of the Sprague family (2.19), descendants of Frederick Douglass, shown in the latter part of the nineteenth century, reveal elements of refinement similar to those found in the homes of their white counterparts. Note the photograph of Douglass, visible just over the shoulder of Rosabelle Sprague Jones, his granddaughter, standing on the right. More typically, African Americans in middle-class homes appeared in domestic service roles, as in the case of this nurse, who tended the children of the Kaspar family, of 1217 M Street, N.W., in the 1890s. Joseph and Annie Kaspar were distinguished musicians and teachers who were born and trained in Europe then immigrated to America.

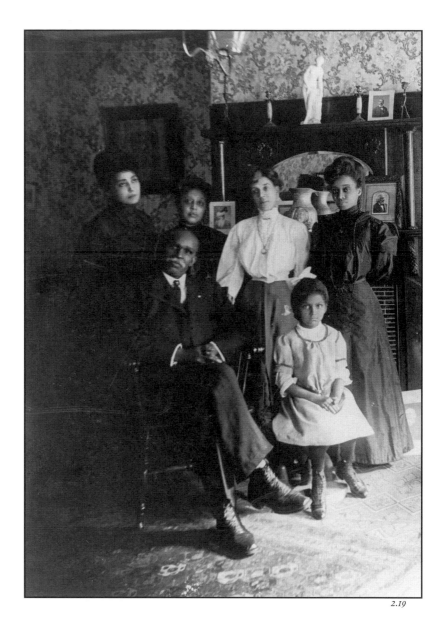

2.19

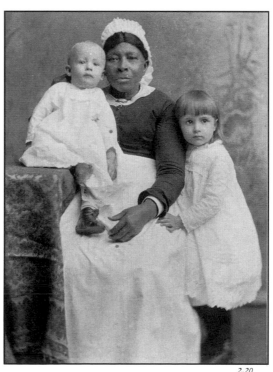

2.20

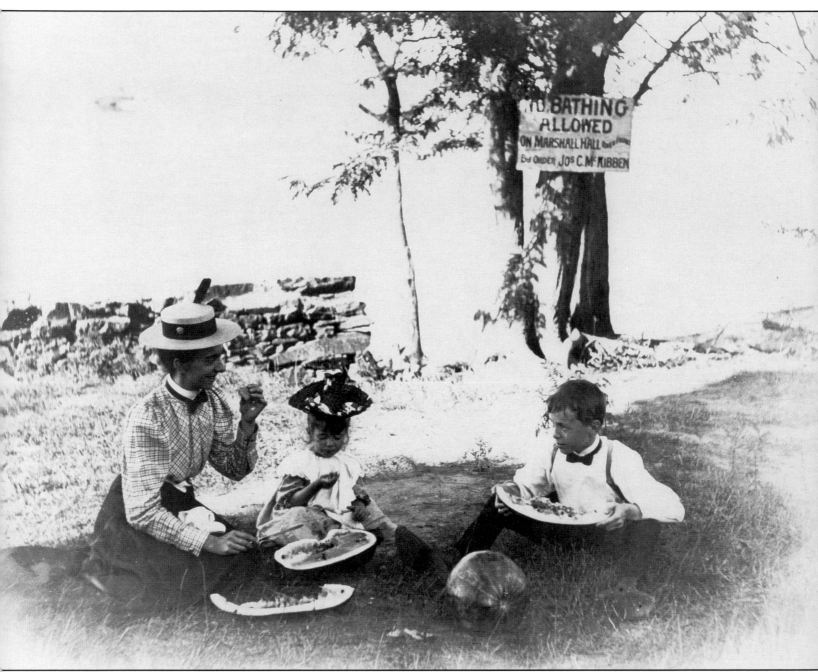

Even as the city grew, the country was never far away, and picnicking ranked high among the customary pleasures of local residents. Henry Arthur Taft photographed his wife Grace with children Mary and Ernest enjoying an outing on the banks of the Potomac River at Marshall Hall, Maryland in 1898 (2.21). A photograph of a Solomon family gathering (2.22) taken about the same time suggests that such occasions were the product of considerable planning. Not only are participants well dressed for the occasion and blessed with a rich table of wine and foods, but three black servants stand in the background ready to

ease the party's needs. Sometimes nature made city streets a playground, as when a heavy snowfall in February 1899 turned 9th Street into a viable route for sledding. This view east from the Taft home, in the 600 block, N.E., shows neighborhood children pulling a "double ripper." Across the street are the type of homes that preceded the more modern row houses like the one the Tafts occupied. In the gap to the right of the small houses can be seen some of the many alley structures that ran through the center of blocks in the builtup portion of the city.

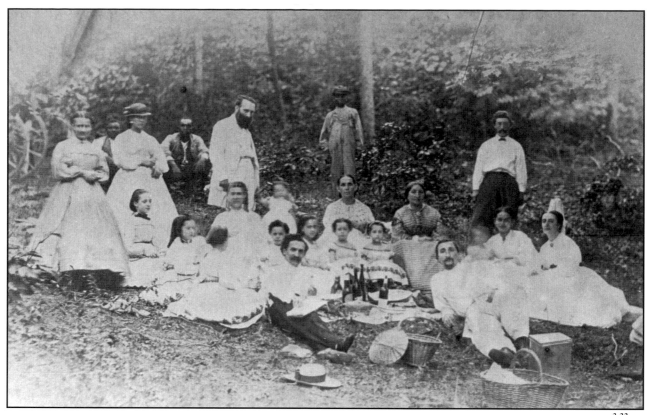

2.22

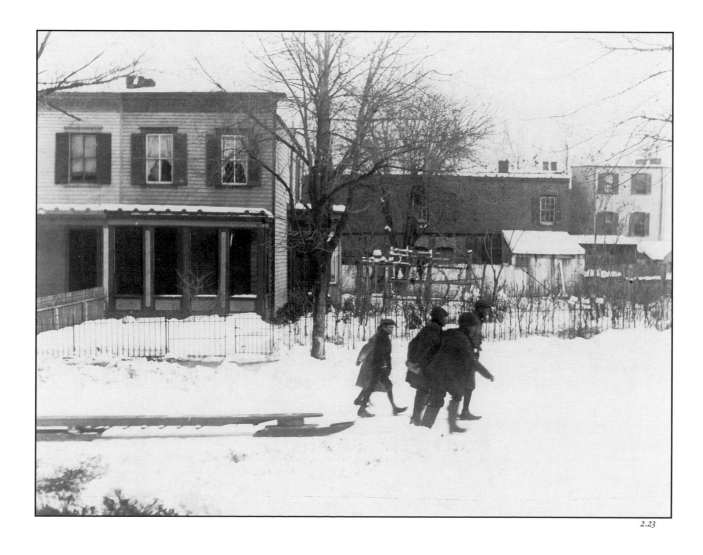

2.23

43

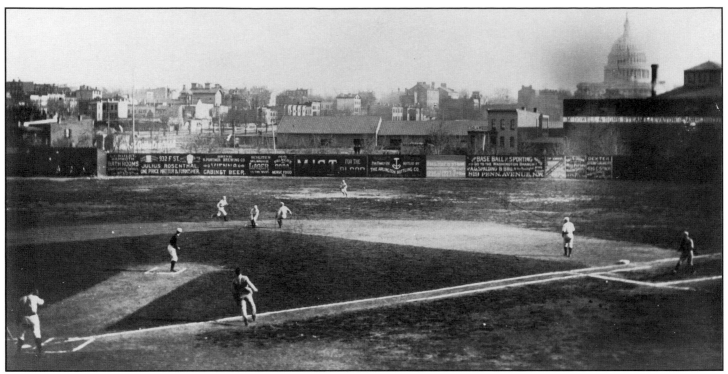

2.24

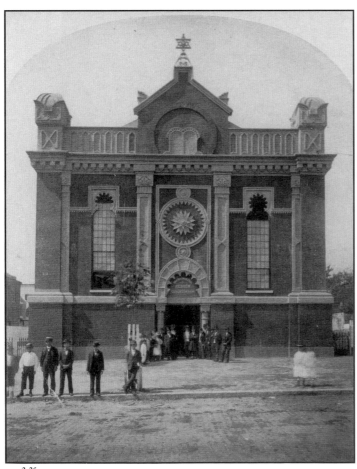

2.25

New forms of mass entertainment emerged with the organization of professional sports, and the baseball park at North Capitol Street and Massachusetts Avenue, N.E., virtually in the shadow of the Capitol, proved a popular attraction. Taken in the late 1880s, the photograph shows the National League Washington team, known as both the "Statesmen" and "Senators," playing in a field whose backdrop is a mix of industrial and residential structures. Despite the presence of the young Connie Mack, the Washington nine finished last three of the four seasons between 1886 and 1889, and the city did not have a National League team for several years thereafter. Early in the twentieth century, the field, which was located in the low-lying area near Tiber Creek popularly known as Swampoodle, became the site of the new Union Station.

Although new activities brought together Washington residents of different backgrounds, the exclusive ties of race and religion remained socially powerful into the new century. The city's Jewish population was initially small enough that the first congregation, formed in 1852, could meet in private homes; but after an influx of Jews during the Civil War, the Washington Hebrew Congregation built this imposing temple (2.25), at 8th and H Streets, N.W., near the small shops operated by Jews along 7th Street. The building is now the home of a black congregation, Greater New Hope Church.

Church rituals formed an important foundation of community. In photo 2.26 members of Georgetown's Mt. Zion United Methodist Church are shown taking advantage of Rock Creek for a mass baptism sometime around the turn of the century. A large number of parishioners were able to witness the ceremony from the P Street bridge. The history of Mt. Zion Church began in the Montgomery Street Church, founded in 1772, where African Americans constituted half the parish. Facing segregation and other discriminatory treatment, black parishioners left to form their own parish in 1814, which makes Mt. Zion the oldest black parish in the city.

Sundays also brought secular occasions for socialization and group solidarity. No ethnic-based social group was more active than the German Schuetzen Verein, whose Schuetzen Park, located east of Georgia Avenue between Hobart and Kenyon Streets, N.W., hosted elaborate annual festivals of concerts, games, and other amusements as well as weekend recreation. This photograph of the group (2.27) was passed along to the *Washington Star*'s John Clagett Proctor by Henry Dismer, proprietor of the Hannover hotel (shown in Chapter 1) and pictured here seated in the center. It suggests both the solidarity and the prosperity of Washington's German American community and the importance of the park, indicated by presence of a permanent shelter.

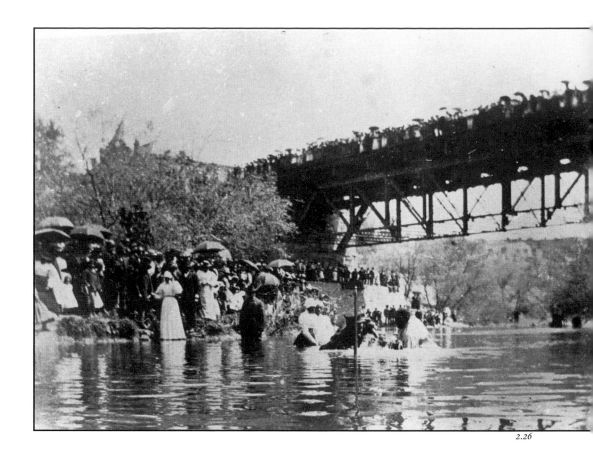

2.26

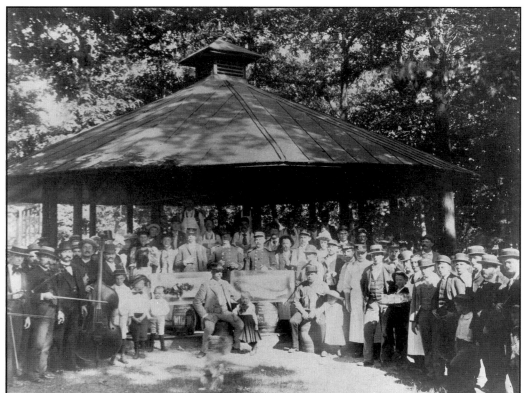

2.27

45

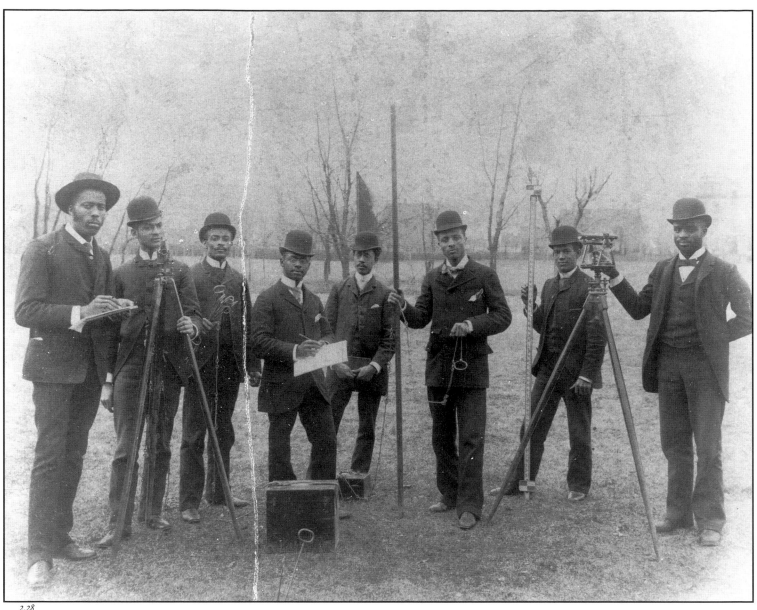

2.28

Founded in 1867, with the assistance of $500,000 from the Freedman's Bureau to purchase land for a site, Howard University offered aspiring African Americans professional as well as liberal arts education. With the support of the federal government, it expanded blacks' opportunities to train in law, medicine, dentistry, and other fields in the 1880s. Accompanying the surveying class shown here in 1893 was Kelly Miller, far right, a Howard graduate who served the university forty-four years, as professor of sociology and later as dean of the College of Arts and Sciences. He was an early contributor to *The Crisis,* the journal edited by W. E. B. DuBois for the National Association for the Advancement of Colored People, and an organizer of the Washington Community Chest. But

despite the university's success, the city around it had, by the turn of the century, adopted most of the Jim Crow practices of segregation that characterized the South. The two other photographs here, taken by Frances Benjamin Johnston in May 1899, were commissioned as part of the United States' exhibit at the 1900 Paris World's Fair. That they were intended as official representations of life in the United States indicates the common acceptance of strict racial segregation of the schools. The black youngsters were attending a school in the 7th division, which was in Washington County; the white girls playing basketball were students at Western High School at 35th and T Streets, N.W.

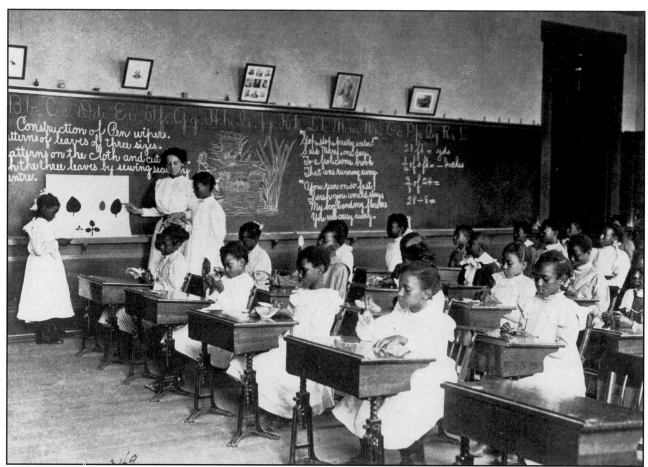

2.29

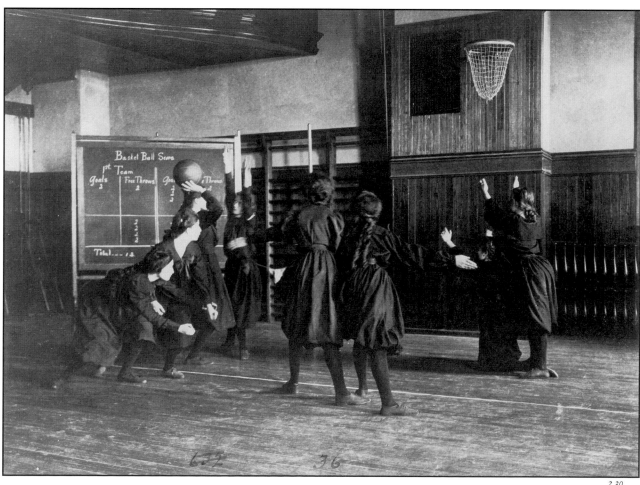

2.30

47

Part II Government City,
1900–1932

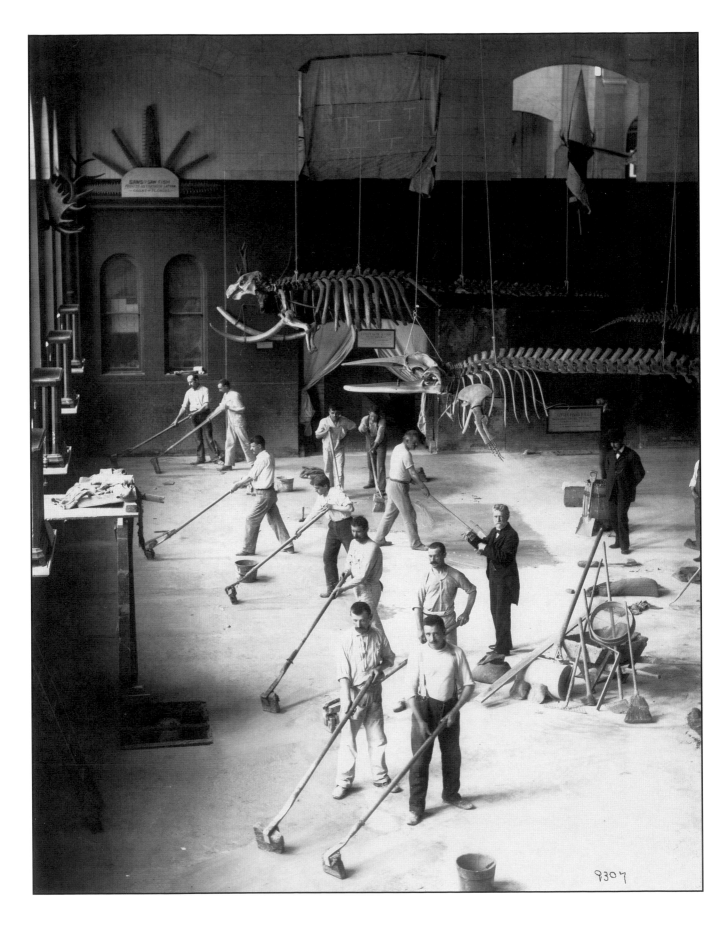

Workers completing preparations for the opening of the Smithsonian's new National Museum, 1910

❦§ 3 Working in a Company Town

As the size of federal employment mushroomed from just under six thousand in 1870 to more than twenty-five thousand in 1903 and on to sixty-five thousand by 1927, Washington solidified its status as a company town. By creating positions in which employees worked with their heads rather than their hands, by providing stable employment, and by pioneering policies for sick and vacation leave, the government provided unprecedented conditions for sustaining a stable middle class. In contrast to factory workers, who worked ten- and twelve-hour shifts, government employees, by a congressional directive of 1883, worked from nine o'clock until four o'clock six days a week with half an hour off for lunch, a forty-two-hour work-week. Although the nature of work in early twentieth-century Washington was neither uniform nor predictable, it was the federal government that set the tone for the city.

Well into the late nineteenth century much of the work government employees performed was technical and demanded administrative as well as clerical skills. The term *clerk* was thus something of a misnomer. As the government grew, however, agencies created new divisions, and the range of individual responsibilities narrowed. The change coincided with the introduction of women to the federal work force and was accelerated by their presence.

Departments first hired women during the Civil War, when U.S. Treasurer Francis Spinner declared that the men cutting the new bank notes authorized under the Legal Tender Act of 1862 ought to be wielding muskets on the front line instead. Women were soon working in many departments. With their pay initially set at $600 a year, only half that routinely allowed men, they represented a considerable savings for the government. Moreover, many were placed in areas where routine, not administrative responsibility, was becoming the rule: counting money at the Treasury, transcribing deeds at the Patent Office, or reviewing applications for hearings at the General Land Office. Although women's pay began to approach that of some men by the turn of the century, overall they lagged behind male government employees. While 42 percent of the women employed in the Treasury Department made $1,200 or more in 1901, two-thirds of the male employees made as much. No women made as much as $1,800, while nearly a quarter of the men did.

New office equipment affected the lives of workers, and there was some correspondence between women's entry to the work force and specialization of equipment. A number of women pioneered use of the Hollerith tabulating machine, the direct

ancestor of the electronic computer. Although as late as 1904 women held less than a quarter of the typist positions, more women than men were applying for such jobs, and it was only a matter of time before they dominated the government's growing typing pools. By 1930 women filled nearly half of all federal clerical positions.

While the growing demand to maintain records increased the number of clerkships, expansion of the government also created industrial work, not least in the Navy Yard, the massive Government Printing Office, and the Treasury's Bureau of Engraving and Printing, each of which employed between four and five thousand people by the mid-1920s. In addition, every large office demanded its share of service personnel: custodians, charwomen, messengers, and maintenance workers. Even single departments sustained a range of activities. In the huge Department of the Treasury, employment ranged from the dirty work of mixing inks and printing money to the meticulous task of engraving printing plates to the highly routinized job of counting the finished bills.

The city's expansion created the need for many additional services. The Potomac Electric Power Company was founded in 1896. Like the largest of the federal departments, Pepco sharply differentiated its work force by status, race, and gender. The same office hierarchies appeared in other large private firms. Job descriptions in smaller companies remained more fluid and informal. Still smaller businesses, frequently run by recently arrived Jewish or Italian immigrants, sold clothing or groceries, mended clothing or shoes, sold daily papers or, on occasion, provided a bit of local manufacturing.

White-collar work and employment in skilled trades dominated in Washington, but access to such jobs was anything but equal racially. While three-quarters of employed whites held white-collar positions in 1930, only about 16 percent of black workers did. Closed out of skilled jobs in the building trades and barred from such positions as operators of city streetcars or buses, most black men had to supplement what jobs they could find with extra employment. Poverty also required many black women to work. While a few achieved professional status in the segregated school system, the great majority held domestic or personal service positions. Of the 44,424 female African Americans listed in the 1910 census, 26,699 were gainfully employed, 23,314 as charwomen, servants, laundresses, seamstresses, housekeepers, and general laborers.

The vibrant Washington Board of Trade lobbied aggressively on behalf of the city's private sector. Responding to the board's effort to recruit both wholesalers and factories, the Washington Chamber of Commerce formed in 1906. Yet another trade group, the Merchants and Manufacturers Association, organized four years later. The Board of Trade's Committee on Trade and Manufacturing declared, "Anything tending to induce manufacturers to locate their plants here [should] receive the earnest support and approval of our citizens." Small successes followed, like the location of a munitions plant on the far side of the Anacostia River. But as early as 1910 the board recognized that Washington's becoming a manufacturing or commercial center was "evidently impossible." The Chamber of Commerce, after a relatively short and precarious existence, merged with the Board of Trade in the mid-1930s, affirming Washington's already well-established character as a center for government and service.

These photographs of the gun factory at the Washington Navy Yard, taken by Frances Benjamin Johnston in 1903, belie Washington's image as a white-collar town. Photo 3.1 shows the vast production facility running some 900 feet and producing heavy weapons up to 16 inches in diameter. Overhead are two of the electric cranes capable of hoisting weapons weighing up to seventy-five tons. In the other photograph skilled mechanics prepare to hoist a new gun. Founded on the Anacostia River in the early nineteenth century, the Navy Yard lost its primary role of shipbuilding when silting curbed navigable access to it. Converted to a weapons plant, the facility received a major boost from America's emergence on the world stage in the Spanish-American War in 1898. The year these photographs were taken, the Army Corps of Engineers described it as "one of the finest gun shops in the world."

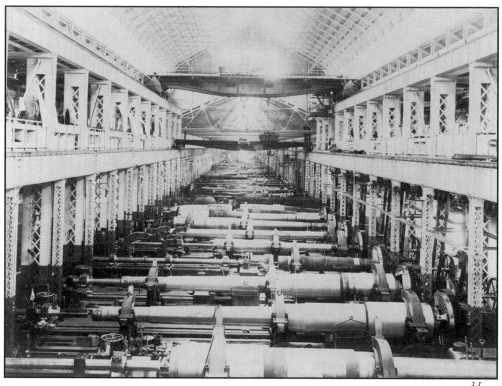

3.1

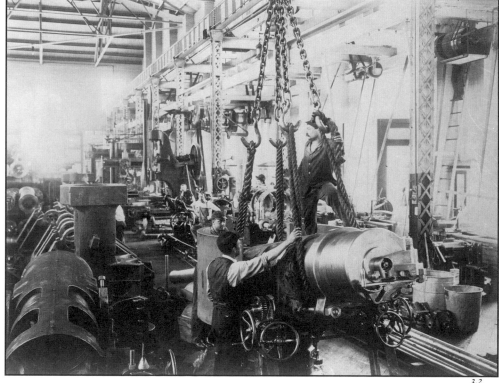

3.2

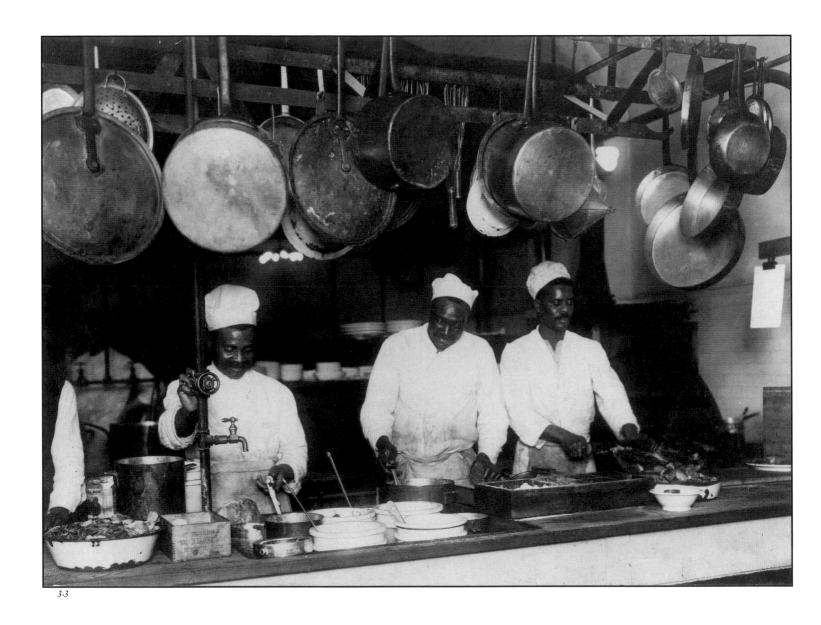

While members of Congress toiled above, service personnel did the jobs that allowed the government to function on a daily basis. The cooks captured in a 1911 photograph (3.3) are preparing meals in the U.S. Senate kitchen, the tools of their trade arrayed above them. Also shown in the setting of his trade is a plumber, pictured in 1908 in the maintenance shop in south wing of the Capitol (3.4). The meandering piping was a consequence of retrofitting water and sewage lines into the Capitol, originally constructed without them.

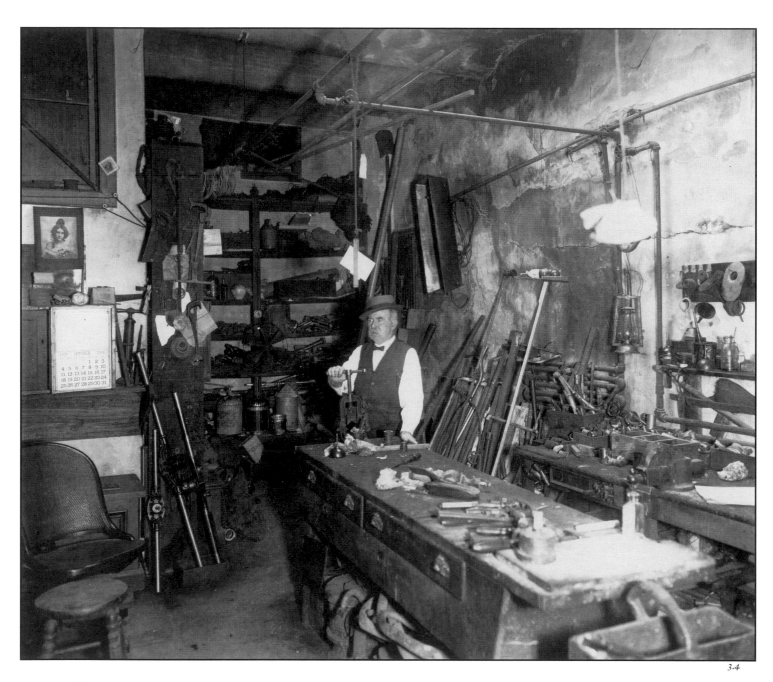

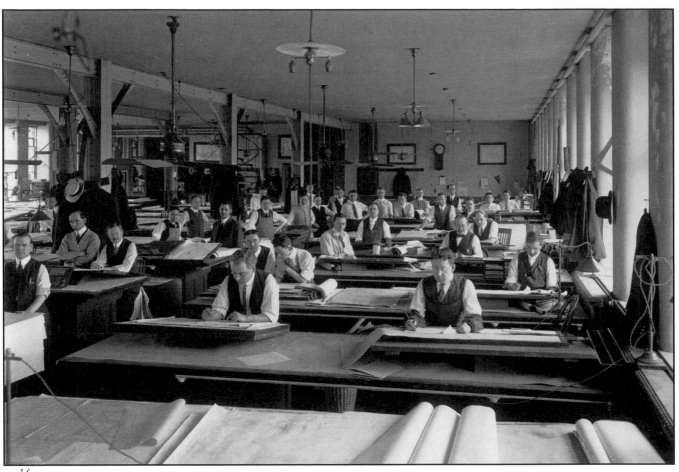

3.5

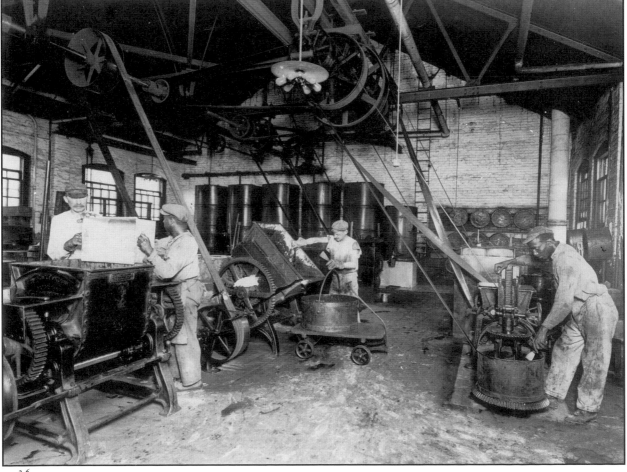

3.6

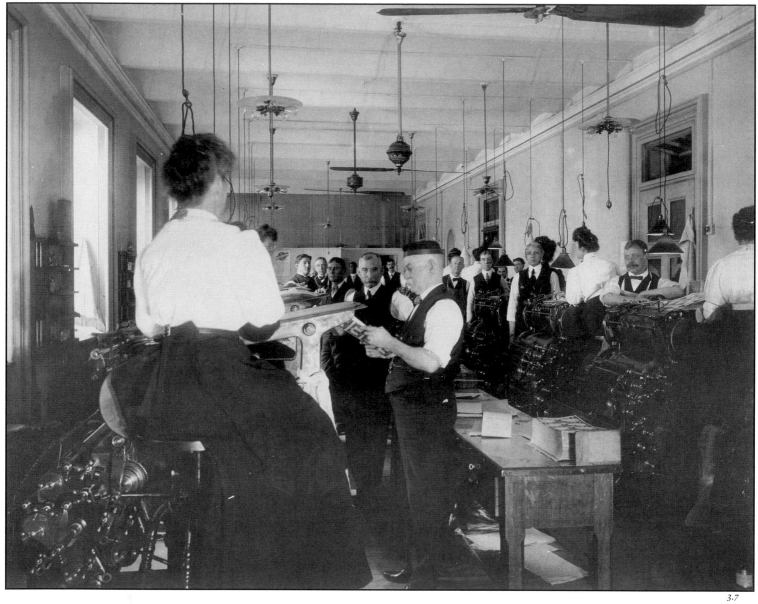

A big department like Treasury could set the pace for whole sectors of public employment. Responsible for issuing one million dollars in currency a day in 1910, Treasury demanded work-intensive activity in a variety of environments, as this series of photographs taken for the government in the early part of the century indicates. Expert engravers (3.5) spent as much as six months detailing each plate. In sharp contrast to the engravers' work environment was the ink-mixing room (3.6), in which, as a contemporary account described, the air was "full of wild and confusing motions," the men "smeared to the elbow with ink, and their perspiring faces begrimed with it." At the presses (3.7), where newly printed dollars emerged, a senior printer reviews work, as women assist the pressmen.

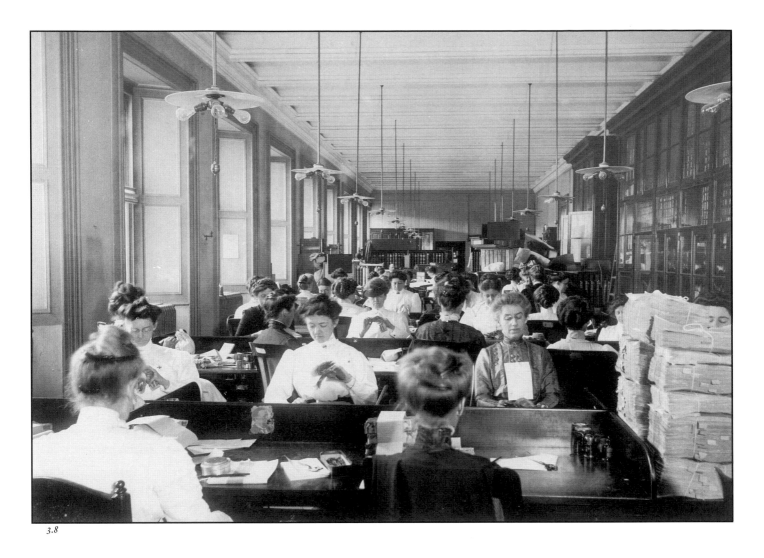

3.8

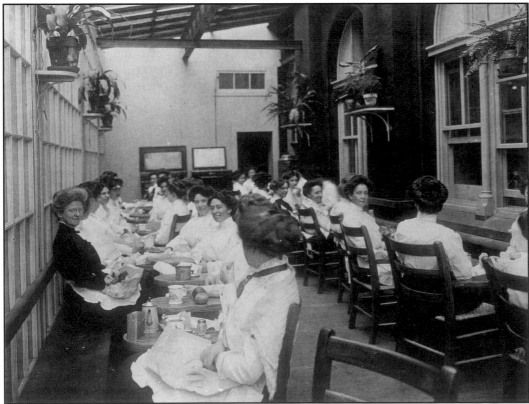

3.9

Elsewhere in the department, women filled the role of counting money and discarding flawed bills (3.8). No men were assigned to this tedious task which required counting as many as thirty-two thousand notes a day. Their presence in the work force gave women a growing sense of solidarity, one that was reinforced during breaks from the routine like this one for afternoon tea.

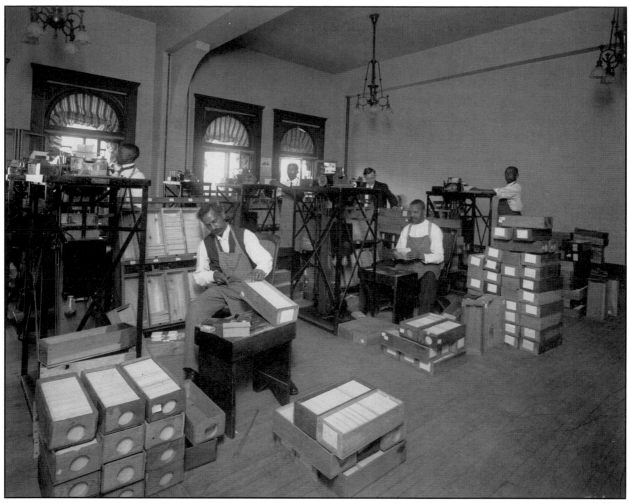

3.10

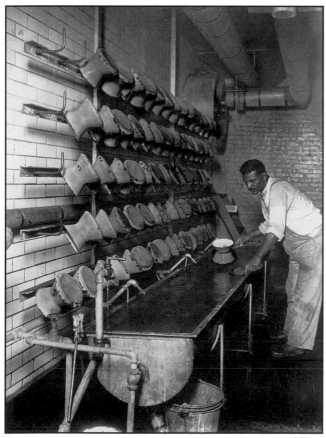

3.11

Blacks filled a number of functions at Treasury, though usually in secondary roles, as assistants to engravers or as custodians or in segregated work settings. In photo 3.10, black workers trim and box currency under the eye of a white supervisor. It was a black man who cleaned and sterilized the many cuspidors that equipped the offices of white-collar workers, in this case at the main Treasury building.

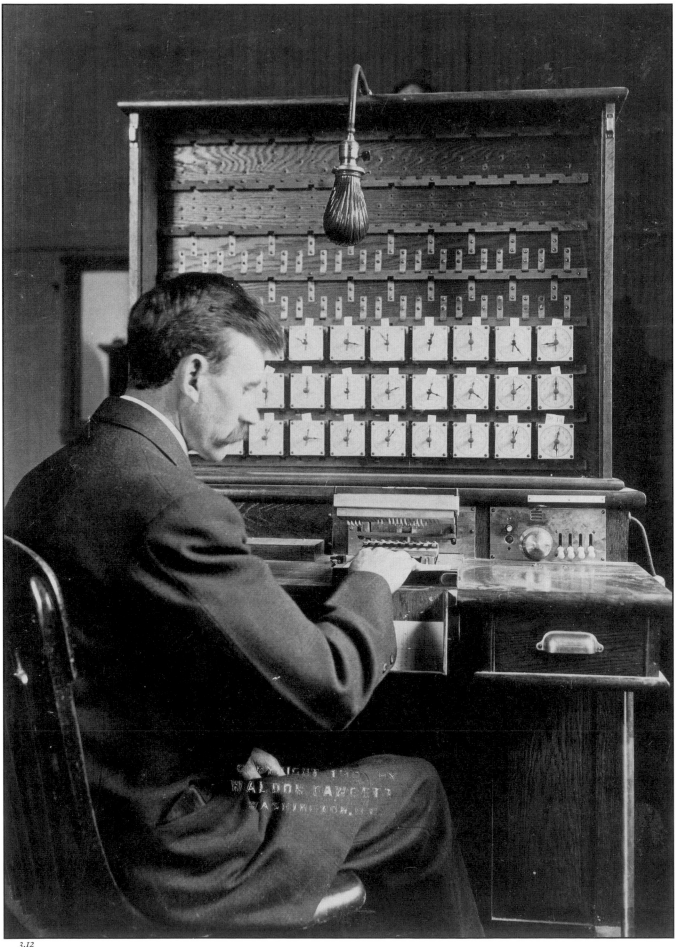

3.12

A government responding to new international as well as national needs required an expanding work force, not the least to keep records. Two photographs (3.12, 3.13), dated 1908 and 1920 respectively, show the early use of computing machinery. The Hollerith tabulating machine had been introduced to help count the 1890 census. Clerks entering information in the form of punched cards could complete as many as eleven thousand cards a day. Developed to handle the massive amount of information required by government, the device promised considerable efficiency but also signified the kind of specialized routine that was dominating increasing numbers of federal office jobs. The third photograph shows an office in the Customs Division in 1910. A single black professional joins the ranks of clerks dealing with the vast amount of paperwork generated by America's rapidly expanding population and international trade.

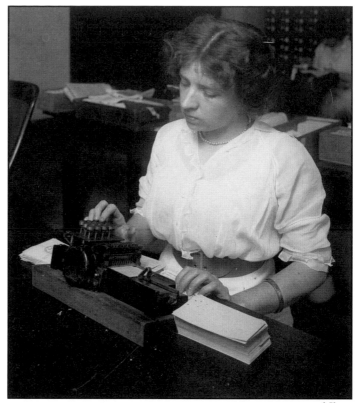

3.13

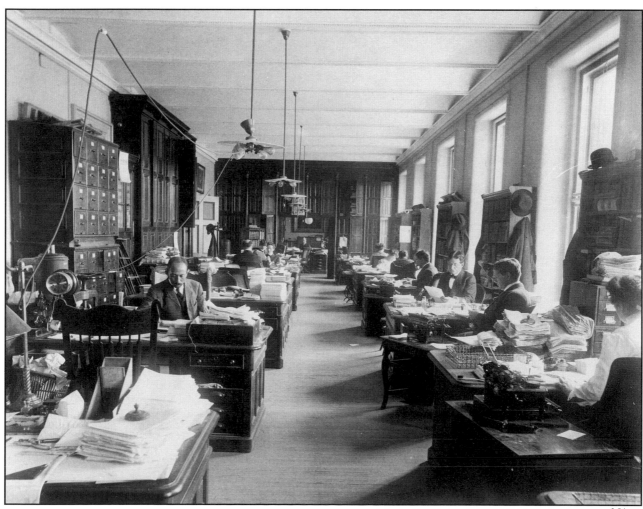

3.14

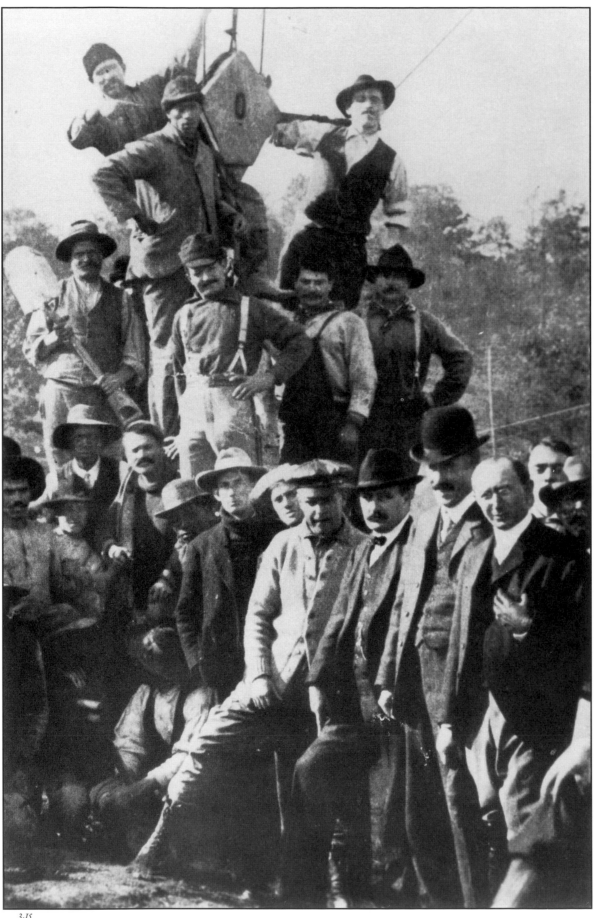

3.15

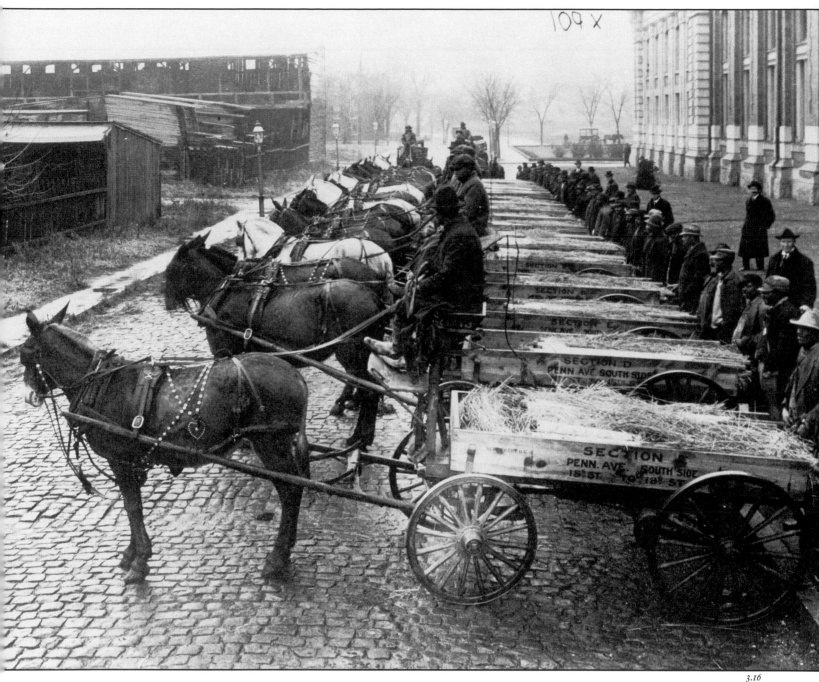

As the city pushed out into relatively undeveloped areas, municipal services needed to be extended. The ornate William Howard Taft Bridge, the first of four to cross Rock Creek, was begun in 1906, to connect the old city with the expanding residential neighborhood of Cleveland Park. Photo 3.15 shows some of the workers who labored in its construction. Their pose was typical of work group photographs and shows a sense of solidarity, even as it reveals, through the presence of the supervisors at the front, something of the hierarchy within the group. When completed in 1907, the bridge was the largest unreinforced concrete bridge in the world. In the second photograph, from the early 1900s, an army of city workers stands in formation outside the new District Building at 15th Street and Constitution Avenue, ready to clean Washington's streets. Their destinations are inscribed on their carts.

3.17

World War I propelled Washington into world prominence. Although America's involvement was relatively brief, it nonetheless demanded a rapid and dramatic expansion of government personnel and facilities. The city's population had risen by over one hundred thousand by Armistice Day, 1918. In photo 3.17 wartime workers on their lunch break crowd the streets outside government offices. To accommodate such numbers, new space had to be found. Makeshift desks were packed into areas not meant for offices, such as one of the display spaces of the Smithsonian's National Museum (3.18), which served an army of war insurance workers. The government also constructed temporary living quarters on public space like the Mall and the plaza fronting Union Station (3.19). Government employment later declined, during the 1920s, but these dormitories survived until 1931, when they were torn down to expand the station plaza.

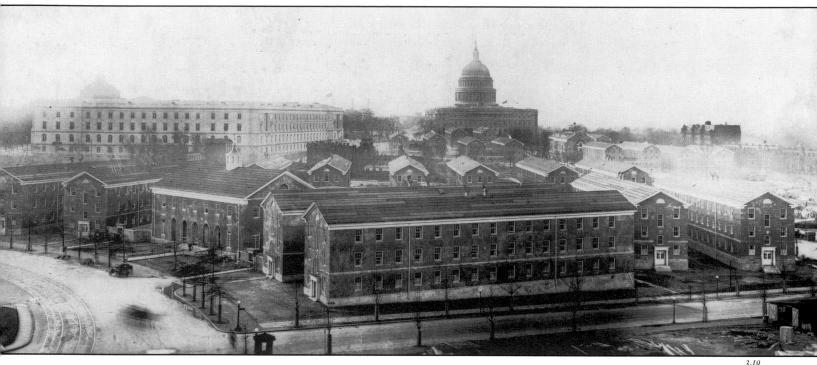

3.19

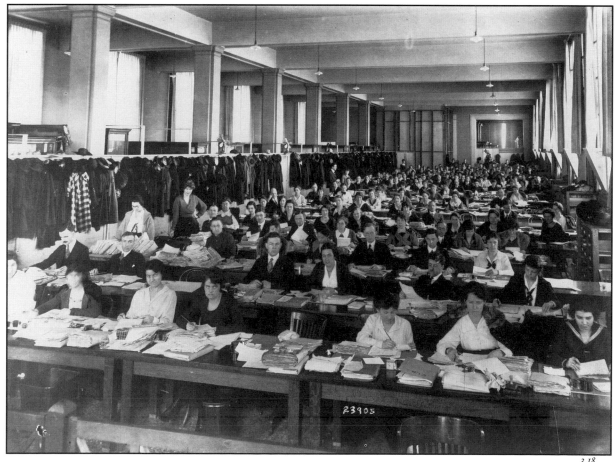

3.18

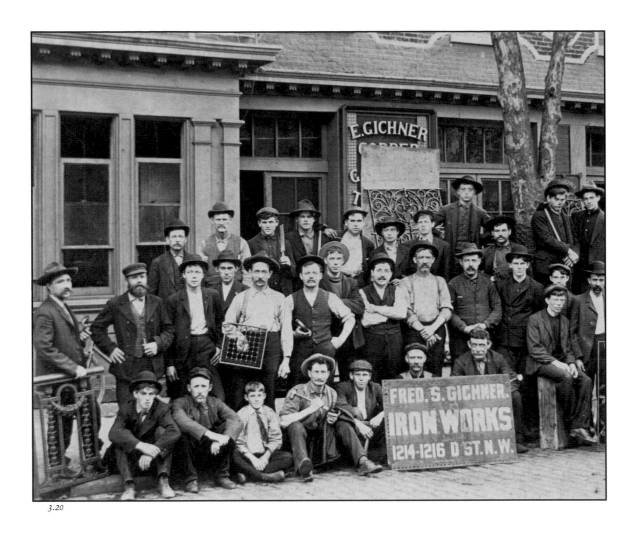

3.20

3.21

66

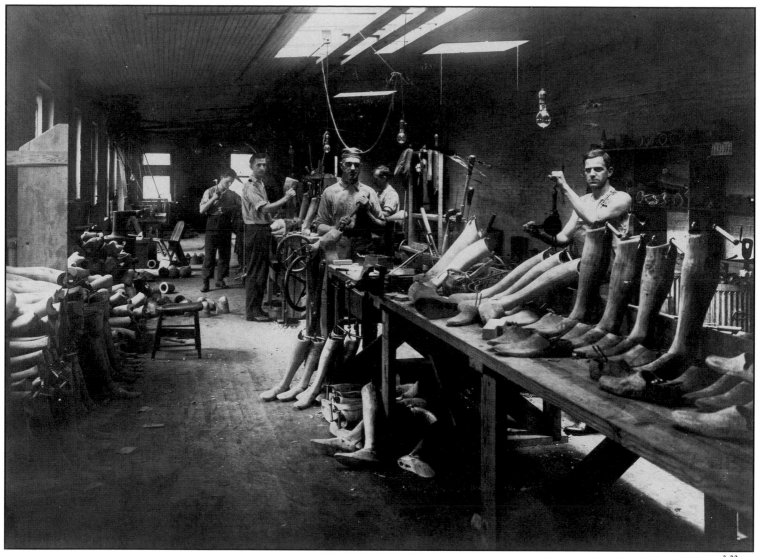

Although not known for its private industry, Washington had its share of small industrial operations. Among the more prominent was the Gichner iron works, located on D Street, N.W. The company, whose workers are shown posing in front of their shop in 1906, was founded by Fred Gichner, an Eastern European Jewish immigrant who worked in Baltimore after his arrival in America in 1890 and then came to Washington to do ornamental work for embassies. He left the A. F. Juris Ironworks in February 1898 to go into business for himself out of a rented store at 12th and E streets. His company quickly expanded, propelling him into a number of other activities, including real estate investments and service as head of the Jewish Social Service Agency. During World War II the company shifted its emphasis from forged ornamental work to custom body building. As late as the mid-1950s it was operating

under a U.S. Navy contract to produce crash and fire trucks.

The L. E. White coal yard, shown in photo 3.21, among the several hundred to be found in the city early in the century, hardly qualified as an industrial plant, but it provided fuel to the plants of many industries and to homes well into the twentieth century. The horse-drawn wagons were a typical feature of such operations, and their drivers formed an important part of Washington's blue-collar work force.

The J. E. Hanger artificial limb factory, at 221 G Street, N.W., pictured here(3.22) in about 1916, was founded in the 1880s by a Civil War veteran who had lost his own leg in battle. The company grew, opening offices abroad during World War I, and subsequently emerged as the largest of about twenty-five such companies operating in the United States.

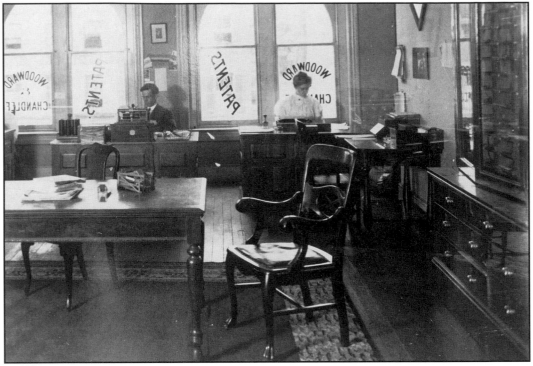

3.23

The government's business spawned a number of associated private enterprises in such areas as patent work and printing. The firm of Horace Woodward and Henry Chandlee, at 12th and F Streets, N.W., as pictured here in 1908, bears the mark of its elevated professional status. Secretaries attending to company correspondence are surrounded by elements of plain but high taste in furnishings and decoration.

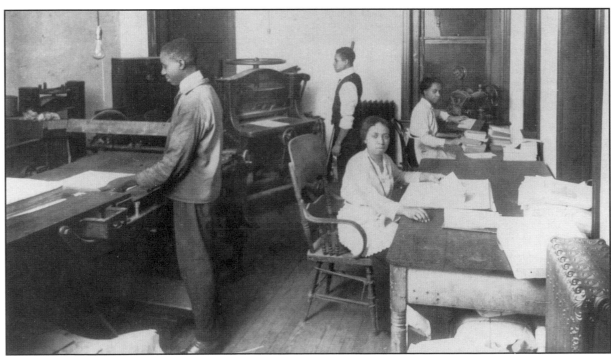

3.24

More modest in physical accoutrements and less visible was the growing printing business of John Goins, pictured here in the mid-1920s. Its location, at 1344 U Street, was in the heart of the black business and cultural district, in the Shaw neighborhood, just north of the downtown. Directly across the street was the Republic Theater and a block away the Lincoln Theater, at 1229 U Street. Goins lived around the corner at 2019 13th Street, N.W.

3.25

3.26

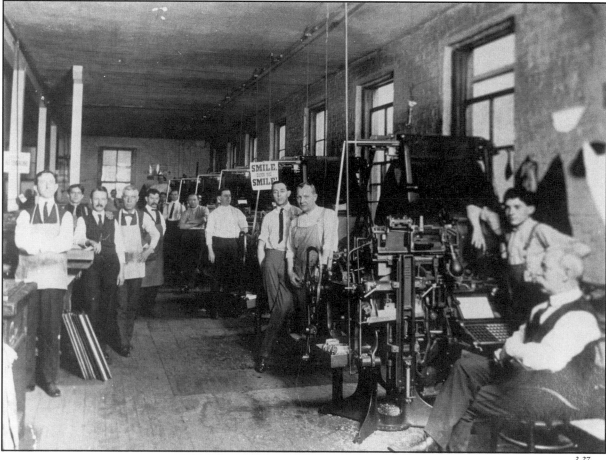

3.27

A particularly successful printing firm was Judd and Detweiler, founded in 1868 as special-
ists in bill heads, order blanks, requisitions, and bills-of-fare for hotels and restaurants.
During its first decade the company began printing books and magazines, establishing its
most significant account in 1890 with the National Geographic Society. In these photo-
graphs we see John G. Judd and Frederick Detweiler sharing the office of the company they
founded, located at 420 11th Street, N.W., and women working side by side with men in
the proofreading department, shown here in 1910. The type was produced at a row of
Linotype machines on the ground floor, where the admonition to smile seems to have had
little effect.

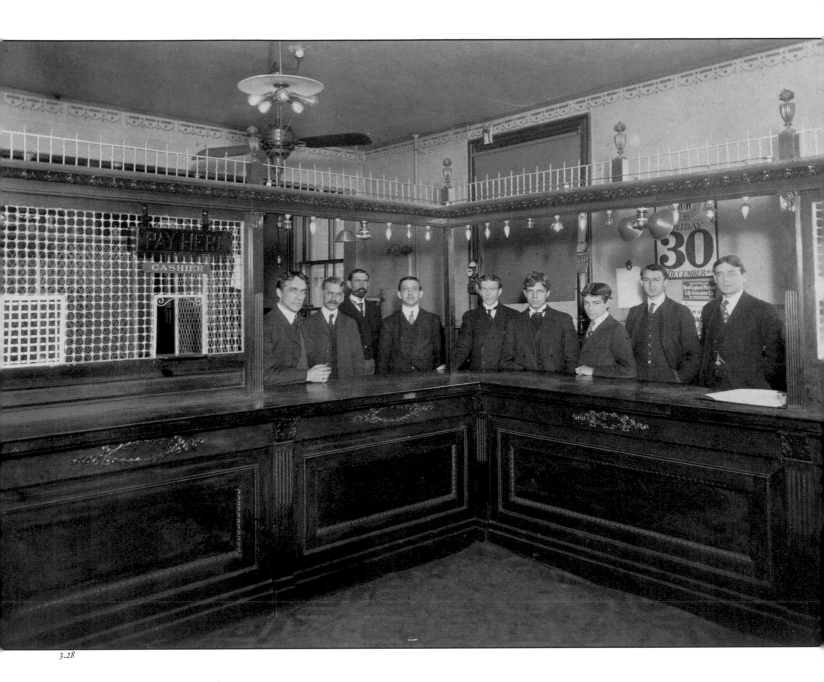

3.28

Another company that instituted a sharply differentiated business hierarchy as it grew was the Potomac Electric and Power Company, founded in 1896. Photo 3.28, presumably taken on December 30, 1904, judging from the calendar on the wall, shows the employees of the commercial department at 213 14th Street, N.W. Among those pictured was Philander Betts (third from left), who as commercial manager served the company only part time. PEPCO listed his full-time occupation as professor at George Washington University. The industrial setting for shop floor workers, pictured in 1904 (3.29), is dramatic, as is the image of workers tending the company's early generators (3.30), which were located at 14th and B Streets, N.W.

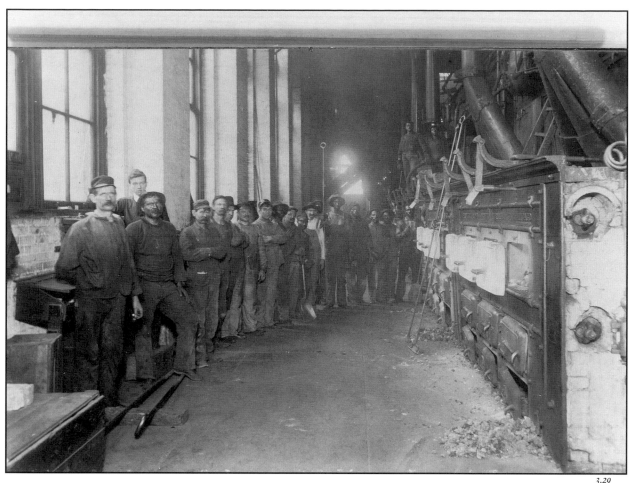

3.29

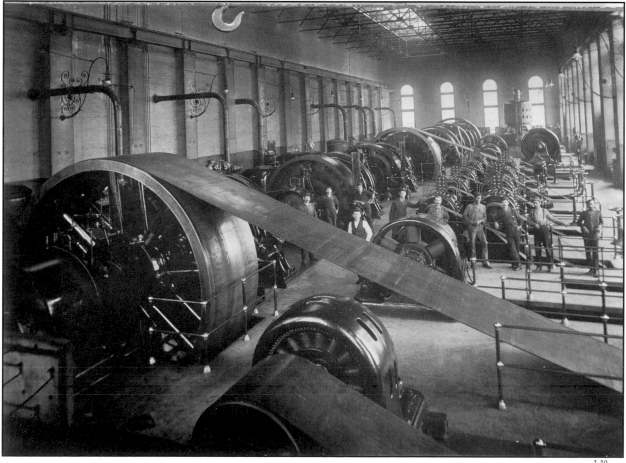

3.30

3.31

Many of the service occupations in the city were filled by recent immigrants. Jewish shopkeepers played an important role in the city in the late nineteenth and early twentieth centuries. Controversy was aroused by the labor of younger immigrants, such as these young Jewish entrepreneurs working as gum vendors and newsboys at 7th Street and Pennsylvania Avenue, N.W., in 1912. The photograph was taken by the pioneering social reform photographer Lewis W. Hine for the National Child Labor Committee and submitted to Congress as evidence of abuses of the District's 1908 child labor legislation. Wrote Hine, "At various times, the streets literally swarmed with youngsters, a few of them five and six years old, many of them from 7 to 12. It was impossible for me to count, or even to estimate the number of them accurately, in the limited time I was in the city, because of the irregularity of employment and the vacillation of the children from place to place." The smallest boy pictured here was listed at eleven years old.

Italians filled many service occupations. Of the 638 employed male Italians listed in the 1900 census, a quarter provided domestic and personal service, forty as barbers. Of the two hundred listed in manufacturing, the great majority were concentrated in boot and shoe repair, like James Zagami, shown here in his Capitol Hill shop at 915 C Street, S.E. around 1912. Zagami was part of a secondary migration to the city. Like many of his countrymen, who entered at other ports and headed right to industrial work before relocating to Washington, he took his first job as a miner in West Virginia.

3·33

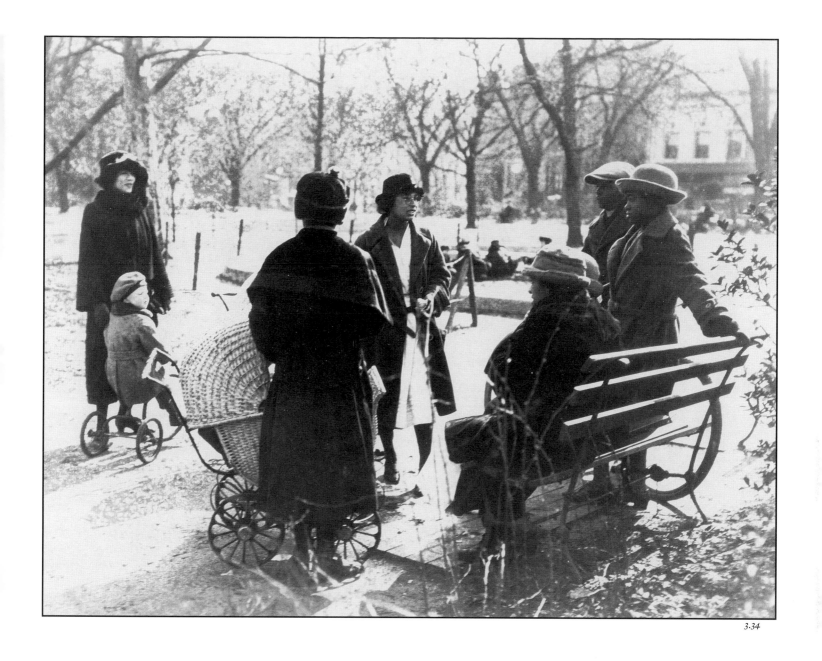

Many service-oriented jobs were filled by African Americans. Despite the advances in education made possible by Washington's segregated but strong school system, the city's blacks, who made up a quarter to a third of the entire population through the first half of the twentieth century, found work largely as laborers or domestics. Photo 3.33 shows laundry workers at the Grace Dodge Hotel, located at 20 E Street, N.W., in the 1920s. In photo 3.34 black maids congregate in Dupont Circle in March 1923. Residents of the still fashionable area west and south of the circle drew help from the poorer, larger African American neighborhoods to the east.

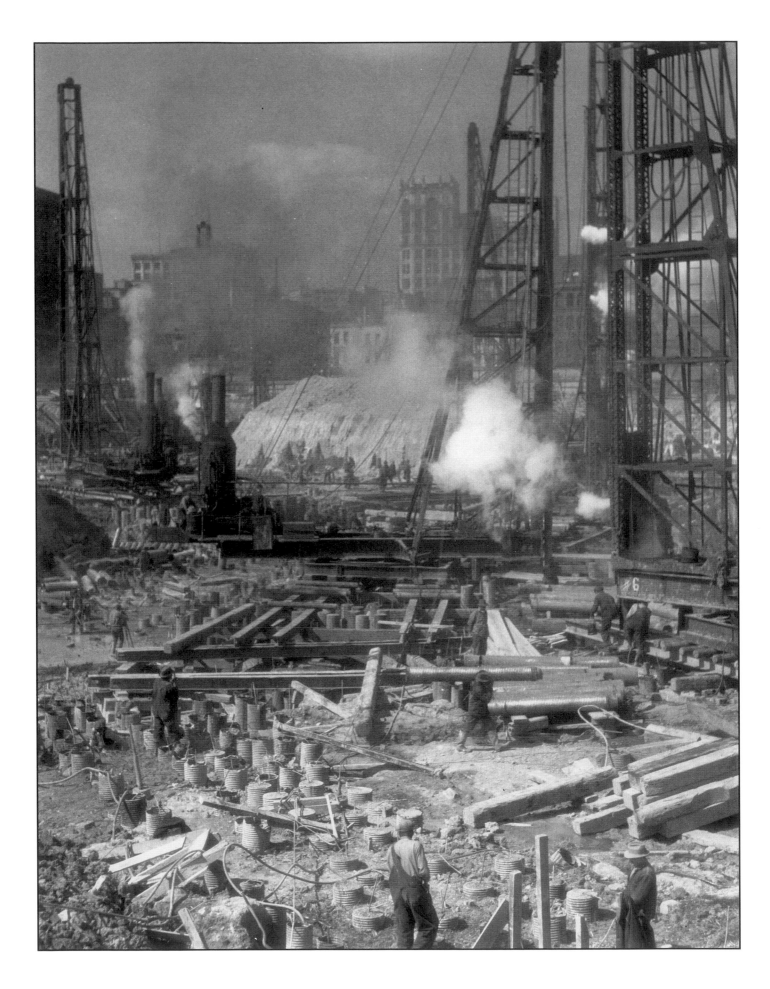

Construction of the new Post Office, circa 1932

✑§ 4 The Remade Center

During the first third of the twentieth century the heart of Washington, D.C., was transformed. The original impetus came from the centennial celebration, in 1900, of the permanent location of the capital in Washington. As the time approached, civic leaders discussed a number of possible memorials to the occasion, including extension of the White House, establishment of a national university, creation of Columbus Park and the planting of centennial trees, and the building of a bridge to Arlington that would memorialize the soldiers lost on both sides in the Civil War. But it was an unofficial committee, appointed by Michigan senator James McMillan and known ultimately as the Senate Park Commission, who developed the most compelling vision for Washington. They presented a plan that unified the previous treatments of the Mall, consolidated federal buildings along its perimeter, and linked this monumental core with the larger metropolitan area through a series of parks and parkways. Unveiled at an expansive exhibit at the recently opened Corcoran Gallery of Art in January 1902, the Park Commission plan became a rallying point for the new City Beautiful Movement. In Washington the concept both evoked the bold vision of the city's original designer, Pierre Charles L'Enfant, and announced the city's intention to present itself in the future as a capital physically worthy of America's new standing as a world power.

Challenged by fiscal conservatives in Congress, the plan at first faltered. Only a new Union Station, designed by the driving force behind the Park Commission, Chicago architect Daniel Burnham, emerged quickly, but it established the concept of creating a monumental presence through buildings in uniform classical design. Efforts to institutionalize the Park Commission's goals failed during the first decade of the century, as Congress refused to fund either of the committees President Theodore Roosevelt named to advise him on the city's development. In 1910 Roosevelt's successor, William Howard Taft, gained congressional approval for a permanent Commission of Fine Arts. Its power was limited to advising government agencies on statues, fountains, and monuments in the District of Columbia. Not until creation of the National Park and Planning Commission in 1926 did the government finally have the tools to complete the Park Commission's vision: a memorial to Abraham Lincoln anchoring the west end of the Mall, a bridge from there across the Potomac to commemorate the losses of the Civil War, and a concentrated group of government

offices—the Federal Triangle—where once a welter of decaying properties had marred the space between the Mall and Pennsylvania Avenue.

The demand for more office space continued. The Federal Buildings Commission, established by Congress in 1916, decried federal working conditions until finally Congress in 1926 authorized a $50 million building program, half of which was to go to the Federal Triangle project. By 1938, as the project drew to completion, this complex formed the city's largest concentration of government employment, providing office space for twenty thousand people.

Influenced by the new standards of taste popularized by the World's Columbian Exposition held in Chicago in 1893, proponents of an aesthetically uniform federal presence denigrated the few grand structures erected in late-nineteenth-century Washington: the eclectic Executive Office Building, the Romanesque Post Office on Pennsylvania Avenue, and the florid Library of Congress on Capitol Hill. Although a different architect designed each of the buildings in the Federal Triangle, a single classical style and monumental scale characterized the whole group. Completed in the mid-1930s, along lines originally envisioned by the Senate Parks Commission, the Federal Triangle stood apart from the city around it as no other single project before it had done.

The consolidation of federal buildings on the south side of Pennsylvania Avenue completed the link between the central nodes of government at the White House and the Capitol, but it created a barrier between the government and the downtown. As growing numbers of automobiles jostled with streetcars along Pennsylvania Avenue, traffic added yet another dimension to the physical separation of city from capital. Yet the downtown benefited from its proximity to the thousands of federal jobs, and the area prospered, adding more stores and entertainment businesses. When the city directory first provided a listing for department stores in 1900, it named fourteen such establishments. Woodward and Lothrop, an early pioneer in the business, added 200,000 square feet of retail space during the first two years of the century. In 1902 the firm consolidated its activities in a single structure covering an entire city block.

Similarly the growing popularity of mass entertainments, especially moving pictures, encouraged construction of new and even luxurious facilities in which to enjoy leisure time. As a destination for theater, dining, and other forms of recreation, the downtown thrived in the first part of the century. Distinct as the federal and commercial sectors were from one another, together they gave central Washington an importance it had never before had.

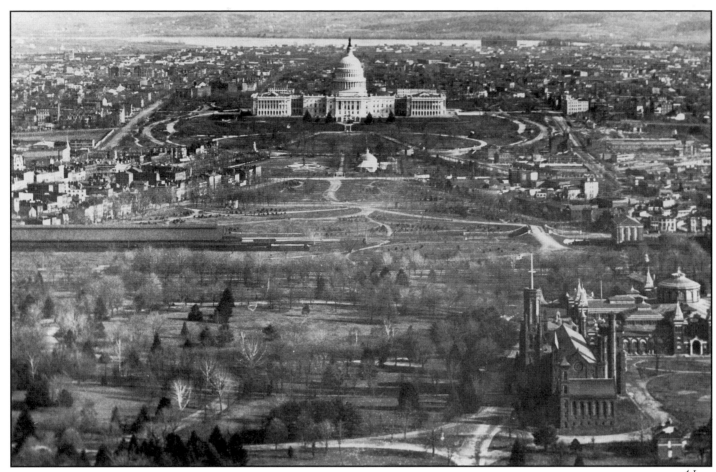

The product of a series of unplanned interventions, the Mall in 1900 had the appearance of a broken set of landscapes and uses. As this aerial view from the turn of the century reveals, it featured both the Victorian buildings of the Smithsonian Institution, in the right foreground, and railroad tracks and a station in the midground. Landscape architect Andrew Jackson Downing's 1851 plan for the Mall intended it as a romantic refuge from the city, an open space with a coordinated set of pathways and gardens. Instead, different treatments of various portions of the Mall gave it a jumbled character that hindered this purpose. Photograph 4.2, from the early part of the century, shows the tracks of the Baltimore and Potomac Railroad and its station at 6th Street and Constitution Avenue (then known as B Street). The B&P was given the rights to the prime location on the Mall in 1871 in order to facilitate arrivals downtown and to provide competition with the Baltimore and Ohio Railroad, but its presence on the Mall provoked both engineers and architects to agitate for its removal. In 1901, when the B&P's parent company, the Pennsylvania Railroad, consolidated with the B&O, the railroad agreed to remove the Mall station and began construction of Union Station at Massachusetts and Louisiana Avenues, N.E.

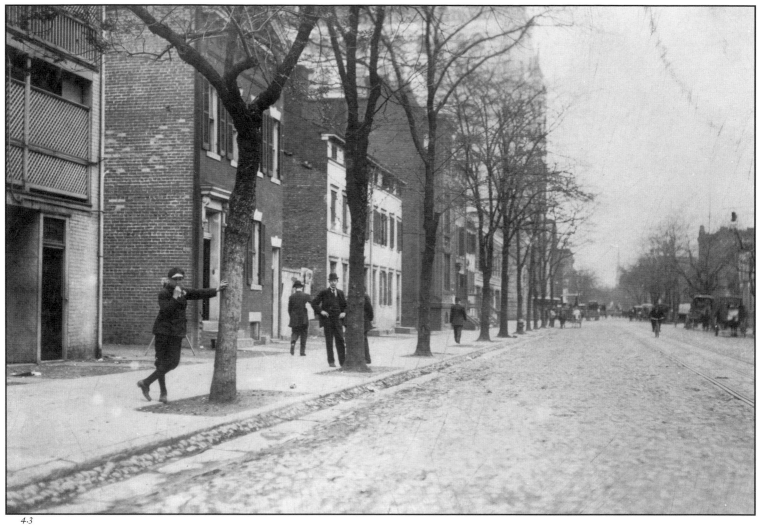

4.3

Although the Senate Park Commission succeeded in implementing a grand plan for the Mall, they had less immediate success in cleaning up the area known as Murder Bay, bounded by 12th and 15th Streets and Pennsylvania Avenue and the Mall. This Lewis Hine photograph from April 1912 (4.3), submitted as part of the National Child Labor Committee's report to Congress, shows a young "night messenger" posing in the red light district of Murder Bay on the 1200 block of C Street. Although hired by Western Union to deliver telegrams, these messengers were known to direct visitors to the brothels for a fee. The second view (4.4), towards Center Market on the right, dated 1927, reveals the old buildings and produce market which existed just west of Center Market along Constitution Avenue prior to the construction of the Federal Triangle complex.

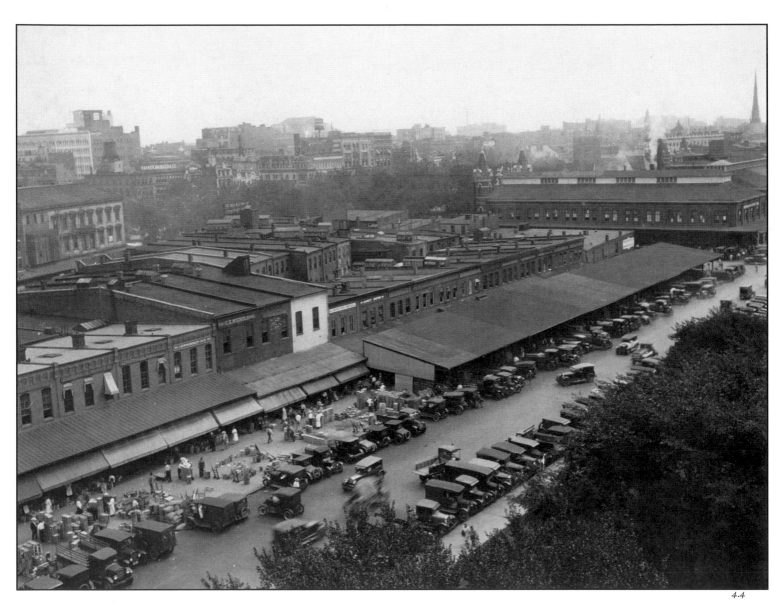

4.5

4.6

Showing the influence of the classical style of architecture popularized by the World's Columbian Exposition in Chicago in 1893, the Smithsonian Institution's new Museum of Natural History (4.5) rises on the Mall circa 1908. In contrast to the red brick that characterized the emerging commercial downtown, directly to the north, this and subsequent federal buildings called for by the McMillan Plan utilized white marble to distinguish structures housing the government. The high costs of the buildings projected for the Mall delayed implementation of the plan, but work proceeded briskly on the new Union Station (4.6), designed by the chief force on the commission, Chicago architect Daniel Burnham. Intended as a monumental gateway into the city, capable of immediately impressing visitors with the magnificence of its beauty, Union Station, shown here in 1928, was larger than the Capitol itself, an ornate structure carefully designed according to classical principles. Note the surviving government "temps" in the left foreground, which soon gave way to open parkland, and the red brick row houses left of the railroad tracks.

As part of the plan to create a monumental federal core at the city center, the Senate Park Commission had called for new federal

buildings between Pennsylvania Avenue and the Mall, to replace the concentration of bars and brothels of Murder Bay, which were considered a nuisance and a disgrace. After considerable delay, the federal government launched a major public buildings program in 1926. Photo 4.7, taken three years later by the Underwood and Underwood company, shows the Department of Commerce building beginning to rise between 14th and 15th streets, part of the complex, bounded by 15th Street, Pennsylvania Avenue, and Constitution Avenue, that came to be known as the Federal Triangle. Photo 4.8, taken about the same time by the U.S. Army, shows the last element of the Park Commission plan being realized in the construction of the Arlington Memorial Bridge, linking the city and Arlington National Cemetery. Its design the subject of controversy for more than a quarter-century, the bridge, as finally constructed beginning in 1926, assumed the classical mode called for by the McMillan Plan. Its terminus on the Washington side was the similarly classical memorial to President Lincoln, which had been dedicated in 1922. Behind the Lincoln Memorial in the center of the photograph are the temporary buildings constructed on the Mall during World War I.

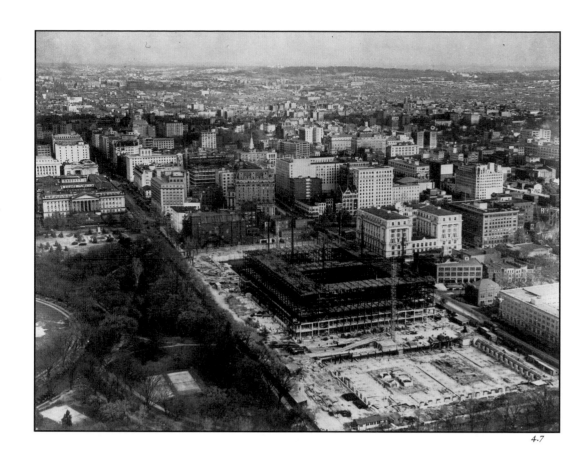

4.7

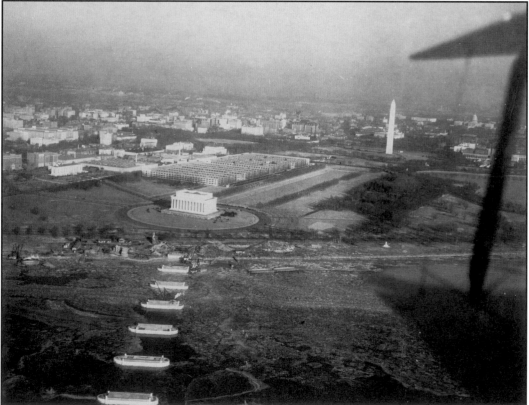

4.8

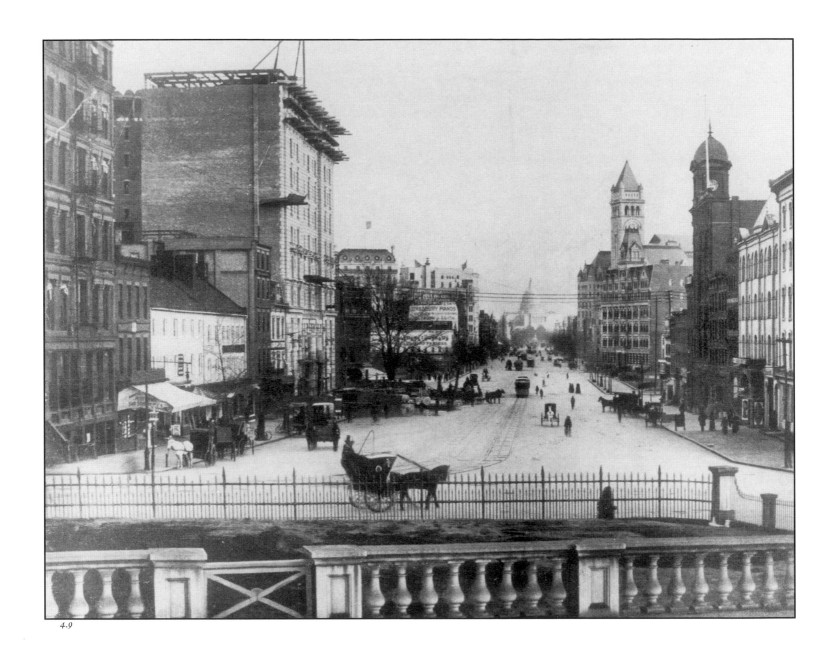

4.9

As a central artery in the capital city, Pennsylvania Avenue drew considerable attention from those who at the turn of the century were trying to beautify the city. A view looking east towards the Capitol from the Treasury Building features prominent buildings such as the Willard Hotel (1901), going up on the left; the granite Romanesque Post Office (1899), with its 315-foot-high tower at center right, a building considered too florid by proponents of the classical style for public buildings; and the red brick Southern Railway Building, whose upper two floors and clock tower were completed in 1903. Only a few of the Federal period structures that once dominated the area, known as Treasury Row, remain at the near left.

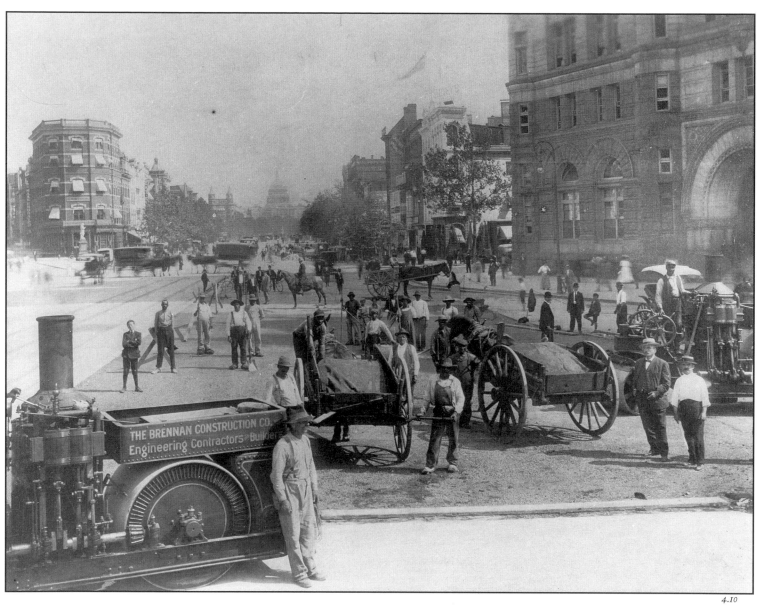

4.10

The photograph showing street work on Pennsylvania Avenue in front of the Post Office provides additional detail of a streetscape planners wanted to improve befitting the grand design for the capital. Shot in 1907 for the city's engineering department, this photograph documents the mixed use of steam- and horse-powered machinery as well as an integrated work force.

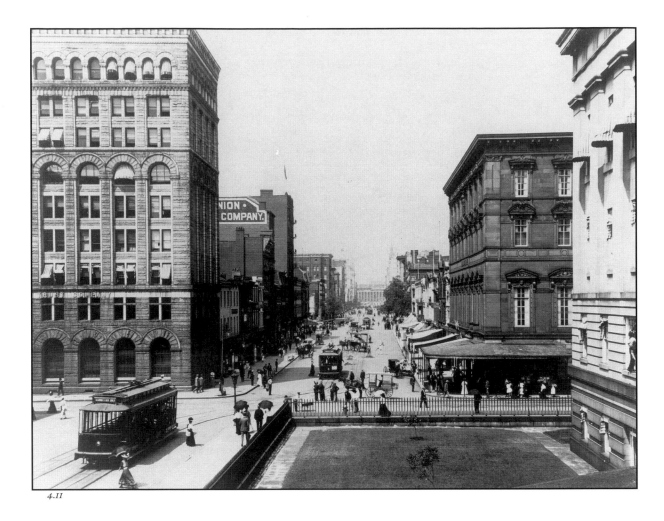

4.11

4.12

As a center of commerce and entertainment, F Street, shown in a view looking west from 9th Street in 1907 (4.11), formed the core of the downtown. Streetcars and carriages brought passengers to its places of entertainment, restaurants, and department stores. This photograph shows how the street had been improved since the time of the Knights Templar parade in 1873 that is shown in photo 1.7. The large building at left is the Washington Loan and Trust building, pictured under construction in photo 1.19 and by 1907 just one of many highrise buildings on the street. The building housing S. Kann's department store in the 1920s, located at 7th Street and Pennsylvania Avenue, was originally the home of the first clothing store opened by Isidore and Andrew Saks and subsequently the Boston Dry Goods House that evolved into Woodward and Lothrop. Kann's occupied the space from 1886 until it was razed in 1979 following a serious fire. At the other end of the downtown, at 15th Street, where the financial district was concentrated, streets and sidewalks filled to capacity during the work day, as a view from the 1920s indicates (4.13).

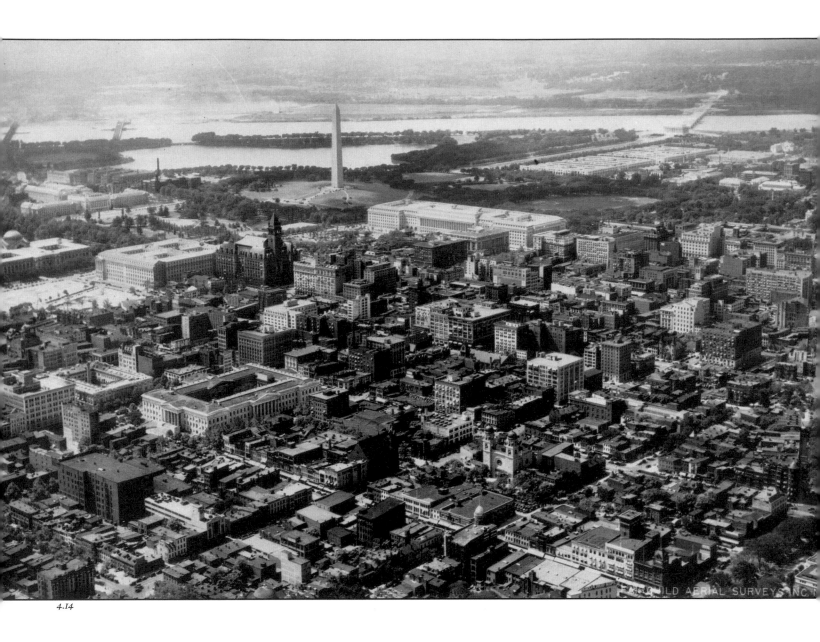

4.14

An aerial view taken in 1934, as work on the Federal Triangle was nearing its peak, clearly shows the difference in architectural style between these neoclassical federal structures and the adjacent downtown buildings, garbed in a variety of architectural styles and built to varying heights. Just to the right of the Washington Monument is the massive Commerce Department building. At left midground, behind the towered Old Post Office, is the new Internal Revenue Service building. In marked contrast to other urban downtowns of the 1930s, Washington's was distinguished by the absence of skyscrapers.

Along with the new century came new forms of mass entertainment. Although radio was not yet in commercial use, telegraphic reports allowed the *Washington Post* to report on baseball games in progress, using a diamond posted above the street for interested spectators to follow. The huge crowd attracted by the legendary 1912 World Series, between the Boston Red Sox and John McGraw's New York Giants, was captured by the Washington photographic studio of Harris and Ewing.

Motion pictures took Washington by storm early in the century. The Palace Theater opened in December 1907, at 307 9th Street, following by about a year the city's first nickelodeon. The Palace was the idea of A. C. Mayer (one of the men to the right of the entrance). Watching his brother get rich showing motion pictures in New York City, Mayer left his job as a diamond salesman at Castelberg's jewelry store to open his own theater in an empty store in Washington. Mayer soon listed himself as president of Abraham Mayer Amusement Company. Management of the theater fell to Aaron Brylawski, third from left, who with his son Julian had worked with Mayer at Castelberg's. The senior Brylawski soon bought Mayer out and continued in the business the rest of his life. The earliest theater district, concentrated along 9th Street and around the corner on Pennsylvania Avenue, sported such exotic names as the Dreamland, the Empress, the Lyric, and the Majestic. By 1911, theaters had opened in a number of neighborhoods; among them were the Welcome on 4 1/2 Street, S.W., the Arcade at 14th Street and Park Road, and the M Street Theater in Georgetown.

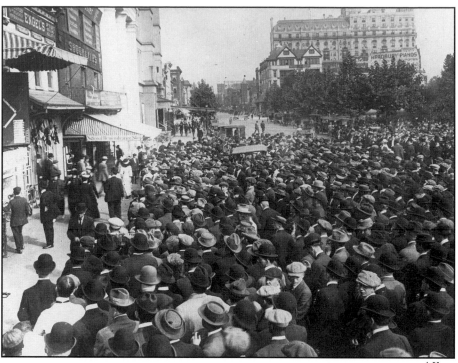

4.15

4.16

4.18

As the motion picture industry matured and large companies consolidated, projection houses moved out of storefronts and into ornate palaces designed specifically for the purpose. Leading the transition in Washington was Keith's High-Class Vaudeville Theater on 15th Street (4.17). Opened in 1912 as a house outfitted for both movies and live shows and shown here a year later, the theater offered such amenities as white Tennessee marble staircases and expansive lounges for up to 1,900 patrons. A movie palace that extended elaborate ornamentation to its exterior was the Leader (4.18), at 507 9th Street in the heart of the commercial district, pictured here in 1922.

The Fox, at 1328 F Street, shown shortly after its opening in 1927, was known as the Capitol from 1936 until its demolition in 1962. It was the city's largest and grandest theater, with 3,500 seats occupying six floors. Introduced to the program alternatively by a large Wurlitzer organ or a fifty-piece symphony orchestra, the Fox audience enjoyed vaudeville actors on stage before the films. Designed by the Chicago theater architects C. W. and George L. Rapp, the building was unusual in that one entered at the mezzanine level and descended to the main floor, by way of this grand marble and bronze staircase.

No downtown center would be complete without places to eat and drink. Shown in 1902 at the Hotel Lawrence bar, at 1331 E Street, are Samuel Gassenbeiner, proprietor, and bartender William Baker. Photo 4.21, dated 1907, captures the venerable Harvey's Restaurant at 11th and Pennsylvania Avenue. Founded in a renovated blacksmith's shop as an oyster house and saloon in 1858, the restaurant received a major boost during the Civil War. As the ranks of transients in the city soared, Thomas Harvey introduced a steaming process to hasten the cooking of oysters, which had traditionally been boiled. The innovation was wildly successful, so much so that the restaurant had to order five hundred wagonloads of oysters a week. Forced in the 1920s to vacate its Pennsylvania Avenue location to make way for the Federal Triangle, the company maintained other prominent city locations into the 1980s.

Love Shoe Store, 1407 H Street, N.E., circa 1909

A Web of Communities

◄§ 5

The rapid rise of America's population and economic power and the steady growth of its governmental responsibilities stimulated Washington's expansion during the first third of the twentieth century. As the population grew from 278,718 in 1900 to 486,869 in 1930, the city's open land quickly filled in, and communities outside the city limits, which had been very small in the nineteenth century, began to catch the population overflow.

The locations of development at the turn of the century were determined by the electric streetcar. Restricted to fixed routes, it encouraged growth in corridors close to its lines. By 1900 Washington had 190 miles of streetcar track, linking downtown and the outer areas of the city into Virginia and Maryland. To the north the Rock Creek Railway ran to Chevy Chase and Kensington, and the Brightwood Electric connected with Petworth, Takoma Park, and Silver Spring. Running northwest, the Tennallytown Electric Road reached Bethesda, while the Washington and Great Falls Electric ran to Palisades, Glen Echo, and Cabin John. The Maryland and Columbia Electric ran all the way to Laurel, and several lines crossed the Potomac into Virginia.

Developers found the row house well suited to dense development along streetcar lines. Its economy of building materials and intensive use of building lots made it attractive to aspiring homeowners of modest means. Long in use in older sections of Washington like the Southwest and Capitol Hill, row houses soon blanketed much the rest of the city, regardless of topography, and by 1927 were home to six of every ten Washingtonians.

A leading example of the streetcar neighborhood was Mount Pleasant, which emerged to the west of 16th Street after it was widened and straightened in 1902 to provide a more imposing gateway into the city. The area between 16th Street and Rock Creek Park quickly filled in during the early part of the century, its two- and three-story row houses incorporating the latest in gas and electric furnishings. Front porches provided a middle ground between the privacy of the home and the public activity of the street and were the site of daily contact between neighbors. The tree-lined streets of Mount Pleasant and the breezes that blessed the heights where its homes were built brought relief from summer heat. A streetcar line reached the end of 16th Street, now renamed Mount Pleasant Street, making access to work or shopping downtown easy for all members of the family.

Demand for living space also encouraged the development of apartment houses. While a number of government employees were drawn to homes in the outer area of the city, the downtown, with its ready access to government offices, businesses, and clubs, remained attractive to many with more transient interests in the city. A shortage of comfortable hotels prompted the construction of Washington's first apartment buildings in the 1880s, but it was not until the early twentieth century that apartment construction really took off. Also coincidental with the extension of the electric streetcar system, apartment house corridors emerged, starting with 14th Street after inauguration of a streetcar line there in 1896. Other corridors quickly emerged along Connecticut Avenue and Columbia Road. By World War I Washington listed 150 apartment buildings. Responding to inflation that made home buying difficult, builders put up another thousand apartment buildings between 1919 and 1931. In the years before and after the war, a single builder, Harry Wardman, erected 400 such structures. By the time of his death in 1938 as many as eighty thousand district residents lived in his buildings.

The rapid expansion of the row house north from the older city core prompted the Commission of Fine Arts to complain of the appearance of a "monotonous . . . shape of blocks of houses instead of isolated residences." But such development had its advantages. In 1925 the majority of Washingtonians rode public transportation to work. A quarter commuted by automobile, and 20 percent walked to their jobs. Half of Washington residents lived within two miles of their work. While the row house neighborhood may have lacked variety, it nonetheless assured a certain efficiency in the circulation of traffic.

The automobile soon challenged that aspect of city life. First introduced to Washington in 1897, the horseless carriage remained largely an oddity in the early years of the twentieth century. Automobiles were used largely for pleasure driving, and the high price of the vehicle kept down its numbers. With only 2,400 vehicles registered in the city in 1908, the city felt little obligation to regulate traffic. Although standard license plates were required as early as 1907 and the speed limit was listed at twelve miles per hour until 1925, the city did not install its first traffic light until that year, when it also created an office of the director of traffic.

The 1920s marked dramatic changes in automobile use which would transform the face of the city. From the 56,000 vehicles registered at the beginning of the decade the number soared to 155,000 in 1930. Use of public transportation dropped accordingly. By 1929 only a third of Washington commuters still used public transportation. Although the city's wide streets had initially facilitated auto traffic, by the mid-1920s both traffic and on-street parking had become problems. The Federal Triangle project did not include space for parking, and as a consequence the Grand Plaza at the heart of the complex became a vast automobile lot. The first private garage opened downtown in 1926, at 13th Street and New York Avenue, but as early as 1930 department stores were worried enough about their customers to develop their own sites for free parking.

Wider use of automobiles encouraged not just the further decentralization of population but the development of different kinds of residential areas. Utilizing land in the relatively undeveloped far northwest sector, where only minimal public trans-

portation was available, William and Allison Miller developed Wesley Heights in 1925 and Spring Valley in 1929. Described as "only ten minutes by motor car from the White House," these suburbs utilized large lots, suited to the hilly topography, along curvilinear streets to create homes for the automobile age. The Miller Company advertised Wesley Heights as "the garden spot of Washington" and Spring Valley as the "garden of homes." To secure the area's exclusivity, the company imposed strict control over all facets of initial development and subsequent sales. Design guidelines assured a harmonious appearance, and high minimum construction costs and restrictive covenants ensured a racially and ethnically homogeneous clientele.

As Washington matured, it offered a greater range of residential accommodation. By the early 1930s Washingtonians in greater numbers resided in hotels, exclusive intown residential areas, or even in emerging suburban towns in Maryland and Virginia. Dispersal of the population heightened distinctions among residents and fragmented the once-compact Washington community.

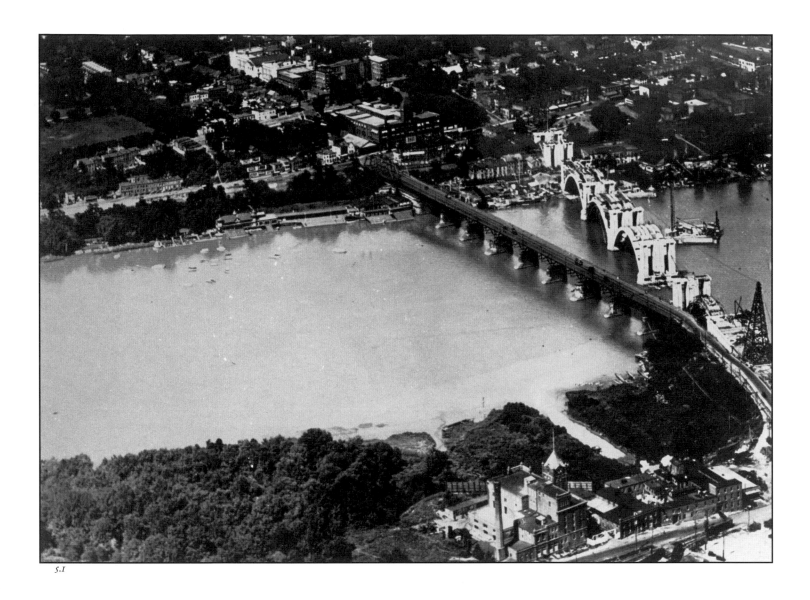

5.1

The expansion of the old city accelerated in the early twentieth century, especially with the advent of electrified streetcars. A 1922 aerial photograph from Rosslyn, Virginia, looking over the Potomac River towards Georgetown, shows the old Aqueduct Bridge, originally constructed to carry barge traffic to Alexandria along the Chesapeake and Ohio Canal but adapted for streetcar traffic in the 1890s. To the right a new bridge rises which would both replace its predecessor and encourage another form of traffic, automobile. The succession of transportation innovations undercut Georgetown's desirability, as residents sought newer homes and the more distant locations made accessible by rapid transit to and from the city. However, Rosslyn itself, shown in the late 1920s in photo 5.2, was not yet one of those locations chosen for new settlement. Laid out after the Civil War, its role was more that of a center for processing supplies coming into the region and for light industry. Over the years it gained a reputation as one of Washington's seedier suburbs.

The mobility provided by improved transportation caused redistribution of ethnic groups in the local population. The 2400 block of Georgia Avenue (5.3), in an area once popularly known as Cowtown, was originally home to Irish and German settlers. They had settled at the edge of the original city boundary, which was at Florida Avenue. By the mid-1920s, when this photo was taken, they had moved farther out, and their places had been taken by African Americans. The area derived its nickname from the period before territorial government when the city required that livestock be confined but Washington County did not. City laws were extended to the county in 1871, but the name stuck, because a number of meat-processing facilities had cropped up along the stream paralleling Sherman Avenue, a block from where this photograph was shot. The presence of such nuisances prevented the area from becoming a prime residential location, even though this commercial strip provided convenient services to nearby residents.

S.2

S.3

99

5.4

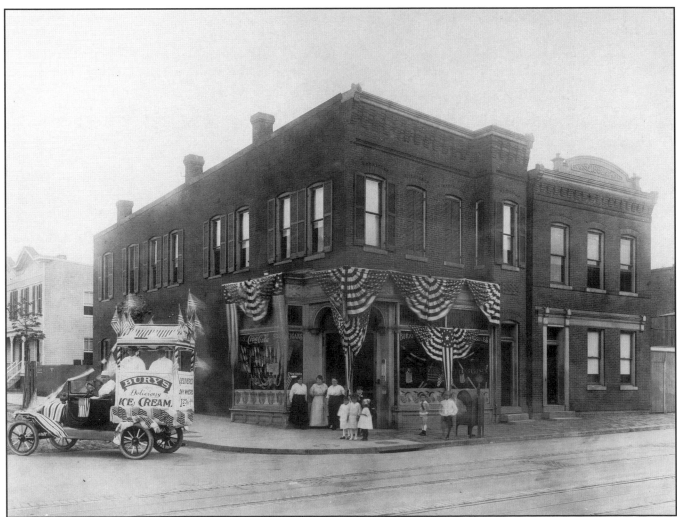

5.5

100

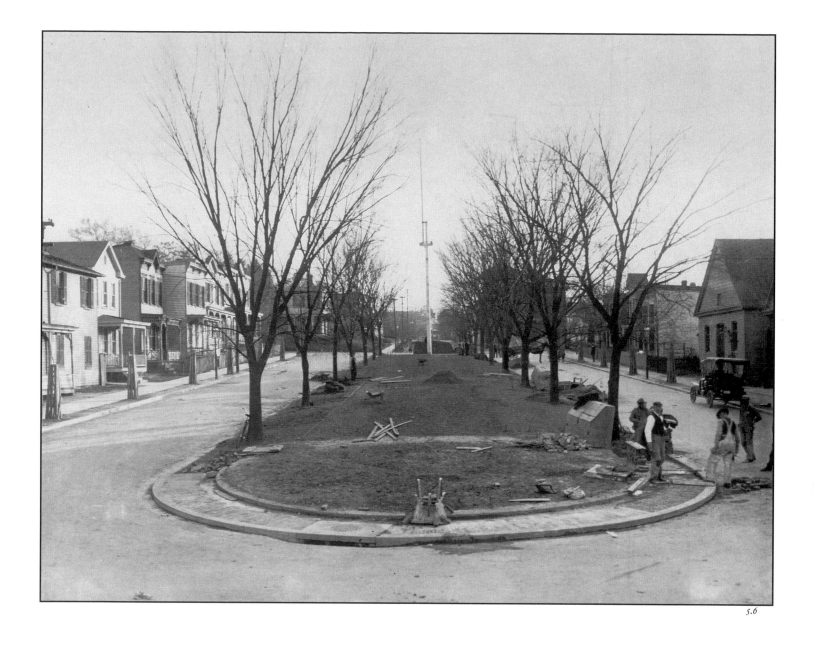

5.6

Anacostia became Washington's first residential suburb, in the mid-nineteenth century. Lack of demand for the first development at Uniontown and the loss to fire of the old Pennsylvania Avenue bridge, which spanned the Anacostia River and connected the area to the city of Washington, slowed initial growth. But construction of a new iron and masonry bridge in 1890 and extension of an electric streetcar line several years later gave the area a boost. By 1905, when this picture of Anacostia's major thoroughfare, Nichols Avenue (5.4), was taken, a richly textured network of churches and commercial establishments had emerged. The main street, named for the first director of nearby St. Elizabeths Hospital, in the Hillsdale section of Anacostia, shows a somewhat cruder form of development than might be found in the new suburban areas of the northwest sector. But the area matured quickly, sprouting many small, well-maintained shops, like Bury's drug store, shown in 1919 (5.5). Black and white children, like the ones shown here, played together in areas like Anacostia, where white Uniontown was adjacent to black Hillsdale. The latter, formed during Reconstruction as a freedmen's camp known as Barry's Farm, remained a black residential concentration. Photo 5.6 records improvements proceeding on Logan Park in the original Uniontown in 1913. Always a center of the community, the park still survives, although it has been renamed for Malcolm X, Marcus Garvey, and Martin Luther King, Jr.

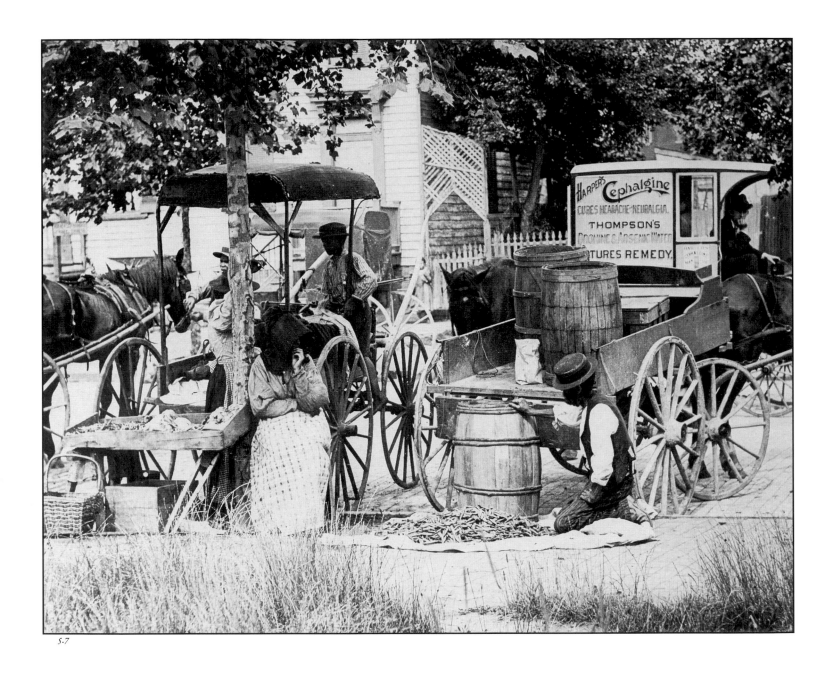

5.7

Dispersal of the city's population created a demand for services in new neighborhoods. In the early 1870s the city government provided funds for a public market that might serve both the residential area clustering between the Capitol and the Navy Yard on the Anacostia River. Built in 1873, Eastern Market emerged as an important neighborhood institution, drawing to it a range of farmers and other salesmen, like the ones shown in this 1910 photograph. The market still operates at its original location, 7th and C Streets, S.E., one of only two such neighborhood markets to survive the pressures of development and modernization that saw the ascension of supermarkets.

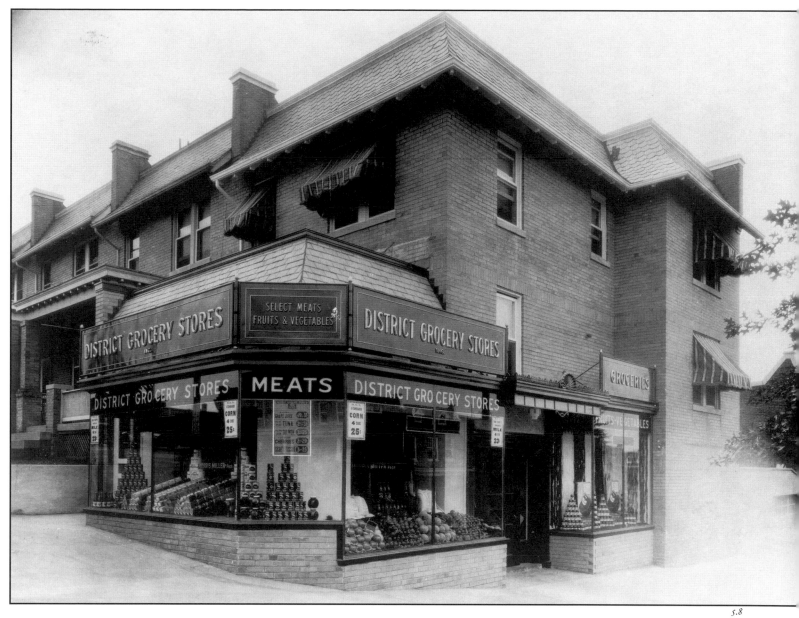

More typically, small individually owned stores would crop out of people's homes to serve neighbors' needs. Morris Miller's store at 1700 Euclid Street, shown around 1929, was just such a personal enterprise. Jewish storekeepers like Miller faced discrimination from wholesalers, and in order to improve their competitive position, twenty-one small owners formed the District Grocery Stores Association in 1921. By buying cooperatively and in time building their own warehouse, these merchants managed to survive as small neighborhood-based institutions, despite increasing chain store competition.

5.9

5.10

Although many Washington residents moved to the new suburban areas, a number of wealthier Washingtonians stayed in the center of the city, some in one of the mansions that dated from the nineteenth century, some in one of the many apartment buildings that went up in the early twentieth century. In 1907 the new owner of the *Washington Post,* John Roll McLean, commissioned the eminent New York architect John Russell Pope to convert McLean's home at 1500 I Street, N.W., built in 1860, into a block-long Renaissance villa. McLean wanted a suitable place to entertain, and in response Pope devoted the entire first floor, with its thirty-foot ceilings, to that purpose. In a 1911 commentary on the building, the architectural critic Herbert Croly characterized such rooms as the drawing room (5.9) as "a self-assertive assortment of incidental furnishings and trappings." After John McLean's death in 1916, his only son Edward inherited the home along with the family's country estate, Friendship, on upper Wisconsin Avenue. He and his wife Evalyn Walsh, pictured here with their infant son Vinson, provided lavish entertainment to a generation of Washington's national and local elite. Edward McLean's involvement in the Teapot Dome scandal in the administration of his close friend Warren G. Harding destroyed his reputation and sent the *Post* into bankruptcy. Evalyn Walsh McLean leased the home to the federal government in 1935. Four years later it was sold and demolished to make way for an office building.

Although Stonelcigh Court, at 1025 Connecticut Avenue, was hardly so extravagant as the McLean home, it did qualify as a luxury apartment house, its one-million-dollar construction cost not matched for another decade. Built in 1902, it resembled a hotel, with its large public café, dining rooms for small parties, drugstore, and smoking room for men. Projecting bays allowed for increased light and space, and most units were large enough to accommodate servants' quarters with a bath. Luxury apartments, which boasted such elegant features as crown molding, arched doorways, and working fireplaces, as illustrated in this 1920s Frances Benjamin Johnston photograph of an apartment at 1661 Cresent Place, N.W., assured residents of sufficient accommodations to entertain in high fashion.

5.11

5.12

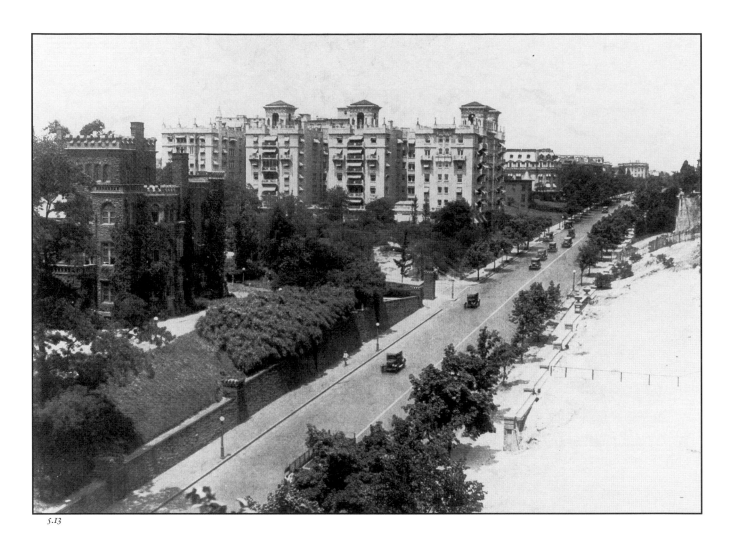

5.13

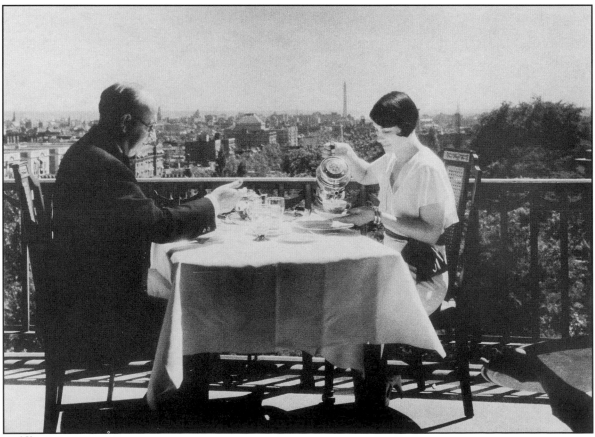

5.15

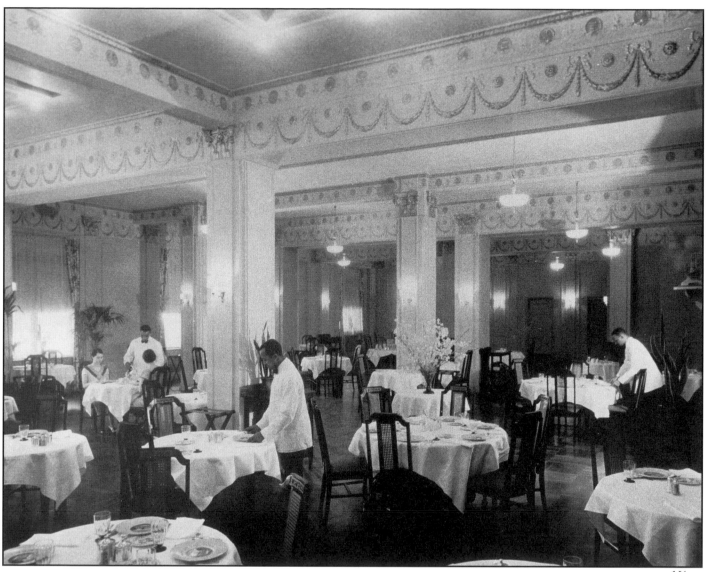

The eleven-acre Meridian Hill Park, shown under construction at the right in photo 5.13, was developed between 1914 and 1936, the inspiration of Mary Henderson and her husband, former senator John Henderson, who wanted 16th Street renamed Avenue of the Presidents as part of the effort to make it the primary gateway into the city. The government purchased the land from Mrs. Henderson for $490,000 in 1910. Opposite it on 16th Street the Hendersons had constructed a castlelike home in 1888, on six acres of land that was then largely undeveloped. By 1920, when this photograph was taken, the area had developed into a corridor of apartment houses, embassies, and imposing private buildings and churches. Just beyond the Henderson castle is Meridian Mansions, now known as the Envoy, built between 1916 and 1918 on land also purchased from Mrs. Henderson. The building cost just under one million dollars. An indication of its close association with the automobile as well as its high status, the complex included a three-story, three-hundred-car garage the top story of which had quarters for chauffeurs and other servants. Residents could enjoy the pleasures of the building's ornate public dining room (5.14) or dine on their own balcony (5.15), taking advantage of a dramatic vista of downtown, as seen in this 1930s photograph.

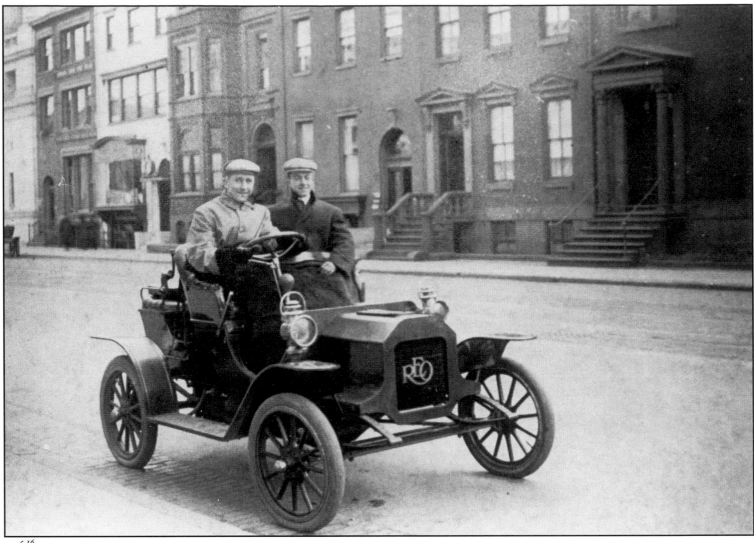

5.16

Very much a curiosity at the beginning of the century, the automobile transformed social behavior as well as the urban landscape. This picture of an early automobilist at 15th and H Streets, circa 1908, shows how little traffic traveled Washington's streets in the early years of the century. By 1922, however, autos not only competed for space on the roads, but long lines formed of applicants for automobile licenses (5.17). Expanded automobile use created the need for new services, and this primitive gas station in Takoma Park and the supply tank on the rails above (5.18) were just two of the accessory activities that changed the urban landscape.

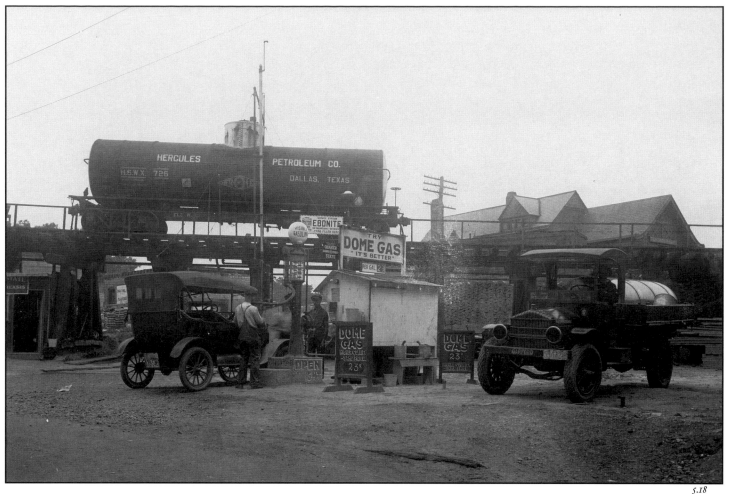

5.18

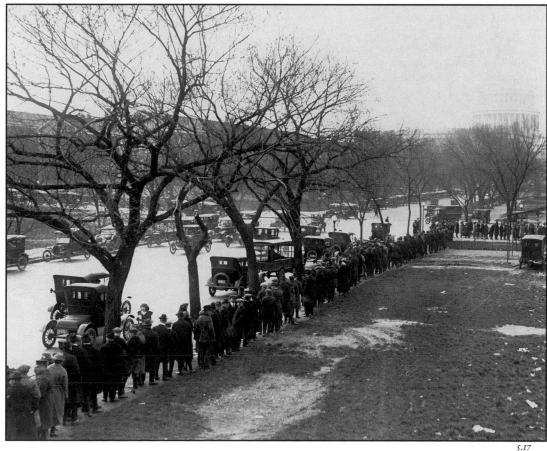

5.17

5.19

5.20

The most dramatic changes in the urban landscape came at its periphery, where wider availability of the automobile encouraged developers to fill in once relatively isolated tracts. Two photographs (5.19, 5.20) of the corner of 13th and Delafield Streets, N.W., were taken by the Department of Agriculture in 1916 and 1923, respectively, to document the number of shade trees, but they demonstrate vividly the extent of the impact of automobile use on development during the intervening years. The landscape has been considerably tamed, utility poles and many houses have gone up, and an automobile replaces the horse-drawn wagon. While some builders put up freestanding homes in line with contemporary standards of taste and affluence that required greater privacy and space for a yard, speculative builders

extended city forms outward by putting up row houses well beyond the traditional areas of such concentrated settlement. Photo 5.21, of the 4500 block of 13th Street, N.W., was taken circa 1920, and photo 5.22, of the area east of Georgia Avenue, N.W., near the Soldiers Home in upper northwest Washington, circa 1925. Taken by the Commission of Fine Arts, the latter image bore the label, "Depredation by Building."

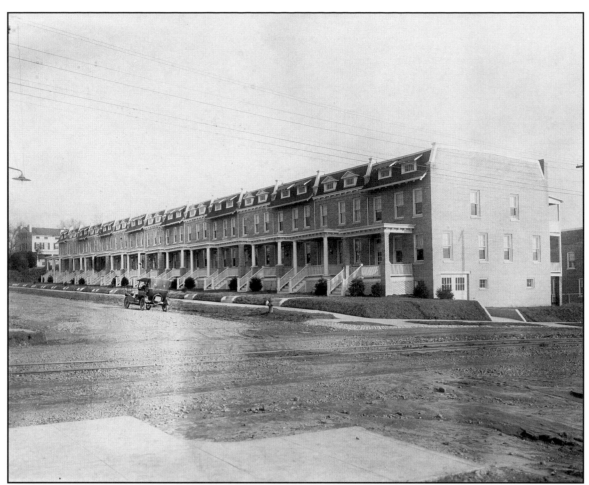

5.21

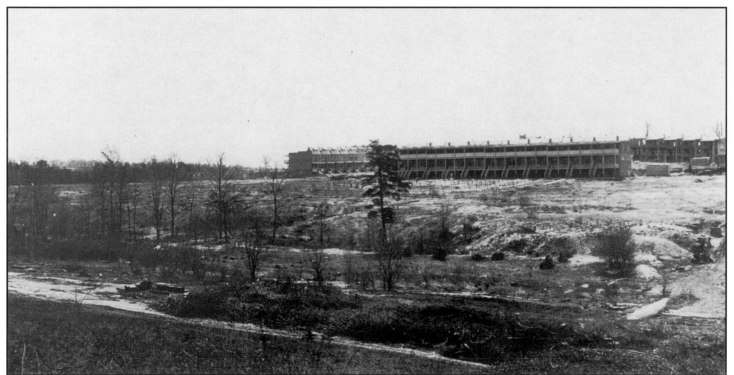

5.22

5.23

As the city extended so too did urban services. One area that developed in response to
streetcar service was Randle Highlands at the Anacostia terminus. The developer of the
area, Col. Arthur Randle, donated land adjacent to his pillared mansion for a new fire
house, Chemical Engine No. 2, shown at right shortly after it opened in 1911 at 2813
Pennsylvania Avenue, S.E. With streets not fully paved and lots not fully filled in, the area
was still quite obviously in the process of development. Service could not always keep pace
with demand, and parts of the city suffered relative neglect. In photo 5.24, children in the
Barry Farms area of southeast Washington pose for a photographer sent in 1915 by the
engineer's office of the Commissioners of the District of Columbia to inspect deterioration
of Stanton Road near the intersection of Sheridan Road. Residents complained that the
city's failure to maintain the roads in the area resulted in many inconveniences: fire trucks
delayed by the necessity of detours, doctors stuck in the mud trying to reach their patients.
In reply to a petition seeking assistance, the commissioners asserted that the repairs were
beyond their control, as the roads had been declared private and thus were ineligible for
public funding. The best hope, they continued, was that Congress might pass special
legislation in its next session to remedy the situation. In a more favored neighborhood, the
city water department installs sewer and water pipes for a new row house development
around 1920 (5.25).

112

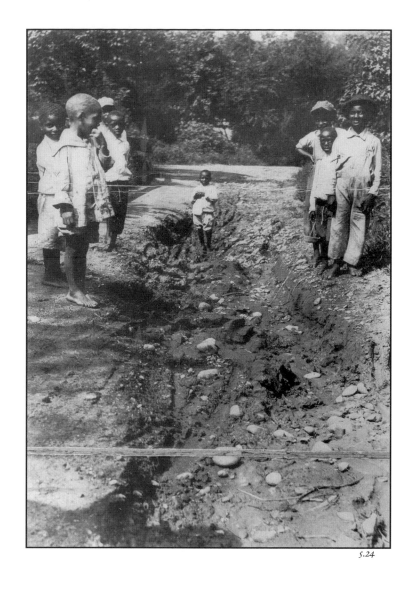

5.24

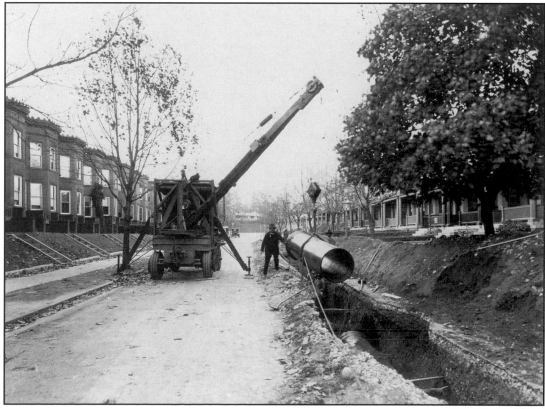

5.25

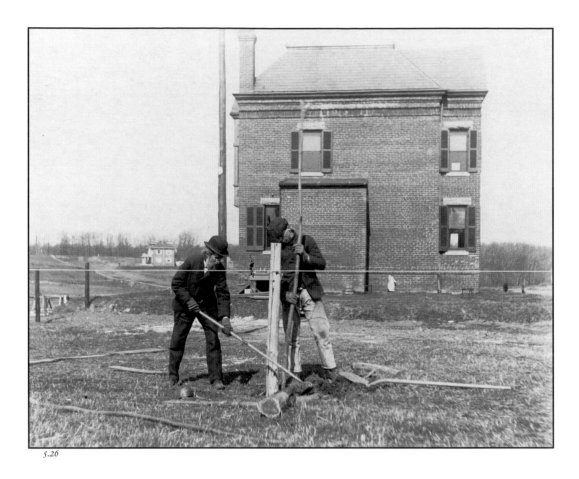

In 1903 photographer Henry Arthur Taft took advantage of the newly opening suburban areas, moving his family from its Capitol Hill townhouse to a freestanding home on a triple lot at 4021 Kansas Avenue, N.W., in North Columbia Heights. He recorded his father and son enclosing a vegetable garden, probably in 1904, profiled against a virtually undeveloped countryside. Streets in the area were still unpaved, trees newly planted, and the sidewalks were made of wood.

5.26

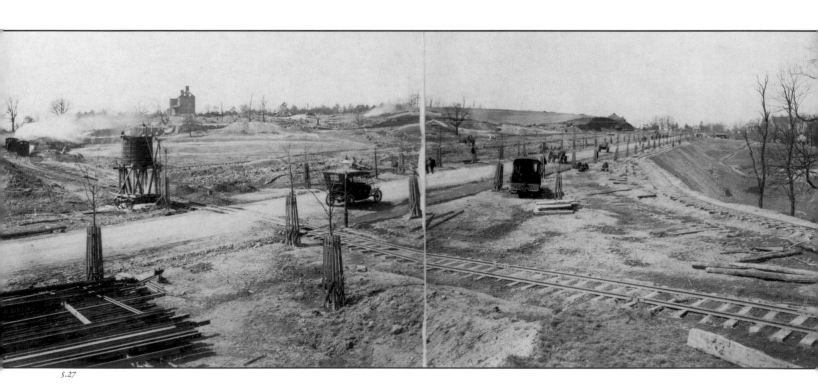

5.27

A photograph of Massachusetts Avenue Heights west of the Naval Observatory looking towards Wisconsin Avenue shows the pioneer state of development in the upper Northwest in 1911. While a few cars make their way to the new residential developments sprouting up nearby, fresh saplings offer just a promise of the amenities that would eventually characterize this preferred residential quarter as it matured.

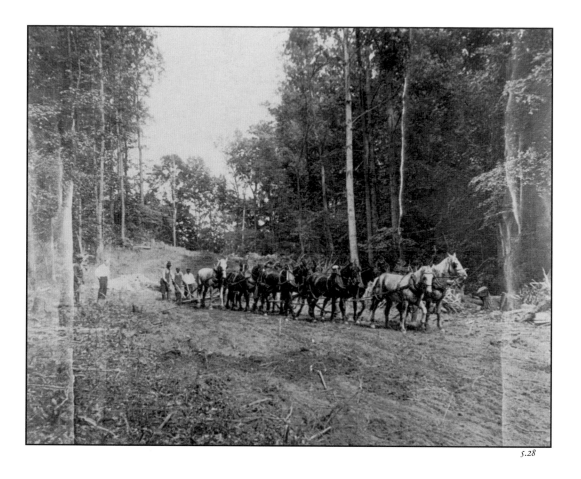

Teams of horses were employed to cut roads between emerging suburbs. This 1911 shot shows men at work on Bradley Boulevard in Bethesda. In photograph 5.29 a lone streetcar makes its way along the Rockville Pike at the intersection of Montrose Avenue circa 1910.

5.28

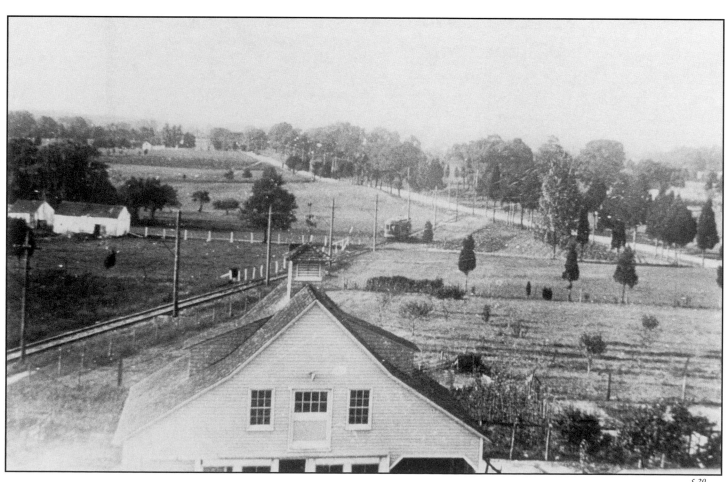

5.29

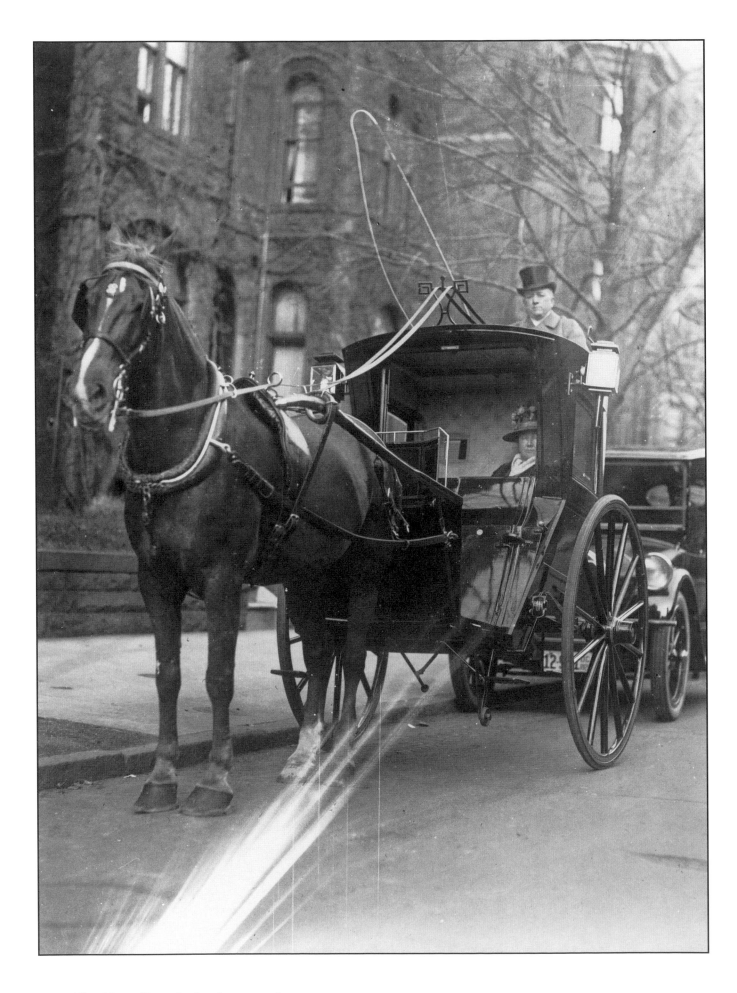

Alice Maury Parmelee in a hansom cab

◀§ 6 Divided Lives

American cities in the first part of the twentieth century exhibited a high degree of social segmentation and racial segregation. Washington shared that condition, but in many ways its pattern was unique. Like southern states, the city sustained a racially segregated school system. Most public accommodations, including virtually all restaurants and department stores, were also segregated, though unlike in the South such practices were enforced more by custom than by overt legal strictures, such as signs posted for separate facilities. Theaters and other places of public amusement also maintained racial restrictions. The races did mix, however, not the least on public transportation, the legacy of laws instituted under Radical Republican leadership during Reconstruction. Although some members of Congress periodically attempted to impose Jim Crow separatism on District streetcars, their efforts were defeated. Indeed, Washington's role as a city on the border between South and North was never so well demonstrated as those times when train passengers arriving from the North at Union Station on integrated transportation were required before they continued South to be reseated in segregated facilities.

In a city so dominated by government employment, federal policy on race was especially important. Attempting to sustain its governing coalition following the Civil War, the Republican Party made federal appointment of blacks a priority. New civil service rules adopted under the Pendleton Act of 1883 made more secure appointments that had previously been subject to shifting political tides, but chances for advancement were limited. By 1908, only a handful of black federal employees had entered supervisory positions, and total federal employment of blacks had shrunk from its peak in the 1890s. Although largely relegated to lesser service jobs, such as messengers and custodians, blacks, including those in professional positions, could still mingle with whites in many federal facilities.

That practice threatened to change with Woodrow Wilson's election in 1912, as Southerners in his cabinet, notably Postmaster General Albert Burleson, objected to racial mixing and attempted to put an end to it. Although President Wilson kept a low profile in the debate, by the end of 1913 he had publicly defended segregation policies in the Bureau of Engraving and Printing and in the Washington City Post Office, justifying his position by saying that "the discontent and uneasiness which had prevailed in many of the departments would thereby be removed." Wilson's position

received further publicity when Secretary of the Treasury William McAdoo publicly defended his decision to segregate the Treasury Department because white women were "forced unnecessarily to sit at desks with colored men." Such admissions provoked a storm of controversy in the black community, prompting statements from the leaders of both wings of its national leadership, Booker T. Washington and W. E. B. Dubois. By early 1914, however, segregation orders had been reversed in the Treasury and the Post Office. Strong opposition had prevented officially sanctioned segregation of federal employment, though it was not fully eliminated.

With only the smallest signs of integration at work in Washington, it was hardly surprising that blacks and whites went about the business of their lives in separate ways. Racial covenants excluded even well-to-do blacks from the most desirable residential areas. Residential associations, given even greater importance in Washington by the lack of home rule, formed along racial lines. The distinction was made clear in their names, white groups taking the name "citizens associations" and black groups calling themselves "civic associations." In their religious activities, whites might establish mission churches for blacks, like St. Mary's in Foggy Bottom or St. Philip's in Anacostia, but their own houses of worship often maintained not just separate racial but also individual ethnic identities. Thus, at the turn of the century, within only a few blocks of each other in Swampoodle, the immigrant quarters near Union Station, separate Catholic churches served Irish, German, and Italian parishioners. Separate synagogues emerged to serve Eastern European as distinct from German Jews. A few social institutions—charities and settlement houses—made some effort to bridge the distance between groups, but in a city that respected racial and ethnic divisions, separatism was the dominant direction of institution building.

(*Opposite*) Despite the dominance of American-born white employees in the federal government, early-twentieth-century Washington retained some European ethnic populations and a considerable black presence. Blacks and immigrants in the city formed their own associations and support groups, none more important than churches and synagogues. Although blacks had mixed with whites in places of worship in the early part of the nineteenth century, they soon formed their own congregations. During the mid-1800s, a number of white churches founded mission efforts to reach poorer Washington residents: Grace Episcopal was established in Georgetown for Irish laborers, St. Mary's and St. Philip's Episcopal churches for blacks in Foggy Bottom and Anacostia, respectively. In photo 6.1 a Sunday school class poses in 1906 before St. Mary's Episcopal Church, at 730 23rd Street in Foggy Bottom. Originally named St. Barnabas Mission and housed in a chapel attached to the Union Army's Kalorama Hospital, the congregation was renamed St. Mary's in 1867.

Surviving efforts by Episcopal leadership to abolish separate black churches, St. Mary's was sufficiently successful to secure construction of the distinctive brick Victorian building pictured here, designed by James Renwick in 1886. The congregation hosted a succession of white ministers until the selection of Alexander Crummell in 1873. Members of the Mt. Zion United Methodist Church, at 1334 29th Street in Georgetown, employed black artisans to erect in the mid-1870s the structure shown in photo 6.2. The elaborate costumes worn for this group picture were part of a fundraising activity brought from New Orleans by the presiding pastor: Divided into twenty-four groups, each headed by an elder as commissioner, "virgins" would contribute $5 each, "princes" would contribute $3, and their "cupbearers" $1 each. With every dollar raised, the elder gained a star in his crown.

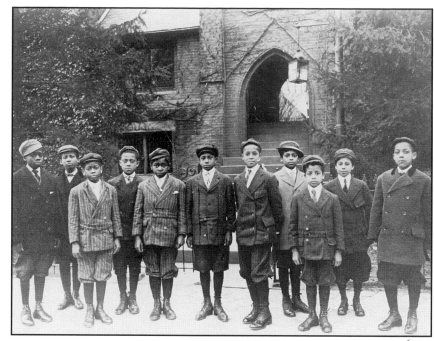

6.1

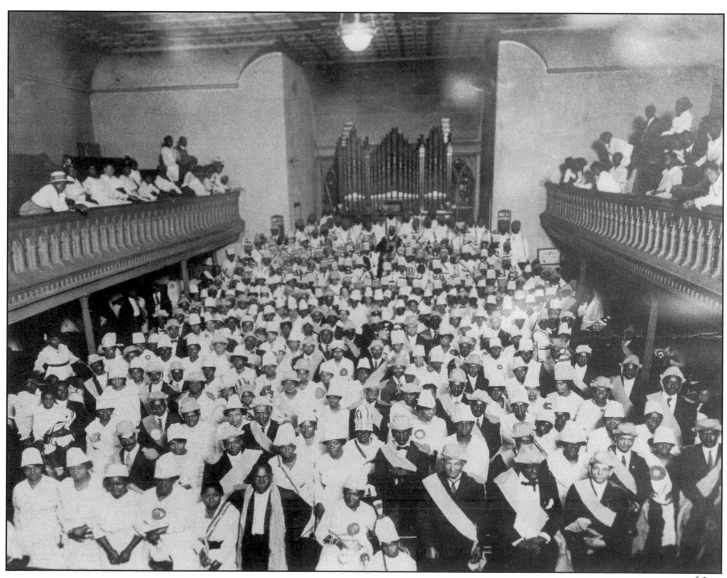

6.2

119

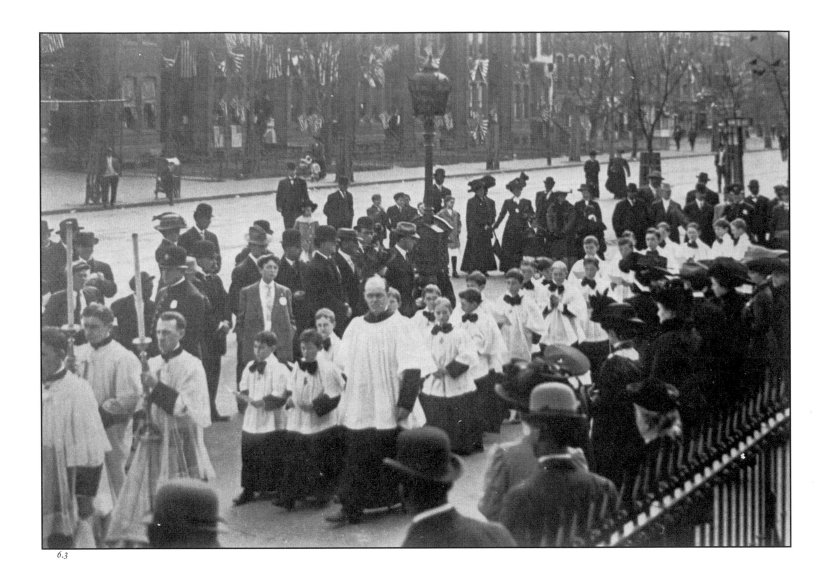

6.3

Among the city's older Catholic churches, St. Aloysius, located on North Capitol Street in
the old Swampoodle neighborhood, offered an important point of community to its
predominantly Irish parishioners. This procession through the residential quarter near the
church in the early twentieth century was but one of the many rituals that bound
congregants together. The city's oldest Jewish congregation, Washington Hebrew Congre-
gation, dates its charter to 1855, though members had held services in private homes for
several years previous to that. The Temple Sisterhood, shown here in 1917 bearing witness
to its patriotic efforts during World War I, served an important function in organizing
social and welfare activities. The ties of religion reached beyond formal institutional
arrangements to bind extended families like that of Isaac Levy, pictured here at his home at
922 4 1/2 Street, S.W. Naturalized in 1874, patriarch Isaac Levy, seated at the center, utilized
the city's relatively fluid opportunity structure to form first a small department store, Levy's
Busy Corner, and then an early movie house, the Welcome Theater. Other family members
pictured here had settled in Georgetown and Anacostia.

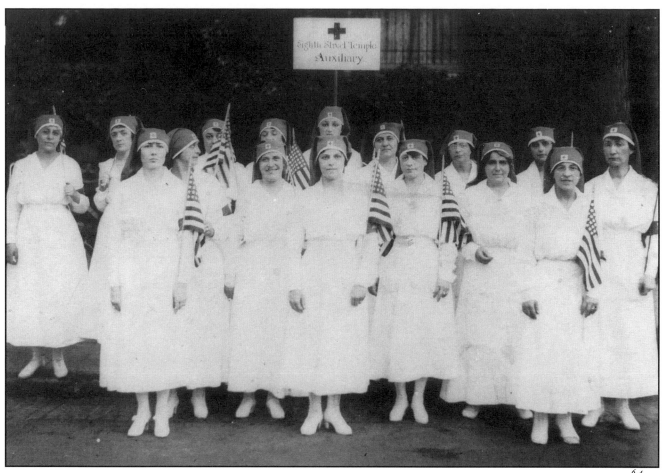

6.4

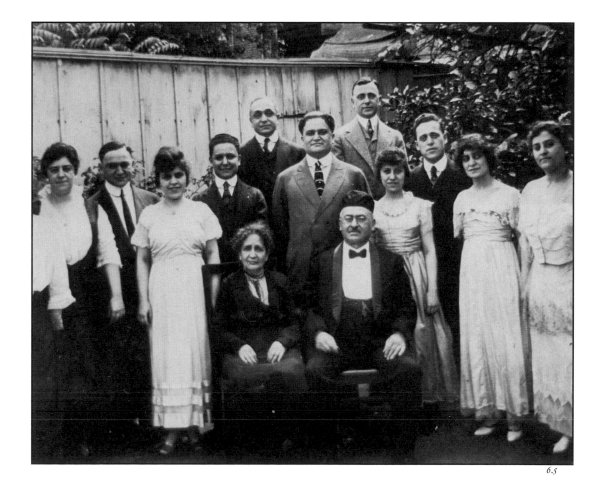

6.5

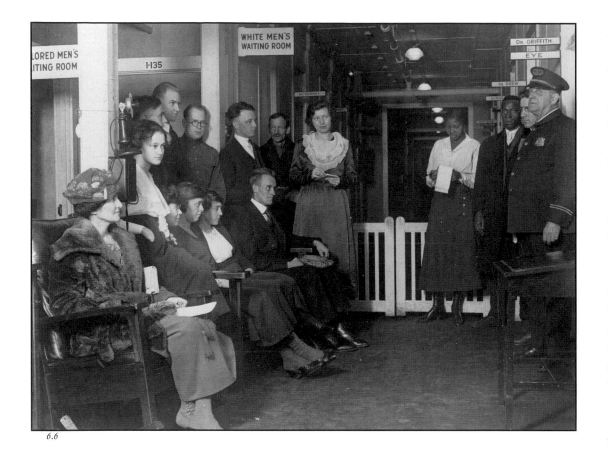

6.6

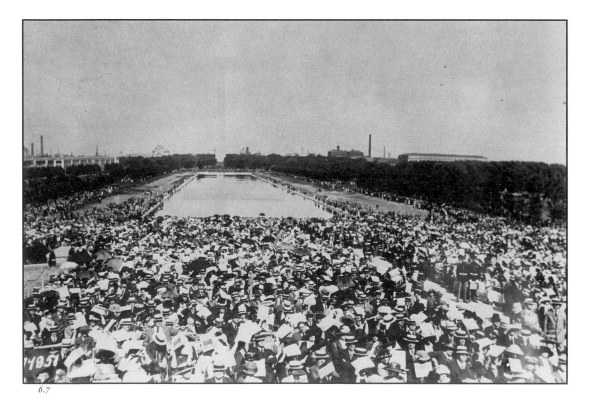

6.7

Determined more in practice than under law, segregation in Washington usually lacked the overt signs of discrimination characteristic of the deep South. When Congress in 1918 directed the Public Health Service to establish clinics to treat sexually communicable diseases, however, it wrote into the legislation that those services be provided "according to local custom," meaning on a segregated basis if appropriate to the locale. Thus, in establishing this federal facility in Washington in 1919 (6.6), the government posted signs designating separate waiting rooms for black and white clients, making more overt the practice that local residents largely took for granted. Again following custom in the segregated city, federal organizers of the dedication of the Lincoln Memorial relegated black participants in the ceremony to a separate area in front of the speaker's platform. Even the featured speaker, Robert Moton, the successor to Booker T. Washington as president of Tuskegee Institute, had to make his way back to the black seating section after giving his rousing tribute to the Great Emancipator. White observers dominated at the ceremony, held May 31, 1922.

Much of the energy Washingtonians dedicated to civic affairs was channeled through neighborhood-based citizens associations. When such associations were first formed, in the last quarter of the nineteenth century, blacks attempted to join but were rebuffed, which forced them to form their own associations. Both the black "civic" associations and the white "citizens'" associations later federated. Photo 6.8 was taken at a meeting of the Federation of Citizens' Associations in 1921. Despite offering more employment opportunities for blacks than its southern neighbors, the Washington area was never far removed from the social mores of the South, and racial stereotypes carried great power. Shot in Rockville, Maryland, by Kensington-based photographer Malcolm Walter, photo 6.9 shows a tableau being presented by the United Daughters of the Confederacy at a women's club party around 1929.

6.8

6.9

6.10

Most recreational facilities were racially segregated. Only whites were permitted access to the beach at the Tidal Basin (6.10), carved out of what had once been mud flats along the Potomac River, shown here in 1922. African Americans sought alternative sites, among them Highland Beach near Annapolis, serving blacks from both the Washington and the Baltimore areas. Founded by Frederick Douglass's son Charles in 1893, after he was denied a room in a nearby hotel, Highland Beach became a summer refuge for many prominent black Washingtonians. A photograph taken at Highland Beach in the early part of the century (6.11) includes Charles Douglass (at right in hat) and social activist and educator Mary Church Terrell (fourth from left), whose arm is over the shoulder of Holly Douglass.

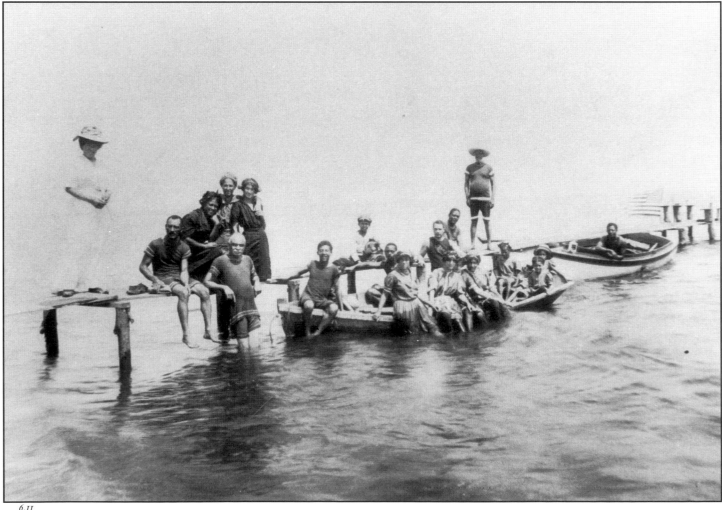
6.11

6.13

6.12

Washington's growing reputation as a social as well as political capital was sufficient during the late nineteenth century to place an especially high premium on fine residences. Because no office space was allocated to members of the Senate, a large home was often necessary for conducting business as well as for entertaining. Senator Joseph Foraker built a mansion (6.12) at 16th and P Streets, N.W., in 1897 for just such reasons. His son Arthur is shown lounging on a leopardskin rug before one of the home's ornate fireplaces. The Foraker home was later purchased by Mrs. Delos (Daisy) Blodgett. The widow of a Michigan lumber magnate, Mrs. Blodgett moved to Washington so her daughters, including Mona, with whom she is pictured shortly after her arrival in 1914 (6.14), could be educated in the capital's boarding schools.

For the well-to-do, enjoying aspects of country living characteristic of English aristocracy, in addition to having a fine home in the city, was important. To accommodate this need, such activities as the Middleburg Hunt formed in the 1920s. Photo 6.15 shows a party arriving by carriage at the sixth annual Middleburg Hunt in Fairfax, Virginia.

6.14

6.15

6.16

6.17

Through hard work and association, substantial black and white middle classes emerged in Washington. For John Goins, his profitable printing business (see photo 3.24) made possible the purchase of a roadster, pictured in the 1920s possibly traveling through the LeDroit Park neighborhood near where he lived. Georgia Fraser Goins, pictured beside her husband, was an accomplished musician and educator. In the 1920s she founded and directed a women's string orchestra. Her mother, Sarah Fraser, was one of the nation's first black female physicians and had an office for many years at 13th Street and Logan Circle. The family worshiped at a black Catholic church, St. Augustine's. They vacationed at Highland Beach and participated in an array of civic activities. A well-endowed Christmas in a comfortable home (6.17) illustrates the success of Georgia Fraser Goins's sister, Leah Fraser Jackson.

Photo 6.18 shows a men's social organization, the Dozen, gathered at True Reformer Hall, at 1200 U Street, one of the landmarks of the vibrant black community of Shaw, just north of the downtown. Formed by Robert Jones, on his arrival from Atlanta in 1914 to assume a government position as a messenger, the organization grew as the original dozen bachelors married. Although this crowd's fashionable appearance suggests affluence, most of them had to struggle to maintain a decent standard of living. According to Jones's daughter, Adelaide Robinson, he had to work three jobs in order to provide for his wife and six daughters. More rarefied, but representative of the rich associational life among African Americans, was this local women's flying club, depicted here in the early 1930s.

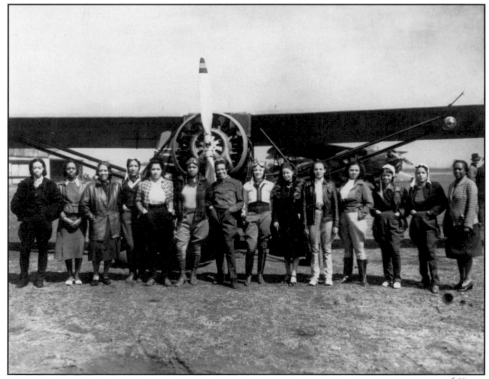

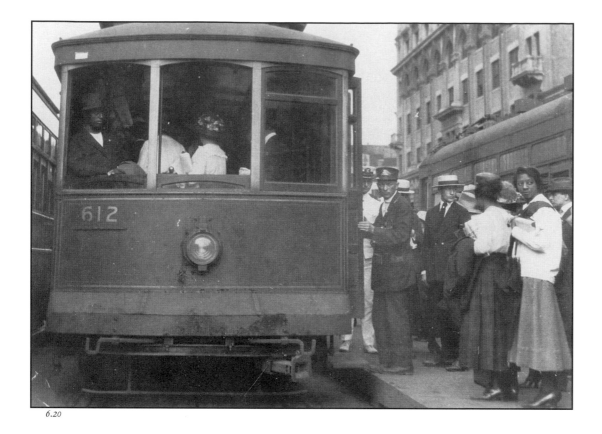

6.20

6.21

Although Washington was largely segregated, some areas of integration existed. As a legacy of Reconstruction, most particularly the efforts of Massachusetts senator Charles Sumner, the city officially operated its public transportation on an integrated basis, as this photograph from the 1920s, showing blacks and whites together on a crowded District streetcar, attests. Yet, according to strong Southern custom, which had its effect in Washington, blacks and whites tended to sit separately. Photo 6.21, taken in July 1932 after a clash between the military and Bonus Army protesters in Anacostia, illustrates the practice of blacks sitting at the back of the vehicle. This streetcar had come from the far southeast, passing through the white Congress Heights area and then the black Barry Farms and old Anacostia areas on the way to 11th and Monroe Streets, N.W. It is likely that the whites boarded first and naturally took the front seats, while black passengers then took the seats in the rear rather than sitting in vacant places next to whites.

As in the South, while they did not go to the same schools, children of different races, especially poor children, mixed on the streets, as in this 1920s photograph taken at the Columbus Fountain in front of Union Station. Similarly, while many cultural activities were effectively segregated, popular entertainments like this circus, held circa 1930 on open land in the developing northeast sector of the city, attracted people of all races.

6.22

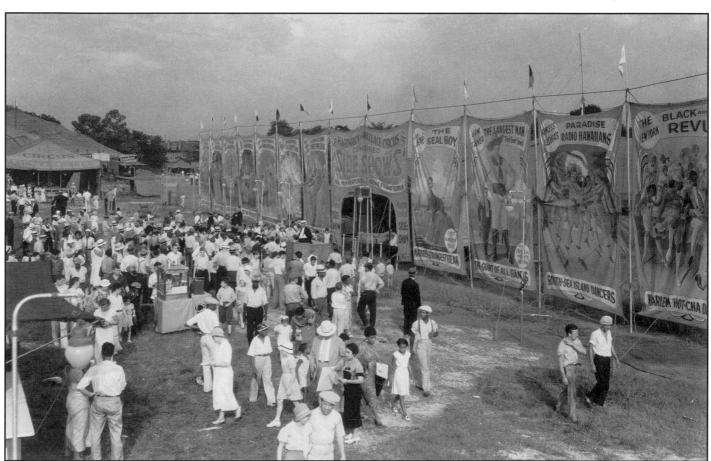

6.23

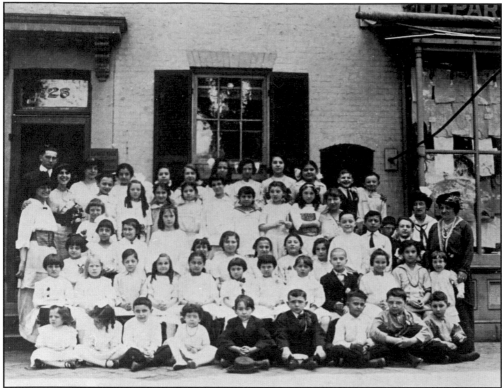

6.24

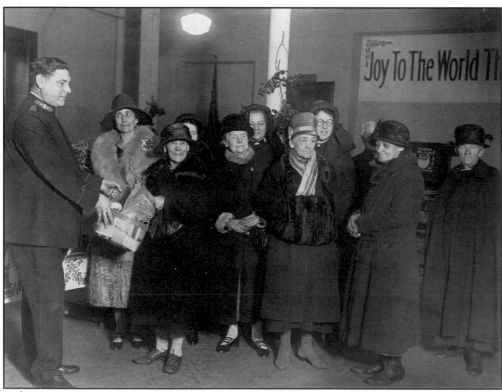

6.25

Each racial and ethnic group tended to form organizations to serve itself. The Alliance House settlement, at 728 4 1/2 Street, S.W., whose children are pictured in 1915 in photo 6.24, was established to serve the growing Jewish population in southwest Washington. A favorite charity for whites was the Salvation Army. Although the objects of their charity were largely whites, the organization did maintain a hotel for black men at 1501 7th Street. In photo 6.25, Mrs. Calvin Coolidge is shown joining volunteers to give out food at the Salvation Army's Christmas party in 1927.

Self-help was an important concept in the black community, and among the most prominent institutions embodying this philosophy was the National Training School for Women and Girls. Founded in 1909 in the Lincoln Heights section of Washington by Nannie Helen Burroughs, the school taught practical and professional skills in housework, gardening, and interior decorating. The clerical training class shown here circa 1920 prepares under a watchful portrait of Abraham Lincoln. In line with its strong sense of racial pride, the school's motto declared, "We specialize in the wholly impossible." Also a source of considerable pride in the black community was the Young Men's Christian Association, opened in 1913. Photo 6.27 portrays those involved in fundraising for the Y's new facility in Shaw. The size of the group suggests the cooperation that made the facility a true community center. A goal of $100,000 was set for the building, and when contributions slowed at $60,000, William Howard Taft, who was a member

of the YMCA for whites, secured a
$25,000 donation from Julius
Rosenwald, president of Sears
Roebuck and an active contributor
nationally to black social welfare
organizations. John D. Rockefeller
added another $25,000 donation to
help finally meet the goal. Built
entirely with black labor, the Y
pool served for baptisms as well as
recreation, and its meeting halls
served the local branch of the
NAACP and the Federation of
Civic Associations, among other
groups. When the black Y success-
fully petitioned for association with
the parent Y, the Shaw facility
became known as the 12th Street
Branch, and in 1972 it was renamed
for Anthony Bowen, born a slave in
Prince George's County, Maryland,
who founded the colored Y in 1853.

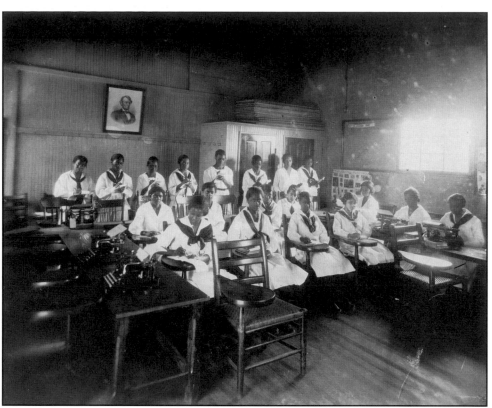

6.26

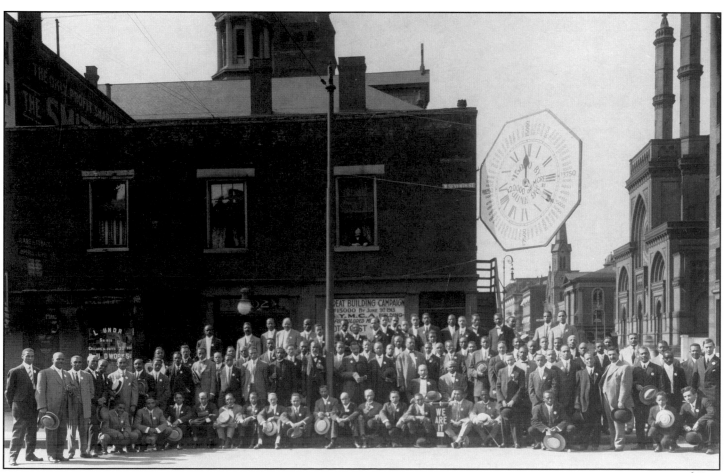

6.27

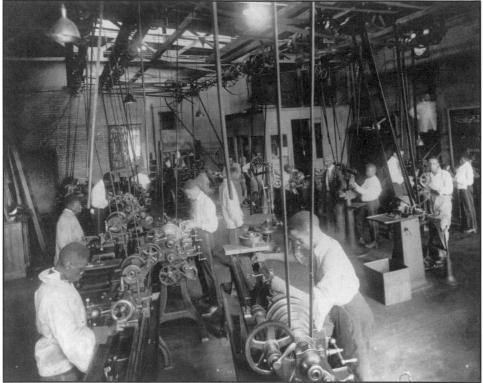

6.28

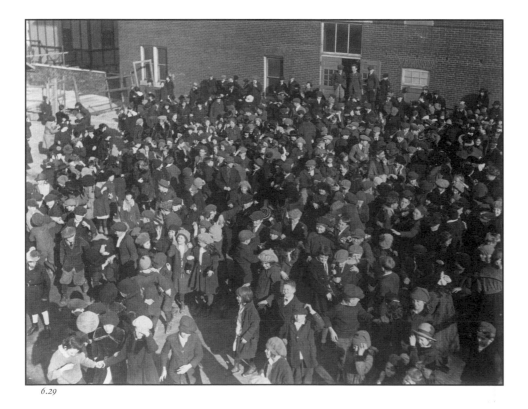

6.29

Among the new opportunities the city offered its residents early in the century was technical training. In line with the practice of the time, the technical schools authorized by Congress in 1899 were strictly segregated: McKinley for whites and Armstrong, shown here in 1916, for blacks. The latter school was named for Gen. Samuel Chapman Armstrong, a white general who had commanded a black regiment during the last two years of the Civil War and later founded and served as the first president of Hampton Institute in Virginia. Following the motto "All forms of labor, whether with hand or head, are honorable," the Armstrong school embraced the self-help philosophy of Booker T. Washington, who appropriately spoke at the dedication ceremony in 1902. With school desegregation in 1954, Armstrong merged into McKinley, and the old school was converted to an adult education center.

Segregated educational institutions were supposed to be equal, although separate. In fact, funds and facilities for whites outstripped those available to the black system. Because of dropping enrollment, the Petworth school at 8th and Shepherd Streets, N.W., a crowd of whose students is shown here in 1920, was designated to become a part of the black system in 1954. The *Brown v. Board of Education* decision that year made the shift unnecessary.

Part III Governing City, 1933–1945

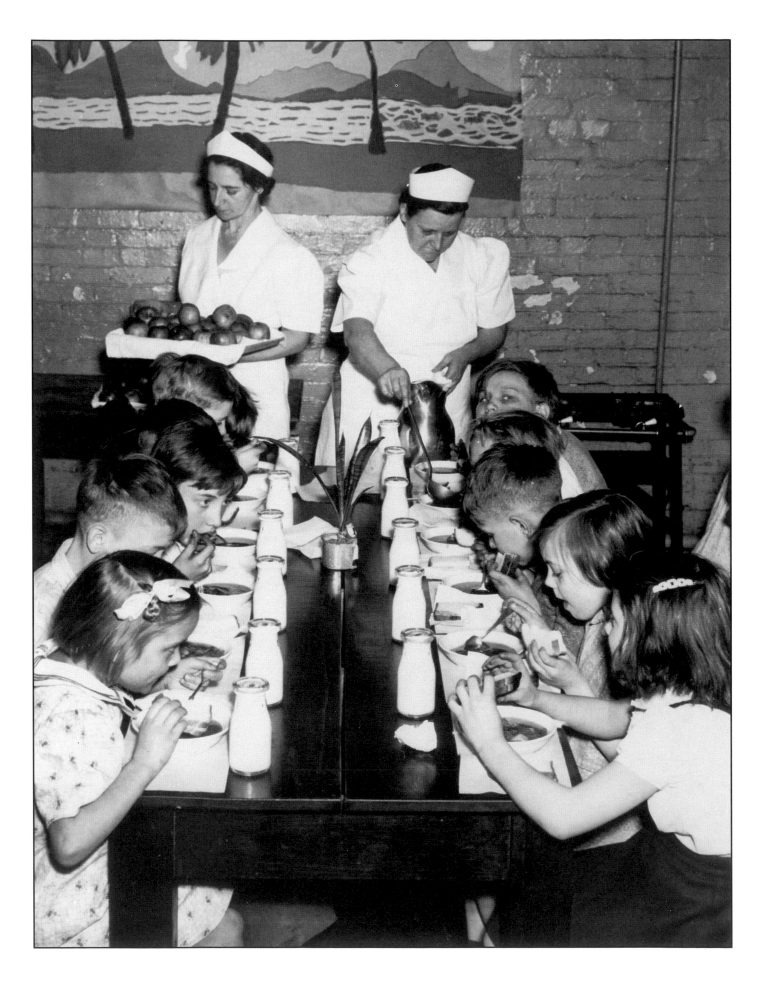

Some of the five thousand children aided locally through the WPA's School Lunch Project,
February 1941

◆§ 7 New Deal Capital

Rarely has Washington's experience varied so much from the rest of the nation's as it did during the 1930s. The Great Depression, which began with the October 1929 Wall Street crash, had a relatively mild impact on the area initially. Just as the slump began to tighten its grip locally, in 1932–33, the advent of Franklin Roosevelt's New Deal administration radically transformed the city. In a short period of time, tens of thousands of new employees joined the government work force, construction accelerated, and public relief programs blossomed. The extension of government activity into every area of national life kept the city prosperous and exciting until the even greater expansion that came with the approach of World War II in 1940–41. Washington was recognized nationally as the paradoxical "boomtown" of the Depression.

The city had not, however, entirely escaped the economic slump. The early 1930s were hard for many Washingtonians, especially for families without at least one government wage earner. Private building declined in 1930 to one-third of the 1929 level, and private businesses laid off workers. Bank failures restricted local credit. Thousands of homeowners fell into arrears on house payments. In the scramble for work, the black community suffered disproportionately, as white workers moved into service jobs they had previously avoided, such as those in hotels and restaurants. By 1932, the overall employment situation was bad enough that on one day about two thousand people lined up at 4:30 A.M. for a distribution of relief checks, and five thousand people applied when the city received funding for some public works jobs that summer. About one-sixth of the city's households received some outside help. Most relief was still being provided as it had been traditionally, through a network of some sixty-five private relief agencies, as well as through local offices of the old District Welfare Board. The form of the assistance was often food or fuel, with money being provided sparingly and sporadically. By the end of 1932, the Community Chest was able to offer destitute families only $100 of private relief annually.

Serious as the situation was, Washington even before the New Deal had been spared the fate of industrial cities, which had unemployment rates approaching 50 percent. Despite its conservative rhetoric, the Hoover administration shielded the seventy-thousand-member local federal work force from the effects of the slump until the middle of 1932. Even when the government adopted its first cost reduction measures, they consisted of furloughs and a 15 percent pay reduction rather than layoffs.

The administration did not cancel the large number of public building projects set in motion before the Depression, and Congress added new projects in 1930 and 1931. Work on the massive Department of Commerce building continued uninterrupted until its completion in 1932, as did construction of the other projects in the new Federal Triangle, the George Washington Parkway, and the Arlington Memorial Bridge. With money from Congress, the District embarked on a well-timed building and maintenance program. Employing ten thousand workers, these efforts served to prime the pump of the local economy just as effectively as later New Deal public works projects.

With government employment stable and public building still visibly proceeding, it took the arrival of the Bonus Army literally to bring the Depression from the nation into Washington. Twenty thousand veterans seeking an early payment on their World War I bonuses camped out downtown and on the flat lands across the Anacostia River in the spring and summer of 1932, until they were finally driven out of town in a violent confrontation in late July. But when the Depression brought the New Dealers into Washington seven months later, they were clearly a force that had come to stay, and they sparked remarkably swift changes in virtually all aspects of the city's life.

The most immediate effect of the New Deal programs was a rapid increase in the number of government employees. From sixty-three thousand in March 1933, the local federal payroll rose to ninety-three thousand by the end of 1934. In addition, the government restored two-thirds of the 1932 pay cut in the middle of 1934 and the remainder in the spring of 1935, further boosting local purchasing power. By the end of the decade, there were 140,000 civilian federal employees in Washington, more than double the number when FDR took office. This expansion of government maintained and further stimulated the public building boom in the city. Not only was the entire Federal Triangle complex completed, but the headquarters of the Department of the Interior, the Department of Agriculture, the Supreme Court, the Library of Congress Annex, and the second House Office Building were constructed as well. Even this was not enough to contain all the new agencies, and the government aided the local real estate industry by renting space all over the city.

Finally, Washington had its own share of the kind of relief projects sponsored by New Deal agencies around the country. The Public Works Administration (PWA) employed 350 men to clear the last trees from the Mall and create the open vista we see today. Another PWA crew cleaned the Washington Monument for the first time in its history. The Civilian Conservation Corps (CCC) built paths and drained the shore so that Theodore Roosevelt Island could be opened as a park in 1936. In a city of professionals and white-collar workers, the Works Progress Administration (WPA) put hundreds to work in libraries and museums and on a variety of literary and artistic projects. These programs relieved the burden on local relief efforts, and the relief caseload fell from twenty-three thousand households in 1934 to eighteen thousand in 1936.

Boosted by the swelling federal work force, the city's population grew from 487,000 in 1930 to 663,000 in 1940. The new Washingtonians were of many types. Most prominent were the professionals, reformers, and intellectuals associated with

the administration. These New Dealers were considered by some long-time residents to bring a more "northern" atmosphere to Washington's proverbially southern ways. There were also, however, thousands of clerical workers who hailed from all over the country; and of the fifty-five thousand new black residents, most had moved from the South. There were jobs in the private sector as well as in the government. Private construction, for example, paralleled the growth of government, rising from $7 million of business in 1934 to $24 million in 1936. New residential neighborhoods appeared in the last undeveloped parts of the city and in nearby suburban Arlington and Montgomery counties. Downtown, the growing importance of the government fed the expansion of associations, lobbying groups, news agencies, and all the other businesses that needed to be represented in the capital.

Despite its prosperity, two problems continued to plague Washington throughout the New Deal years. One was housing. Some ten thousand residents—the vast majority black—still lived in several hundred dilapidated houses on alleys and small streets in the older parts of the city. About seven thousand housing units lacked running water. Pictures of alley homes with the Capitol looming in the background became a staple subject of New Deal photographers. Drawing upon reform efforts dating back decades, the New Dealers addressed the local problem through the 1934 creation of the Alley Dwelling Authority, which proved to be a prototype for later city housing authorities. The agency tried to remake areas of the city identified as slums, through land condemnation and the erection of public housing. The process was slow and complex, however, and by the end of the 1930s the Alley Dwelling Authority and associated New Deal agencies had erected only about three thousand housing units.

The second problem, linked to but far more intractable than the housing issue, was racial segregation and discrimination. Even the New Deal reformers rarely addressed the local situation directly. Their new housing projects, for example, were all formally segregated. The courts upheld the legality of private racial covenants, constraining opportunities for African Americans to move out of their existing residential areas. The reformist atmosphere of the New Deal stimulated some changes in segregation, but they were not profound. The New Negro Alliance ran a "Don't Buy Where You Can't Work" campaign against stores that sold to but did not hire blacks, like A&Ps in black neighborhoods. This effort resulted in the hiring of some black workers. Some WPA groups performed before integrated audiences, and the Interior Department integrated the cafeteria in its new building when it opened in 1937. But 90 percent of all black federal workers were still in custodial jobs, and most public and private activities remained rigidly segregated when the decade ended. The New Deal's enormous economic successes in Washington were thus not balanced by comparable social improvements. Yet throughout the period, the city served as a magnet for newcomers both black and white, testimony to the uniquely fortunate circumstances it enjoyed during the 1930s.

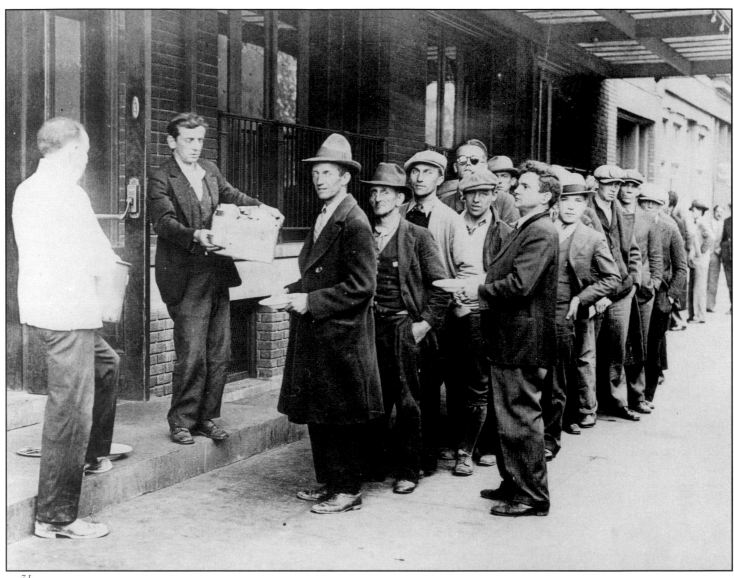

7.1

Tens of thousands of Washingtonians had to turn for help to traditional providers of charity at some time during the 1930s, although Washington did not see the massive unemployment lines of other cities. Photo 7.1 shows a group of men waiting to receive relief supplies, probably in the early part of the decade. Both public and private relief agencies were reluctant to provide able-bodied unemployed men with cash, fearing it would deter them from seeking work and worrying it might not be spent for food and shelter for their families.

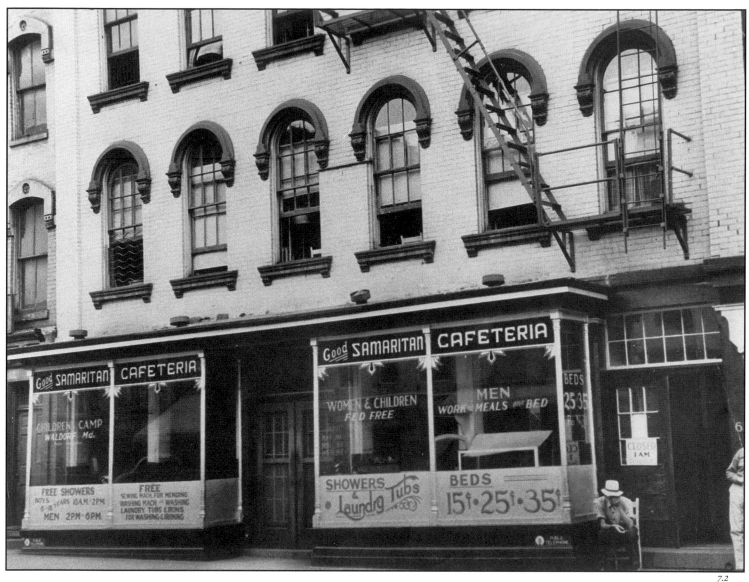

Similarly, the Good Samaritan home, at 638 D Street N.W., pictured here in September 1936, made men work for their room and meals while feeding women and children for free. The home and cafeteria were located on the eastern fringe of downtown, where pawnshops, gaming arcades, and similar enterprises flourished. The same agency which operated Good Samaritan also had a children's camp in Waldorf, Maryland, and a shelter at 619 N Street N.W. The persistence of high unemployment and the changing eligibility requirements and funding fluctuations of various New Deal work programs meant that despite the city's prosperity, such private charities were kept busy until World War II.

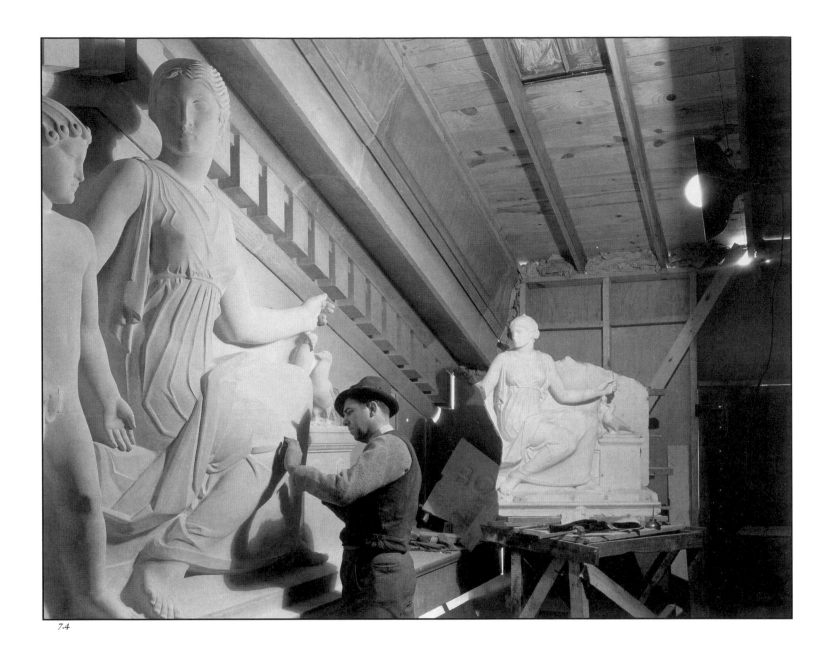

7.4

The Federal Triangle was the largest of the many construction projects that helped sustain the city's economy in the worst days of the Depression. Work on the seventy-acre site began in the late 1920s and was fortuitously timed, for it peaked in the most severe years of the economic slump. A May 1936 aerial view (7.3) shows, left to right, the eight-acre Commerce Department building on the Triangle's western edge, completed in 1932, and, built subsequently, the Labor Department headquarters, Interstate Commerce Commission, Internal Revenue Service, Justice Department, and National Archives. The only major building yet to be completed was the Federal Trade Commission, at the eastern peak of the Triangle,

which opened in 1937. The Federal Triangle is also visible in the upper left of photo 7.5, its uniform building height interrupted by the tower of the Post Office Building. In addition to employing thousands locally, the huge project brought hundreds of specialized craftsmen and artists to Washington to create the elaborate sculpture, murals, and other artwork that adorn the Triangle's Classical Revival buildings. Photo 7.4 shows Desmond Donnelly, son of New York carving contractor John Donnelly, in a shed at the southeast corner of the Justice building, examining the pediment sculpture *Ars Boni,* by the artist Paul Jennewein. Behind him is the plaster model used to guide the work.

In addition to the Federal Triangle, the government spent millions of dollars and employed thousands of workers on other projects around the city. Photo 7.5, also from May 1936, shows the completed Union Station Plaza. While the plaza's Columbus Fountain dated from 1912, it was not until the summer of 1931 that temporary dormitories constructed during World War I (see photo 3.19) were removed and work was begun on extending the plaza to link the station with the Capitol. By the time the project was completed, in 1934, the plaza featured a new basin and reflecting pool, extended a half a mile to the Capitol, and had a legislative garage and streetcar lines running underneath. Its completion also gave Washington an unbroken swath of greenspace stretching from Union Station to the Lincoln Memorial.

The explosion of government activity that characterized the New Deal created more jobs than existing federal office space could handle, despite building projects like the Federal Triangle. Newly created agencies either squeezed themselves into existing buildings, as the Civilian Conservation Corps did in the new Post Office, or more commonly found temporary accommodations elsewhere. Many rented space in buildings just to the north or west of the White House. For example, the Works Progress Administration was at 1734 New York Avenue N.W., the Social Security Board at 1712 G Street N.W., and the National Labor Relations Board at 1010 Vermont Avenue N.W. This photograph of an unidentified office was taken in 1939 and illustrates both the overcrowding of the staff and the massive amounts of paper that the new agencies generated and which then almost engulfed them.

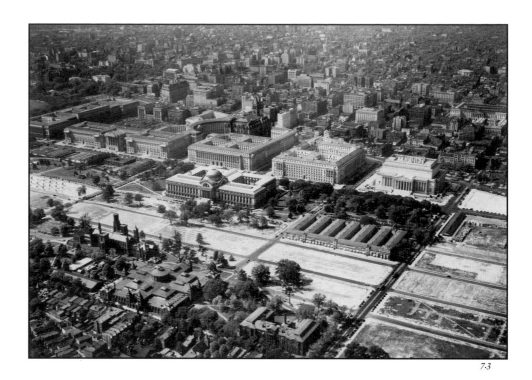

7.3

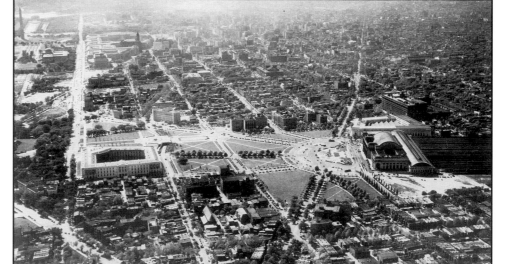

7.5

7.6

7.7

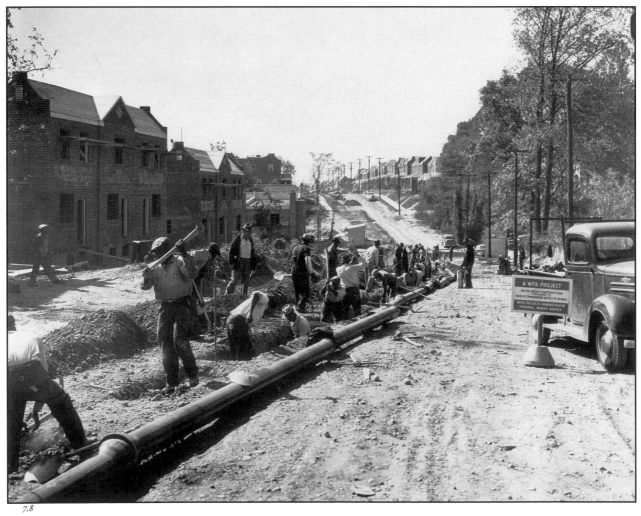

7.8

142

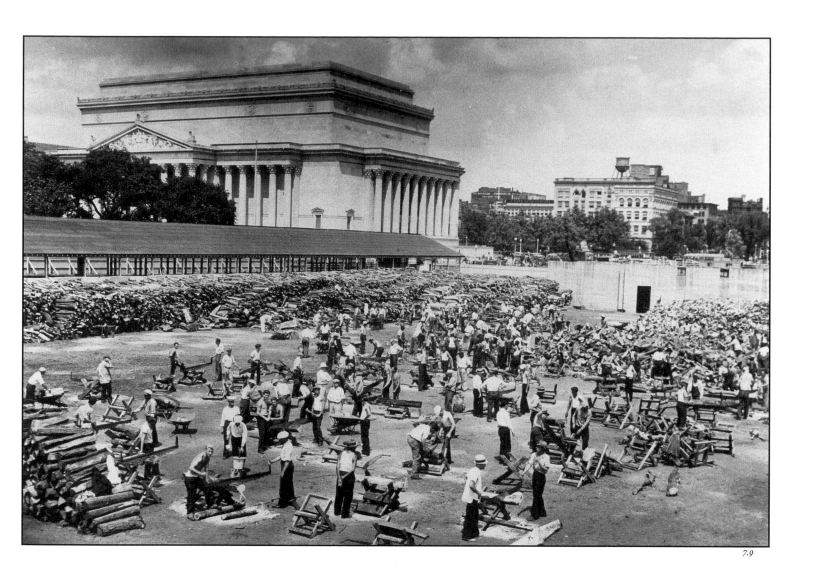

7.9

The most popular New Deal relief programs were those which provided work or training and left the city with tangible physical improvements. Shown in photo 7.7 in March 1940 is Camp Mount Hamilton, at 28th and M Streets, N.E., a Civilian Conservation Corps camp for black youth that had just been cited as a CCC Honor Camp. The CCC, run on semimilitary lines by the War Department, carried out projects on federal, state, and local government properties. Enrollees could spend up to two years in a CCC camp. In this camp, which housed two hundred, participants had been busy since 1935 clearing land and installing roads, fences, bridges, and ponds in a 400-acre site on the grounds of the National Arboretum. In explaining the camp's commendation, the white commanding officer praised the enrollees' upkeep of the barracks, recreation hall, and study hall. The Works Progress Administration, established in 1935 to implement a coherent long-term employment relief plan, concentrated much of its effort on conventional public works projects, such as installing a water main along a stretch of I Street, S.E. (7.8). Some of the jobs provided by the WPA drew criticism as make-work projects. Here, scores of men labor in August 1935 in the District woodyard, across from the National Archives (7.9). Wood gathered in Arlington Cemetery or Rock Creek Park was chopped and sawn for distribution to the poor.

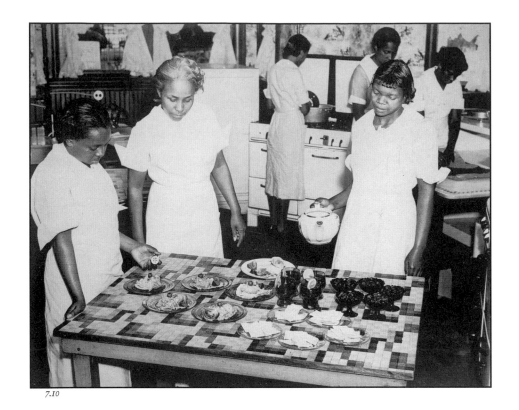

7.10

The WPA also embarked on a wide variety of employment training and cultural programs, three of which are depicted in these official government photographs. The Household Service Project, created in 1936, was originally intended for both black and white women between the ages of 18 and 35, but it soon became an entirely black program. In its training centers, at 1114 O Street N.W., 400 South Capitol Street, and 78 I Street N.W., women pursued an eight-week course that covered cleaning, washing and ironing, making beds, cooking, and serving. By 1939, about three hundred women had been trained and placed in private homes.

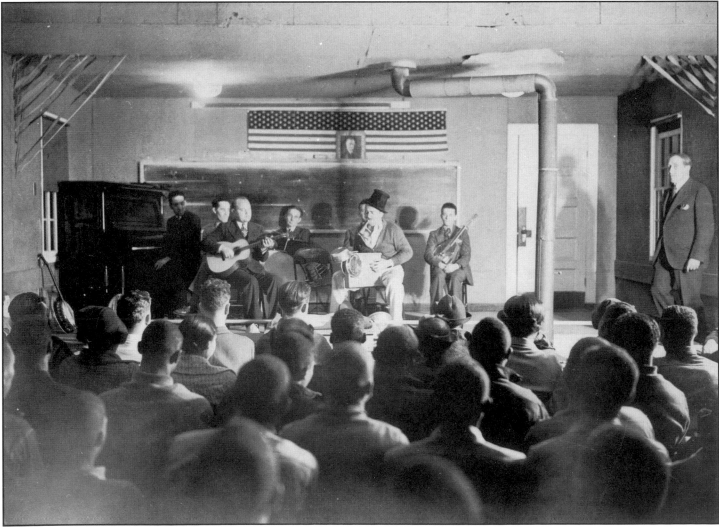

7.12

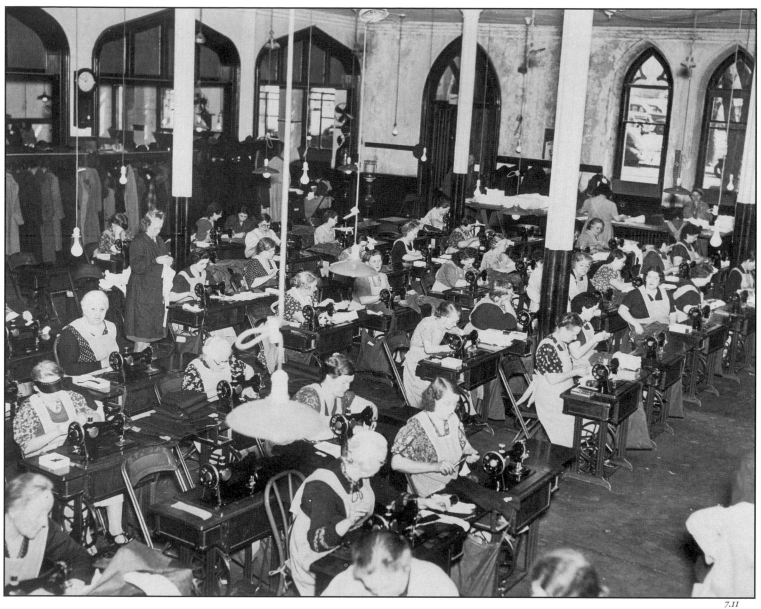

More extensive was the Sewing Project, designed to aid women of both races who were the sole support of their families. The project employed twenty-two hundred women at its peak and was still providing work for over a thousand at the end of the decade. Photo 7.11 shows the interior of the Metropolitan Methodist Church, at C Street and John Marshall Place N.W, which was equipped with three hundred sewing machines. Working thirty-five hours a week, a woman could earn almost $50 a month. The Sewing Project provided new or altered garments for hospitals and social service agencies and took in work from the public.

Far more controversial than these training programs were the New Deal cultural programs supporting literature, history, and the arts. Here the Vaudeville Unit of the Federal Theater Project performs, before an integrated audience—a rare instance of a New Deal agency challenging racial segregation. The Theater Project nationally had a clearly radical flavor, and conservatives in Congress succeeded in abolishing it in 1939.

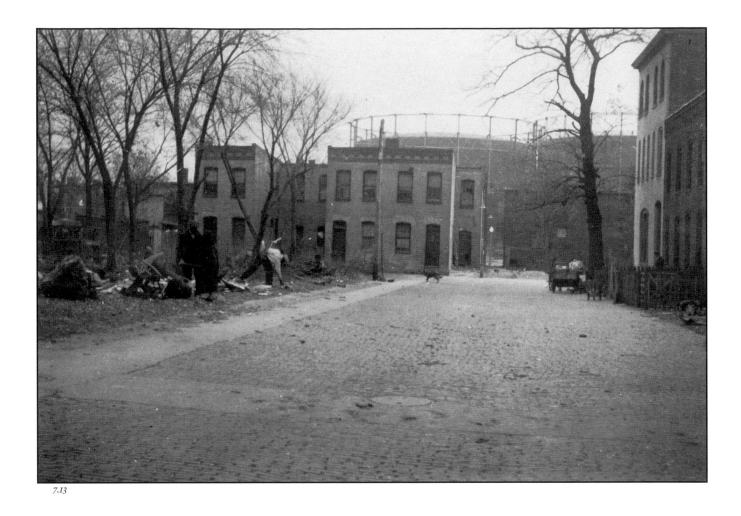

7.13

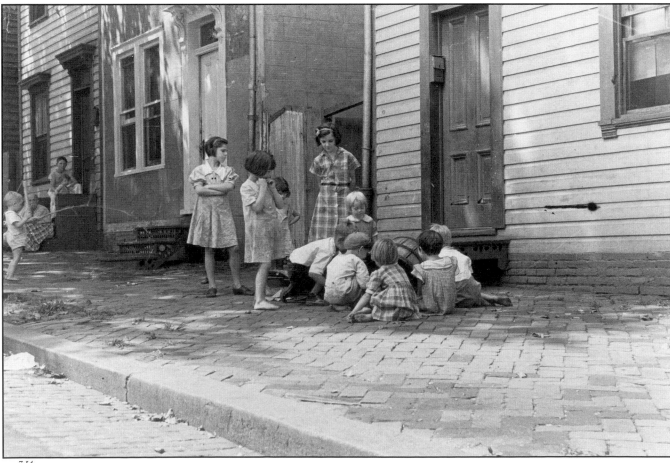

7.14

146

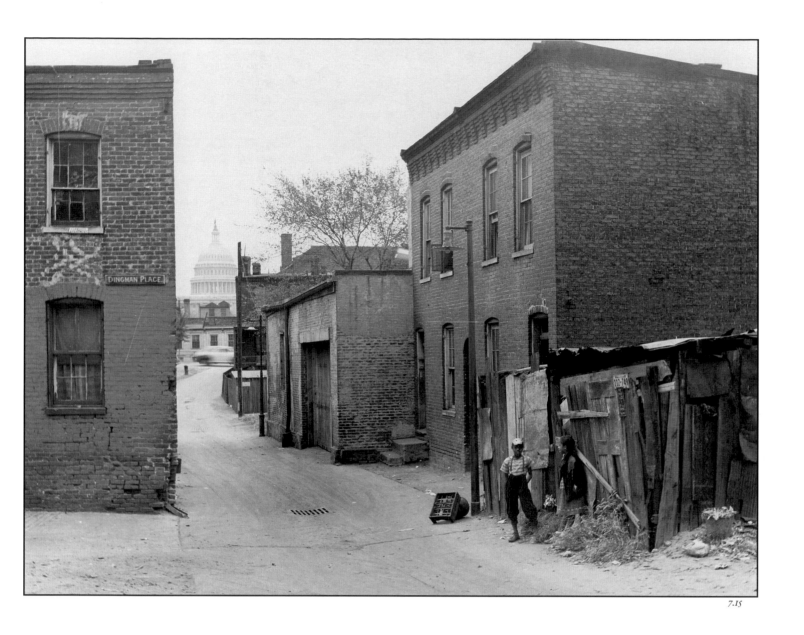

With unemployment in the city relatively moderate, Washington's most severe poverty in the 1930s seemed to be concentrated in the old alleys and small streets surrounding the city's center. Houses there had generally been built between the Civil War and the 1890s and were usually two-story brick structures measuring about 12 feet by 24 to 30 feet. In alleys hidden from main streets, homes often clustered around a central water pump and relied on outdoor toilets. As late as 1937, eleven thousand families had no indoor toilets and nine thousand Washington homes were lighted by oil lamps. Depicted here are three such areas in the older parts of the city. Snow's Court (7.13) extended between 24th and 25th Streets and K and I Streets in Foggy Bottom, in the shadow of the Washington Gas Company tanks. About two hundred people lived in Snow's Court when this view was taken in November 1935. Although almost all of the people living in alley houses were black, there were still many whites living in very modest means in parts of the old city. On one of Georgetown's poorer streets, Farm Security Administration (FSA) photographer Carl Mydans captured children at play in September 1935 (7.14). Dingman Place, N.W. (7.15), was frequently photographed, because its location, between New Jersey Avenue and North Capitol Street and E and F Streets, was just a few blocks from the Capitol. This image was taken in September 1941 by Marion Post Wolcott, another of the documentary photographers working for the FSA. The FSA photographers documented the living and working conditions of poor and working-class Americans, often—as in these cases—emphasizing their tenacity and resilience in the face of economic adversity.

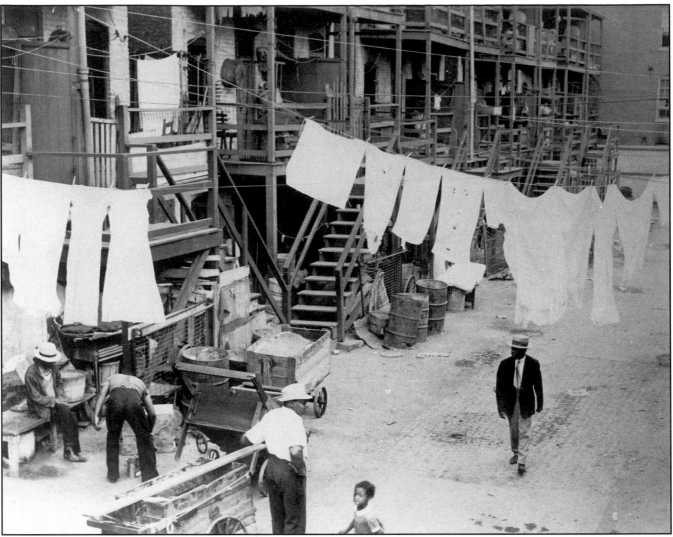

7.16

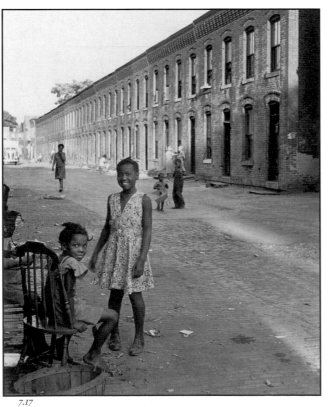

7.17

The alleys and small side streets formed more complex communities than the frequently applied label *slum* might imply. Many of their residents held jobs in office buildings around the city. Business of various kinds, from "junking" and produce vending to operating speakeasies and stills, was conducted in alleys. But violence was relatively rare and usually controlled by the residents, who were often linked by kinship. A U.S. Housing Authority photograph of Logan Court (7.16), between First and Capitol Streets and Pierce and L Streets—with more than sixty houses one of the largest inhabited alleys—illustrates how people used their alleys to work, do their laundry, and store vehicles and materials, such as wood for fuel and scrap metal for sale. Photo 7.17 was taken in 1943 on a street in southwest Washington by Godfrey Frankel, a writer for the *Washington Daily News* and an amateur photographer. It reveals that the alleys and back streets could offer a safe haven in which children could play under the watchful eyes of adults.

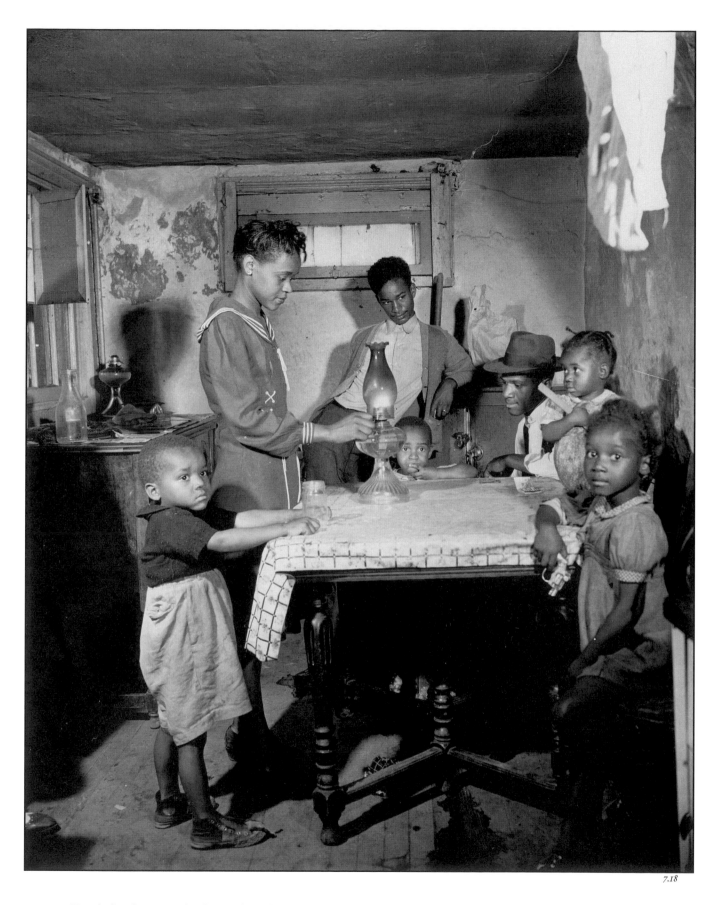

Frankel's photographs depict the vibrancy and sense of community found in many poor neighborhoods. But the overcrowding and material deprivation were real. In photo 7.18, Gordon Parks pictured a family of seven living in a home without electricity in southwest Washington in June 1942.

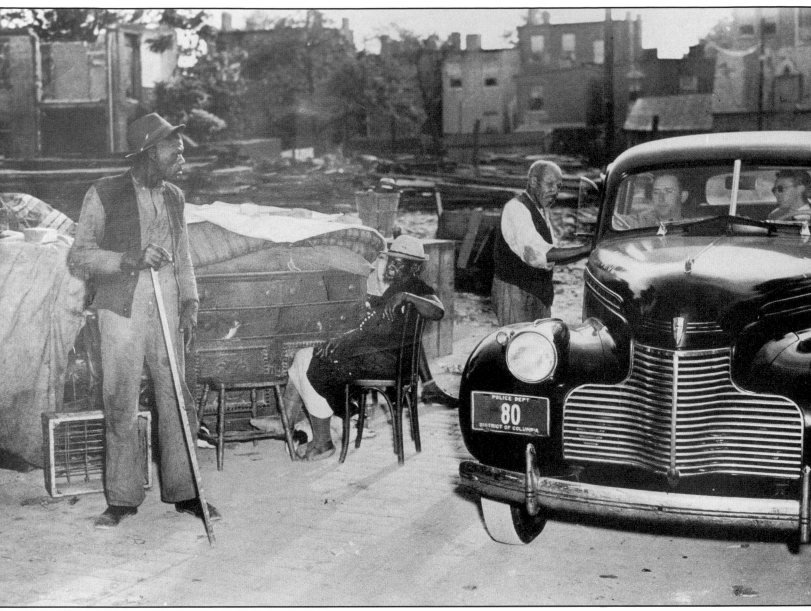

7.19

Slum clearance and, more importantly, public housing, were the New Deal's proposed solutions to the local housing problem. But the destruction of what to middle-class reformers appeared unhealthy and dangerous slums often meant to the residents the loss of familiar surroundings and friends. Depicted here in August 1941 is an old couple who had tried to resist eviction from the shack in which they had lived for many years. The scene may have been at Holly Court, New Jersey and P Streets, N.W., where homes were torn down that month for replacement by a playground. Residents displaced by such demolition were supposed to have the chance to move to new public housing projects. The aerial photograph (7.20), taken in June 1941, shows three projects built by the Alley Dwelling Authority for black tenants on a site north of Griffith Stadium. The Kelly Miller apartments, shown under construction, opened in the fall of 1941 and eventually totaled nearly two hundred units. Rents ranged from $11 per month for a two-room unit to $37 per month for five rooms. Adjacent to the Kelly Miller project are the two buildings of the thirty-one-unit Williston Apartments (bottom center), which opened in 1937, and close to the stadium, in a horseshoe arrangement, are the eighteen units of the V Street Homes, opened in 1938.

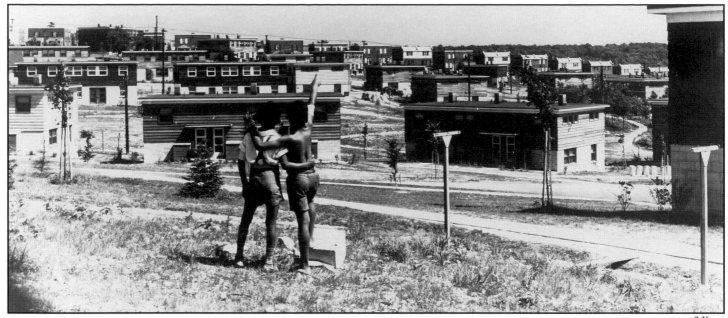

7.21

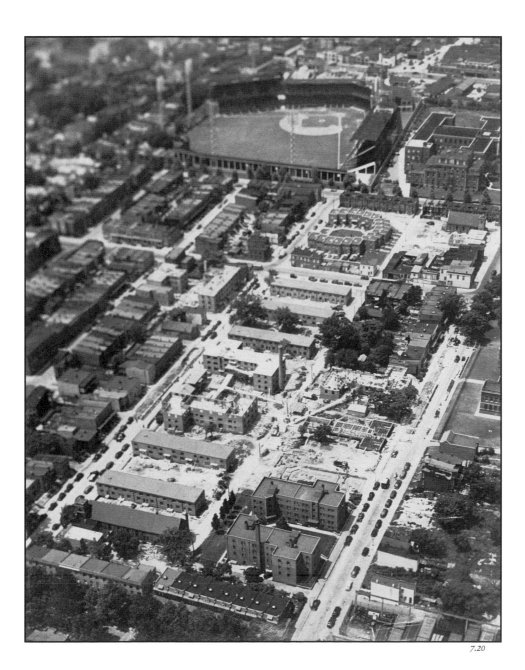

7.20

Photo 7.21 shows the Frederick Douglass Dwellings, on Alabama Avenue between Stanton Road and 21st Street, S.E., designed by Washington's leading black architect, Hilyard Robinson. An ambitious attempt to create a community of single-family homes in small units in Anacostia, the project featured 309 four-room apartments renting for an average of $21 per month when it opened in 1941. Unfortunately, the location's limited access to jobs and transit lines limited its residents' economic opportunities.

7.22

7.24

The only public housing project built in Washington by a national New Deal agency was Langston Terrace, located north of Benning Road, N.E., between 21st and 24th Streets. Constructed in 1937–38 by the Public Works Administration and designed by Hilyard Robinson, it had 274 apartments, along with educational and recreational facilities, on the fourteen-acre site shown in this aerial photograph. The project's social building featured a terra cotta frieze entitled "The Progress of the Negro Race," by local artist Dan Olney, shown in a January 1938 newspaper photograph (7.24). The frieze depicted John Mercer Langston, legal counsel to Washington's first board of health, during Reconstruction, and later dean of Howard University Law School, pointing the way for Virginia farm tenants to better industrial jobs in the city.

Following the example of
such pioneer community
planning efforts as
Radburn, New Jersey,
Robinson had Langston
Terrace built in a U
formation around a
common, where adults
could socialize and
children, like little Dwight
Cropp (7.23), shown
flanked by his two
brothers, could play.
Rents were on a sliding
scale from $19.50 to $31.50
per month, based on
income. Once a family
exceeded a specified
income, it had to move;
and many did, subse-
quently achieving middle-
class lives. The first
tenants of Langston
Terrace, selected from a
waiting list of thirty-seven
hundred, took up resi-
dence in May 1938. Photo
7.25 shows truck driver
Alfred Tillman and his
wife being shown the
project shortly before it
opened. The Tillmans
moved into one of the
four-room units with
their two small children.
Tillman's steady employ-
ment and ability to pay
the $27 per month rent
were crucial to the
family's selection as
tenants, since people on
relief were not admitted
to the project. When fully
occupied, Langston
Terrace was home to
almost nine hundred
black Washingtonians,
and for almost all of them
it represented a consider-
able improvement in their
living conditions.

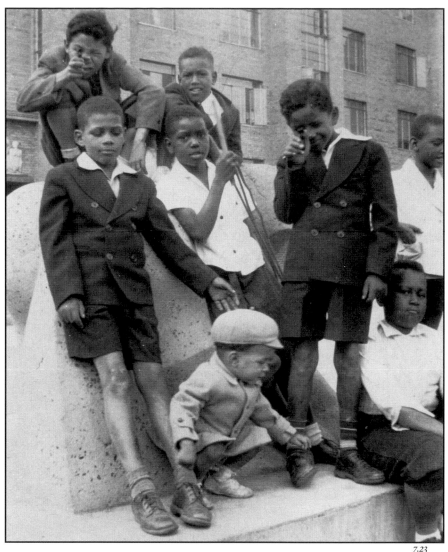

7.23

7.25

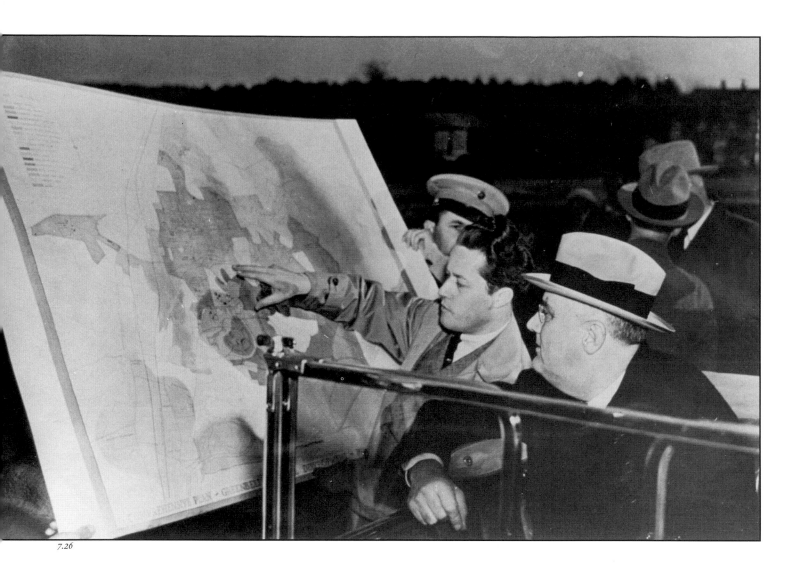

7.26

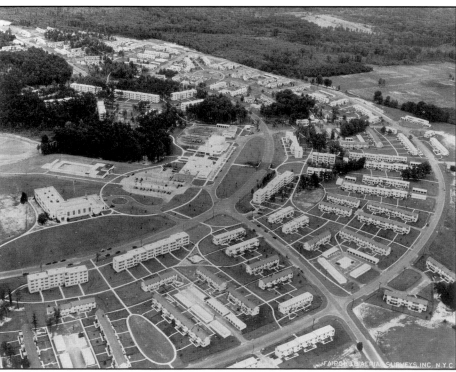

7.27

Thirteen miles outside Washington, the government's Resettlement Administration took a more comprehensive approach to the problem of overcrowded cities. It created a complete planned community for whites in Greenbelt, Maryland. Drawing on models of "garden cities" dating back to the nineteenth century, the federal government built planned towns surrounded by open land outside Washington, Cincinnati, and Milwaukee. The program was a favorite of President Roosevelt, who is shown here looking at the plans for Greenbelt, Maryland, in November 1936. The completed community, shown in a September 1938 aerial photograph (7.27) comprised some 3,300 acres and was intended for a population of about three thousand.

The government had been able to buy the land, overworked as farmland, especially for tobacco growing, for only about $90 per acre. As part of the attempt to create a vital community center, planners grouped at the city core a movie theater, a grocery, barber and beauty shops, a gas station, a bus station, a post office, and both police and fire departments. Although the homes were modest in size—in keeping with government policy to accommodate those who could afford only $20 to $45 per month—all homes were equipped with modern conveniences and rooms that looked out on grass and trees (photo 7.29). Largely because such developments competed directly with private enterprise—in contrast to more traditional low-cost public housing projects, which did not—only three greenbelt communities were completed nationally, and the Resettlement Administration was abolished in 1938.

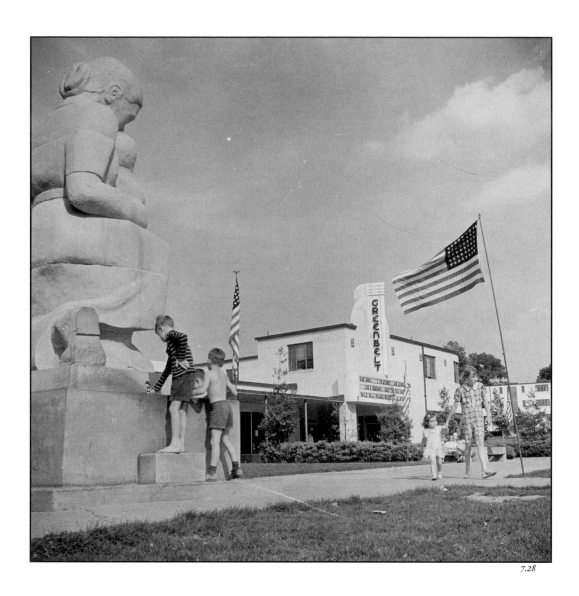

7.28

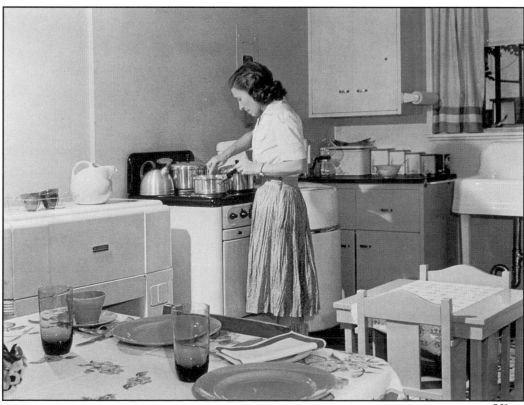

7.29

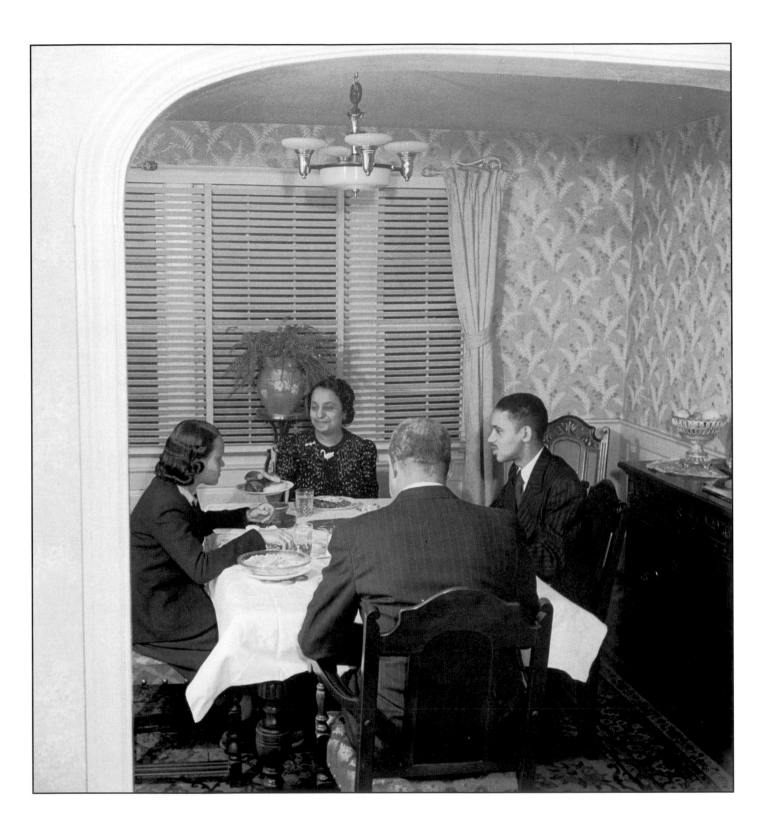

The caption of this May 1942 photograph identified the husband as a doctor, the wife as a teacher, and the son and daughter as a Howard University student and a high school student.

8 A Bourgeois Town

On the eve of World War II, the black folksinger Leadbelly warned "all the colored folks," "Don't try to buy no home in Washington D.C. / Cause it's a bourgeois town." In fact, despite discrimination, blacks had been moving into Washington and buying homes throughout the 1930s; thousands more would arrive during the war. Yet "bourgeois town" was in many ways an accurate label, for by 1940 the capital had developed into a major city based almost entirely on bureaucracy and other white-collar work. The great majority of Washington's whites—almost three-quarters of the city's people—had a level of income and a life style that was certainly middle class by contemporary standards. The relatively few wealthy old families played a small part in the city's overall life, and there were no major industries to challenge the dominance of politicians and civil servants. Common opinion held that although Washington lacked the excitement and culture of European capitals, neither did it contain large concentrations of poverty and unemployment. What Washington did have was a vital and relatively new downtown encircled by neighborhoods varying widely in age, appearance, and racial and ethnic composition. This characteristic urban diversity was combined with a pace, ambiance, and pattern of social relationships that most residents thought of as recognizably "southern." The pervasive influences of climate and race were as powerful as the work of government in binding together the entire area.

Metropolitan Washington now clearly extended beyond the boundaries of the District of Columbia. Within the District, only a few areas in the southeast and far northeast, like Deanwood and Marshall Heights, remained semirural, with unpaved streets and few city services. The zone of continuous urban development outside the city included Alexandria and most of Arlington County, the area from Bethesda and Chevy Chase to Silver Spring and Takoma Park in Montgomery County, and the Hyattsville and College Park sections of Prince George's County. The Key and Memorial bridges had stimulated growth in northern Virginia, and the whole area along Lee Highway to Glebe Road was developing rapidly. Suburban growth in Maryland had recently been spurred by the completion of East-West Highway and the extension of New Hampshire Avenue. In contrast, development east of the Anacostia in both Maryland and the District was still limited drastically by the river, the nearby heights, and the lack of good roads.

By 1940 the metropolitan area included nearly a million residents, and two-thirds

of them lived within the District, despite the rapid growth of the suburbs in the 1920s and 1930s. The basic composition of Washington's population had remained remarkably stable, growth in the 1930s swelling the white population by 120,000 to a total of 474,000 even as the black population increased to 187,000. Nor had the New Deal influx significantly changed the city's ethnic make-up, as Washington's foreign-born remained only 7 percent of the population. The largest immigrant communities were the ten thousand Eastern European Jews and five thousand Italians. Overall, the typical Washington family in 1940 was white, lived in a row house built before 1930, and contained at least one government worker, who commuted to work by public transportation. Even the city's blue-collar work force was largely government related. The major industries were the utilities, the Navy Yard, with six thousand employees, and the Government Printing Office, which employed fifty-five hundred. Printing was also the most important private production industry, but more people were employed tending to the two million sightseers who visited Washington annually.

The monumental core that most visitors came to see was still new in 1940. The clearing of the Mall and creation of the Reflecting Pool, the completion of the Federal Triangle and construction of such important buildings as the National Gallery of Art and the Supreme Court succeeded in giving Washington the overwhelmingly impressive center envisioned in the turn-of-the-century Senate Park Commission plan. At the same time, the downtown center of commerce and entertainment continued to flourish several blocks to the north of the Mall. Pennsylvania Avenue business life had suffered as a result of the elimination of Center Market and the concentration of federal buildings on its south side, but the area of department stores and other shops around F Street between 7th and 15th Streets prospered. The downtown area was complex and highly specialized. A collection of pool halls and arcades lined 9th Street, N.W.; first-run movie houses were concentrated between 12th and 15th Streets; while 15th Street from E to K Streets, near the Treasury Department, was known as Little Wall Street, for its brokerage houses and banks. Linked closely to the downtown were the rows of embassies, offices, churches, and association headquarters which stretched up 16th Street to Park Road and from Dupont Circle west along Massachusetts Avenue.

The residential areas near downtown included some of Washington's richest and poorest neighborhoods. To the northwest was Kalorama, an exclusive community. Both the Dupont Circle area and Georgetown had concentrations of wealthy families, the latter also being home to many prominent New Dealers who encouraged the local historic preservation movement. But the inner parts of the city were home as well to the majority of black Washingtonians, most of whom lived in much more modest circumstances. West of the White House, some four thousand African Americans lived near the utility plants, factories, and breweries of Foggy Bottom. Another substantial, though decreasing, portion of the working-class black population was scattered around the back streets of Georgetown. The largest black communities were in the near Northwest and Southwest. About eighty thousand black residents lived from Massachusetts Avenue up to Harvard Street between North Capitol and 14th Streets. Within this area were black Washington's major institutions, including Howard University, Elder Michaux's Radio Church of God, and those in the lively U Street

commercial and entertainment district. Many middle-class families lived in LeDroit Park and sent their children to the prestigious Dunbar High School. Newer middle-class black neighborhoods were beginning to appear as well in the Northeast, in communities such as Kingman Park and De Priest Village. Below the Mall, in Southwest Washington, twenty thousand African Americans lived to the east of what was then called 4 ½ Street, while the white residents, including a substantial number of Jews, lived to the west.

An increasing Jewish presence was also found in Brightwood and Petworth, north of the city's main black community. In these middle-class white areas of the Northwest, new row homes and small apartment houses offered a better life to people who could move out of the older areas of the city. Other areas of Northwest Washington, such as the older communities of Woodley Park and Cleveland Park, Connecticut Avenue with its newer line of apartment buildings, and the section west of Rock Creek Park where exclusive neighborhoods had recently been developed, catered to the city's professionals and executives. Southeast and northeast Washington contained more modest white communities, linked to the city's center by streetcar lines but dominated by small single-family homes and organized around their own local commercial strips and neighborhood institutions. Brookland, for example, was home to many Washingtonians of Irish and Italian parentage and a concentration of Catholic schools and churches.

Throughout the city and the suburbs, a formal code of segregation governed schools and other public facilities, as well as housing and employment. Within Washington, there were separate school systems for white and black students, whites constituting about 60 percent of the public school children. The black school system, while underfunded, was highly respected nationally and boasted three senior high schools. Segregation was carefully maintained in all aspects of recreation. Public funds paid for five white swimming pools in the city and three black pools, thirty playgrounds for white children and fifteen for blacks. The only theaters downtown that admitted blacks relegated them to the upper tiers, and the cafeterias and luncheonettes that did serve an integrated clientele made black customers stand while eating. Clothing stores that allowed black shoppers did not let them try on clothes. In response, the black community created and sustained its own churches, fraternal organizations, businesses, and entertainment district apart from whites.

The racial divide obscured the fact that most black Washingtonians held steady jobs and lived in neighborhoods similar to those of most whites in the city's older areas. In these densely populated parts of the city a great deal of life was lived on the street, especially in the hot middle months of the year, and daily routines such as using the same transit lines and shopping at local stores bound people together. But a different pattern of urban life, based on cars and more dispersed single-family homes, had already become the ideal in many of Washington's newer and wealthier white neighborhoods. Here, divisions of class were often as important as those of race. The development of Tenleytown as an attractive middle-class community, for example, involved the forced departure of both white and black residents of the old Fort Reno area. They made way for such modern amenities as a reservoir, a park, and two new schools—Deal Junior High and Woodrow Wilson Senior High School. Residents of

communities developed west of Rock Creek Park in the 1920s and 1930s, such as Spring Valley and Wesley Heights, relied almost exclusively on the automobile for both commuting and shopping. As early as 1930, the first shopping center with its own parking—the Park and Shop—had appeared along upper Connecticut Avenue, and later in the decade a Giant supermarket with parking on the roof opened on Wisconsin Avenue in Tenleytown.

By then the number of local automobile commuters was almost equal to the number of public transit users. Washington was the most automobile oriented major city in the country, outdistancing even Los Angeles. The city had one car registered for every three residents, the highest figure in the nation and a telling indicator of its exceptional prosperity. The hundred thousand automobile commuters severely strained Washington's slowly expanding highway system and its completely inadequate downtown parking facilities. But the automobile also facilitated the decentralization in employment that accompanied the region's spreading population. The National Institutes of Health moved out to Bethesda during the late 1930s, and the Department of Agriculture's Beltsville research center expanded its facilities. They were among the precursors of a much larger move being contemplated by the War Department in 1940. The erection of its massive new headquarters in the northern Virginia suburbs, rather than in Washington as originally planned, confirmed and symbolized the new shape of the metropolitan area—as well as signaling the imminent shift of the city's focus from civilian to wartime military concerns.

(Opposite) Around 1940 most Washingtonians lived in one or another type of row house neighborhood. Photo 8.1 shows the area of First and L Streets, N.W., looking east toward North Capitol Street, in November 1935. An old and overwhelmingly African American neighborhood near the city's center, it still had the mix of two-story row homes, commercial buildings, and industries—mostly printing and publishing—that had characterized Washington in the nineteenth century. Blocks in such neighborhoods were the kind most commonly divided up by developers, who placed alley dwellings rather than backyards in their centers. Clearly visible behind the row homes on the main street is Logan Court, depicted in photo 7.16. Photo 8.2 was taken in March 1936 in front of the A&P store at 2302 4th Street, N.E., where the communities of Eckington and Brookland come together. Despite the small apartment houses, this newer area appears far less crowded than the older area a few miles to the south. Fourth Street here was a typical neighborhood commercial street; the A&P was flanked by a barber shop and a beauty shop, and another grocery and a drug store stood next to the Edgewood Hardware store, visible at the intersection of Adams Street. Although Washington had a reputation as a nonethnic city, the names of the street's businessmen evidence ethnic diversity: Henry Lee (laundry), Samuel Tripi (shoe repair), Benjamin Cherkasky (billiards), Nazret Carcoginian (grocer), and E. G. Schafer (plumbing supplies). A shot of an exclusively residential street, taken in the late 1930s on 21st Street, N.E., just below Benning Road, shows how the basic row house idea was flexible enough to incorporate many features which were by then becoming associated with a desirable middle-class lifestyle.

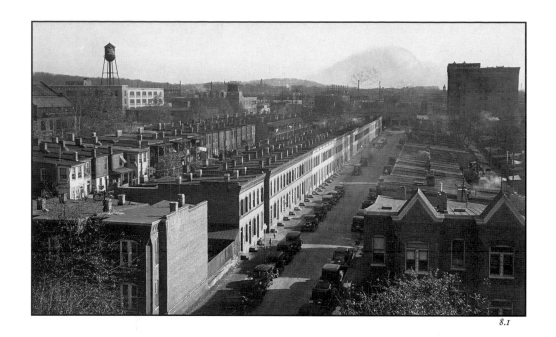

8.1

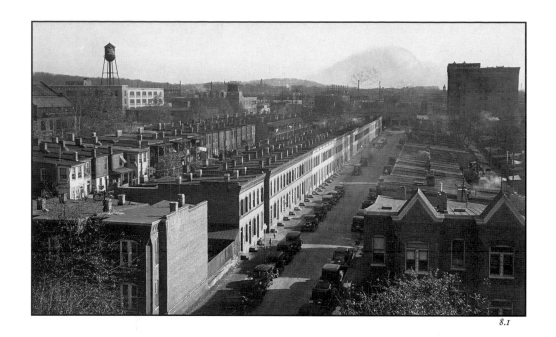

8.2

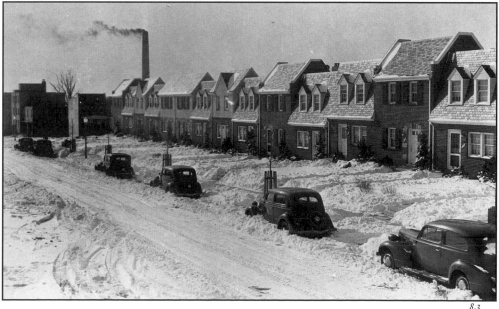

8.3

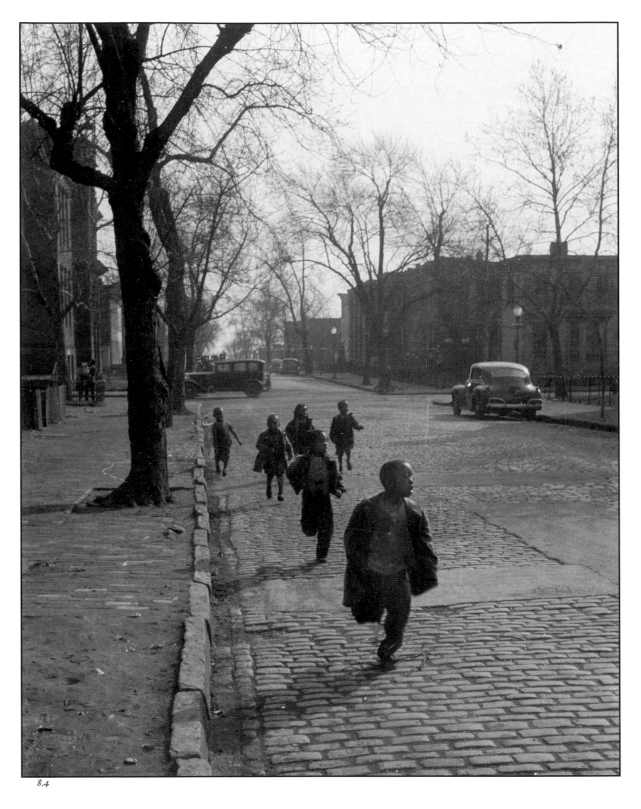

8.4

Southwest Washington was one of the city's most complex neighborhoods. Isolated from
the rest of the city by the Mall, a creek, and rail lines, it lacked some of the amenities of
more favored places of residence; but its modest row homes, convenient stores, restaurants,
and places of entertainment offered a decent location for newcomers, whether African
Americans from the South or Eastern European immigrants. Yet the Southwest contained
some of the city's worst housing, and it was racially divided, whites living to the west of 4th
Street and blacks to the east. Most black residents of the Southwest, like their white
counterparts, enjoyed the neighbohood's pleasant and relatively little used streets, as shown
in a 1943 photograph by Godfrey Frankel (8.4), which also depicts the characteristic street
and sidewalk paving of the time.

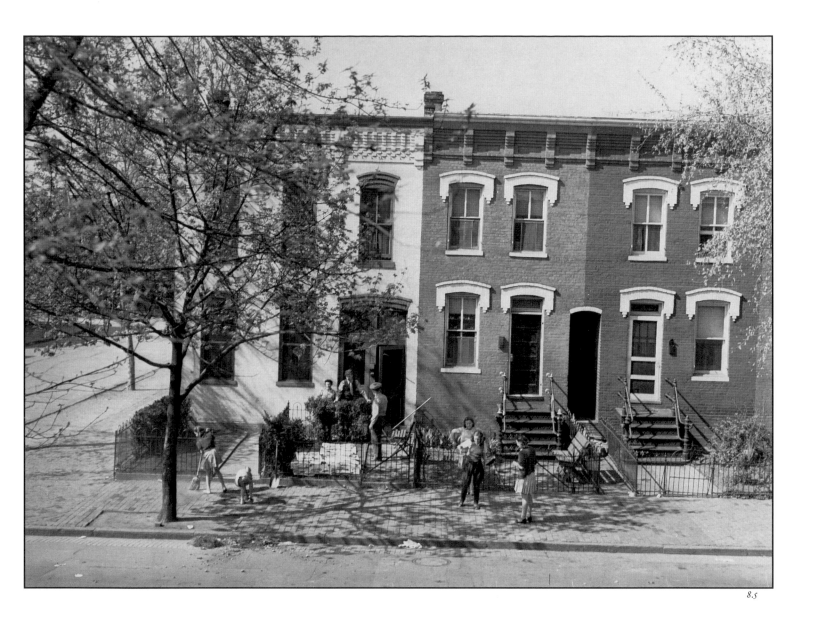

The Southwest's most desirable features were captured in the spring of 1942 by Louise Rosskam, a photographer for the Office of War Information (OWI), successor to the FSA. In the white area, she found a group of residents gathered at the corner of N and Union Streets. The small front yards and iron fences were characteristic of much of the community. The area had a substantial Jewish population. Shown in photo 8.6 is the Kessler family, of 904 4th Street, S.W., at their Passover Seder in 1939. Samuel Kessler, front row, was in the shoe repair business, and the Seder was being held in his home. The block on which he and his wife lived was unusual for Washington, because it was predominantly Jewish, from the Cohens and Silvermans across the street to Levy's Department store at the end of the block. (See also photo 6.5.)

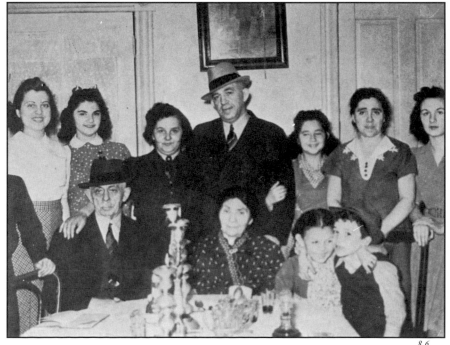

8.7

8.8

164

In the rapidly developing suburbs, the availability of land made the detached single-family home an attainable ideal for thousands of families. Many were modest, like this home on Lincoln Street in Bethesda (8.7), for sale in April 1937. The five-room house on a 60-foot by 120-foot lot sold for about $5,650. More elaborate colonial homes, like the ones going up in a new subdivision in Arlington in May 1942 (8.8), were also built, although wartime needs temporarily curtailed private building. Arlington's population expanded steadily during the 1930s, and during the succeeding decade the number of homes in the county more than doubled. Silver Spring, a railroad suburb along the B&O line since the first decade of the century, was another growing area. Photo 8.9 shows commuters awaiting the train to Washington in May 1941, at which time the community was in the midst of an expansion that raised its population from about eight thousand in 1934 to fifty thousand in 1948.

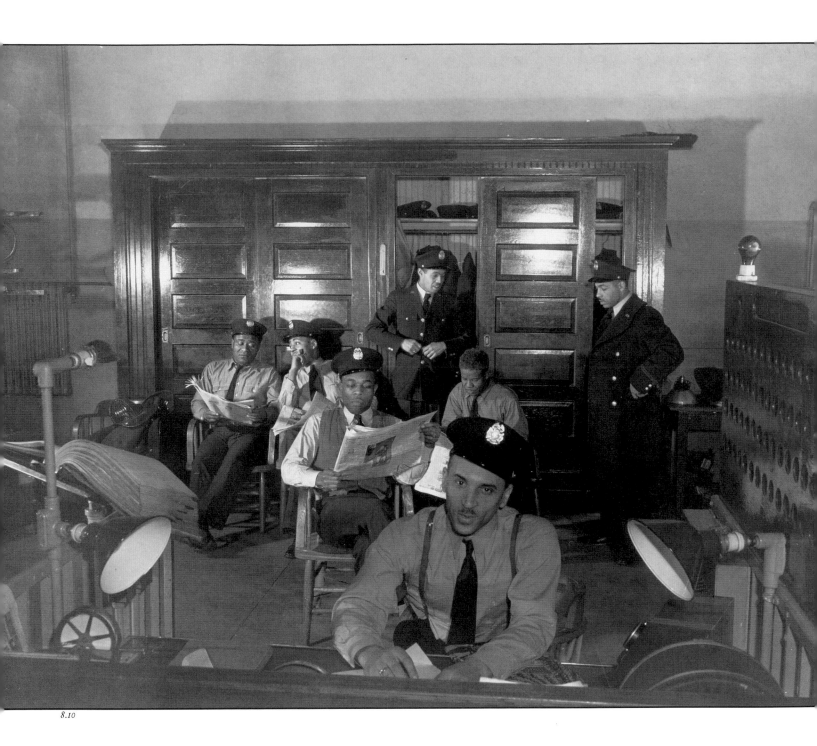

8.10

Many in Washington's black community, while decrying segregation, took pride in the separate institutions and services they were forced to maintain. In January 1943 Gordon Parks did a series of photographs for the Office of War Information on Washington's oldest all-black fire company, Station Number 4. The company was organized in 1919 at the request of one of the four blacks then serving in the city's fire department. He correctly saw a separate black station as his only chance for advancement. Parks's series of photographs, taken for the wartime propaganda agency, was clearly designed to show the contributions of African Americans to the city's general welfare, rather than to criticize segregation in the fire department. We see the men at their station house, at 913 R Street, N.W., and cleaning a hose after a fire in a movie theater. The fireman in the white helmet held the rank of sergeant in the department. The black company was more than welcome fighting fires in white as well as black communities and by all accounts engaged in a friendly professional competition with white stations.

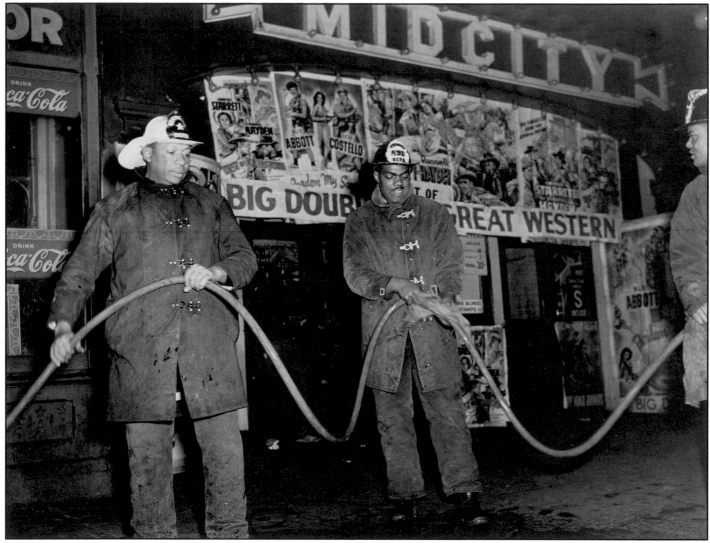

8.11

The fireman at center in the theater fire shot and shown backing a truck into the station house is former college football star Paul Honesty. Separate black stations persisted until integration was ordered in the fall of 1954 over the protests of white firefighters, who objected to sharing living quarters with their black colleagues.

8.12

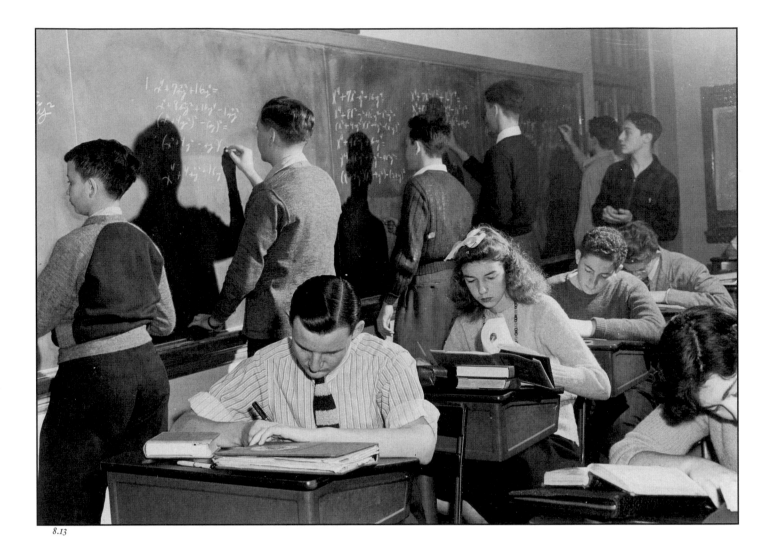

8.13

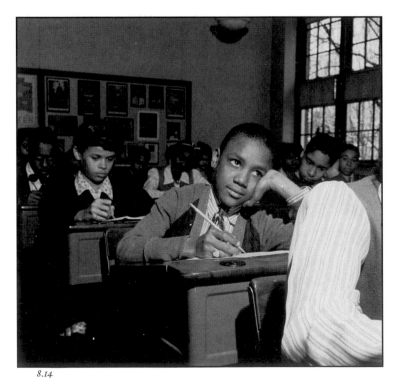

8.14

Like the fire department, the segregated schools exhibited many similarities despite their formal division into separate systems. These two OWI photographs depict students in new schools, and the students adhere to the same dress code, with most of the boys in both pictures wearing ties. The white students are in an algebra class in Woodrow Wilson High School in October 1943. The high school opened in 1935 on the old site of Fort Reno, to serve the growing white school-age populations of Cleveland Park, Tenleytown, and Chevy Chase. Although the black school system usually did not receive funding proportionate to the black student population, support was sometimes available for the construction of black schools. The students in photo 8.14, shown in March 1942, are in Banneker Junior High School, located at 9th and Euclid Streets, N.W. The school was dedicated in February 1940 with a series of events that included the observation of Negro History Week. Like Wilson High School, Banneker initially served about eight hundred students. While lacking the spacious grounds of Wilson, Banneker did have a modern gym, cafeteria, and clinic.

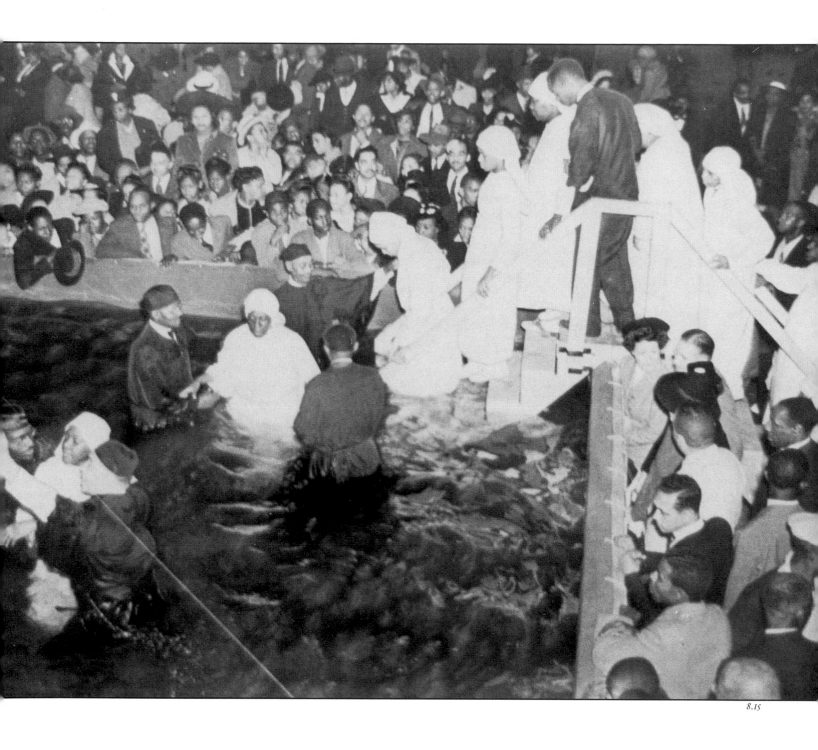

8.15

Religious observances followed ethnic and class lines as well as racial divisions. Especially popular and influential in the black community in the 1930s and 1940s was Elder Lightfoot Michaux, the "Happy Am I" preacher, whose Church of God had its own radio show and social welfare programs. Photo 8.15 shows Elder Michaux (lower left with arm raised) baptizing worshipers in a canvas pool set up in Griffith Stadium in September 1941.

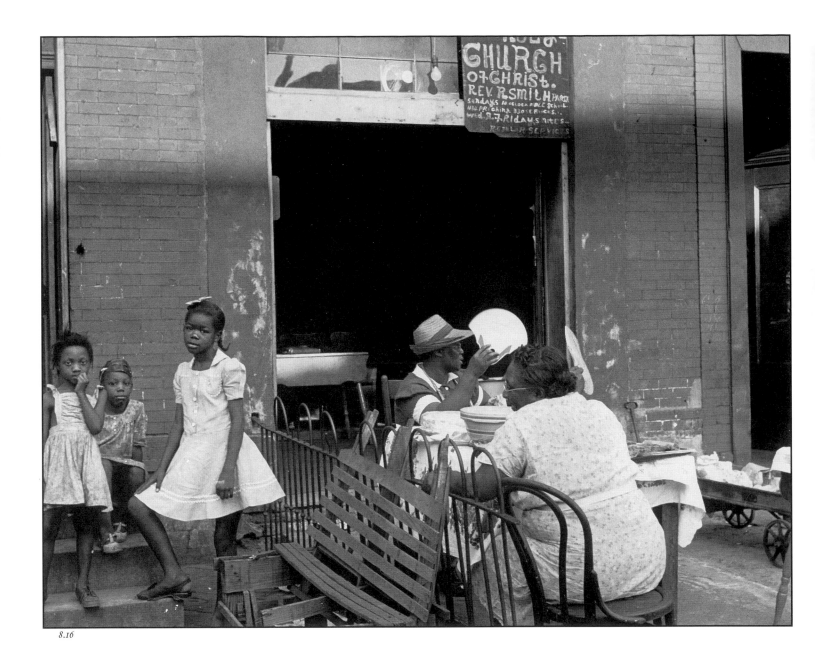

8.16

Many poor African Americans attended services in small storefront churches rather than the larger and better-established churches of the middle class. In 1943, Godfrey Frankel photographed the Holy Church of Christ in a southwest alley (8.16). According to the sign, Reverend R. Smith, pastor, offered Bible school and preaching on Sundays, and services on Sundays and Wednesday and Friday nights. At the other end of the organizational spectrum was the Holy Rosary Catholic Church (8.17), at 3rd and F Streets, N.W., pictured here at a women's auxiliary dedication ceremony in April 1934. Originally organized in 1913 to serve the growing Italian community concentrated near Union Station, in the area popularly known as Swampoodle, Holy Rosary was just one of several Catholic parishes serving different ethnic communities in that area. By the time this photograph was taken, many of the first generation immigrants had already moved away from the densely built-up area around the church. Congregations were constantly being created in new and changing neighborhoods and reflected the nature of the vicinity's population. Photo 8.18 shows worshipers leaving the First Wesleyan Methodist Church, at 735 31st Street, S.E., in Anacostia. The church had been founded not many years before this photograph was taken by OWI photographer Esther Bubley in March 1943.

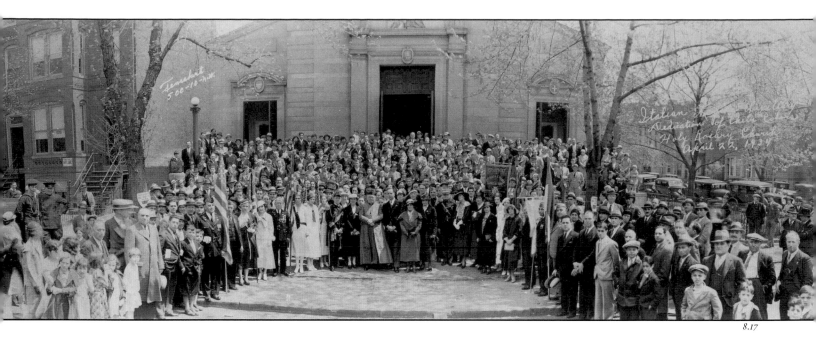

8.17

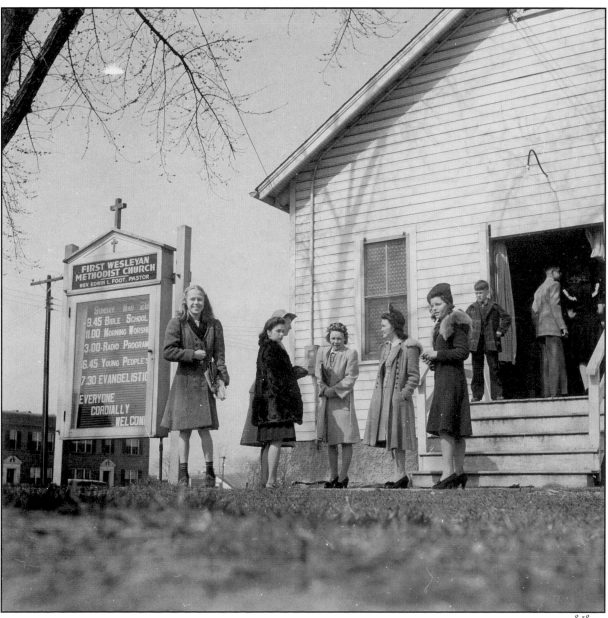

8.18

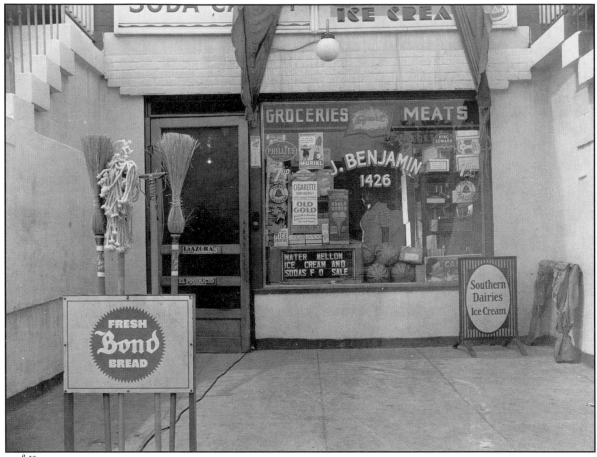

8.19

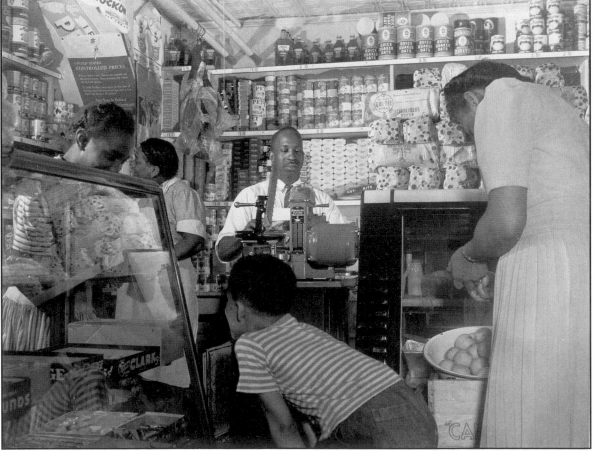

8.20

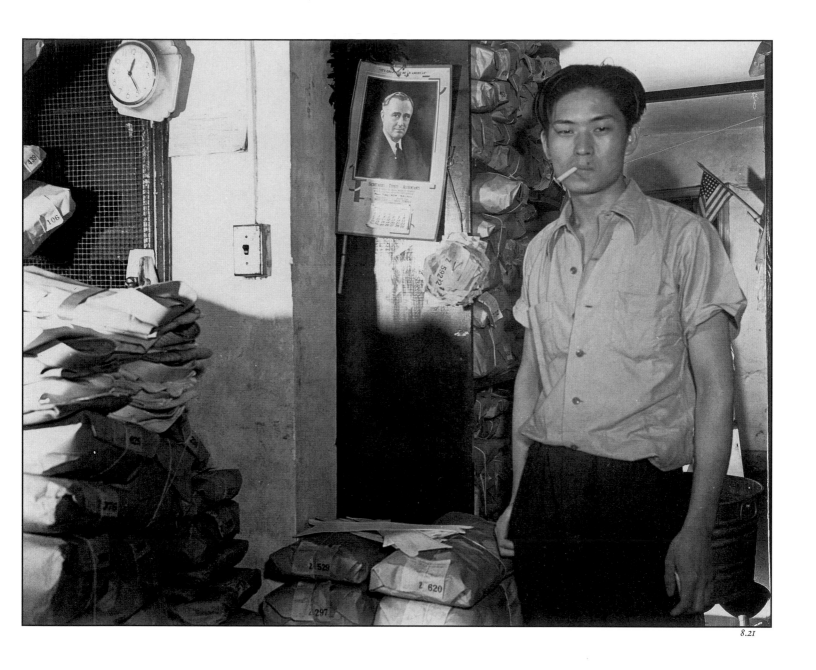

Central to neighborhood life, in addition to such formal institutions as schools and churches, were stores and shopping. As part of his documentation of the life of Ella Watson, a government cleaning woman who lived at 1433 11th Street, N.W., near Logan Circle, Gordon Parks photographed the grocery store and laundry that she patronized. In August 1942, John Benjamin operated the store at 1426 11th Street, N.W., seen in these exterior and interior photographs. He had a second store at 909 4th Street, N.W. Benjamin's neat and well-stocked store was clearly designed to serve all the traditional functions of a complete neighborhood grocery. In the basement of Ella Watson's building was a Chinese laundry, operated by Johnnie Low, who posed between a photograph of President Roosevelt and an American flag.

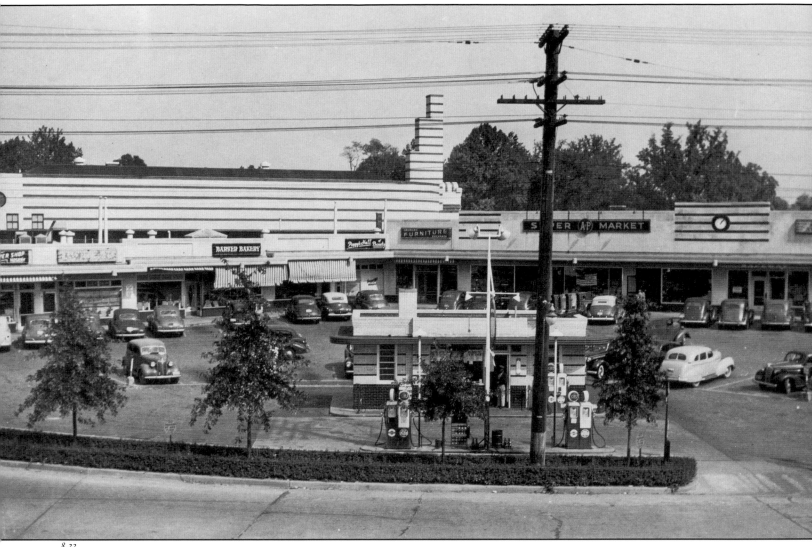

Across town and in the suburbs, these traditional enterprises were being challenged by new types of stores and shopping centers. One of the factors in Silver Spring's rapid growth was its booming shopping district. The ultra-modern art deco Silver Spring Shopping Center, at Georgia Avenue and Colesville Road, shown here in 1942, was the largest such complex to be built in the Washington area before World War II. With ample off-street parking and a service station in the middle, the center had been created with the automobile foremost in mind. A "Super A&P Market" served as the center's anchor store.

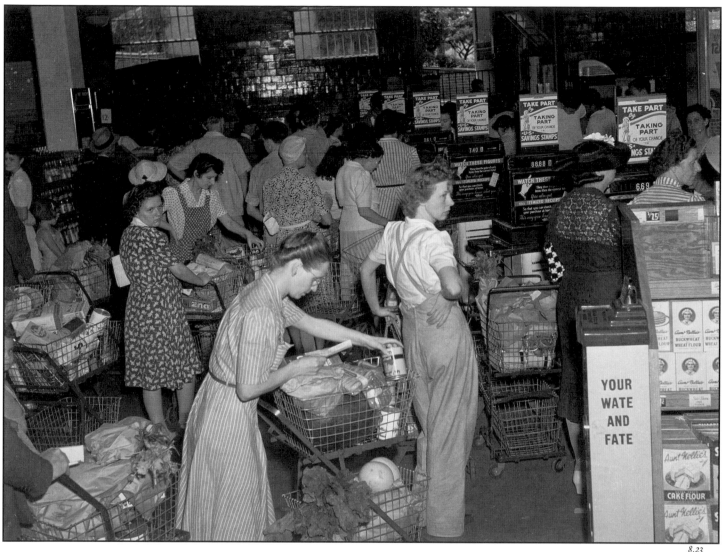

Such supermarkets were first introduced in the Washington area in 1936. Their wide variety of offerings combined with such innovations as wheeled carts, self-service, and rapid machine checkout made them immediately popular with shoppers like those shown in a Giant supermarket in the summer of 1942.

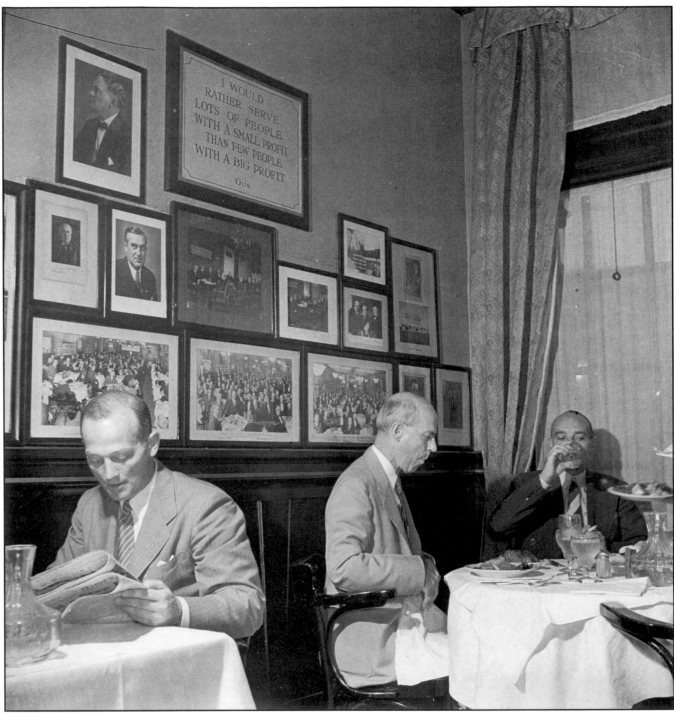

8.24

The photographers who worked for the Farm Security Administration and the Office of War Information are justly famous for capturing an unusually full range of everyday life in America. Photographs by two of them depict restaurants serving very different types of Washingtonians. Marjory Collins photographed luncheon at the Occidental Restaurant in the Willard Hotel, at 1411 Pennsylvania Avenue, N.W., in July 1942 (8.24). Then under the management of Frederick Bucholz, son of founder Gustav, the restaurant had been in business since 1906. It was more famous for its more than six hundred autographed pictures and its motto "Where Statesmen Dine" than for its fairly ordinary menu, whose highlights included London broil with potatoes.

A photograph by John Collier shows the interior of an early Hot Shoppe, in December 1941. This restaurant, at 14th and G Streets, N.W., was one of the earliest components of the empire of J. W. Marriott, who began with a nine-seat Hot Shoppe in Washington in 1927.

Very few Washington restaurants served black customers. Photo 8.26 shows one that did, a diner in the heart of the black U Street business district, at 12th Street, in the mid-1940s.

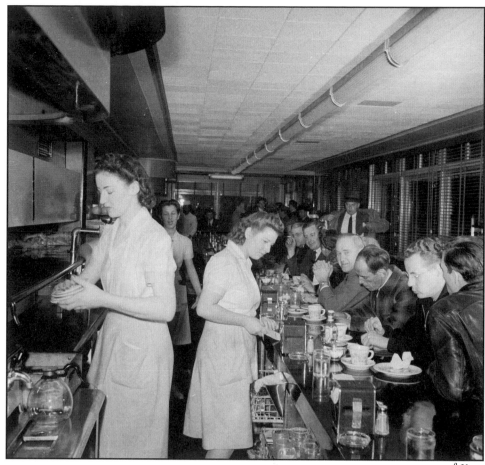

8.25

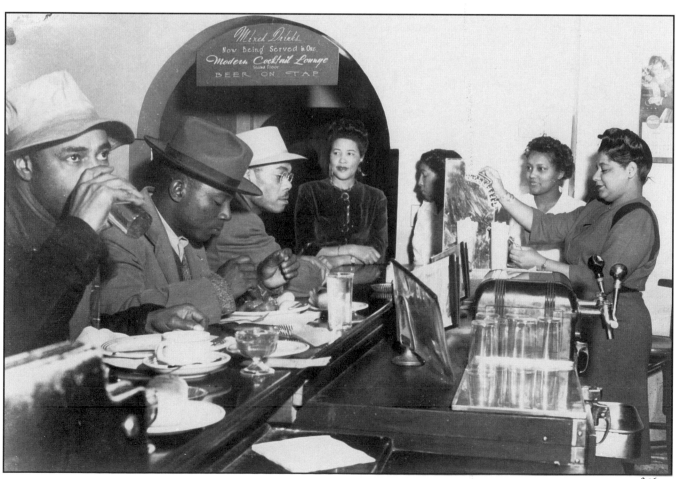

8.26

8.27

Washingtonians entertained themselves in a wide variety of ways, although only the most wholesome and uplifting tended to be captured by the camera. The Metropolitan Police Boy's Clubs, like this one shown in February 1941, were designed to provide recreational and vocational facilities for boys in poor neighborhoods, in large part to keep them out of trouble. The local clubs were begun in 1933 and were supported by police fundraising. Membership in the four clubs—three for whites and one for blacks—peaked just before World War II at 16,500.

8.28

Concerts at the Watergate Barge were also popular with young people, especially when they could find a canoe of their own. The barge was anchored just above Memorial Bridge facing Riverside Drive in the summers from 1935 into the 1960s. Thousands of listeners would sit on terraced stairs or in canoes for the twice-weekly concerts, usually by the National Symphony Orchestra or a military band. The raising of canoe paddles, seen in this August 1941 photograph, was a salute to the National Anthem.

8.29

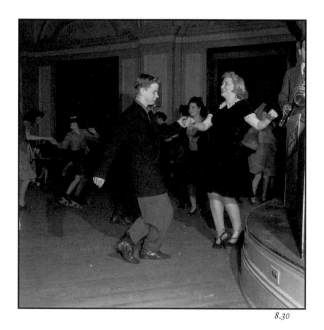

8.30

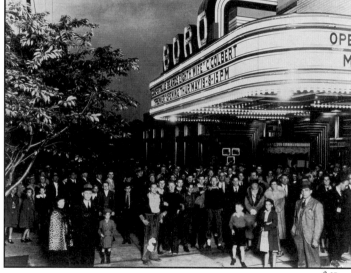

8.31

Newer types of mass entertainment were also present in Washington in the late 1930s. Professional baseball had existed in the city for many decades, but the sports scene changed dramatically in 1937, when George P. Marshall, a local businessman, brought the National Football League's Boston Redskins to Washington. Led by quarterback Sammy Baugh, they won the championship in their first season in town. As this photograph of the overflow crowd at a Giants-Redskins game at Griffith Stadium the following year illustrates, professional football quickly became enormously popular in the area. Adults had been troubled by the jitterbug craze, which

had started in the 1930s, and sought to supervise what they could not control. A 1943 OWI photograph by Esther Bubley pictures couples at an Elks Club dance described in the photographer's caption as "the cleanest dance in town." Movies, however, remained the most popular mass entertainment, and the opening of a new movie theater was cause for local celebration. Here residents of Bethesda gather on Wisconsin Avenue under the fashionably streamlined marquee of the Boro Theater, awaiting its opening in May 1938. The theater was another indication of Bethesda's rapid development and prosperity.

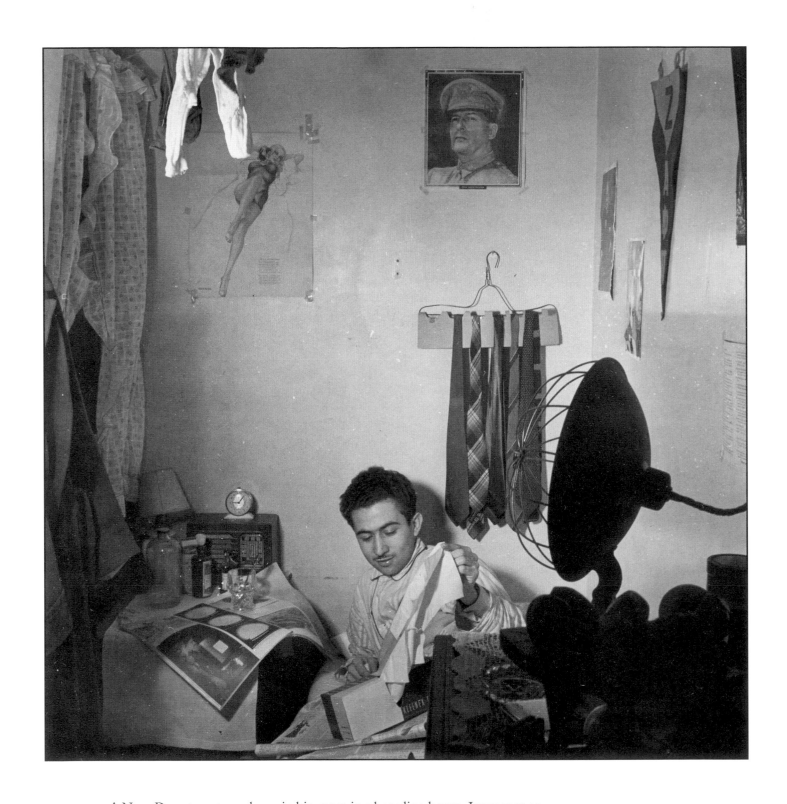

A Navy Department employee in his room in a boarding house, January 1943

❧ 9 Homefront Headquarters

Washington during World War II was in many ways an exaggerated version of the city during the headiest days of the New Deal. It was exciting, innovative, over-crowded, and its citizens were consciously at the center of events—international as well as national. People came to Washington from all over the United States and lived under circumstances that strained the bounds of social convention. For most, the excitement of new experiences and participation in great events was balanced by the limitations which the war imposed on daily life and the tedium of long hours at routine jobs. There was real tragedy as well, in the steady stream of War Department telegrams informing families that loved ones had been killed or wounded in the fighting overseas.

Before America's losses began with Japan's December 1941 attack on Pearl Harbor, Washington had spent two years gradually shifting from civilian to military concerns. On the outbreak of war in Europe, President Roosevelt had declared a limited state of national emergency, and the defense buildup began in earnest after the fall of France to the Nazis in the spring of 1940. As part of the drive for military production, the administration recruited businessmen, who came to Washington to work for salaries of one dollar a year; mostly Republicans, they gave the city a more conservative cast than it had had during the previous decade. Along with these admin-istrators came a wave of new clerical, professional, and war production workers, as mobilization sped up throughout 1940. The government actively advertised nation-wide for workers to move to Washington to fill clerical jobs paying an attractive $120 per month. The last vestiges of the Depression faded into memory as the number of Washingtonians formally seeking employment fell from 62,000 to 27,000 in the course of that one year. Simultaneously, the number of civilian employees of the War Depart-ment rose from 7,000 to 41,000. Late in 1940 the government reinstituted the draft, bringing the threat of war home to tens of thousands of local families. The next summer, thousands of construction workers began building the Pentagon, in Arling-ton on the site of the city's old airport.

The burgeoning of the wartime bureaucracy began with the creation of agencies such as the Office of Price Administration and the Lend-Lease Administration and accelerated in 1942 with establishment of such additional organizations as the War Production Board and the Office of Strategic Services. In the wartime emergency, civil

service requirements were loosened, and practically anyone with a high school diploma and typing skills could get a job. Offices were dependent on manual typewriters and on carbon paper for copying, and the war consumed an unprecedented amount of paper and clerical effort.

Government employment in the Washington area soared from 140,000 in 1940 to 276,000 by the end of 1942. It remained around that figure until the end of the war. There were massive concentrations of war workers throughout the area—40,000 at the Naval Weapons Plant, another 25,000 at the Navy Munitions Buildings, over 30,000 in the cluster of low-rise temporary office buildings that stretched west of the Washington Monument on both sides of the Reflecting Pool. When the Pentagon opened in the summer of 1943, another 40,000 went to work there. Development even reached east of the Anacostia River, as the government opened buildings in Suitland and Andrews Air Force base was completed in 1943. Throughout downtown Washington, the government took over all available office space. Government employees worked long hours; 48 hours per week was the minimum, and 54 hours—9 hours a day for 6 days a week—was typical.

Because able-bodied men were being drawn from the work force to enter the military, the war opened job opportunities for women around the country. In Washington, where manufacturing hardly existed, there were few "Rosie the Riveters" during the war. Instead, thousands of women who had joined the women's branches of the army and the navy (WACs and WAVEs) performed a whole range of tasks from filing to code breaking. Even larger numbers of women did the bulk of the white-collar and clerical work at the civilian agencies that continued during wartime. The labor shortage also opened opportunities for black Washingtonians, and many who may have had marginal employment secured regular wartime jobs. Although blacks participated enthusiastically in the war effort and sent their sons into service, prewar racial barriers remained. Under threat of a protest march on Washington, Roosevelt in June 1941 signed an executive order banning racial discrimination in hiring for government agencies and firms doing defense work. The order did not affect workplace segregation—separate but equal was still the law of the land—or any aspect of civilian jobs. Washington's major racial crisis of the war occurred when the Capital Transit Company complied with the wishes of its white drivers and refused to hire blacks in that position, despite a shortage of white drivers. Picketing and demonstrations in May 1943 failed to persuade the company, which survived until 1957 without ever hiring a black motorman.

As in the 1930s, such discrimination did not prevent thousands of blacks from joining even larger numbers of whites in moving to Washington. From a population of 663,000 in 1940, the city grew to well over 800,000 by the end of the war. But unlike during the 1930s, this influx came up against a housing shortage, created in April 1942 when the War Production Board banned nonessential residential and road construction. Fewer than twenty thousand units of private housing were built in the Washington area during the war. With demand for housing far exceeding supply, the city imposed rent control on January 1, 1942. Tales of the housing crisis became Washington's most pervasive war stories. All over the city, owners subdivided big houses built earlier in the century into apartments in which wartime workers doubled

or tripled up. Apartment houses and hotels were filled beyond their theoretical capacities. Renters devised elaborate schemes to obtain housing, and landlords did the same to evade price controls.

The government tried to ease the crisis by providing both temporary and permanent housing, such as the Slowe Residence Hall near Howard University for black women and the Meridian Hill Residence on 16th Street for white women. About two thousand WAVEs lived in temporary barracks on Nebraska Avenue. The charismatic black minister Elder Michaux oversaw the construction of the Mayfair Mansions, an apartment complex for six hundred middle-class black families. In Virginia, near the newly built Pentagon, the Defense Housing Corporation constructed permanent garden apartments at Fairlington, and the government also helped finance the Park Fairfax development. Arlington witnessed the largest local population growth outside the District, as its population doubled from 57,000 to 120,000 between 1940 and 1944.

Rationing vied with the housing shortage as the most irritating aspect of daily life in wartime Washington. Starting in the spring of 1942 with sugar, rationing was imposed on coffee, gas, fuel oil, meat, butter, cheese, and shoes over the next year. Consumers had to learn the intricacies of a complex system of coupons and ration books. For the most part, the system worked, but scandals and raids enlivened the city throughout the war. Automobile tires had been restricted at the start of the war, and no new private cars were produced after February 1942. This restriction, combined with gas rationing, produced four years of overcrowding on the area's public transit system. Rationing and the general shortage of prewar consumer goods were particularly frustrating in Washington, since its residents enjoyed the highest average household income in the country—over $5,000 a year compared to $4,000 in New York.

In contrast to the gloom of rationing, a more exciting side of wartime Washington came from government efforts to make people feel they were making a contribution to the war. Air raid drills and blackouts seemed somewhat plausible early in the war, but it gradually became clear that Washingtonians could not really pretend they were on the front lines. Scrap drives for metal and rubber, victory gardens, and bond rallies provided more tangible results and carried the war effort into the city's neighborhoods. Less official forms of excitement abounded as well. Tens of thousands of people—mostly young—had left their home towns and were living in Washington in close quarters. Like other cities, Washington gained a reputation as a "wide open town" during the war. Many of the young women in the city were lonely, and thousands of soldiers and sailors were always in town on leave or temporary duty. The government and private groups strove mightily to provide various forms of wholesome entertainment for this population. Fifty thousand citizens participated in the War Hospitality Committee. But simultaneously, bars and nightclubs and other centers of amusement thrived along G and H Streets downtown and in other parts of the city. When the bars closed at midnight, thousands of servicemen took to the streets. The Capitol Hill grounds became a well-known rendezvous for lovers. Periodic raids on night clubs and houses of prostitution served only to restrain rather than eliminate such business.

As victory grew near, the administration tried to prepare for the transition back

to peacetime. Government employment in the Washington area leveled off and then began to decline slowly even before the war ended in the summer of 1945. Four years of the conflict left Washington with an uncertain legacy. There were pent-up demands of all kinds: for housing, for consumer goods, and for racial justice. At the same time, the war—on top of the New Deal—had brought the Washington area unprecedented growth. The war hastened the development of both the city, which reached the highest population in its history, and the larger metropolitan region. Yet fears abounded nationally that peace would bring a recession. Locally, a drastic reduction in the federal work force—both civilian and military—seemed inevitable. It was thus not at all clear in 1945 how the unsatisfied demands of the area's citizens would be met or the region's expansion sustained.

(Opposite) Wartime jobs in Washington attracted thousands of women from the metropolitan area and around the country. In photo 9.1 three employees of the Public Building Service enjoy lunch at Rawlins Park near the Interior Department building. Gloria Ohliger (left) was from Capitol Heights, Maryland, but her friends Mary Joyner and Hazel Olsen had come to the city from Tallahassee and Minneapolis, respectively. The war allowed large numbers of black women to obtain well-paying clerical jobs, although traditional patterns of segregation and discrimination persisted. In photo 9.2 black clerks and their white supervisor in the War Department's card punching section prepare thirty-six thousand checks to be sent to dependents of enlisted men in September 1942. These were the first full payments under the 1942 Service Men's Dependent Act. The overcrowding in wartime Washington was often visible at Union Station, shown here in a photograph by Gordon Parks made in November 1942. The war was the last great heyday of the American train system, and Union Station was busy twenty-four hours a day. Emblematic of the thousands of new residents pouring into wartime Washington was the sign addressed specifically to "New Government Employees," offering assistance by the Traveler's Aid Society.

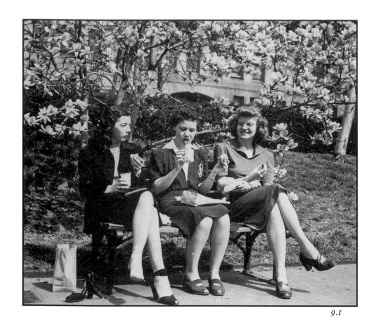

9.1

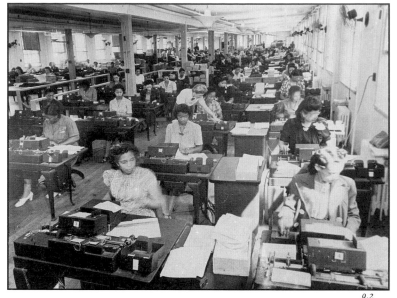

9.2

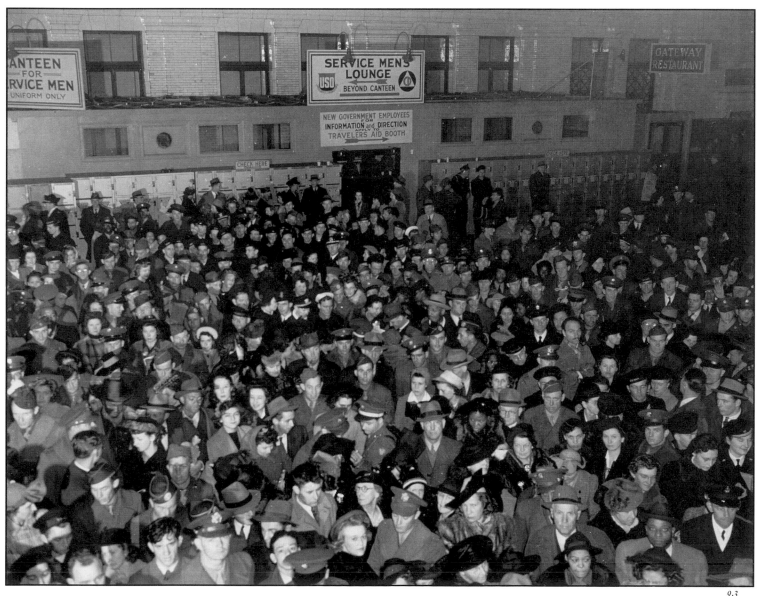

9.3

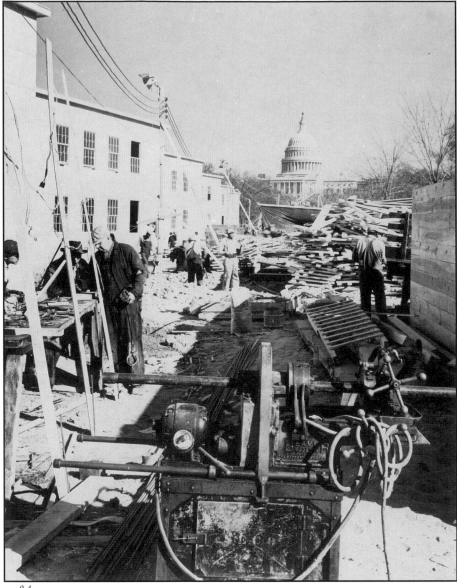

9.4

As in World War I, the start of hostilities was accompanied by a burst of construction. Photo 9.4 shows temporary buildings ("tempos") being built in December 1941, shortly after Pearl Harbor. Most of the tempos, which filled the Mall, were quickly constructed two-story buildings with bare walls and few amenities, like those pictured in photo 9.4. The tempos proved sturdy, however; to the distress of many Washingtonians, most lasted into the 1960s. The need for such office space is evident in photo 9.5, taken the same month. It shows the offices of the Foreign Liaison Bureau of the Lend-Lease Administration, located in a requisitioned apartment house. Although clearly this apartment was not designed for use as an office, every available square inch was being used. It was not uncommon for desks in such vital wartime agencies to be used around the clock, in three eight-hour shifts. Within a few months, almost four hundred buildings had been transformed from civilian to military uses.

New dwelling space was as high a priority in Washington as new office space. Although Washington's Alley Dwelling Authority (ADA) had been slow in building public housing before the war, Congress renamed it the National Capital Housing Authority (NCHA) and gave it a mandate to rapidly erect permanent and temporary housing throughout the area. In all, various public agencies built about thirty thousand housing units locally.

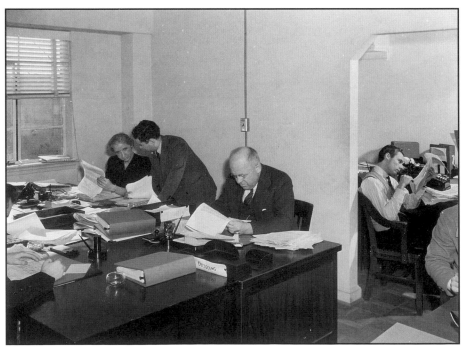

9.5

The Highland Dwellings, at Atlantic and 4th Streets, S.E., are shown in photo 9.6 nearing completion in March 1942. This 350-unit project built by the Alley Dwelling Authority was intended mainly for Navy Yard workers. Private builders working with the government accounted for as many new homes during the war as did public agencies. Photo 9.7 shows building contractor Samuel Plato and his staff in March 1943. Plato was supervising the construction of Wake and Midway Halls, accommodations for one thousand African American female war workers.

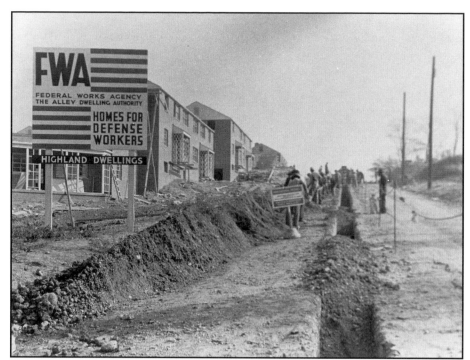

9.6

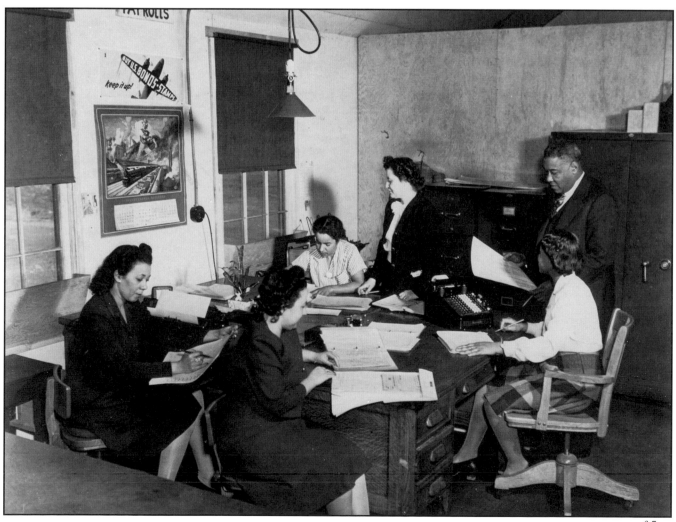

9.7

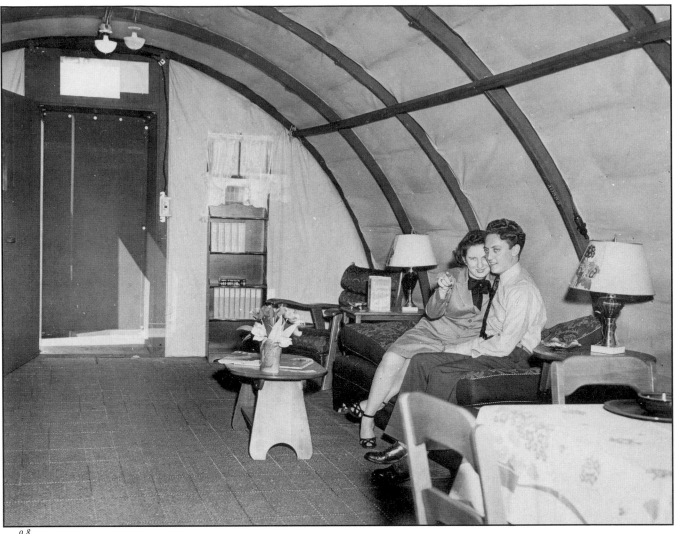

9.8

9.9

One of the most memorable symbols of the wartime housing shortage was the Quonset hut, named after the Rhode Island city where they were first manufactured. Fortunately, Washington had only several hundred of these prefabricated corrugated metal shelters. The couple pictured here at least had some privacy in theirs. More typical Washington living conditions were captured in this January 1943 photograph by the OWI's Esther Bubley. While a bridge game progresses, one of the room's tenants tries to get some sleep. Three beds are visible in this room, but it would not have been uncommon for more than three women to share such a room. Low supply, high demand, and government salaries fixed for most at about $1500 per year inevitably created overcrowding.

One compensation for the overcrowding that pervaded daily life was the excitement of a wartime capital that was free from any real danger or serious deprivation. Except for the large number of men and women in military uniform in photo 9.10, the contrast with damaged and impoverished wartime capitals could hardly be greater. The government photographer who took the photograph in October 1942 noted that it was taken at 9 P.M., adding that the scene was illuminated by the lights from the theater marquee. Uniforms became fashionable at parties given by the capital's social elite. Shown here are officers and other guests at a party at Evalyn Walsh McLean's "Friendship." Mrs. McLean had sold the original Friendship estate on Wisconsin Avenue to the government and transferred the name to this mansion, at 3304-10 R Street, N.W. Her new home and its soirées became, in the eyes of many liberals and the President himself, a center for wealthy reactionaries opposed to the administration's prosecution of the war.

9.11

9.10

189

9.12

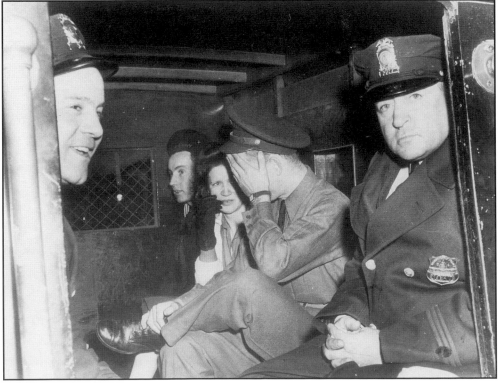

9.13

The relaxed morals and increased vice problem that usually characterized wartime cities were rarely captured on film. Government photographers were told to take pictures that would lift morale, and newspapers were encouraged not to publicize the war's seamier side. Nevertheless, Esther Bubley of the OWI did a series of photographs on boarding house life that included relatively straightforward depictions of men and women together. A January 1943 photograph (9.12) was accompanied by the caption, "A boarding house rule forbids men guests to come into girls' rooms and vice versa." The second photograph, which appeared in local papers, shows some of the sixty people arrested in a series of vice raids in November 1942. Four small hotels were raided at 10 P.M. in an attempt to control prostitution, which had become more organized in the city since the beginning of the war. The servicemen who were picked up were turned over to military authorities. Pressure from the armed forces, concerned about high venereal disease rates among their men, ensured that the raids would continue for the duration of the war.

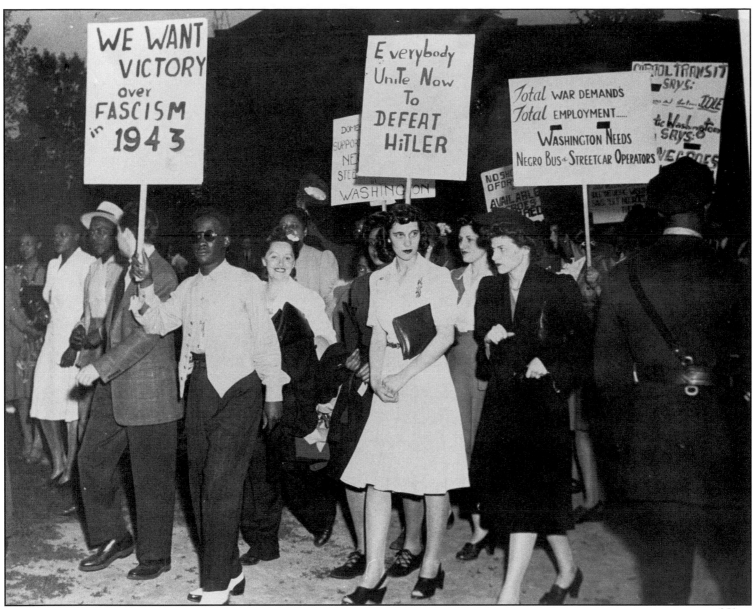

Wartime contributions of African Americans combined with the radical legacy of left wing movements of the 1930s to produce some overt challenges to the prevailing racial order. An integrated crowd demonstrated in favor of the hiring of black motormen by Capital Transit in May 1943 (9.14). The signs make explicit the links many saw between advancing democracy at home and fighting for it abroad.

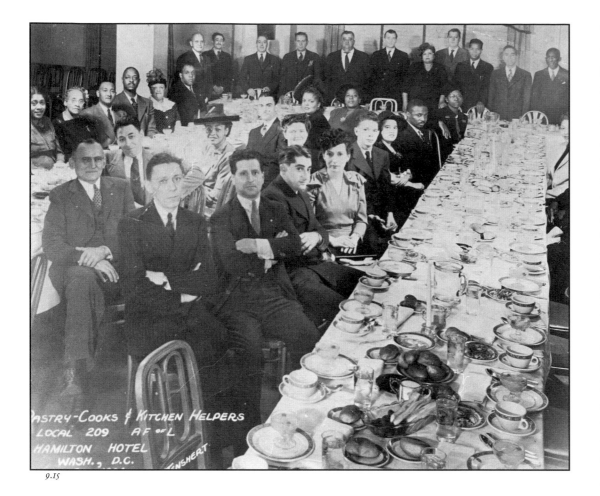

9.15

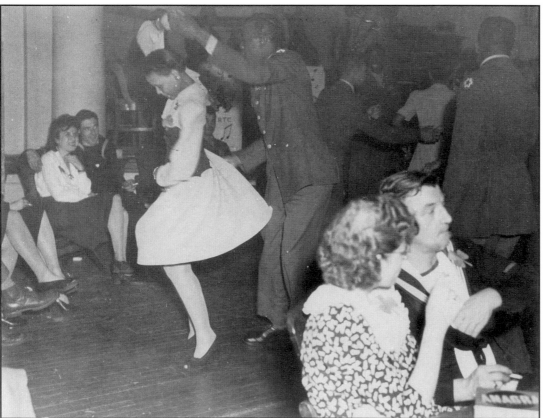

9.16

While some labor unions, such as those representing the white motormen, resisted integration, other unions, especially those controlled by leftists of various stripes, were commonly in the vanguard of integration during the war. Pictured here (9.15) is a meeting of the Cooks, Pastry Cooks, and Kitchen Employees local in December 1944. The local was part of the comparatively conservative American Federation of Labor but a few years after the war was accused by its parent union of being under communist influence. A far more radical break with social customs was sponsored by the United Federal Workers, a Congress of Industrial Organizations union established in 1937. At its labor canteen, pictured in March 1944 (9.16), black and white couples shared a dance floor and socialized together. From its beginnings, the union had organized both black and white government employees. Like the cooks' union, the government workers' organization, renamed the United Public Workers, came under attack for communist domination in the immediate postwar period.

The excitement of the war was brought home to Washingtonians in many ways. Photo 9.17 shows girls in the cafeteria at Woodrow Wilson High School in October 1943 listening avidly to a former classmate who had graduated the previous June and joined the Navy. Mass bond rallies were designed as much to keep people involved in the war as to raise money. On June 30, 1942, hundreds of retail clerks held a rally at the District Building at the heart of downtown to help launch a new national "Buy a Bond" campaign (9.18). The next day they stopped all normal sales at noon for fifteen minutes to sell war bonds and special war stamps. At Hecht's department store, for example, a Victory Corsage of nine ten-cent war stamps was sold for a dollar. The July 1942 campaign had a national goal of a billion dollars, of which about eight million was to be raised in Washington. In all, about $85 million in bonds were sold in Washington during 1942 through both special promotions like this and payroll savings plans.

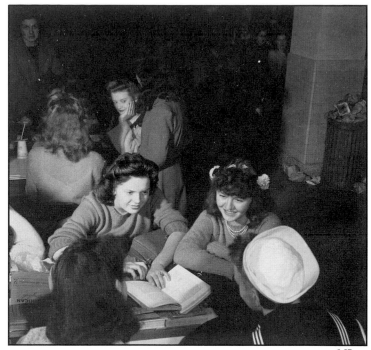

9.17

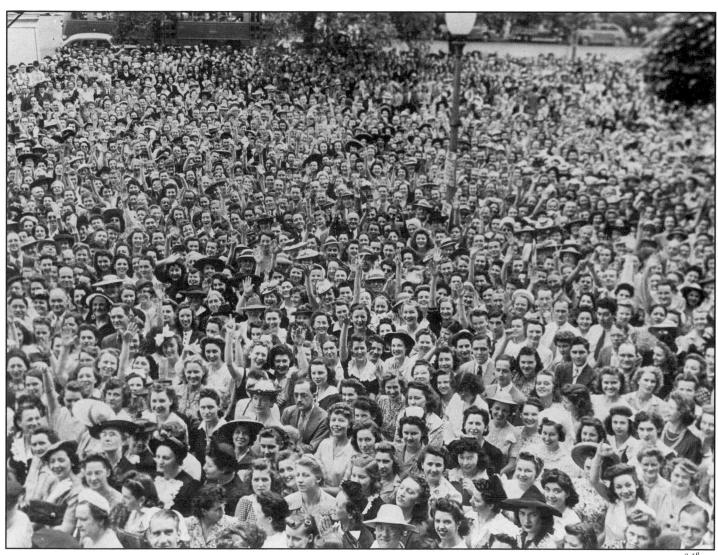

9.18

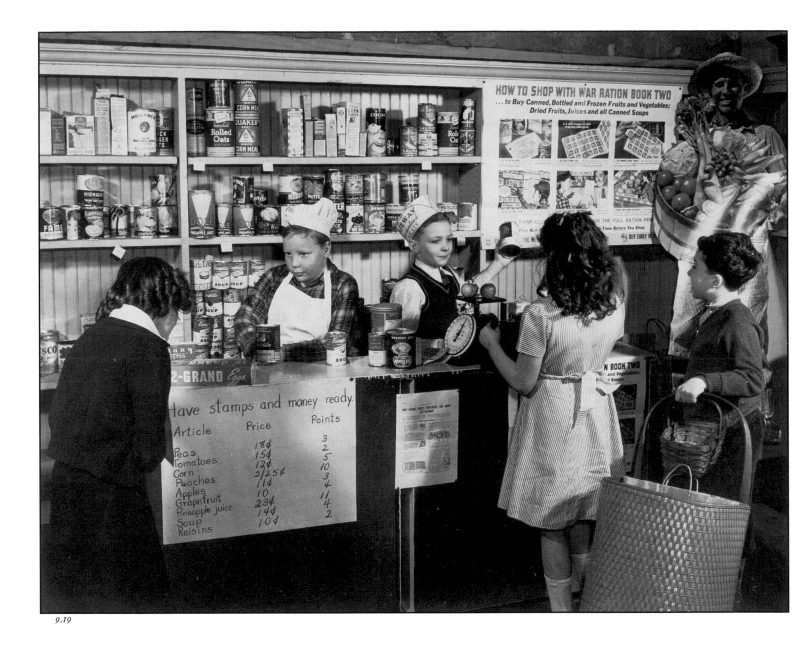

9.19

HOW TO SHOP WITH WAR RATION BOOK TWO
... to Buy Canned, Bottled and Frozen Fruits and Vegetables;
Dried Fruits, Juices and all Canned Soups

Have stamps and money ready.

Article	Price	Points
Peas	18¢	3
Tomatoes	15¢	2
Corn	12¢	5
Peaches	2/25¢	10
Apples	11¢	3
Grapefruit	10¢	4
Pineapple juice	23¢	11
Soup	14¢	4
Raisins	10¢	2

The government used wartime shortages of food and raw materials to involve the
entire population in the war effort. As a February 1943 OWI photograph illustrates,
even school children were enlisted in rationing, in part as an incentive to their parents
to follow the rules. These students at Park View Elementary School, at Warder and
Newton Streets, N.W., are learning to buy canned and bottled foods using the
rationing system's points and coupons. Canned goods were rationed not because of a
scarcity of food but to conserve the tin used in the cans. Even more serious was the
shortage of rubber, caused by the Japanese conquest of the Dutch East Indies and
Malaya. In June 1942 President Roosevelt personally launched a national rubber scrap
drive, managed by the petroleum industry. In photo 9.20 a Washington resident
contributes to the drive by adding an old bicycle tire to the pile at a Georgia Avenue
gas station. Within a month, Washingtonians had collected over a million pounds of
scrap rubber. Nationally the drive gathered 450,000 tons of scrap rubber and helped
ease the crisis until gas rationing and synthetic rubber effectively ended it.

9.21

In contrast to the pressing military needs for tin and rubber, local Victory Gardens were useful mainly for boosting morale and helping people feel they were making a contribution, especially since the amount of food most amateur gardeners produced was fairly small. Public, institutional, and some private land all over the Washington area was made available to volunteer gardeners. Two couples are shown here working their plots off Fairlawn Avenue, S.E., in April 1943. By then about 650 acres had been made available to the program, enough for almost ten thousand of the standard 30-foot by 50-foot plots.

9.20

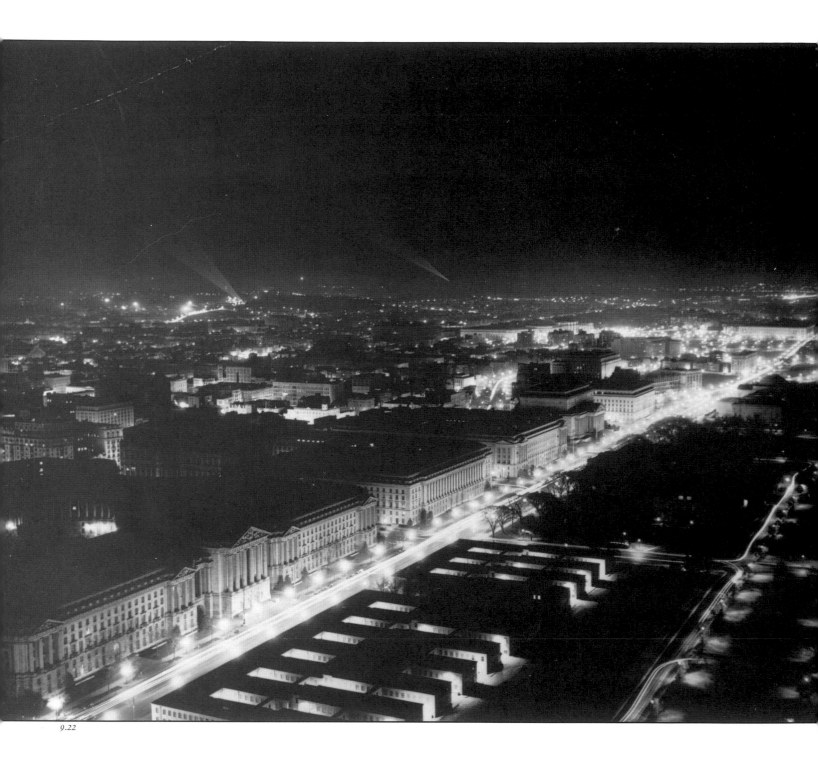

9.22

Civil defense was another activity in which morale building was more important than the actual contribution to the war effort. However, there was a real, although unfounded, fear of enemy aerial attack in the first months of the war, when the fighting was going badly for the Allies. Photo 9.22 shows Constitution Avenue and downtown Washington just before the first total blackout, on April 15, 1942. Sirens and flashes on the air raid warning system preceded the fifteen minute practice blackout, which covered the whole metropolitan area. In photo 9.23 Howard University's medical unit demonstrates treatment of an air raid victim. The unit was headed by the prominent medical researcher Dr. Charles Drew, who appears in a white jacket near the rear of the ambulance. By June 1944, when the third photograph was taken, all plausible threat of aerial attack was long gone. The 40-mm anti-aircraft gun served less for defense and more to remind the populace that, in the well-worn phrase, "Don't you know there's a war on?"

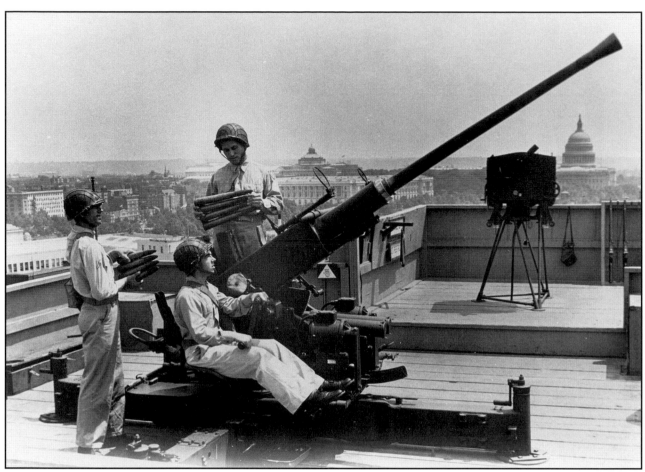

9.24

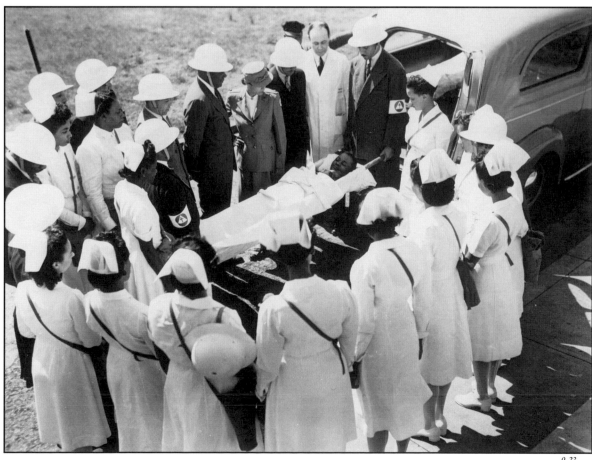

9.23

197

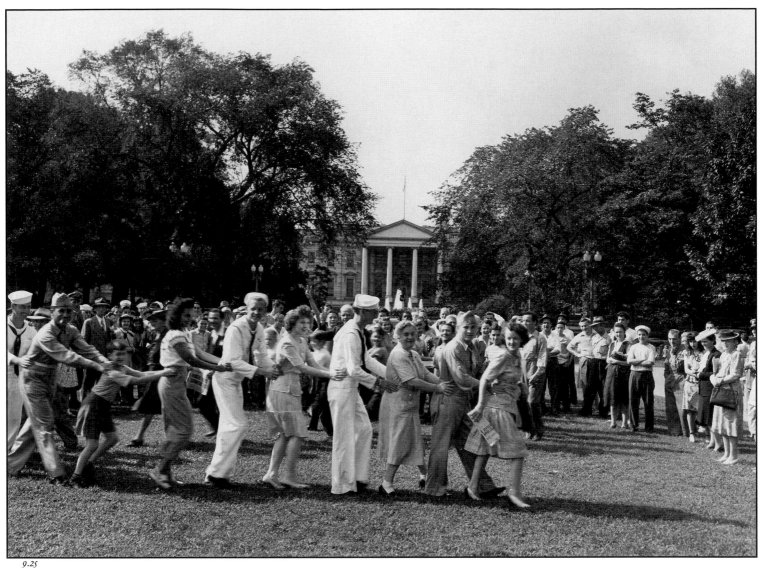

When the war with Germany ended in May 1945, the reaction in Washington was subdued; too many people were aware of how formidable a foe Japan still remained. But when President Truman announced Japan's surrender, at 7 P.M. on August 14, a massive celebration immediately engulfed the city. In Lafayette Park, opposite the White House, the crowd formed a conga line and then called for the President. He appeared, shook some hands through the iron fence, and said hopefully, "This is the great day. . . . This is the day when fascism and police government ceases in the world."

Part IV Emergent Metropolis, 1945–1965

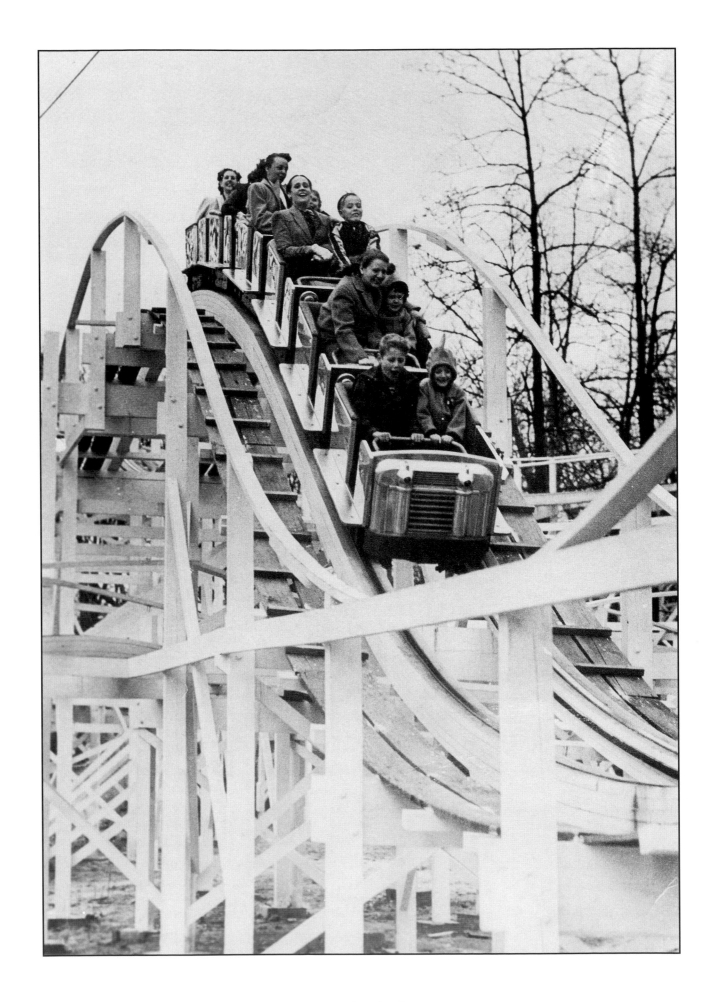

Riding the Comet Junior roller coaster at Glen Echo, April 1950

\blacktriangleleft 10 The American Way of Life

In the two decades after World War II, the United States, and the Washington area in particular, enjoyed unprecedented prosperity and sustained economic expansion. But this was also the grimmest period of the Cold War, whose effects intruded on daily activities and the city's larger civic life. While fostering a sense of anxiety and suspicion, the Cold War helped sustain Washington's affluence. The "military-industrial complex," in President Eisenhower's phrase, flourished with the creation of new security agencies. The combination of international competition and domestic prosperity contributed to the demise of official racial segregation in the Washington area. Aspiring to world moral leadership, America found it difficult to continue such overt discrimination in its capital. Nor was discrimination tenable in the face of a black community which had contributed substantially to the war effort and which shared in, and gained confidence from, the prosperity of the postwar years.

Prosperity was especially welcome following the fear that victory would sink America back into depression. Instead, pent-up consumer demand, the baby boom, and government policies such as cheap veterans' housing loans and education grants inaugurated a period of economic growth which lasted, with only a few minor interruptions, from 1947 to 1973. Even after the Republicans recaptured the White House in 1953, they did virtually nothing to roll back popular New Deal social welfare programs or reduce federal civilian employment. Federal pay raises often outpaced the low inflation rate, which averaged only 2 percent per year until the late 1960s. Median family income in the metropolitan area rose by 80 percent between 1950 and 1960. Although areas of severe poverty remained in the inner city, average black family income in the city nearly doubled. The standard of living continued to rise rapidly well into the 1960s. Between July 1963 and July 1964, for example, the local federal payroll increased by 15 percent and unemployment remained under 3 percent—meaning that, essentially, the area enjoyed full employment.

The most visible manifestations of the area's affluence were the suburban housing boom and the acquisition of new consumer goods by the vast majority of the population. Even residents who could not afford a house in the suburbs usually managed to buy a refrigerator, a washing machine, and a vacuum cleaner—previously unaffordable luxuries. More people bought second cars and many traded up to new cars faster than before the war. But the most important new consumer item of these

years was undoubtedly the television. It had been perfected before the war, and several hundred Washingtonians, including the Speaker of the House, participated in an experimental broadcast in early 1939, transmitting interviews from the Washington Monument grounds to an audience at the National Press Club. It was not until 1947, however, that the legal and technical requirements for the local reception of network broadcasts were fulfilled and home television sales began to soar. In Washington, the spread of television was stunningly rapid. By February 1949, there were over one hundred thousand sets in the area; two years later, 220,000; and by 1954 the number had risen to over 650,000, with sets by then in most homes. Never before had an invention with such a profound effect on people's daily lives been adopted so quickly.

Washington's prosperity was unfortunately due in considerable measure to the Cold War, which had begun in earnest early in 1947, just eighteen months after V-J Day. Worldwide competition with the Russians and a hot war in Korea in 1950–53 naturally sustained traditional military spending and Pentagon employment. In addition, Russian achievements such as the launching of the first Sputnik satellite in 1957 spurred government support for scientific research and development. Of the 322 research and development companies in the metropolitan area in 1963, only 43 had existed in 1950. The Cold War also led to the creation of large new security agencies, such as the Central Intelligence Agency in Langley, Virginia, the Atomic Energy Commission in Germantown, Maryland, and the top-secret National Security Agency at Fort Meade, Maryland. The placement of these and several other agencies in the metropolitan hinterlands was related to the fear of all-out nuclear war which haunted America after the Russians first exploded an atomic bomb in 1949.

Another kind of fear—of an internal communist menace—also pervaded the country and deeply affected Washington. In 1947 the Truman administration established a Federal Employee Loyalty Board. For the first time since the creation of civil service laws in 1883, government workers faced losing their jobs for their political beliefs in peacetime. The FBI and the Civil Service Commission Loyalty Board examined about two million federal employees nationally. By 1956 three thousand had been fired and twelve thousand had resigned because of alleged left-wing political associations that in many cases dated from the 1930s or World War II. While the number of workers affected in Washington was not large, the loyalty program was the most overt manifestation of a great change in political and social life after 1948. New Deal liberalism and a war in which Soviet Russia had been America's ally had legitimated progressive ideas on the local scene for a decade and a half. Now the most radical New Deal experiments, such as the WPA arts projects, were gone, as were the most radical of the New Dealers themselves. Instead of the Farm Security Administration, dispatching photographers to depict hard times and working people, Washington acquired the United States Information Agency (USIA), producing scenes of American prosperity for distribution abroad as weapons in the Cold War.

The grand exception to the conservatism of the era was the crumbling of official segregation of and discrimination against African Americans. In Washington as elsewhere, change came through a combination of legal actions and political pressure. On the federal level, the Supreme Court in 1948 outlawed restrictive housing cov-

enants and President Truman issued orders integrating the armed forces and banning discrimination in the federal government. But in the same year, Washington's National Theater closed rather than allow integrated audiences, and the city continued to operate separate schools and playgrounds for blacks and whites. Progress in fighting segregation came in fits and starts over the next half-dozen years. In the midst of demonstrations pro and con, the public swimming pools were gradually integrated. The YMCA and the Arena Stage theater integrated in 1950, and the next year some downtown hotels began to accept black registrants at predominantly white meetings. Attempts by black Washingtonians to eat at most downtown restaurants were unsuccessful until 1951, when Hecht's department store integrated its lunch counter. Two years later, the Supreme Court ruled illegal any discrimination against blacks in public places in Washington, after protesters challenged segregation at Thompson's restaurant at 715 14th Street. Soon thereafter downtown movie houses and stores integrated as well.

In 1954 the public schools remained the most important bastion of official segregation in the District, the parochial schools having integrated in 1949. In May, the Supreme Court ruled in *Brown v. Board of Education* that separate but equal school systems were inherently unequal and therefore unconstitutional. Included in the Court's decision was the case of Spottswood Bolling of Southeast Washington, who had been denied admittance to the new but all-white Sousa Junior High School, at 37th Street and Ely Place, S.E. Local education officials made no attempt to resist school integration, although the white Federation of Citizens' Associations tried to block its implementation the following September. With the exception of a protest by students at three high schools in October, school desegregation went smoothly. Washington had integrated its schools faster than any other officially segregated city in the country.

Over the next several years, the local fight against discrimination focused on schools in Maryland and Virginia, and various types of private organizations, accommodations, and recreational facilities in the District. Within the city, segregation gradually ended in the Fire Department, professional groups such as the bar and medical associations and the National Press Club, private social agencies, and most hospitals. Virginia resisted school integration until 1959, however, and private facilities like Glen Echo amusement park in Maryland held out into the 1960s. But by the mid-1960s formal public segregation had been essentially eliminated from the area. Simultaneously, the area's booming economy was opening hitherto forbidden white-collar and downtown retail jobs to African Americans.

The end of official segregation was a significant change for all Washingtonians who had lived under the old arrangements. But by the mid-1960s the limits of change were apparent as well. Blacks were still excluded from almost all positions of public and private power. Job discrimination was still pervasive in the private sector, especially above entry-level positions and in union apprenticeships. There was little social interaction between the races. Most visibly, the schools had become resegregated only ten years after integration. For a few years after the Supreme Court decision, optimism had reigned among civil rights activists, who noted that in 1957 the great

majority of District schools had students of both races. By 1965 that was no longer true. The small majority of black students in the system in 1954 had become three-quarters of the school population by 1959 and almost 90 percent by 1965.

The resegregation of the schools was mainly a consequence of the continued, though unofficial, segregation of residence, ironically aggravated by the era's affluence. Integration had been undermined in large measure by the movement of thousands of white families to the suburbs. Although officially sanctioned segregation was over, it had been succeeded by sharp social and racial divisions between the city and its metropolitan surroundings.

(Opposite) The Cold War made Washington a truly international city for the first time in its history. Military, security, foreign aid, and international agencies located in the area brought thousands of foreigners to Washington for short visits or extended tours of duty. A USIA photograph (10.1) records the visit of cocoa farmers from the Gold Coast to the Beltsville Agricultural complex in 1956. The next year, the British colony received its independence, as Ghana, and the United States began vying with the Soviet Union for influence in the new country. Washington also received its share of Cold War refugees. Pictured in another USIA photograph are John Semely, a pianist, and his wife, Eugenie, carefully posed in a quintessentially American setting. They had fled Hungary after the failed anticommunist uprising in October 1956, eventually relocating in Washington.

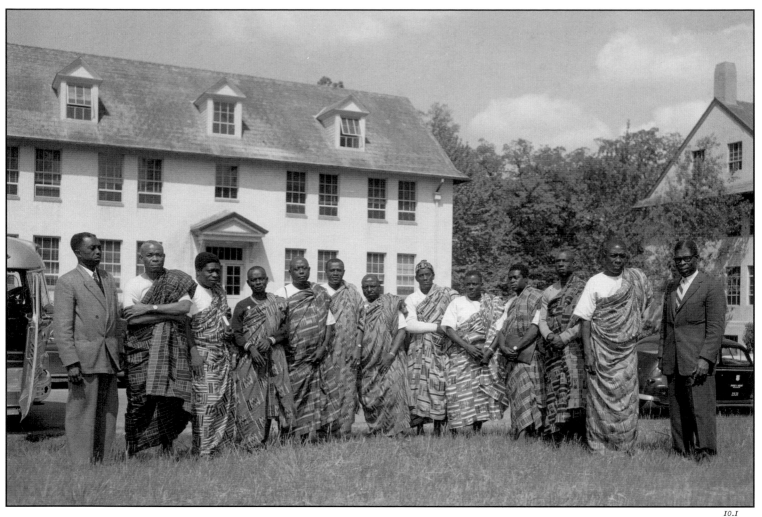

10.1

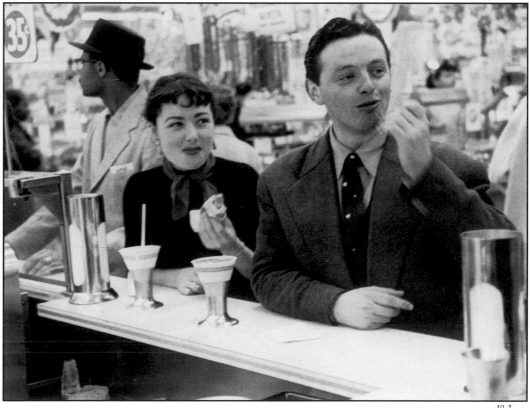

10.2

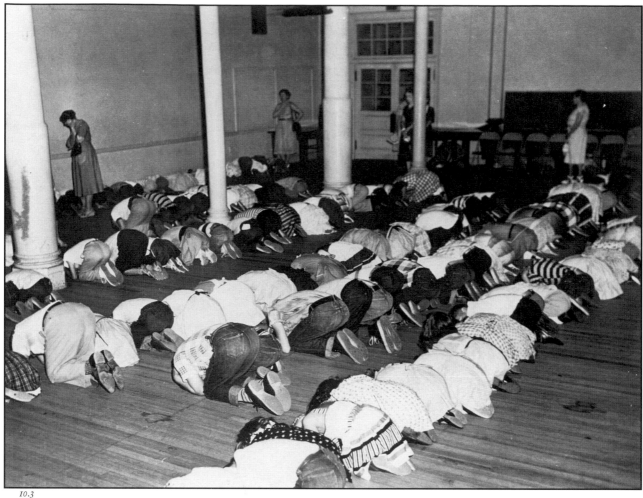

10.3

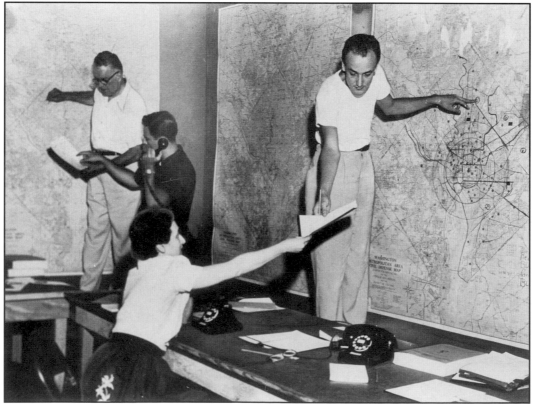

10.4

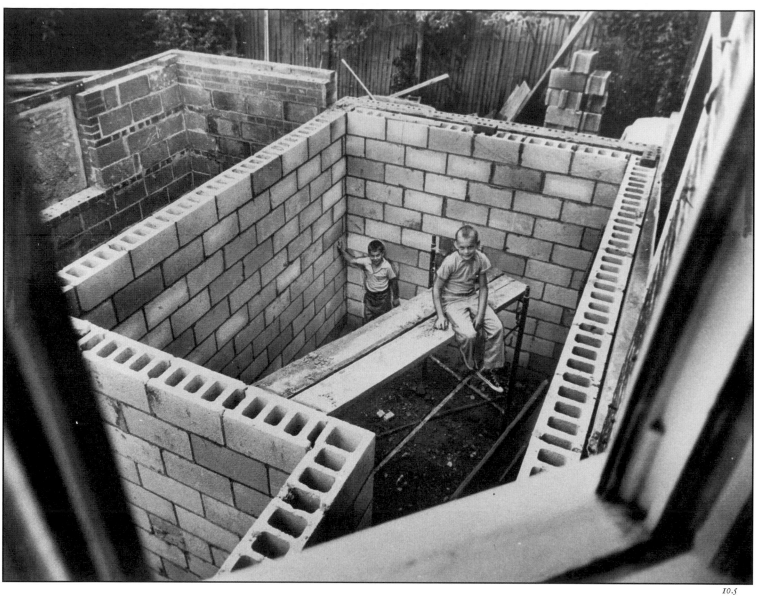

After the Russians successfully exploded an atomic bomb in 1949, fears of a nuclear war suddenly seemed very real. Unlike the Germans in World War II, the Russians eventually did develop the capacity to deliver an aerial attack to American soil. Civil defense drills became almost as common as they had during the war, although many were skeptical about their usefulness in the case of atomic attack. Photo 10.3 shows a "duck and cover" drill at the Thompson Elementary School, at 12th and L Streets, N.W., in June 1954. In a practice exercise held in July of that year, Deputy Civil Defense Director H. P. Godwin (far left in 10.4) and his assistants gather information. The map shows a projected "ground zero" near the White House. As concerns about missile attack and radioactivity grew during the decade, some Americans built home "fallout shelters," where they planned to keep their families alive for weeks or months until it was safe to emerge. Shown here is the Luchs family shelter under construction on the 3600 block of Appleton Street, N.W., in July 1960. The shelter craze, encouraged by the Kennedy administration, peaked in the early 1960s but then faded as its impracticality became evident and the Cold War gradually eased.

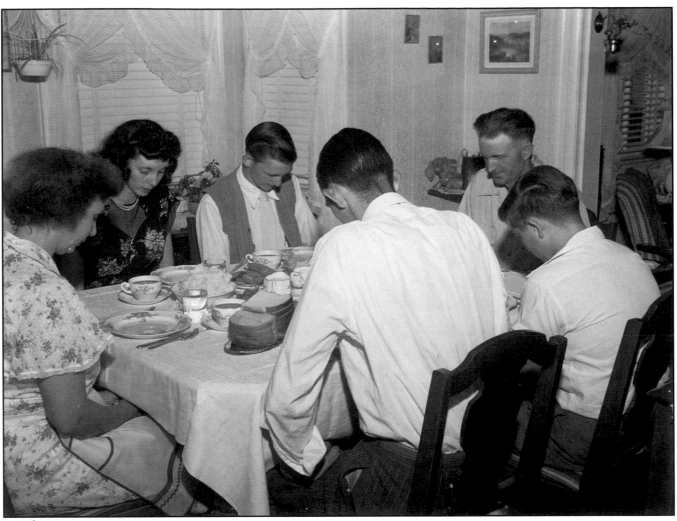

10.6

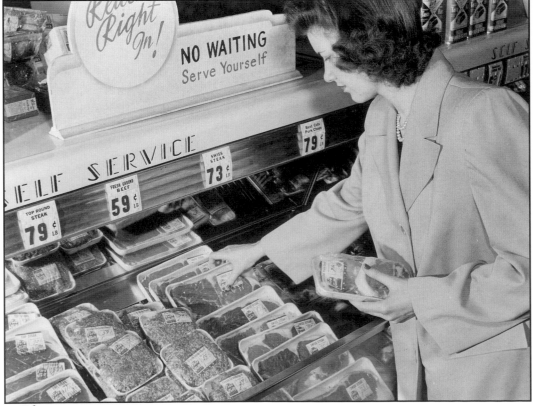

10.8

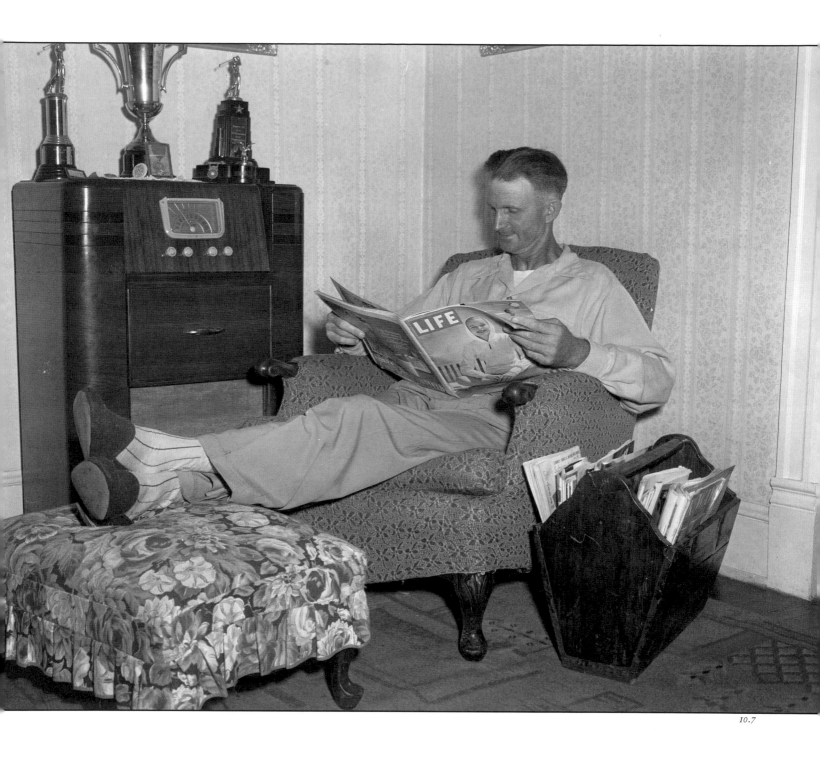

From the end of World War II until the mid-1960s, American affluence was truly exceptional, and the government was eager to tell the world. State Department and then USIA photographers continued to use the technique of the carefully posed documentary series that had been developed by the FSA photographers. In 1948, a State Department photographer did a series on the Earl Marcey family, of 1101 North Taylor Street in Arlington. Photos 10.6 and 10.7 shown here are captioned, "The family life of an American truck driver is similar to that of other American workers." The abundance of food on the Marceys' table would have been especially striking to residents of other countries in 1948. Photo 10.8, taken in 1949 by the State Department, again stresses the cornucopia of food in America. The caption explains that all the meat shown is wrapped in cellophane and has the weight and price clearly marked. The location of the shot was the Food Fair at 1805 Columbia Road, N.W., one of eight supermarkets then operated by the chain.

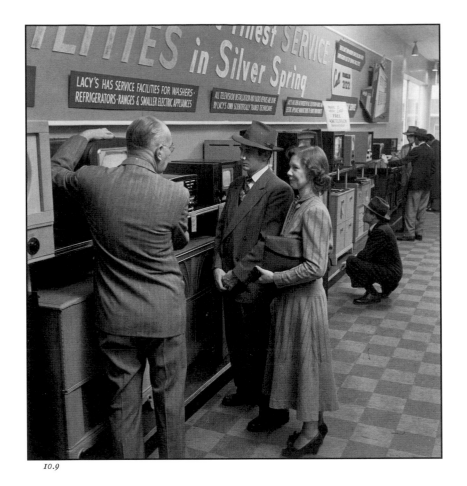

Within a few years of becoming commonly available, television had created an entire new industry and changed domestic life forever. Photo 10.9, taken at Lacy's in Silver Spring in 1950, illustrates how quickly television had become a standard electrical appliance, despite a fairly high price of several hundred dollars. It also shows that the original large cabinets with tiny screens had already given way to larger screens in smaller cabinets. In January 1950, a *Washington Star* photographer depicted the A. Jackson Corys, of Piney Branch Road in Takoma Park, at home with their new television. That same month, in a survey of three hundred suburban families, family members reported staying home for 30 to 40 percent more of their free time than they had before buying their sets. The survey also found that living rooms were being reoriented—as shown here—entirely around the televsion, and concluded that the television was having an effect on American life comparable only to that which the automobile had had in the early part of the century.

10.9

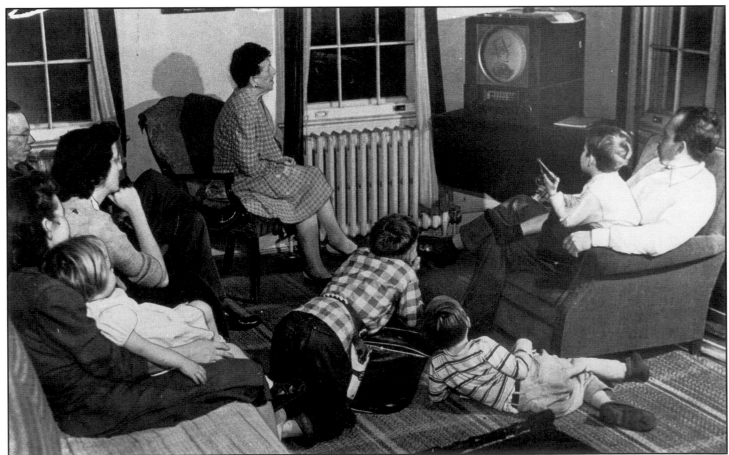

10.10

Television soon became most Washingtonians' main source of news and entertainment. Network channels, independent stations, and educational television were all in place by the late 1950s. *Panorama Potomac,* the set of which is shown here in 1957, was a local morning show on WTOP (Channel 9) which combined news, sports, weather, and children's stories. National television shows like *American Bandstand* provided viewers all across the country with a common immediate experience. In the case of *Bandstand,* teenagers everywhere learned the same songs and dance steps. In photo 10.12 teenagers dance at Crosby's Shoe Store, at 11th and F Streets, in April 1958, as part of a promotion for Dick Clark Shoes—an early example of the marriage of rock music, television, and marketing.

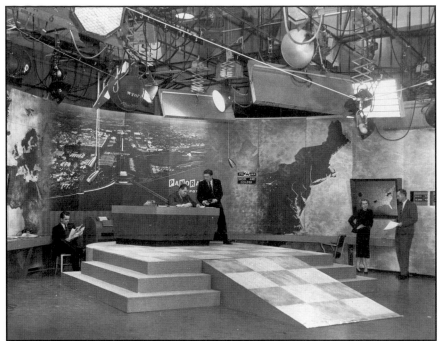

10.11

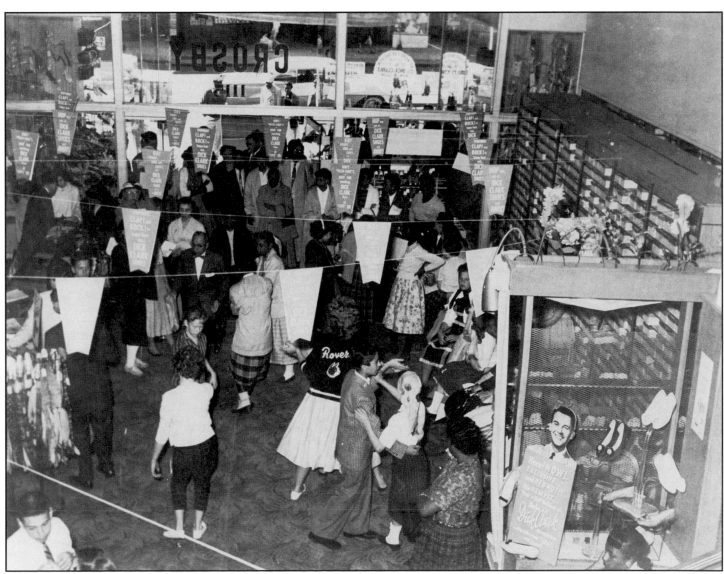

10.12

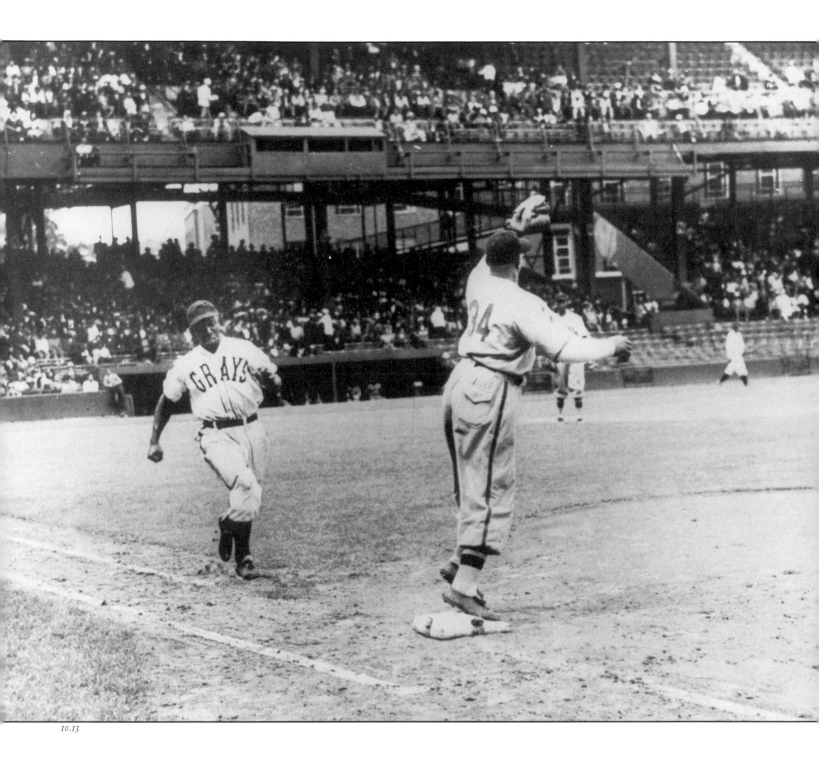

10.13

Segregation was still the norm in virtually all aspects of life in postwar Washington. Despite Jackie Robinson's integration of baseball in 1947, it was not until 1954 that the Senators signed their first black player. Washington had several Negro League teams during the twentieth century, but the Homestead Grays were by far the best. Shown here is a crowd at Griffith Stadium watching Matthew Carlisle scratching out a hit against the Philadelphia Stars around 1946. Originally a Pittsburgh team, in 1937 the Grays began playing in Griffith when the Senators were out of town. They often outdrew the American Leaguers, and with reason; the 1946 Grays featured three future Hall of Famers: Cool Papa Bell, Josh Gibson, and Buck Leonard.

Washington's officially segregated school system also survived for a decade after the end of World War II. Pictured here is a crowded classroom at all-black Dunbar High School in 1949. Opened in 1916, Dunbar was widely considered the best black public high school in the country; its graduates included many of the area's black professionals as well as such nationally prominent figures as Dr. Charles Drew, General Benjamin Davis, Judge William Hastie, and Secretary of Housing and Urban Development Robert Weaver. The school was a source of pride among many African Americans who nevertheless deplored segregation. The government understood that official segregation contradicted American ideals and during the Cold War sometimes went to odd lengths to conceal the practice. A 1948 State Department photograph (10.15) was taken in a third grade class at the Seaton School, on I Street between 2nd and 3rd, N.W. Without any acknowledgment that blacks were excluded from attendance, the official caption proclaimed, "Several children of Chinese descent are seen here enjoying the same privileges as the American child."

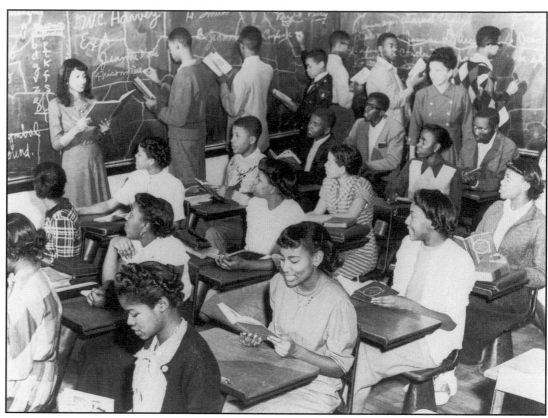

10.14

10.15

10.16

White resistance to integration in Washington was often sharp but brief. In June 1949, black youths began to use the public swimming pool in Anacostia as part of a campaign to integrate recreational facilities. Fights broke out with whites and, as seen here, the Park Police intervened. The following year, the city's swimming pools were officially integrated. In October 1954, a month after school integration began, white students at Eastern, McKinley, and Anacostia high schools began a protest strike which lasted for several days and eventually involved about twenty-five hundred students at the three high schools and four junior high schools. In the march shown in photo 10.17, protesters were led by an Anacostia resident whose baby carriage carried a sign asking, "Do we have to go to school with THEM?" Photo 10.18 shows Anacostia students praying at a meeting with their principal and a local disk jockey, Art Lamb, who urged them to return to class and respect American democratic principles. More than half of Anacostia's students struck, but they returned to classes within a week, after being threatened with suspension or loss of privileges.

10.17

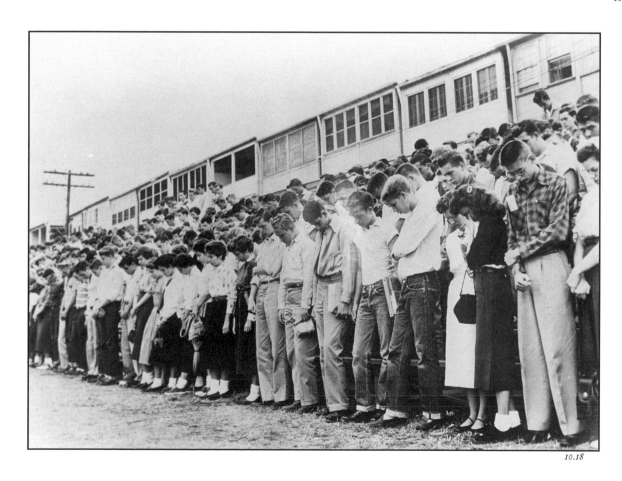

10.18

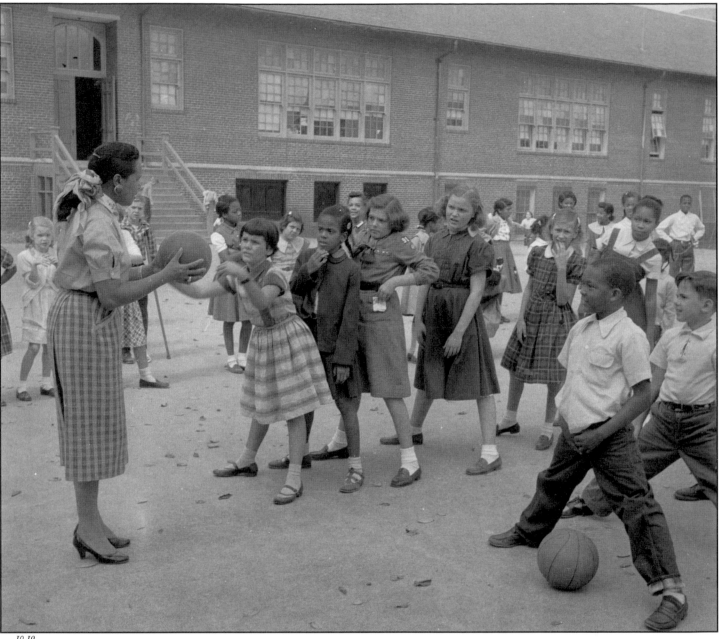

10.19

For the most part, integration was accomplished with relatively little overt protest. Government photographers and news magazines were eager to tout the apparent success story in the nation's capital as a model for more recalcitrant southern cities. Photo 10.19, taken by the USIA, shows midmorning recess at the John Burroughs School, at 18th and Monroe Streets, N.W., in 1955. A *US News & World Report* photograph from the Barnard School, at 4th and Decatur Streets, N.W., in May of that year shows an integrated royal couple presiding over school festivities. Despite these pictures, integration set off an immediate acceleration of white flight from the school system. In a recent year, the Burroughs School had only two white students and the Barnard School had none at all.

While formal segregation crumbled in the city of Washington, it remained very much alive in suburban Virginia and Maryland. Virginia countered the federal government's insistence on eventual school integration with a variety of delaying tactics. A final burst of "massive resistance" measures succeeded in keeping many Virginia students of both races out of school for a time before the anti-integration campaign collapsed. Shown in photo 10.21 are the students and faculty of Arlington's Hoffman-Boston High School in 1958 and the four students who were the first African Americans to attend integrated public schools in Virginia. Gloria Thompson, Ronald Deskins, Lance Newman, and Michael Jones, ages twelve and thirteen (photo 10.22), entered Stratford Junior High School in Arlington in February 1959 without incident.

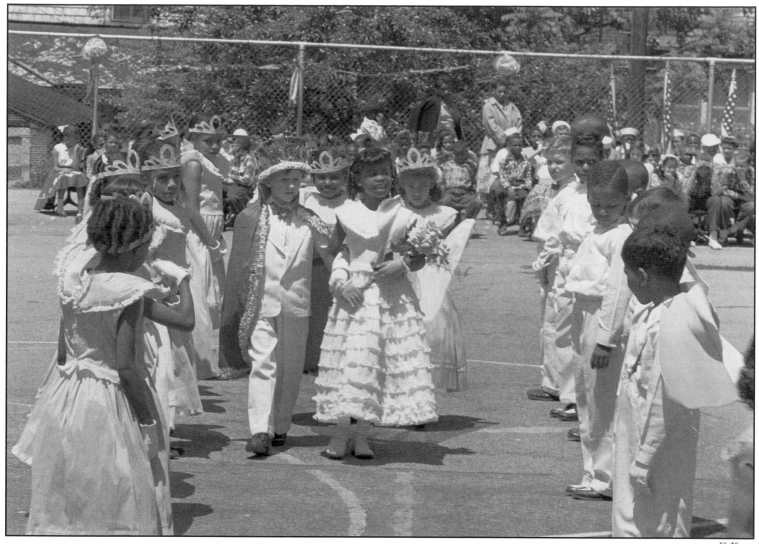

10.20

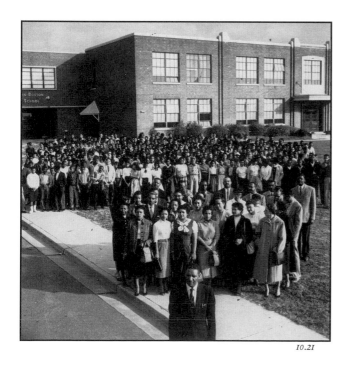

10.21

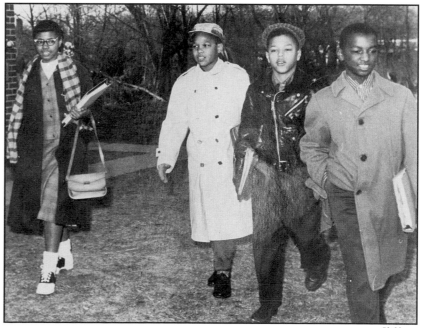

10.22

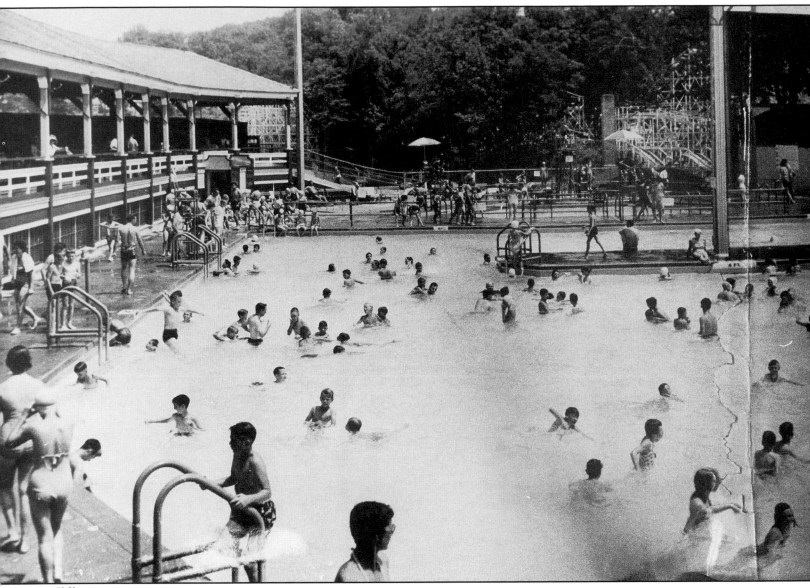

Glen Echo Amusement Park, just across the District line in Maryland, had entertained hundreds of thousands of white Washingtonians since its opening in 1910. But the privately owned park remained segregated through the 1950s, as this 1957 photograph of the pool and the frontispiece to this chapter illustrate. In 1960 local civil rights groups finally began a campaign to integrate Glen Echo, using the sit-in tactics that were becoming common throughout the South. Seventy-five black and white protesters picketed the park in June 30, while black protesters attempted to enter the park with tickets purchased for them by their white allies. In photo 10.24 a park policeman talks to one of the five protesters who were arrested for trespassing when they refused to leave the merry-go-round. The protest bore fruit at the beginning of the next season, when blacks were finally admitted. Alfred Beal and Larry Murrell, both ten-year-olds from the District (10.25), became the first black patrons of the park, on March 30, 1961.

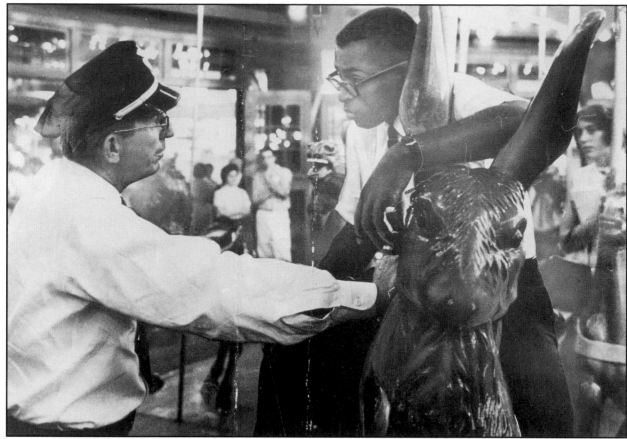

10.24

 10.25

219

In front of the Trinidad Boys Club in northeast Washington, July 1951

11 The Changing City

Post–World War II Washington combined a rapid and profound change in racial make-up with a remarkably stable and sound economic foundation. Many neighborhoods east of Rock Creek Park shifted from white to black, while some wealthy white communities near the city's core became even whiter. Simultaneously, business and political leaders embarked upon an ambitious program of highway construction and urban renewal designed to transform the heart of the city by tearing down its more dilapidated structures. Their efforts, which generally met with limited success, were most effective in southwest Washington. Elsewhere, commercial and residential areas alike were remade by tens of thousands of private endeavors.

The key factor in the city's overall prosperity remained the federal work force. The popularity of New Deal social programs and the size of the Cold War military and security complex made permanent the vast expansion of local employment opportunities, both inside and outside government, which had occurred between 1933 and 1945. In the immediate postwar years, local federal employment fell to about 200,000, but it soon increased again, reaching 260,000 by the early 1960s. The many organizations and services—trade associations, contractors, law and accounting firms—dependent on the government expanded even more rapidly, as did local government jobs. Services for the twenty million people visiting the city annually in the 1960s supplied the largest source of private employment. Industry remained almost negligible, providing only about thirty-five thousand area manufacturing jobs. Printing and publishing, the largest local industry, employed some fourteen thousand workers. An important feature of area jobs was their concentration in the center of Washington, at a time when many other downtowns were losing their economic base. Even in the mid-1960s, when twice as many people lived in the suburbs as in the city, the majority of Washington area residents worked in the District, with the largest concentration of jobs located in the federal buildings around the Mall. Thus, the downtown core remained vital and expanding, in contrast to the unsettled flux that characterized the surrounding residential communities.

The racial transformation within the District's borders was of historic importance. In 1945, Washington was about one-third black, a proportion not very different from what it had been since the city's creation. After the war, whites moved in large numbers to the new suburbs and blacks migrated to the city from the South. In 1957 Washington became the first major city in the country to have a black majority. By

1970, the historic racial balance had been completely reversed, as more than two-thirds of Washingtonians were African American. In sheer numbers, compared to the late 1940s, the city had 300,000 fewer whites and 300,000 more blacks, while its total population had remained stable at roughly three-quarters of a million.

To a considerable degree, the change in the city's population was simply a continuation of the time-honored process of people moving to newer neighborhoods further from downtown when they could afford to do so. But such moves usually carried them outside the District, into the suburbs. The racial change within the District of Columbia was thus far more drastic than the change in the metropolitan area as a whole, in which the proportion of white to black stayed about two to one.

Within Washington, neighborhood change was often a matter of class as well as race. The end of legal restrictive covenants in housing in 1948 eventually opened up some middle-class white neighborhoods to black professional and white-collar residents. The departure of these upper- and middle-class blacks was a blow to some of the older black neighborhoods, such as Shaw and LeDroit Park. The vacated larger homes in these communities were often broken up to provide rental apartments for individuals and poorer families. Housing and living conditions deteriorated in many of the neighborhoods surrounding the downtown on the north, east, and south. The process of neighborhood racial change was rarely easy. Unscrupulous realtors tried to panic whites into leaving communities once the first blacks moved in. While several years of transition often elapsed, during which a neighborhood appeared to be racially mixed, most communities eventually shifted from overwhelmingly white to over-whelmingly black.

In the 1950s, the racial transformation of neighborhoods was particularly notice-able in the Northeast. As some traditional black enclaves declined, Brookland became a predominately middle- and upper-middle-class black community. The far Northeast experienced both expansion and racial change almost simultaneously in the years after World War II. Benning Heights was developed in the years around 1950 as a semi-suburban area of single-family homes for white government workers. By the end of the decade it had become a mainly black community, which retained its suburban atmosphere and connections. Northeast Washington as a whole was nearly 90 percent black in 1960. In upper northwest Washington, areas such as Brightwood and Mount Pleasant also had become predominantly black middle-class neighborhoods by the mid-1960s. Resistance to "block busting" in Shepard Park delayed but did not prevent the gradual northward movement out of the city of that community's Jewish popula-tion. Southeast Washington, across the Anacostia River, had grown steadily after 1945 and in the 1950s accommodated some of the few white working-class communities inside the District. Rapid racial transition in this section came in the 1960s.

In contrast to the changes affecting many of the city's middle- and working-class white neighborhoods, the more affluent sections west of Rock Creek Park remained almost unaffected. In the early 1960s, over 100,000 white residents shared the area with only 5,000 African Americans. One of the area's few traditionally integrated neighborhoods, Georgetown, became increasingly wealthy and increasingly white. Following the diversion of most through traffic from Georgetown streets, accom-plished by completion of the Whitehurst Freeway in 1949, Congress declared the area a historic district. The Commission of Fine Arts had to approve all physical alterations

and new construction in Georgetown. As the neighborhood increased in desirability, housing prices rose, and multi-unit dwellings shifted back to single-family occupancy. In the process, Georgetown's African American population fell, from almost a quarter in 1940 to 3 percent by 1960.

Although urban planners had targeted Foggy Bottom as a problem slum area in the 1940s, it had failed to qualify for federal redevelopment funds, in large part because private redevelopment had begun. The expansion of George Washington University and the movement to the area of government agencies, such as the State Department, together with the area's proximity to downtown offices, accelerated investment in new construction, including many apartment buildings. At the other end of the Mall, Capitol Hill's desirable location near federal employment and its sound old housing stock had also created a movement for renovation and historic preservation there. Reflecting the strains within the city, two very different groups had moved into the neighborhood by the early 1960s. One was affluent whites, some associating Capitol Hill with the urbane style of the Kennedy administration. The other was poor and working-class black families displaced from their homes in nearby southwest Washington.

Southwest Washington was the one residential area in the city which the government transformed by fiat, a prime national example of the housing and urban renewal programs characteristic of the postwar decades. Although the city had drawn up extensive plans for comprehensive redevelopment of many poorer sections and for rings of highways within the District, only the Southwest's plan was fully implemented. Between 1954 and 1958 bulldozers virtually leveled the neighborhood, and old structures were replaced with government buildings below the Mall, the Southwest Freeway, and new apartment buildings and town houses. The project caused so much controversy that the city abandoned a similar redevelopment project contemplated for the Adams-Morgan neighborhood and altered its approach in Shaw to stress rehabilitation over demolition. Community opposition also blocked highway construction that would have cut through neighborhoods such as Cleveland Park and Brookland, leaving only the Southwest, Southeast, and Anacostia Freeways as surviving fragments of what was to have been a much more extensive system of inner-city highways. Although the redevelopment process had slowed by the mid-1960s, the displacement that accompanied the project in the Southwest and in smaller urban renewal and highway programs placed considerable stress on the existing stock of low-income housing and created a demand for more public housing for displaced residents. Fifty thousand people already lived in public housing, concentrated in the city's poorer areas, particularly southeast Washington.

Downtown Washington prospered nonetheless. The older shopping area of F and G Streets east of 15th Street still flourished in the years before the full maturation of the suburban malls. To the west, in the area around Farragut Square, K Street, and Connecticut Avenue, new construction expanded uncontrollably, producing corridors of almost identical office blocks. Washington still lacked any genuine cultural center, but with the federal establishment firmly anchored in the city's center, downtown Washington remained unquestionably the commercial and economic heart of the whole metropolitan region.

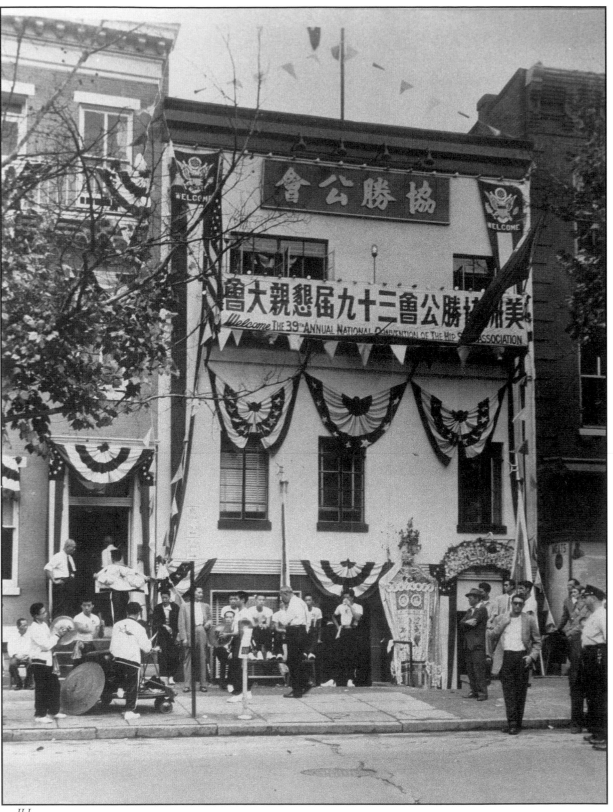

協勝公會

美洲勝公會三十九屆懇親大會
Welcome THE 39ᵀᴴ ANNUAL NATIONAL CONVENTION OF THE HIP SING ASSOCIATION

II.I

Despite the stresses placed on them by urban change, Washington's older neighborhoods remained viable, lively with community activities and street life. The city's small Chinese community had been moved by its leaders in the 1930s to the area around 6th and H Streets, N.W., after the initial settlement was demolished to make way for the Federal Triangle project. By the time this photograph was taken in September 1957, many Chinese had moved their residences to the suburbs, but businesses and community institutions remained in the city. A local Chinese orchestra was on hand to greet four hundred delegates of the Hip Sing Merchants' Association, holding their national convention in Washington.

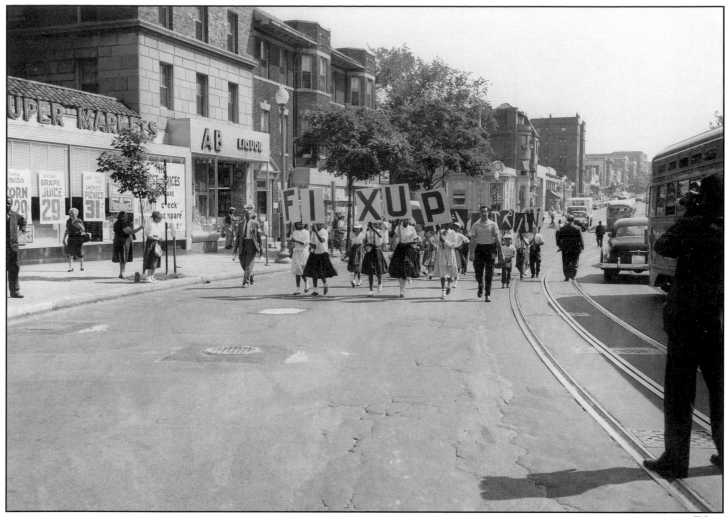

Adams-Morgan in the late 1950s was
threatened by racial transition, and the
neighborhood's physical decline stimulated
government plans for massive urban
renewal. But community activists orga-
nized across racial divides to save the area,
forming groups like the Adams-Morgan
Community Council in 1958. In photo 11.2
a "Fix-Up" parade winds its way down
Columbia Road in 1959, passing the Food
Fair whose interior is depicted in photo
10.8. By 1965 the idea of demolition and
redevelopment in Adams-Morgan had been
successfully defeated. Not far to the
northeast of Adams-Morgan, on the other
side of 16th Street, was Columbia Heights,
a nieghborhood that had shifted from
white to black occupancy by the mid-1960s.
An August 1966 photograph (11.3), taken
near the intersection of 13th Street and Park
Road, shows the continuing use of the
local streets and stoops for socializing,
typical of all the city's older communities.

II.3

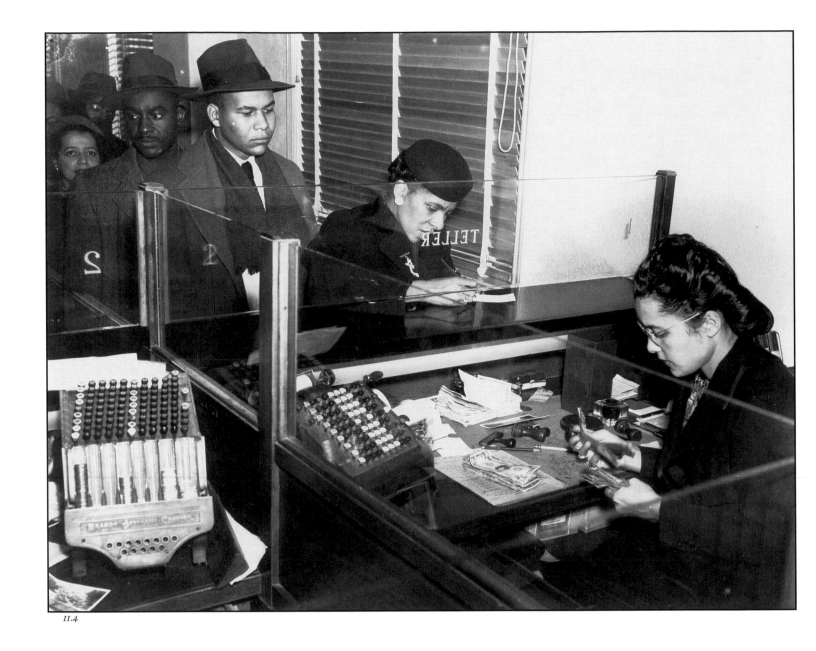

The center of black Washington in the 1940s and 1950s was the business and entertainment district located around 14th and U Streets, N.W., in the Shaw neighborhood. Robert McNeill, who received a boost for his interest in photography from an unpaid Works Progress Administration assignment to take pictures of African Americans in Virgnia, documented the life of Washington's "black Broadway," U Street, on his return from service in World War II. Among the important institutions McNeill captured in the black community was the Industrial Bank, at 11th and U (11.4). Organized by Jesse H. Mitchell in 1934, it took in deposits of $192,000 its first day and prospered by concentrating on a basic menu of home mortgages and savings accounts. Another popular business was Harrison's Cafe (11.5), at 455 Florida Avenue, N.W., not far from Howard University. One of the few places blacks could go out for a good meal, Harrison's bent the city's curfew by allowing customers to retire to private rooms upstairs for drinks after midnight. A number of beauty parlors located in the area. The Washington salon under the name of Madame C. J. Walker, whose innovation in hair treatment in the early part of the century made her nationally famous and a millionaire, did its best to pamper its customers (11.6). Because the shop also served as a training school, customers could get discounts when they chose treatment from one of the apprentices.

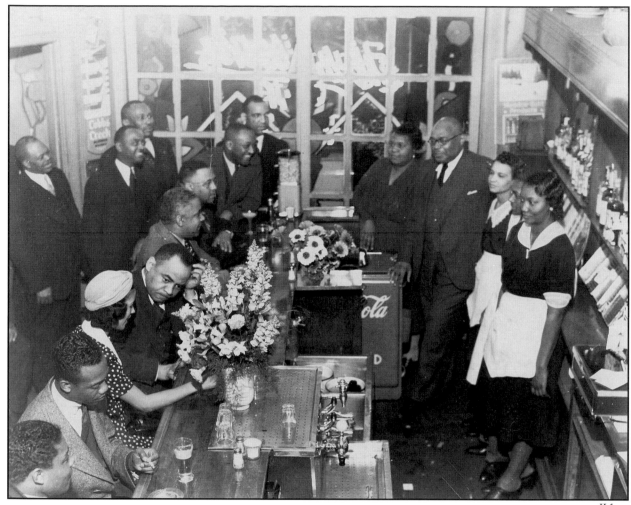

II.5

II.6

11.7

The U Street corridor was best known for its entertainment. Here patrons enter the Lincoln Theater, at 1215 U Street. Built in 1921 in the style of the grand movie palaces, the sixteen-hundred-seat theater offered both first-run movies, which black audiences could not see downtown, and stage acts that had appeared at such venues as New York's Apollo Theater. When this picture was taken the theater was at the peak of its prosperity, and its associated Colonnade dance hall was the most popular club on U Street. At the other end of the entertainment corridor, at 7th and T Streets, was the Howard Theater, which had opened in 1910 as the first legitimate theater for blacks in the country. The Howard showcased all of the top jazz performers of the 1930s through the 1950s, and crowds like that pictured here were common.

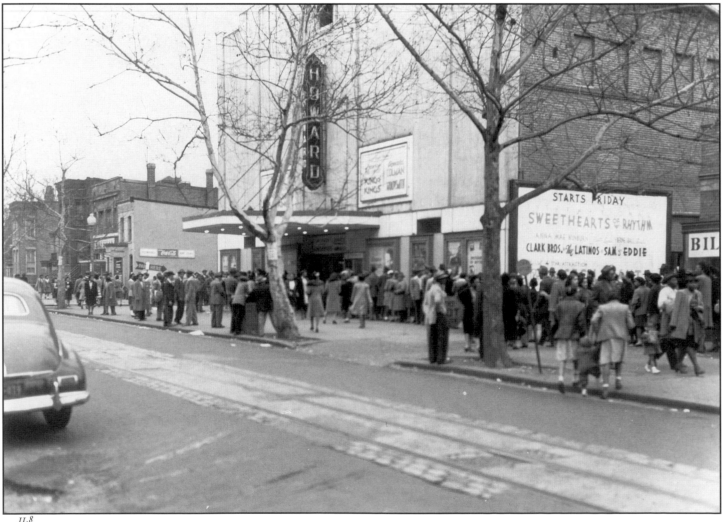

11.8

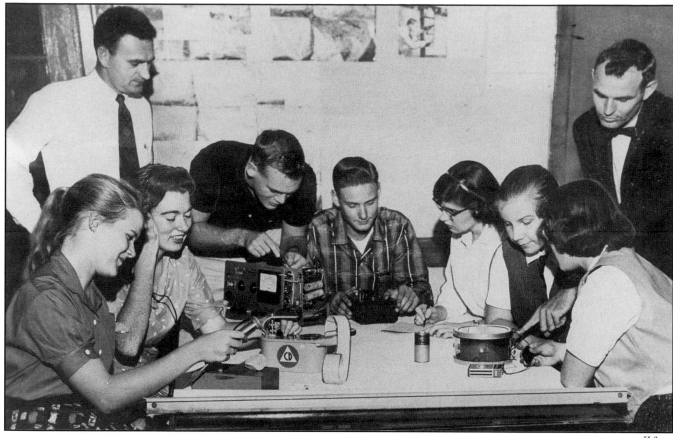

Southeast Washington east of the Anacostia was predominantly white and largely working class until the middle 1960s. At the start of the decade, only about five thousand of the nearly fifty thousand residents south of St. Elizabeth's Hospital were black. Despite the fears of school integration expressed in the 1954 protests, Anacostia High School, built twenty years earlier for the white community, was only barely affected by the change for the first several years. The year schools integrated, Anacostia reported 1,268 white and only 6 black students. A photograph from November 1958 (11.9) shows students at the school working on a science project relating to radiation. When racial change came to the far Southeast, it was remarkably swift, as both white residents and white businesses, like Curtis Brothers Furniture store (11.10), moved to the suburbs. From nearly 60 percent in 1965, the white population had shrunk to less than 15 percent just five years later. Here Curtis Brothers, at its old location on Nichols (now Martin Luther King) Avenue, kicks off its annual home furnishing demonstration in 1959, with a local beauty queen in attendance, posed under the store's trademark giant chair.

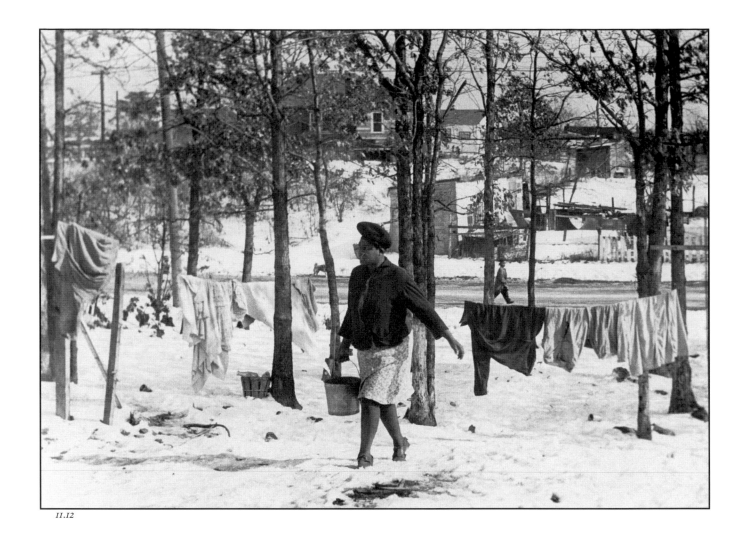

11.12

11.11

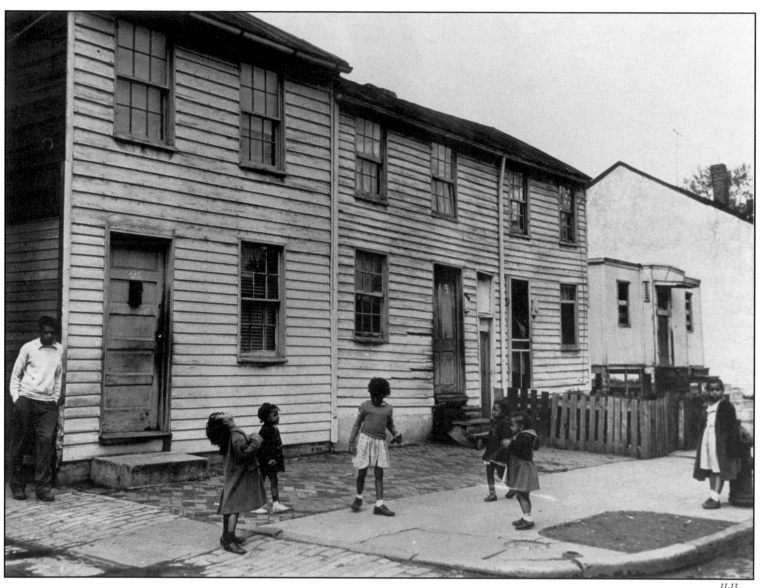

The federal government's efforts to reshape Washington's poorest areas began in earnest in the late 1940s. Congress passed several laws giving local authorities increased powers to condemn and demolish existing buildings and to replace them with public or private redevelopment projects. The most obvious targets for slum clearance were the alley dwellings, which had survived more than three decades of governmental efforts to eradicate them. Posed awkwardly in April 1949 are Senators Theodore Green, Paul Douglas, Wayne Morse, Raymond Baldwin, and Homer Ferguson on a tour, organized by Douglas, of alleys near the Capitol (11.11). On the outskirts of the city, Marshall Heights, shown here in February 1948 (11.12), was another area targeted early for redevelopment. The almost entirely black community around East Capitol, Benning Road, and Southern Avenue lacked many of the most basic municipal services. Most of the houses in the area were wood frame structures without running water, gas heat, or indoor plumbing. But, responding to community opposition to redevelopment, planners and government officials soon decided to concentrate their renewal efforts not on such outlying neighborhoods but on the city's core. In particular, they turned their attentions to southwest Washington, focusing on housing conditions such as those depicted in photo 11.13, taken at 219 F Street, S.W., in April 1949.

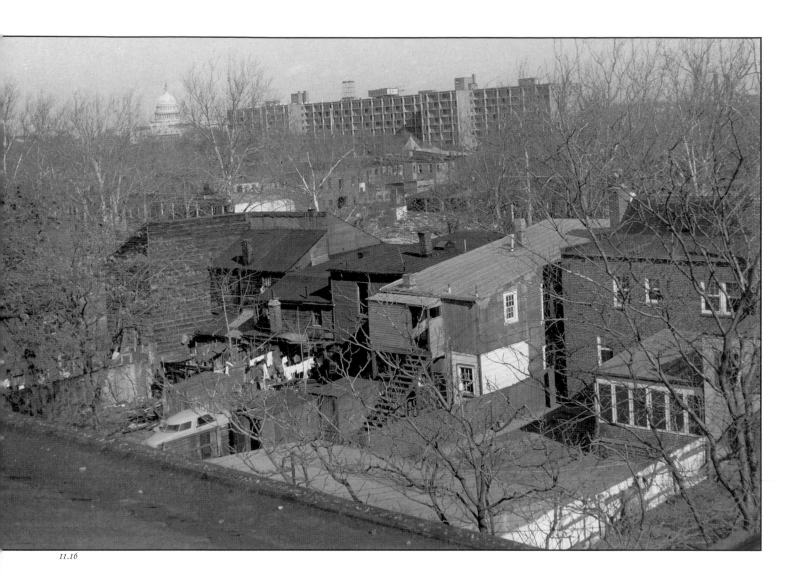

11.16

11.14

232

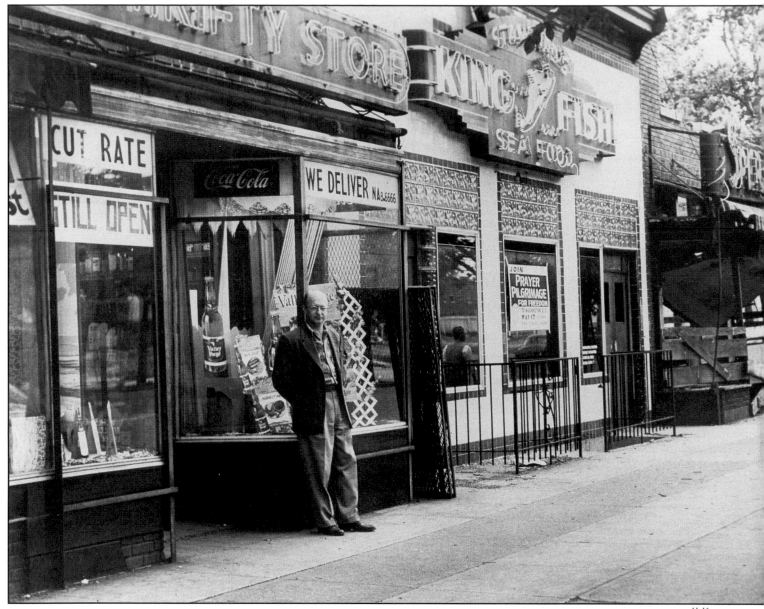

Urban redevelopment in the Southwest was intended to be comprehensive. Planners decreed that virtually the entire neighborhood be demolished and replaced by private apartment buildings and town houses, public housing projects, government buildings, and highways. Beginning in 1954, the project soon produced scenes which troubled many Washingtonians. A June 1956 photograph from the Washington *Star* labeled "Set Back by Progress" (11.14) shows Mrs. Ezra Lazar and her brother-in-law Samuel Holstein gazing at a vacant block once inhabited by patrons of their small grocery store. In 1957 Bernard Green posed in front of his liquor store at 624 4th Street (11.15), the last store remaining open on the block, once part of a bustling Jewish business district, which had included the adjacent King Fish Restaurant and Sperling Department Store. East of 4th Street, houses once occupied by blacks were replaced by public housing projects. A Redevelopment Land Agency photograph from circa 1960 (11.16) depicts the progress of redevelopment, as the crowded old houses like those in the foreground were replaced by new apartment buildings like the one beyond. But relatively few former residents could afford the new accommodations, and most were relocated to public housing projects in the Southeast or dispersed themselves throughout the city.

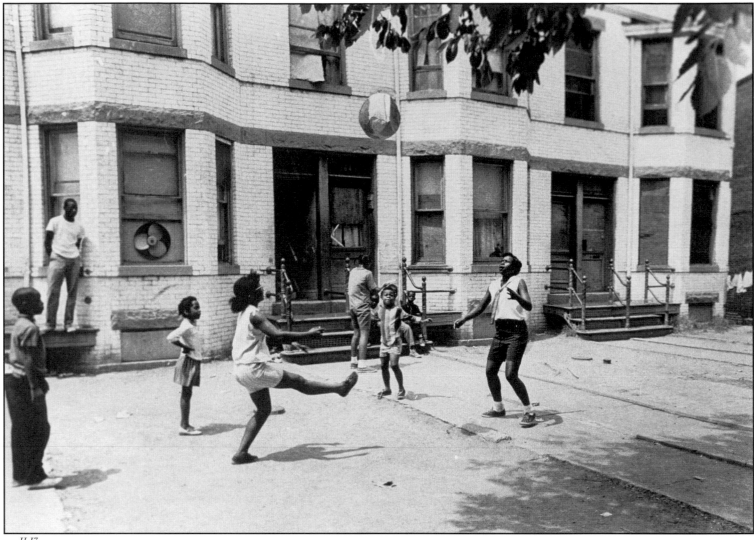

Efforts to improve living conditions by eliminating poor housing seemed to increase the need for large-scale public housing projects. In a June 1965 scene (11.17), children play on Potomac Avenue, S.E., near 14th Street and Pennsylvania Avenue, in front of their homes, scheduled for demolition. Thirty-two families faced eviction from two rows of houses that had been cited for hundreds of code violations. But the families complained that they had been unable to find other affordable housing. In the 1950s and early 1960s, high-rise apartment projects offering modern conveniences and some open space seemed an appropriate response to the problem. The Arthur Capper Dwellings at 5th and L Streets, S.E., seen here in a 1961 USIA photograph (11.18), had opened three years earlier. They were the first elevator-serviced public housing units in the city and the first major project completed since the end of the war. The photograph presents the project as a racially integrated, spacious development oriented towards working-class families with children. A similarly optimistic image is presented in photo 11.19, an August 1963 picture of the Benning Terrace project showing the Little Litter Club in action. This neighborhood had only recently changed from almost all white to overwhelmingly black. The Benning Terrace project, at Benning Road and Fitch Street, S.E., was a 281-unit complex sponsored by the Kiwanis Foundation specifically for moderate-income families displaced by urban renewal projects.

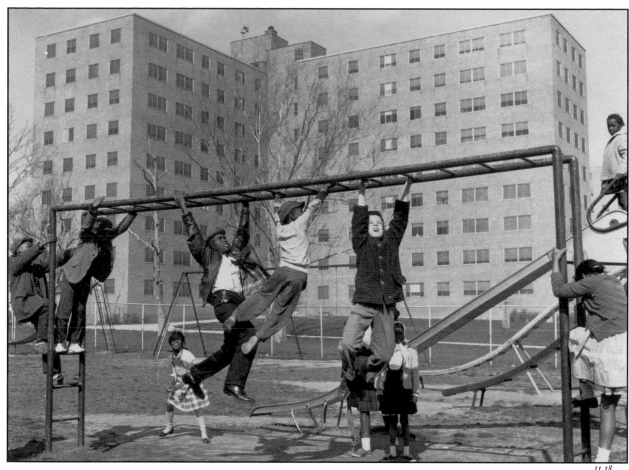

11.18

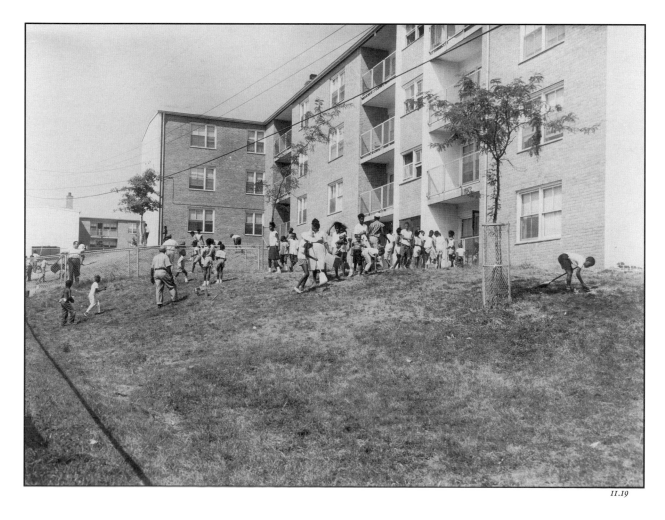

11.19

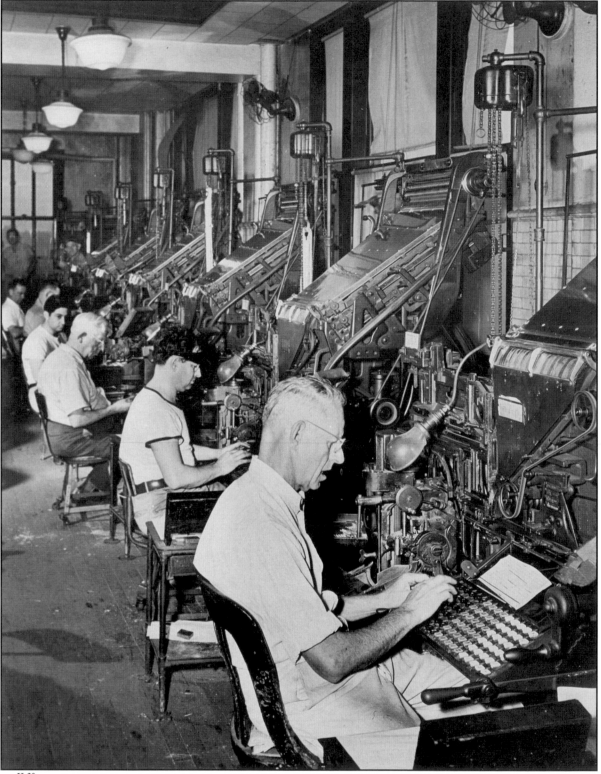

II.20

The area's changing employment pattern included stagnation or decline for many of the city's oldest industries, while service industries, except domestic and personal service, boomed. By the early 1960s, the city had fewer than twenty thousand manufacturing workers among its more than half-million employed residents. Printing and publishing remained the most important of the city's industries after the war. When this 1948 photograph of the *Star*'s linotype operators was taken, the city boasted four daily newspapers. One of these, however, was the *Times-Herald,* the result of a 1939 merger which had reduced the number from five, a precursor of the eventual demise of all major dailies except the *Post.*

The postwar economy was hard on the city's breweries, too. Heurich's Brewery, in Foggy Bottom (11.21) closed in 1956, laying off one hundred workers. The 1894 building hosted the Arena Stage for the next five years but was demolished in 1962 (11.22) to make way for approaches to the Theodore Roosevelt Bridge.

11.21

11.22

11.23

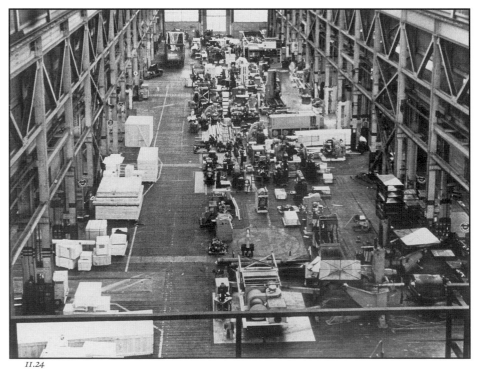

11.24

The closing of an even older Washington enterprise, the Naval Weapons Plant, drew vigorous protest from its workers, here seen marching at Ninth Street and Virginia Avenue, S.E., in April 1960. The Navy insisted that the facility was outmoded and closed it at the end of 1961. Photo 11.24, taken on the last day of that year, shows machinery crated up in one of the production areas.

II.25

The downtown shopping area along F and G Streets that had developed in the early decades of the century remained the center of the area's retail trade. A December 1948 photograph taken at 12th and F shows a typically busy scene, including trolleys, which would be phased out in favor of buses over the next decade.

II.26

II.27

The big department stores were still identified primarily with their downtown locations, and each had its own traditions and promotions. Woodward and Lothrop had an annual Christmas shopping event called Stag Night, during which only men were allowed into the store. Photo 11.26 shows male shoppers browsing in unfamiliar territory during the Stag Night of 1955. The downtown also remained the center of entertainment of all kinds. Photo 11.27 shows late night patrons of the Casablanca nightclub in September 1950. Liquor laws prohibited drinking in public establishments after midnight, even on Saturday nights. One result was the proliferation of "private" after-hours clubs, routinely subjected to raids by the vice squad. The police also paid regular visits to pinball and gaming arcades, which still thrived along 9th Street. In photo 11.28 an underage patron exits an arcade on the 500 block of 9th Street in which adults can be seen playing pinball. The occasion for this May 1952 Washington *Star* photograph was yet another raid on the street's gaming establishments.

A new and very different downtown sector emerged northwest of the old center in the two decades after World War II. This 1956 aerial photograph looks east along K Street and Pennsylvania Avenue, which intersect at Washington Circle, and depicts both the older downtown east of 15th Street, at upper center, and the newer clusters of office and apartment buildings, on upper left around Farragut Square and in right center in Foggy Bottom.

11.29

11.30

The area around Connecticut Avenue and K Street became the center of the expanding service sector and of lobbying groups and professional associations. Merchants in the old downtown clearly recognized that the split in Washington's central business district threatened their long-term livelihood. In an attempt to maintain the old shopping district in the face of competition from elsewhere within the city and from suburban shopping centers, the District government in the mid-1960s installed a mall on F Street.

242

But services and other businesses continued to move to the newer downtown. Construction like that shown here in 1964 at 20th and L Streets, N.W. (11.31) and 17th and I Streets (11.32) boomed in the newer center. Although there was nearly universal agreement that the repetitive glass and concrete blocks were an aesthetic wasteland, nevertheless central Washington avoided the economic decline that afflicted so many other downtowns in the 1960s.

11.31

11.32

Housing development in Wheaton, Maryland, May 1957

❧ 12 The Region Reshaped

The scarcities of World War II had put a premium on centrality of residential location; living close to work was important when transportation by private automobile was either difficult or impossible due to gas rationing. In contrast, postwar affluence made decentralization both possible and desirable. Government-insured housing loans and veterans' benefits became available to consumers who had delayed housing purchases for years, but in 1946 the District's housing market was the tightest in the country. Because the city itself lacked much space for new construction, the vast majority of new homes went up in the suburbs. Development followed the major transportation routes out of the city. In suburban Maryland, housing construction moved up Wisconsin Avenue into Bethesda, up Georgia Avenue into Silver Spring and Wheaton, and out Riggs Road into Hyattsville. In the 1940s the population of Maryland's suburban counties doubled: Montgomery's from 89,490 to 194,182 and Prince George's from 83,912 to 164,401. In Virginia, population rose apace. While in 1940 the city had contained 60 percent of the metropolitan population, its 663,091 far outpacing the 304,894 in the suburbs, by 1950 the suburbs had approached parity. By 1960 the proportions of city and suburban population had reversed, the outer areas claiming 63 percent of the metropolitan population of over two million.

To the natural desire of families to obtain housing at the lower prices offered in the suburbs the government added another incentive to suburbanization. In the years immediately following the war, in order to minimize the possible effects of atomic attack, key federal facilities decentralized their offices, thereby increasing employment options outside the city.

Seeking to gain a share of the government-related job growth in Washington, nearby suburban areas made their own efforts to attract new businesses, a practice most fully developed in Arlington County, Virginia. The home of many government workers in the early 1940s, Arlington attempted during the early 1960s to upgrade through urban renewal the business area located in Rosslyn, but conservative local businessmen blocked the effort. As an alternative strategy, the county adopted new zoning codes to encourage the construction of office buildings. The new regulations allowed buildings of up to twelve stories if developers were willing to pay for new streets, lighting, and sewer and water lines. Otherwise, the height of buildings was limited to thirty-five feet, or about three stories. The effort worked, and by the mid-

1960s the area just across the Potomac River from Georgetown had become the location of some fifteen thousand jobs. As the earlier lumber yards, penny arcades, liquor stores, and one-story motels gave way to office towers, Rosslyn came to be known as a "new federal city," the fourth largest concentration of trade associations in the nation. Even so, two of every three federal jobs were located in Washington, and the suburbs remained overwhelmingly residential.

Development in suburban regions tended to follow patterns established in adjacent city areas. Beyond the more affluent neighborhoods of the Northwest, builders constructed similar homes on relatively large plots in Maryland's Montgomery County. Beyond the poorer residential enclaves of Washington's Northeast and Southeast emerged more modest garden apartments in Prince George's County, hastily constructed at relatively low cost to take advantage of immediate postwar demand.

The outward flow of both population and federal jobs encouraged Washington's dominant retailers to open suburban branches. The first experiment, by Garfinckel's in 1942, remained within the city, in the neighborhood of Spring Valley. The following year, the Hecht Company opened the area's first suburban outlet, in Montgomery County. Jelleff's, Hahn's, Lerner Shops, Giant Food, People's Drug, and Sears and Roebuck soon joined Hecht's in establishing suburban locations. Woodward and Lothrop followed with a large store just over the District line on Wisconsin Avenue in the Bethesda–Chevy Chase area of Maryland. Hecht's, Kann's, and Woodward and Lothrop added Virginia stores, the first two opening branches in Arlington, and Woodward and Lothrop opening one in Alexandria. An estimated 100,000 customers took advantage of annual "Shop Silver Spring" weeks in the 1950s, receiving such prizes as European trips and a $22,500 home.

Suburban growth marched hand-in-hand with expanded automobile use, a factor that can be measured by the increases in traffic recorded in the 1940s: up 98 percent along University Boulevard, 86 percent on Wisconsin Avenue, and 78 percent on East-West Highway. Local authorities widened many major routes, including Arlington Boulevard, Shirley Highway, and Connecticut, Georgia, and New Hampshire Avenues. In order to reduce congestion, planners called as early as 1953 for an inner-county expressway—the Beltway as it came to be called—which opened in 1964. Originally conceived primarily as a bypass system to relieve the city of through traffic, the new highway quickly emerged as a central element in the development of the suburbs. This fact was immediately perceived by area businesses, including the Giant Food Company, which proclaimed on the eve of the official opening, "tomorrow . . . suburban Washington becomes one big happy family. The Beltway blazes a path for future development of our city. New clusters of suburban life will spring into existence at heretofore undeveloped areas that adjoin the spanking new concrete-and-asphalt dual ribbon." Attract new business it did. Even as the Beltway neared completion, the number of industrial parks in Montgomery County increased from one to twelve. Nine more emerged in Prince George's County. Soon much of the area between the Beltway and the city line was as fully built up as was the city.

After World War II, many predicted that Washington would suffer an economic collapse as the government cut back in both personnel and purchasing. But neither the government nor the city's population shrank. Quite the contrary. Builders, taking advantage of the availability of construction materials that had been scarce during the war, put up houses at a record rate. Despite this, a housing shortage continued into the 1950s. A solution for hundreds of families was houseboat living; shown here are Mrs. Norman Zent and her daughter in 1947. In established areas where families doubled up or new houses were squeezed onto the few remaining lots, population density soared. Arlington, Virginia, a desirable residential area because of its close proximity to government facilities on both sides of the Potomac, grew by almost 80,000 during the 1940s to 135,000 at the end of the decade. Arlington saw its public services stretched to the limit, as a 1950 photograph reveals. Here parents are visiting an overcrowded Arlington classroom before the county embarked on a major school construction program.

12.1

12.2

12.3

12.4

The availability of open land and government backed mortgages unleashed a torrent of building in the suburbs, much of it in large tract developments. Ayrlawn (12.3), just west of the expanding National Institutes of Health complex in Bethesda, Maryland, provided an ideal environment to rear children. Shown here around 1957 are Stephanie Green and her neighbor Richard Greer in front of 5910 Johnson Avenue, where she lived with her parents, Paul and Shirley Green. Architect and builder Carl Freeman, a prolific builder of Washington suburban homes, placed the living room at the back of this and other Ayrlawn houses and equipped them with generous window space, to encourage the residents to enjoy the outdoors. Suburban development found ready demand, as indicated by the line of people waiting to see a model home in Annandale, Virginia; within a few weeks of its opening in October 1950, about ten thousand visitors had inspected the model. The home offered a living room, two bedrooms, a kitchen, a bath, and a carpet, and sold for approximately $10,000. Inside (12.6), prospective buyers inspect the plat map to locate possible home sites among the hundreds planned. Although the exteriors of these homes tended to be very similar, the model's contemporary furnishings suggested ways buyers could personalize the interior and feel fashionably up-to-date. These latter two photographs and the one of Ayrlawn's construction were taken by the State Department to illustrate American affluence.

12.5

12.6

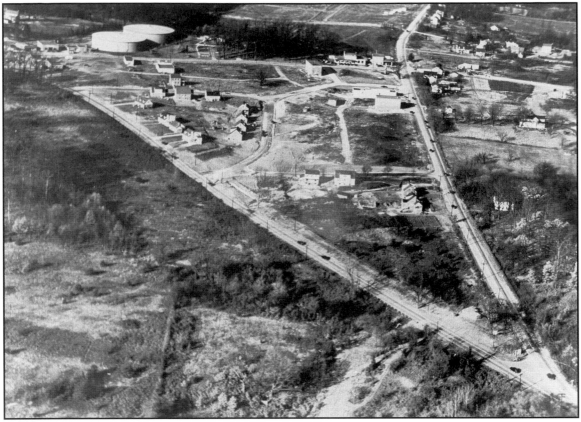

12.7

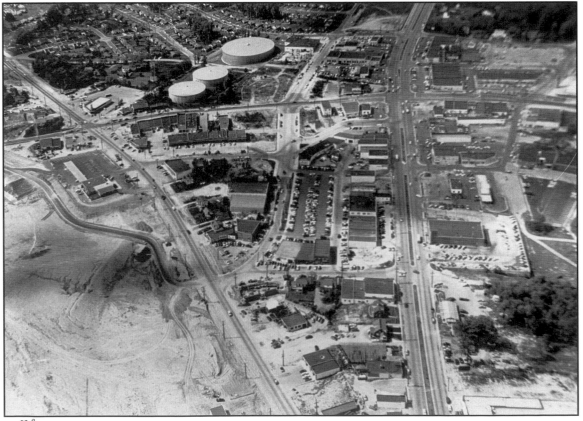

12.8

The community of Wheaton, Maryland, in many ways typified the suburban boom. An area of only scattered development in 1947, when the first photograph in this group was taken, during the next decade it rapidly filled in. In 1947, five businesses occupied the triangle formed by Georgia Avenue (to the right in 12.7), Old Bladensburg Road (now Viers Mill Road) (to the left), and the Kensington-Wheaton Road (now University Boulevard). By 1957 (12.8) they had been joined by food markets, hardware stores, barber shops, a dry cleaner, a branch bank, and a children's ballet school. When Georgia Avenue finally converted from a narrow hardtop road to a modern dual highway in 1953, the town staged a massive parade in celebration.

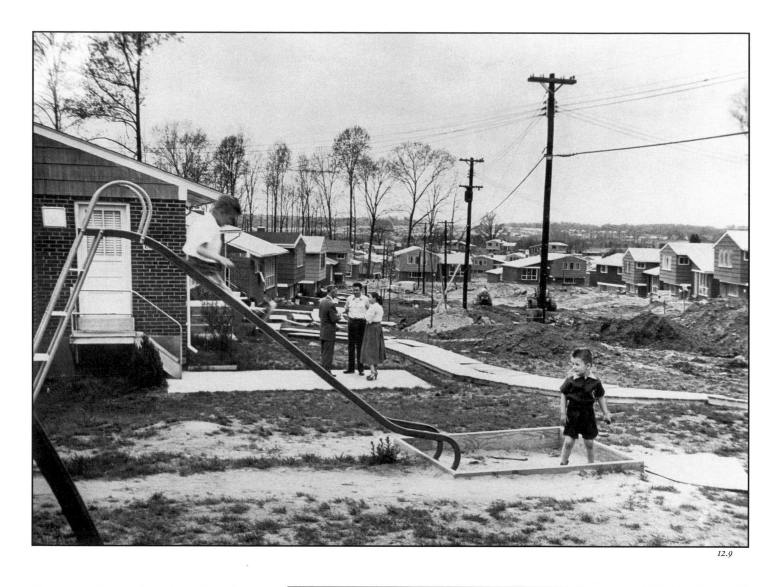

Photo 12.9 shows a brand new housing development in Wheaton in 1955. With costs at less than $20,000, couples found these homes sufficiently attractive to ignore the unfinished landscaping. A 1955 overview of the area (12.10) shows the extent of development west of Georgia Avenue (on the right). The curvilinear pattern of suburban development stands in marked contrast to the grid of urban development. At right center is an essential element of the growing community, the new Wheaton High School. On the left, Connecticut Avenue, with its widely separated lanes, proceeds north and then curves out towards open land that was soon to be developed.

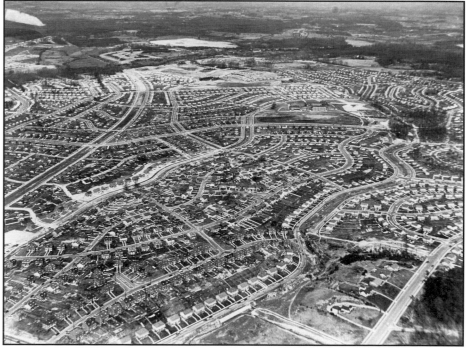

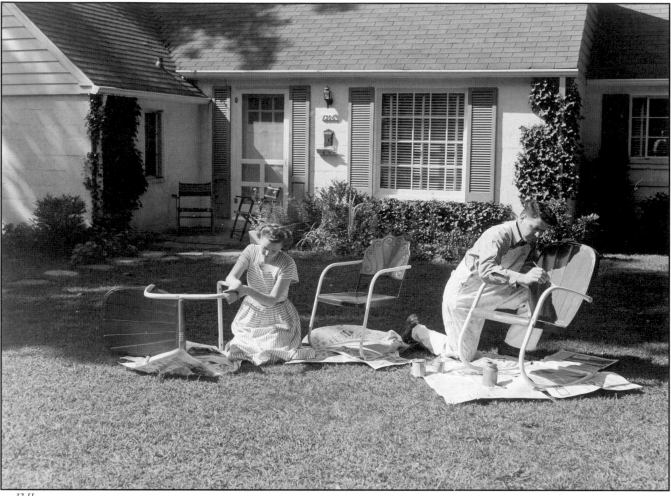

12.11

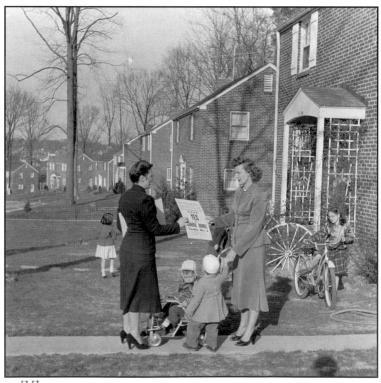

12.12

The new suburbs were intensely family oriented, as the two State Department photographs here were meant to convey. In the first, Mr. and Mrs. Walter Mess, of Seaton Lane in Falls Church, Virginia, work together painting the furniture for their carefully manicured lawn in front of their well-kept home. New communities spawned new civic organizations, and the school needs created by the postwar baby boom attracted the attention or these groups. The second photograph captures an advocate of a new school bond issue making her pitch to an interested mother in Arlington in 1950. The issue, the third school bond proposal in four years, was thoroughly debated. With the new census indicating there were more children under five than the eighteen thousand already in the school system (see photo 12.2), and with forty-nine sections of students going to school in quarters not designed for school use, a coalition of twelve countywide organizations formed to circulate pamphlets promoting the bond issue.

The automobile left a lasting imprint on the suburban landscape, as an aerial view taken around 1949 indicates. At the top is the Pentagon, on the Virginia shore of the Potomac River, nestled in a web of highway interchanges and parking lots. To the left is the Shirley Highway, initially built during World War II with defense money; to the right are the Jefferson Davis Highway (Route 1) and the George Washington Parkway (far right). The land between these highways became the site for the Crystal City office corridor that was developed in the 1960s.

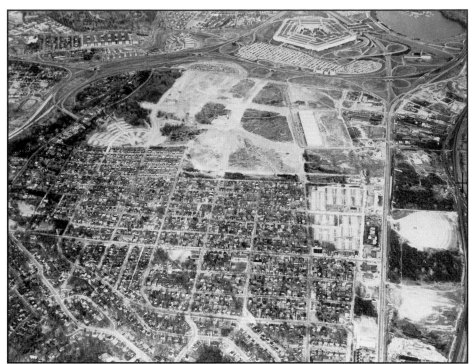

12.13

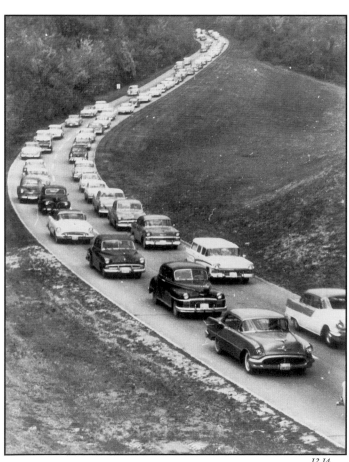

12.14

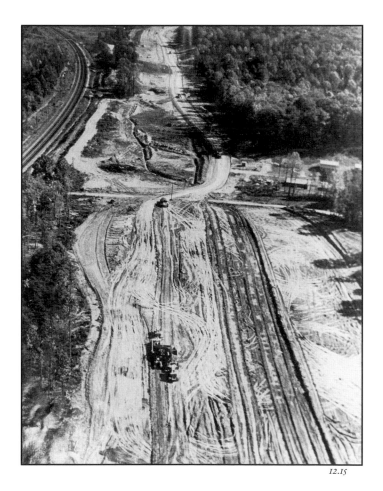

12.15

Getting to work in Washington proved a problem, despite ambitious road building. As early as 1959, traffic backed up on the approach to the Key Bridge in Georgetown along the George Washington Memorial Highway (photo 12.14). Another aerial view (12.15) shows construction of the Capital Beltway cutting through Prince George's County in the early 1960s. Although the land nearby was still open, that changed quickly, as the highway encouraged developers to build suburban tracts ever farther from the city.

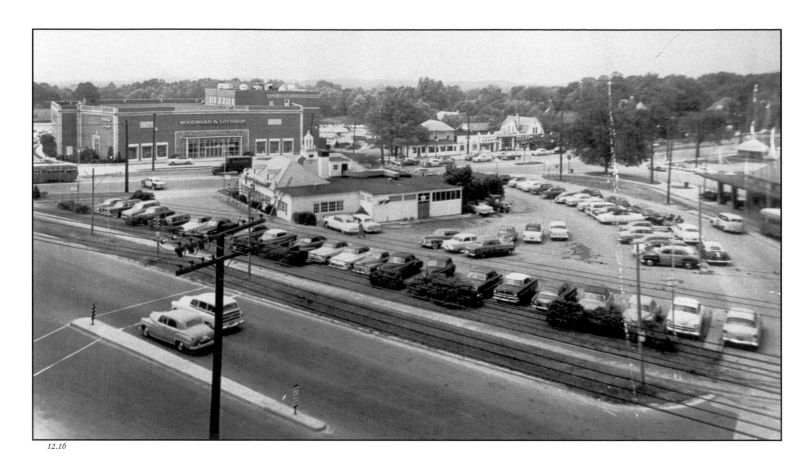

12.16

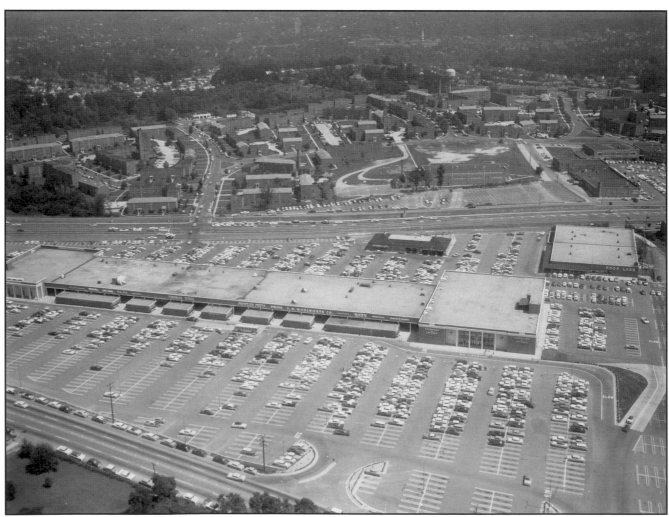

12.17

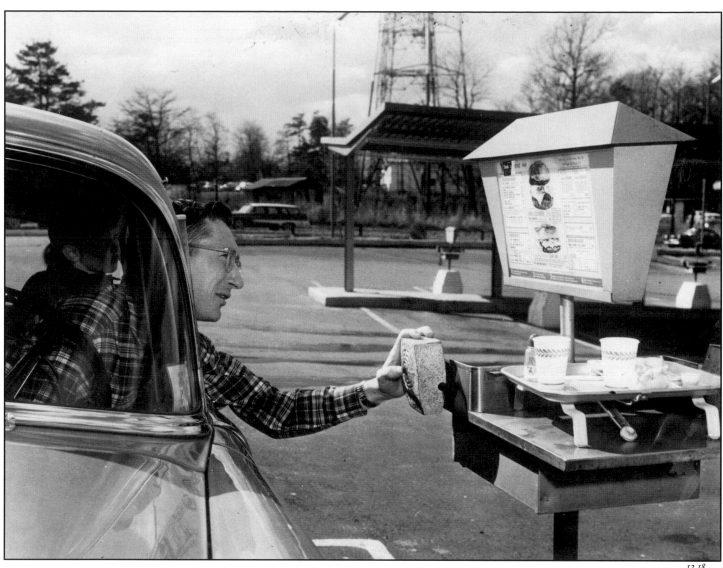

It was only a matter of time before commerce followed the flow of residential development to the suburbs. The new Chevy Chase Shopping Center, when it opened in 1954 (12.16) on Wisconsin Avenue just beyond the District line at Western Avenue, featured a branch of Woodward and Lothrop described in advertising circulars as being easy to reach and having a "super-size parking lot with easy approach from three streets." Developed by Garfield Kass, a Rockville native, and his son-in-law Irving Berger, who originally came to Washington to work at in the Internal Revenue Service, the new center spawned even more ambitious centers farther from the city core. Several years later, Kass and Berger opened Seven Corners Shopping Center on a thirty-three-acre tract in Fairfax County, Virginia. Taking its name from the convergence of major highways in the area, the new center (12.17) provided parking for twenty-five hundred cars. Branches of the downtown department stores Woodward and Lothrop and Garfinckel's provided the anchors for what was becoming a standard shopping center format. Beyond the shopping center, filling an area of equal size, are the Willston Apartments, the first high-density dwelling units built on a large scale in the county. Another commercial entity serving the automobile-dependent suburbanite, the fast food outlet, quickly appeared. Photo 12.18 shows the drive-through ordering station of the Tops Restaurant outlet in Arlington, at the intersection of the George Mason and Lee highways.

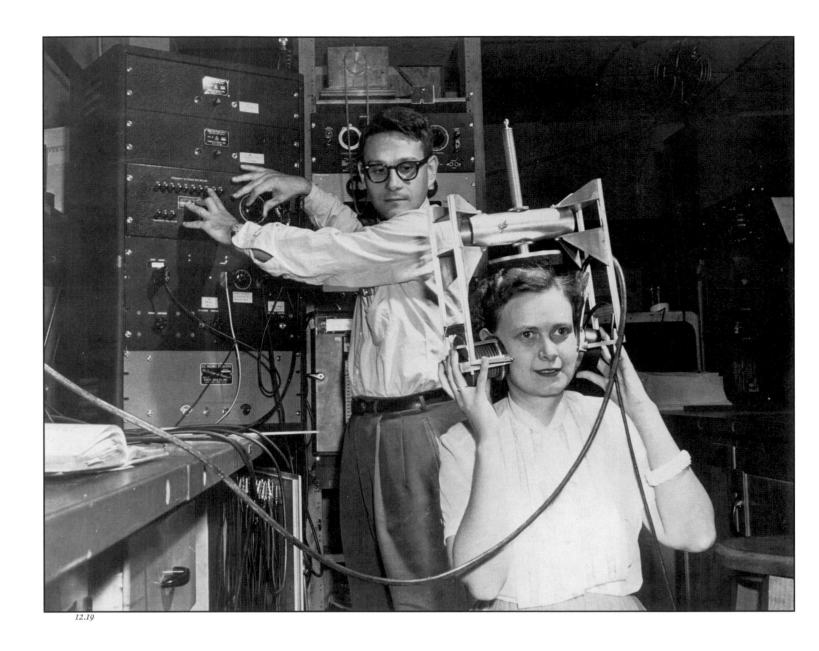

12.19

One of the forces driving the expansion of the metropolitan area was the government's growing role in sponsoring scientific and defense-related research. These efforts required not just vast facilities but highly trained workforces, and locating the sites near new homes proved a happy marriage between work and residence in the growing outer suburbs. This USIA photograph illustrates new hearing equipment being tested at the National Bureau of Standards in Gaithersburg, Maryland.

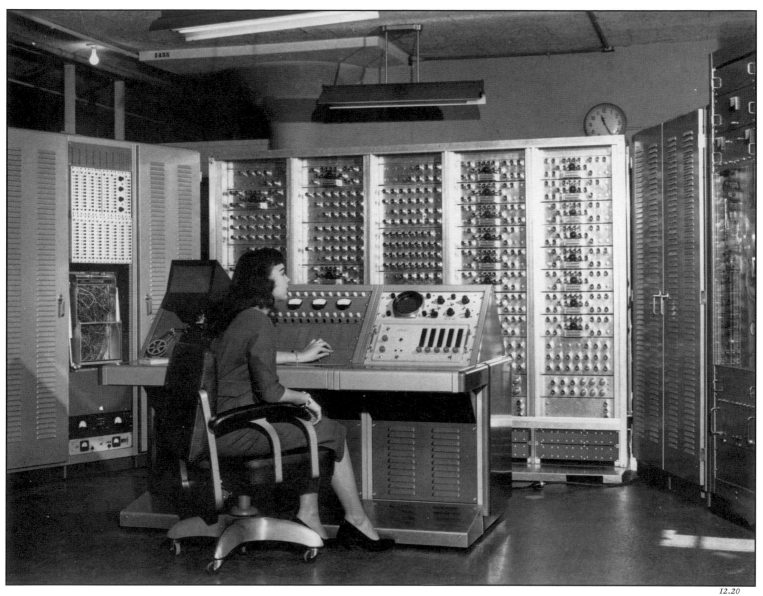

12.20

A massive new computer being put to use at the Census Bureau at Suitland, Maryland, in 1959 is shown in this USIA photograph. The computer, called FOSDIC, for Film Optical Sensing Device for Input to Computer, translated information from census microfilm to computer tape at the rate of ten inches of film per second.

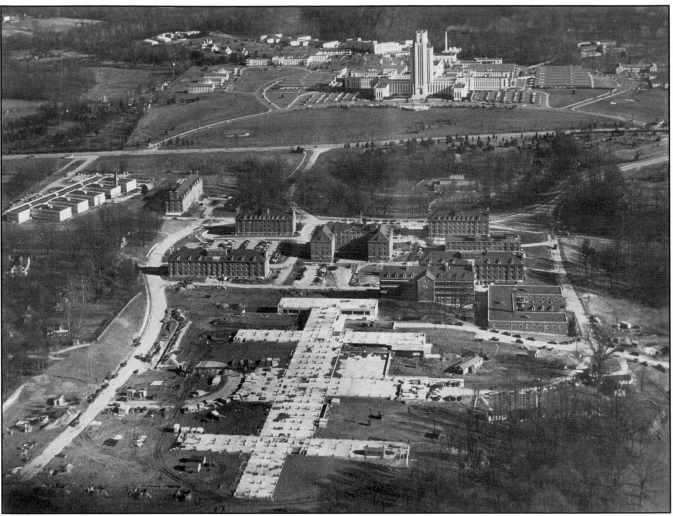

12.21

12.23

Among the more important among the federal government's suburban facilities was the National Institutes of Health, in Bethesda, Maryland. Shown under construction in 1950 (12.21) is the new clinical center. The center provided a rich source of employment opportunities for skilled mechanics, like these instrument makers, shown in 1956 (12.22), as well as research scientists. A product of the Cold War, the Goddard Space Center was cut out of forest in Beltsville, Maryland, as is obvious in a 1961 aerial photograph (12.23). The Baltimore-Washington Parkway, seen in the foreground, and the Capital Beltway, completed in 1964, accelerated development in the area, and the open land seen here quickly filled in with houses and commercial facilities. Inside the space center (12.24), a scientist conducts a vibration test on a space payload in 1961. Together with Washington's other suburban defense- and information-related government facilities, Goddard revealed the geographic impact of the a postindustrial economy.

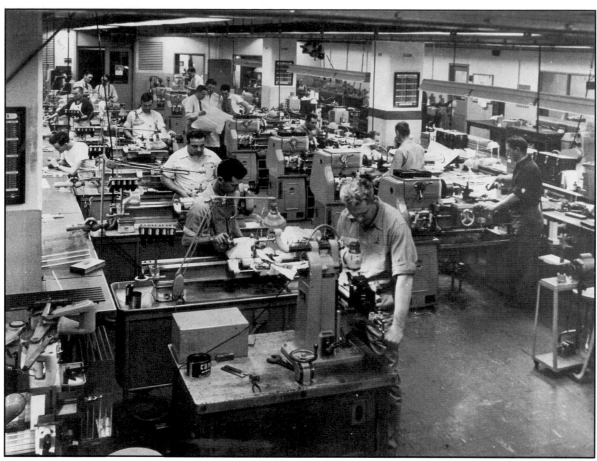

12.22

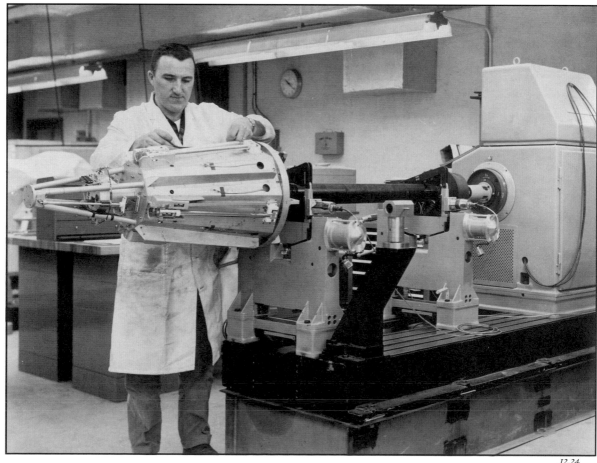

12.24

The changing suburb — Wisconsin Avenue, Bethesda, 1994

Epilogue

The wars of the 1960s—in Vietnam abroad and against poverty at home—further expanded the government's presence in Washington, adding eighty-eight thousand new federal jobs during the decade. Job growth slowed during the next fifteen years, but activities associated with government, including federally funded research, defense contracts, and the presence of more than two thousand trade and professional associations, helped make the Washington area one of the fastest growing regions in the country. In a postindustrial period when government, information, and services dominated the economy, the Washington metropolitan area underwent the kind of transformation that later helped create the sunbelt boom. In the last years of the 1980s, Washington had the fastest growing white-collar job market in North America and Europe.

Growth was metropolitan, not urban. For while the entire metropolitan area grew from just over two million to more than four million people between 1964 and 1994, the city of Washington continued to lose population; from over 750,000, the District's population fell to under 600,000. At 85 percent of the metropolitan population, Washington's suburbanites dominated to an extent exceeded in the United States only by Atlanta.

In the 1960s the federal government did, however, reverse the Cold War policy of dispersing its facilities throughout the region, and thus assured a continuing job concentration at the core of the city. But as federal employment fell from roughly 40 percent to only a quarter of metropolitan jobs between 1940 and 1965, the expanding private sector exemplified the national trend to decentralize. By the early 1990s more than half the metropolitan population both worked and lived in the suburbs. Moreover, suburban residents found it possible to satisfy the whole range of modern needs, from leisure time activity to specialized services, without ever having to travel to the city. The area's basketball and hockey teams located in suburban Maryland, and despite the prospect in 1994 of luring them downtown, the city's chief sporting franchise, the Redskins football team, spoke of moving to Maryland. The Kennedy Center provided a prime cultural attraction in the city when it opened in 1971, but it too faced competition from the suburbs: from Wolf Trap Farm and George Mason University's Patriot Center in Northern Virginia and from Merriweather Post Pavilion in suburban

Maryland, as well as a host of smaller cultural centers. Professionals, such as accountants and lawyers, although slow to follow retailers, also opened branch offices in the suburbs. Washington's largest private employer, George Washington University, established a campus in Northern Virginia. Although it employed more than eleven thousand faculty and nonstudent workers, George Washington's largest economic impact in 1993 was on suburban Maryland, which received half the university's direct and indirect expenditures. Even 41 percent of the District's own forty-five thousand employees lived outside the city.

While the federal government had less direct impact on suburban development in the 1980s than earlier, it continued to help determine the particular character of the metropolitan area. As federal employment in the Washington area fell from over a quarter in 1970 to under a fifth in 1987, federal purchasing of goods and services more than made up for declining government employment. Federal purchases in the metropolitan area reached nearly $7 billion in 1983—more than in any but four states in the nation—and the largest portion was from Washington's suburbs. In addition to defense expenditures for goods, military employment represented a significant factor in the local economy through the years of the Cold War. In 1986, for instance, the Department of Defense employed, in Northern Virginia alone, 98,324 full-time active-duty military personnel and some 106,000 civilians, most of whose offices were concentrated near the Pentagon. Overall, the Department of Defense provided $3.2 billion of the $5 billion in federal contracts and about half the federal employment in Northern Virginia. The Crystal City office corridor that emerged between the Pentagon and National Airport in the 1970s became in the 1980s a prime location for defense contractors, with almost all of its seven million square feet of office space given over to that use. The location of other defense-related industries between Tysons and Dulles Airport, at the boundary between Fairfax and Loudoun counties, was stimulated both by the opening of a new toll road in the area and by massive government expenditures in the 1980s for the Strategic Defense Initiative.

Completion of the Capital Beltway in 1964 accelerated the pace of decentralization, easing movement between suburban jurisdictions, and encouraging concentration of new employment and retail centers at the Beltway's chief interchanges. The most prominent example of this creation of suburban centers emerged in Northern Virginia at Tyson's Corner. The site of only a country store in 1945, by the mid-1980s the location held an office complex housing more than twenty-seven thousand jobs in sixteen million square feet of office space, making it the second largest employment center in the region. A similar "edge city" emerged around another transportation center, Dulles Airport. Although relatively isolated when it opened in 1962, Dulles soon stimulated phenomenal development, becoming the focal point for 80 percent of Northern Virginia's commercial growth during the 1970s. In the process, Fairfax County, once a country preserve for the area's well-to-do, diversified and surpassed all other local jurisdictions in population.

In the 1970s and 1980s, an influx of new government funding, this time for biomedical research, generated yet another business corridor, this one along Interstate 270 in Maryland's Montgomery County, where the National Institutes of Health were

located. The creation of twenty thousand new jobs among one hundred firms in this area between 1980 and 1982 alone contributed to the rapid growth of nearby towns in upper Montgomery County. The town of Gaithersburg, for instance, grew from eight thousand to more than fifty-four thousand residents in the course of a decade. Of the many new jobs generated in Montgomery County in the 1980s, a third went to technical professionals, many of them engineers. In Prince George's County, the location of the Beltsville Agricultural Station and the Goddard Space Center near the Baltimore-Washington Parkway also stimulated growth, including the conversion of a once barren 350-acre tract eight miles from Washington into a booming town of sixteen thousand called New Carrollton. By the mid-1980s seventeen suburban centers—all containing more jobs than bedrooms and referred to as "factories of the Information Age"—surrounded the historic urban core.

Expected to help sustain the prosperity of the downtown when it opened in 1976, the area's Metro subway system instead encouraged creation of more competing urban nodes outside the city. By 1990, 12 regional malls and at least 120 shopping centers were located within a 25-minute drive of the average suburban home. Watching their own commercial districts decline under this competition, older suburban areas in Alexandria, Arlington, Bethesda, and Silver Spring seized the opportunity offered by subway stops to encourage new development. In place of the low-scale and familiar Woolworth's dime store and Lowen's toy store that stood on Wisconsin Avenue, the Bethesda Metro station inspired, for instance, a twelve-story Hyatt hotel, a seventeen-story office building, and a three-story arcade of restaurants and boutiques. To these were added apartments, a concession to two-career families who valued the easy accessibility to jobs either in the city or the suburbs. At Arlington's Clarendon and Ballston subway stops developers marketed new complexes of apartment, office, retail, and sports facilities to upwardly mobile professionals.

As older residential areas gave way to high-rise buildings, the demography of Washington's inner suburbs shifted from the traditional single-family residence of the original suburbs to smaller living units. During the 1970s, population declined in all the inner suburban jurisdictions. The portions of Montgomery and Prince George's counties that lay inside the Beltway each dropped in population by about 10 percent, as did Arlington County and Falls Church in Virginia. Household size dropped in the older Maryland cities of Bethesda, Silver Spring, Chevy Chase, and Rockville. According to the 1990 census, only 37 percent of households in Arlington and 33 percent in Alexandria included a married couple.

With the buildup of the inner suburbs, the locus of traditional suburban family living shifted outside the Beltway to Fairfax and Loudoun counties in Virginia and to the outer reaches of Montgomery and Prince George's counties. Despite urban development in the eastern portion of Fairfax County, household size there held at 3.4 in the 1980s, as builders continued to construct single-family homes throughout most of the county. The other counties contiguous to Washington's first ring of suburbs grew substantially during the 1970s and 1980s, leading to the observation that the suburbs were producing their own suburbs.

As the suburbs boomed, the city of Washington did not wither, at least as long as

general prosperity continued. In defiance of a retail drain from city to suburbs, the city's oldest department stores, Hecht's and Woodward and Lothrop, built or rehabilitated stores downtown in the mid-1980s. Office development at the city core accelerated. Although Washington ranked only sixteenth in population among American cities, it had the third largest concentration of commercial office space. As land prices rose, modern structures replaced many of the older buildings in the city core. Even as merchants applauded the demolition of the tawdry strip of burlesque houses along 14th Street, other older businesses—such as Rich's Shoe Store, which had been located downtown for more than a century, S. S. Kresge, and Morton's and Garfinckel's department stores—went out of business. In place of the last small-scale service establishments arrived armies of lawyers, accountants, economists, and other government- and information-related professionals.

Residential Washington continued to undergo its own transformation. The 1968 riots that followed the murder of Martin Luther King, Jr., in addition to devastating several older midtown commercial strips, accelerated white flight to the suburbs. Outside the city core, the most pronounced changes in racial composition were in Anacostia, which saw a drop in white population from two-thirds in 1960 to less than 15 percent a decade later, and Mount Pleasant, where the black population rose from a quarter to nearly two-thirds during the same period. Drastic as such shifts in demography appeared at the time, they were not always permanent; Mount Pleasant had shifted back to a fairly even racial mix by 1990, having nearly equal white, black, and Hispanic populations. Parts of Washington remained home to white-collar professionals, notably the area west of Rock Creek Park and select intown neighborhoods, such as Foggy Bottom, Dupont Circle, Adams-Morgan, and Capitol Hill, that became "gentrified" during the 1970s and 1980s. The character of the city as a whole changed, however, as much of the middle class—black as well as white—moved out. Part of the reason for the shift was the decline in blue-collar and clerical jobs, the victims of computers and other modern technologies. Just as important to black migrants from the city was the lure of better housing and school opportunities in the suburbs. After open occupancy extended to the suburbs in 1968, a growing number of the black middle class—an estimated 20 percent in the 1970s alone—followed the lead of their white counterparts a generation earlier. In the course of a single generation, the majority of the area's black population moved to the suburbs; Prince George's County became the nation's only suburban county with a black majority.

Migration left the District of Columbia more socially divided than ever. Although Washington's median income ranked highest among the nation's largest cities, gross figures could not hide the poverty at the lower end of the social scale. Thirty percent of the city's population, 180,000 people, received welfare assistance in 1990. Half the District's black families were headed by a woman, compared to a third twenty years earlier. Already a city divided between federal and local identities, Washington became a premier example of a two-tiered economy: one reliant on a shrinking base of blue-collar opportunities, the other geared to highly skilled professionals.

Washington's entire history has been characterized by such complex relationships: between local and federal, black and white, the powerful and the dispossessed.

America's ascent to the apex of world power during and after World War II heightened awareness and concern over the gap between democratic ideals and the disturbing realities of unfulfilled opportunity within the city of Washington. Visually, the contrast provided an easy target, and photographers have often portrayed the two aspects of the city in opposition to one another. Such images extend those advanced in earlier periods of activism, especially the Progressive and New Deal eras. Examination of a larger range of photographic images of Washington's history, however, reveals much in common with—not apart from—the experience of the nation's other major cities.

Note on Sources

Photographic resources for studying Washington's history are rich and diverse. Most of the photographs in this book came from four major repositories: the Historical Society of Washington, D.C., the Library of Congress, the Martin Luther King, Jr., Public Library, and the National Archives. We also drew, however, on a number of smaller repositories and private collections.

The Historical Society of Washington, D.C. (founded in 1894 as the Columbia Historical Society) has an extensive collection of photographs focusing on the private side of life in Washington and on the physical city. The collection is especially rich in late-nineteenth- and early-twentieth-century materials. At the Historical Society, we used the central photographic reference collection, which includes many images donated by John Clagett Proctor, a long-time chronicler of life in the District, and the Goode, Jeunemann, McLean, Street Lighting, and Taft collections.

Library of Congress photographic holdings relating to Washington are detailed in Kathleen Collins, *Washingtonian Photographs: Collections in the Prints and Photographs Division of the Library of Congress,* published by the Library in 1989. The collections we found most useful were those of the National Photograph Company, Theodor Horydczak (a commercial photographer), the Farm Security Administration (later Office of War Information), *US News & World Report,* Lewis Hine (National Child Labor Committee), and Frances Benjamin Johnston. We drew as well upon a street survey of Washington conducted at the turn of the century and on the Library's general Washingtoniana print collection.

The Martin Luther King, Jr., Public Library (the D.C. public library system's central downtown branch) has a useful general collection of local photographs. Its unique resource, however, is the photographic morgue of the *Washington Star,* which incorporates that of the *Washington Daily News,* which predeceased the *Star*. The newspaper collection is particularly strong for the years from 1945 until 1981, when it went out of business, but also includes considerable material dating back to the 1920s. The photographs are supplemented by the newspaper's clipping and vertical files, which are by themselves an outstanding resource for modern Washington history.

Because the District of Columbia was governed directly by the federal government for so long, the National Archives contain much local material. The Archives' *Guide to the Still Pictures Branch* provides summaries of its collections, or Record Groups as they are known. Most of our photographs come from the holdings of the Treasury Department (Record Group 56), Commission of Fine Arts (66), Works Progress Administration (69),

Signal Corps (111), Public Buildings Service (121), Office of War Information (208), United States Information Agency (306), and National Capital Planning Commission (328).

In addition to tapping the collections of these four institutions, we have used photographs from the District of Columbia Archives, the Moorland-Spingarn Research Center at Howard University, the Jewish Historical Society of Greater Washington, the Montgomery County Historical Society, Peerless Rockville, and the Smithsonian Institution Archives. We have also drawn upon photographs collected for an exhibition on the Italian-American community, which are now on deposit in the Department of Special Collections of George Washington University's Gelman Library.

To interpret the photographs, we used a variety of primary and secondary sources, mainly at the King Library and the Historical Society. City directories and property atlases supplemented the information found on the photographs themselves and in the King Library's newspaper files. Guides to the city were useful, especially the WPA's 1937 *Washington: City and Capital,* in the Federal Writers' Project's *American Guide Series.* Among secondary sources, we found especially informative *Washington: City of Magnificent Intentions,* compiled by Keith Melder (Washington, D.C.: Intac, 1983), which was developed for use in the city's schools. Also invaluable were the two-volume compilation by Constance McLaughlin Green, *Washington: A History of the Capital, 1800–1950* (Princeton: Princeton University Press, 1976) and the following additional works: Kathryn Schneider Smith, editor, *Washington at Home: An Illustrated History of Neighborhoods in the Nation's Capital* (Northridge, Calif.: Windsor Publications, 1988); National Capital Planning Commission, with Frederick Gutheim, consultant, *Worthy of a Nation: The History of Planning for the National Capital* (Washington, D.C.: Smithsonian Institution, 1977); Pamela Scott and Antoinette Lee, *Buildings of the District of Columbia* (New York: Oxford University Press, 1993); James Goode, *Capital Losses: A Cultural History of Washington's Destroyed Buildings* (1979), and James Goode, *Best Addresses: A Century of Washington's Distinguished Apartment Houses* (1988), both published by the Smithsonian Institution Press. We also used drafts of *Between Justice and Beauty: Race, Planning, and the Failure of Urban Policy in Washington, D.C.,* by Howard Gillette, Jr. (Baltimore: Johns Hopkins University Press, 1995).

Among our other secondary sources were James Borchert, *Alley Life in Washington: Family, Community, Religion and Folklife in the City, 1850–1970* (Urbana: University of Illinois Press, 1980); Douglas Evelyn and Paul Dickson, *On This Spot: Pinpointing the Past in Washington, D.C.* (Washington, D.C.: Farragut Publishing, 1992); David Brinkley, *Washington Goes to War* (New York: Knopf, 1988); Cindy Aron, *Ladies and Gentlemen of the Civil Service: Middle-class Workers in Victorian America* (New York: Oxford University Press, 1987); Howard Gillette, Jr., and Alan Kraut, "The Evolution of Washington's Italian American Community, 1890–World War II," *Journal of American Ethnic History* 6 (Fall 1986): 7–27; Carl Abbott, "Dimensions of Regional Change in Washington, D.C.," *American Historical Review* 95 (December 1990): 1367–94; and, on the subject of Washington panoramas, *Capital View: A New Panorama of Washington, D.C.,* a volume published by the National Museum of American Art in 1994.

We consulted important photographic essays appearing in *Washington History,* the journal of the Historical Society of Washington, as well: Jane Freundel Levey, "The Scurlock Studio," 1 (Spring 1989): 41–57; Leo J. Kasun, "Henry Arthur Taft: Glimpses of Everyday Life," 2 (Spring 1990): 50–67; and Barbara Orbach and Nicholas Natanson, "The Mirror Image: Black Washington in World War II–Era Federal Photography," 4 (Spring–Summer 1992): 4–25.

Photo Credits

The photographs in this volume are reproduced courtesy of, and where necessary by permission of, the institutions and individuals listed below.

Clark-Lewis, Elizabeth: 9.15
Cropp, Dwight: 7.23
District of Columbia Archives: 4.10, 5.24, 11.2
District of Columbia Public Library: 1.8, 1.14, 1.20, 1.21, 1.29, 4.1, 4.9, 4.17, 4.19, 5.7, 5.13, 6.20, 7.20, 8.2, 8.28, 9.13, 9.24, 11.30, 12.14
District of Columbia Department of Housing and Community Development: 11.16
Foraker, Julia B.: 6.13
Frankel, Godfrey: 7.17, 8.4, 8.16
Gelman Library, George Washington University: frontispiece, 3.32, 8.17
Gillette, Howard, Jr.: E.0
Green, Shirley L.: 12.4
Historical Society of Washington, D.C.: P.0, P.3, 1.0, 1.7, 1.9, 1.10–13, 1.16–19, 1.25, 1.26, 2.0, 2.5–7, 2.9, 2.11–13, 2.16–18, 2.20, 2.21, 2.23, 2.24, 2.27, 3.15, 3.16, 3.23, 3.34, 4.6, 4.11, 4.20, 4.21, 5.1, 5.3, 5.9–12, 5.14–16, 5.26, 6.7, 6.8, 6.10, 6.12, 6.14, 7.16, 7.21, 8.27, 9.8, 9.11, 11.29
Jewish Historical Society of Greater Washington: 2.22, 3.20, 4.16, 5.0, 6.5, 6.24, 8.6
Langston, Raymond: 6.11
Library of Congress: P.1, P.2, 1.1–6, 1.15, 1.22–24, 1.27, 2.1, 2.3, 2.4, 2.8, 2.14, 2.15, 2.29, 2.30, 3.1–4, 3.9, 3.12, 3.19, 3.21, 3.22, 3.28–31, 3.33, 4.0, 4.3, 4.7, 4.12, 4.13, 4.15, 4.18, 5.4, 5.5, 5.8, 5.17, 5.18, 5.21, 5.23, 5.25, 5.27, 6.0, 6.6, 6.15, 6.22, 6.23, 6.25, 6.26, 6.29, 7.4, 7.6, 7.14, 7.15, 7.17, 7.18, 7.26–28, 8.0, 8.1, 8.5, 8.8, 8.10–14, 8.18–21, 8.23–25, 9.0, 9.3, 9.5, 9.9, 9.12, 9.16, 9.17, 9.20, 9.21, 9.25, 10.14, 10.20, 11.3, 11.19, 11.31, 11.32
Longstreth, Richard: 12.13
McNeill, Robert: 8.26, 11.4–8
Montgomery County Historical Society: 5.28, 8.9, 8.22, 8.31
Moorland-Spingarn Research Center, Howard University: 2.19, 2.28, 3.24, 6.16, 6.17, 6.19, 6.27, 6.28, 10.13
Mt. Zion United Methodist Church: 2.26, 6.2
National Archives: 1.28, 2.2, 3.5–8, 3.10, 3.11, 3.13, 3.14, 3.17, 4.2, 4.4, 4.8, 4.14, 5.2, 5.6, 5.19, 5.20, 5.22, 6.21, 7.0, 7.1, 7.3, 7.5, 7.7, 7.8, 7.10–13, 7.29, 8.3, 8.7, 9.1, 9.4, 9.7, 9.10, 9.19, 9.22, 9.23, 10.1, 10.2, 10.6–9, 10.11, 10.15, 10.19, 10.21, 11.18, 11.20, 12.2, 12.3, 12.5, 12.6, 12.11, 12.12, 12.17–20, 12.23, 12.24
Peerless Rockville: 5.29, 6.9
Robinson, Adelaide J.: 6.18
Smithsonian Institution Archives: 2.10, 3.0, 3.18, 4.5
St. Aloysius Catholic Church: 6.3
St. Mary's Episcopal Church: 6.1
Washington Hebrew Congregation: 2.25, 6.4
© Washington Post, by permission of D.C. Public Library: 3.25–27, 7.2, 7.9, 7.19, 7.22, 7.24, 7.25, 8.15, 8.29, 8.30, 9.2, 9.6, 9.14, 9.18, 10.0, 10.3–5, 10.10, 10.12, 10.16–18, 10.22–25, 11.0, 11.1, 11.9–15, 11.17, 11.21–28, 12.0, 12.1, 12.7–10, 12.15, 12.16, 12.21, 12.22

Index